Picture Bible Old Testament

Volume 2
I Samuel 16
to
Malachi

Also in this series:

Picture Bible Old Testament

Volume 2

I Samuel 16 to Malachi

Script by Iva Hoth

Illustrations
by André Le Blanc

Bible Editor
C. Elvan Olmstead, Ph.D

SCRIPTURE UNION
47 Marylebone Lane, London W1M 6AX

© 1973 David C. Cook Publishing Company, Elgin, Illinois 60120
First published 1973
First published in this edition 1978 by Scripture Union, 47
Marylebone Lane, London W1M 6AX.

ISBN 0 85421 532 8

Printed in Great Britain by Purnell & Sons Ltd.
Paulton (Bristol) and London.

ILLUSTRATED STORIES

FOREWORD

Much of the information we receive comes to us visually—on television, through adverts, in newspapers. So we find it increasingly hard to concentrate on a mass of solid print.

This is why the Picture Bible has been produced. It is for everyone for whom reading can be a boring chore. It is not designed to displace the more usual Bible, but it is a Bible reading aid, a way-in for people to read and enjoy the Bible for themselves.

The Brazilian artist, André Le Blanc, researched and checked each detail of the artwork, making many trips to the Middle East and visiting villages where the way of life has barely changed since Bible times. He studied the landscape of Palestine and the features and facial expressions of its people.

As a result, the Bible stories are presented vividly and accurately. Palestine becomes a real place, and the Roman and Eastern worlds living cultures. Above all, the men and women of the Bible are seen as real people who knew God in their everyday experiences.

It is our aim that men and women of today may meet this same God as they read the Picture Bible.

KINGS AND PROPHETS

We will have a king . . .
That we also may be
like all the nations.
And the Lord said to Samuel,
Hearken unto their voice,
and make them a king.
. . . and he shall know that
there is a prophet in Israel.

I SAMUEL 8: 19, 20, 22;
II KINGS 5: 8

A Giant's Challenge

FROM I SAMUEL 16: 23—17: 26

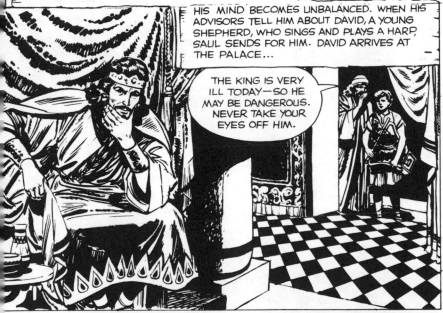

TWICE KING SAUL DELIBERATELY DISOBEYS GOD. THE PROPHET, SAMUEL, HAS TOLD HIM THAT HIS KINGDOM WILL BE TAKEN FROM HIM. SAUL IS AFRAID—AND AT TIMES HIS MIND BECOMES UNBALANCED. WHEN HIS ADVISORS TELL HIM ABOUT DAVID, A YOUNG SHEPHERD, WHO SINGS AND PLAYS A HARP, SAUL SENDS FOR HIM. DAVID ARRIVES AT THE PALACE...

THE KING IS VERY ILL TODAY—SO HE MAY BE DANGEROUS. NEVER TAKE YOUR EYES OFF HIM.

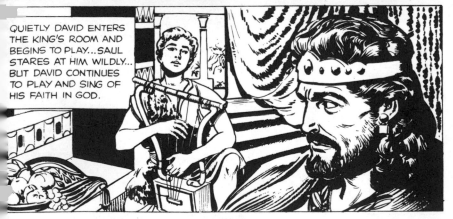

QUIETLY DAVID ENTERS THE KING'S ROOM AND BEGINS TO PLAY...SAUL STARES AT HIM WILDLY... BUT DAVID CONTINUES TO PLAY AND SING OF HIS FAITH IN GOD.

AT LAST KING SAUL RELAXES AND FALLS QUIETLY ASLEEP. AFTER THAT DAVID IS OFTEN CALLED TO THE PALACE. HIS MUSIC QUIETS SAUL'S TORTURED MIND—AND IN TIME THE KING SEEMS WELL AGAIN.

AND WHEN WORD COMES THAT THE PHILISTINES ARE PREPARING FOR AN ATTACK, SAUL LEADS HIS ARMY AGAINST THEM. DAVID'S THREE OLDEST BROTHERS JOIN THE KING'S FORCES.

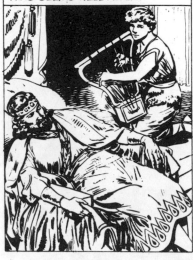

ONE EVENING DAVID COMES IN FROM THE FIELDS TO FIND HIS FATHER BUSY PACKING FOOD.

THIS IS FOR YOUR BROTHERS. I WANT YOU TO TAKE IT TO THEM.

I'LL LEAVE RIGHT AWAY. WHAT'S THE LATEST NEWS FROM THE FRONT?

NOT GOOD, AND I'M WORRIED.

WHEN DAVID REACHES THE ISRAELITE CAMP, HE FINDS THE SOLDIERS STRANGELY QUIET.

WHAT'S THE MATTER?

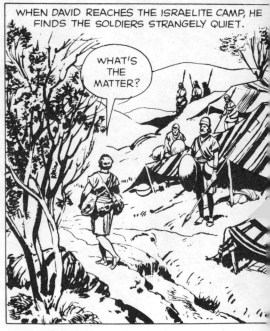

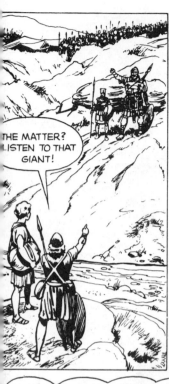

THE MATTER? LISTEN TO THAT GIANT!

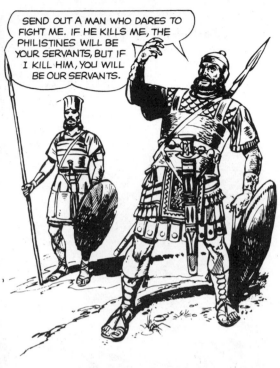

SEND OUT A MAN WHO DARES TO FIGHT ME. IF HE KILLS ME, THE PHILISTINES WILL BE YOUR SERVANTS, BUT IF I KILL HIM, YOU WILL BE OUR SERVANTS.

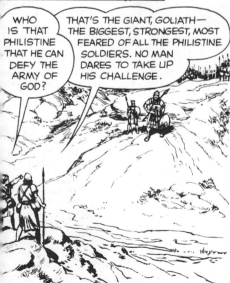

WHO IS THAT PHILISTINE THAT HE CAN DEFY THE ARMY OF GOD?

THAT'S THE GIANT, GOLIATH— THE BIGGEST, STRONGEST, MOST FEARED OF ALL THE PHILISTINE SOLDIERS. NO MAN DARES TO TAKE UP HIS CHALLENGE.

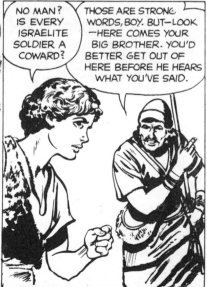

NO MAN? IS EVERY ISRAELITE SOLDIER A COWARD?

THOSE ARE STRONG WORDS, BOY. BUT—LOOK —HERE COMES YOUR BIG BROTHER. YOU'D BETTER GET OUT OF HERE BEFORE HE HEARS WHAT YOU'VE SAID.

309

The Challenge Is Met

FROM I SAMUEL 17: 28-48

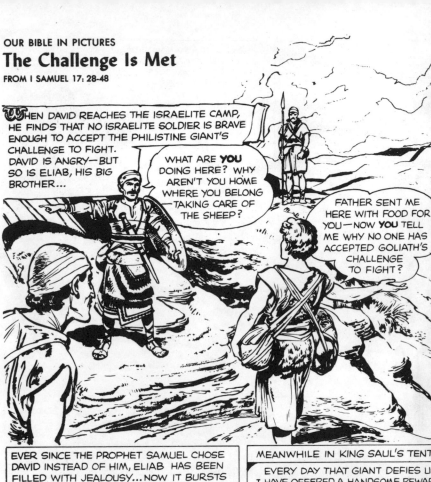

THEN DAVID REACHES THE ISRAELITE CAMP, HE FINDS THAT NO ISRAELITE SOLDIER IS BRAVE ENOUGH TO ACCEPT THE PHILISTINE GIANT'S CHALLENGE TO FIGHT. DAVID IS ANGRY—BUT SO IS ELIAB, HIS BIG BROTHER...

WHAT ARE **YOU** DOING HERE? WHY AREN'T YOU HOME WHERE YOU BELONG—TAKING CARE OF THE SHEEP?

FATHER SENT ME HERE WITH FOOD FOR YOU—NOW **YOU** TELL ME WHY NO ONE HAS ACCEPTED GOLIATH'S CHALLENGE TO FIGHT?

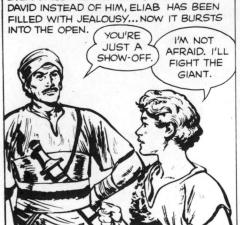

EVER SINCE THE PROPHET SAMUEL CHOSE DAVID INSTEAD OF HIM, ELIAB HAS BEEN FILLED WITH JEALOUSY...NOW IT BURSTS INTO THE OPEN.

YOU'RE JUST A SHOW-OFF.

I'M NOT AFRAID. I'LL FIGHT THE GIANT.

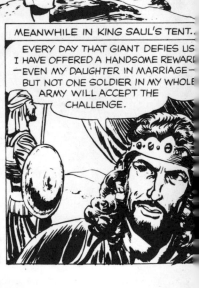

MEANWHILE IN KING SAUL'S TENT...

EVERY DAY THAT GIANT DEFIES US I HAVE OFFERED A HANDSOME REWARD—EVEN MY DAUGHTER IN MARRIAGE—BUT NOT ONE SOLDIER IN MY WHOLE ARMY WILL ACCEPT THE CHALLENGE.

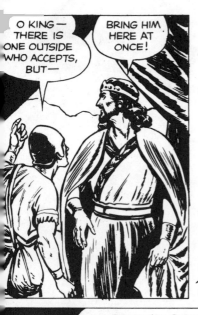

O KING— THERE IS ONE OUTSIDE WHO ACCEPTS, BUT—

BRING HIM HERE AT ONCE!

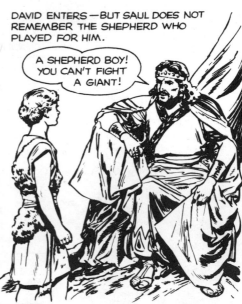

DAVID ENTERS—BUT SAUL DOES NOT REMEMBER THE SHEPHERD WHO PLAYED FOR HIM.

A SHEPHERD BOY! YOU CAN'T FIGHT A GIANT!

THE LORD WHO HELPED ME KILL A LION AND A BEAR WILL HELP ME NOW.

MAYBE YOU'RE RIGHT— AT LEAST YOU HAVE COURAGE, GO, AND THE LORD BE WITH THEE. YOU CAN WEAR MY OWN ARMOR.

I CAN'T WEAR THIS— I'M NOT USED TO FIGHTING IN ARMOR. BESIDES, MY PLAN IS NOT TO DEFEND MYSELF, BUT TO ATTACK!

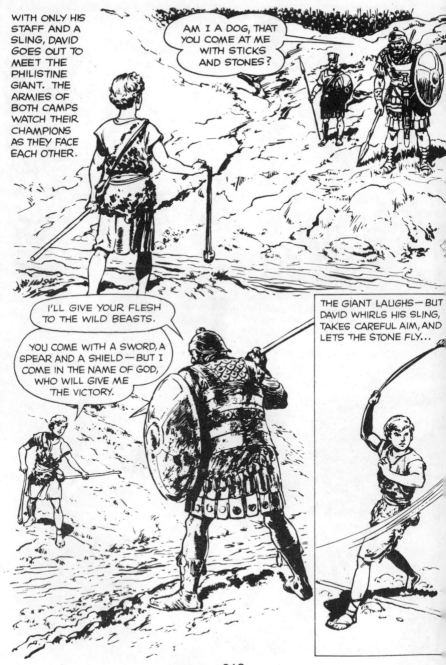

WITH ONLY HIS STAFF AND A SLING, DAVID GOES OUT TO MEET THE PHILISTINE GIANT. THE ARMIES OF BOTH CAMPS WATCH THEIR CHAMPIONS AS THEY FACE EACH OTHER.

AM I A DOG, THAT YOU COME AT ME WITH STICKS AND STONES?

I'LL GIVE YOUR FLESH TO THE WILD BEASTS.

YOU COME WITH A SWORD, A SPEAR AND A SHIELD — BUT I COME IN THE NAME OF GOD, WHO WILL GIVE ME THE VICTORY.

THE GIANT LAUGHS — BUT DAVID WHIRLS HIS SLING, TAKES CAREFUL AIM, AND LETS THE STONE FLY...

312

The Jealous King

FROM I SAMUEL 17: 48—18: 9

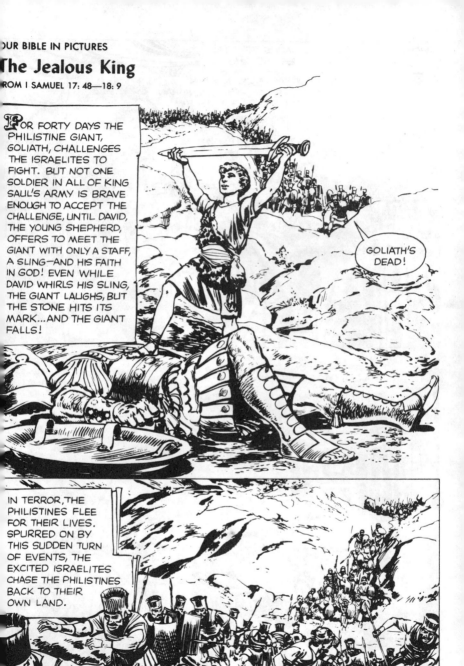

FOR FORTY DAYS THE PHILISTINE GIANT, GOLIATH, CHALLENGES THE ISRAELITES TO FIGHT. BUT NOT ONE SOLDIER IN ALL OF KING SAUL'S ARMY IS BRAVE ENOUGH TO ACCEPT THE CHALLENGE, UNTIL DAVID, THE YOUNG SHEPHERD, OFFERS TO MEET THE GIANT WITH ONLY A STAFF, A SLING—AND HIS FAITH IN GOD! EVEN WHILE DAVID WHIRLS HIS SLING, THE GIANT LAUGHS, BUT THE STONE HITS ITS MARK...AND THE GIANT FALLS!

GOLIATH'S DEAD!

IN TERROR, THE PHILISTINES FLEE FOR THEIR LIVES. SPURRED ON BY THIS SUDDEN TURN OF EVENTS, THE EXCITED ISRAELITES CHASE THE PHILISTINES BACK TO THEIR OWN LAND.

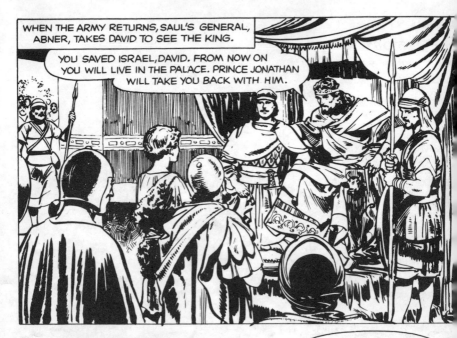

WHEN THE ARMY RETURNS, SAUL'S GENERAL, ABNER, TAKES DAVID TO SEE THE KING.

YOU SAVED ISRAEL, DAVID. FROM NOW ON YOU WILL LIVE IN THE PALACE. PRINCE JONATHAN WILL TAKE YOU BACK WITH HIM.

DAVID AND JONATHAN BECOME TRUE FRIENDS— AND MAKE A PACT OF FRIENDSHIP.

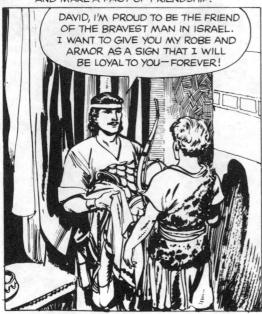

DAVID, I'M PROUD TO BE THE FRIEND OF THE BRAVEST MAN IN ISRAEL. I WANT TO GIVE YOU MY ROBE AND ARMOR AS A SIGN THAT I WILL BE LOYAL TO YOU—FOREVER!

THANK YOU, JONATHAN. GOD IS MY WITNESS THAT I WILL BE YOUR FRIEND UNTIL DEATH.

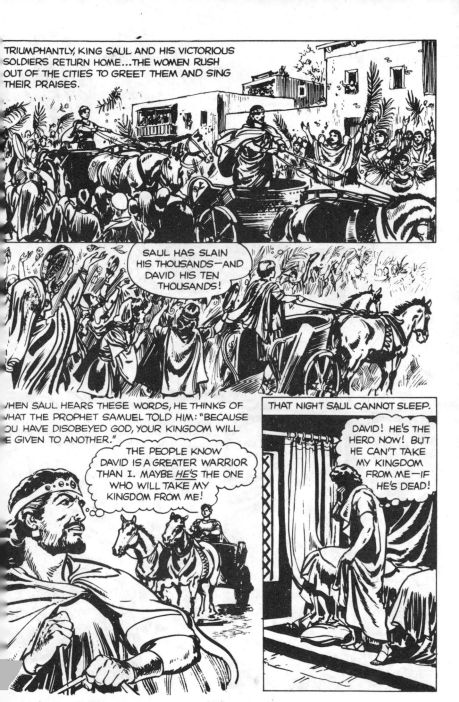

TRIUMPHANTLY, KING SAUL AND HIS VICTORIOUS SOLDIERS RETURN HOME...THE WOMEN RUSH OUT OF THE CITIES TO GREET THEM AND SING THEIR PRAISES.

SAUL HAS SLAIN HIS THOUSANDS—AND DAVID HIS TEN THOUSANDS!

WHEN SAUL HEARS THESE WORDS, HE THINKS OF WHAT THE PROPHET SAMUEL TOLD HIM: "BECAUSE YOU HAVE DISOBEYED GOD, YOUR KINGDOM WILL BE GIVEN TO ANOTHER."

THE PEOPLE KNOW DAVID IS A GREATER WARRIOR THAN I. MAYBE *HE'S* THE ONE WHO WILL TAKE MY KINGDOM FROM ME!

THAT NIGHT SAUL CANNOT SLEEP.

DAVID! HE'S THE HERO NOW! BUT HE CAN'T TAKE MY KINGDOM FROM ME—IF HE'S DEAD!

315

Plot to Kill

FROM I SAMUEL 18: 10—19: 11

WHEN THE PEOPLE SING THEIR PRAISES TO DAVID, SAUL BECOMES JEALOUS. HIS JEALOUSY DRIVES HIM ALMOST MAD AS HE THINKS THAT DAVID MIGHT BE THE ONE WHO WILL TAKE HIS KINGDOM FROM HIM. TO SAUL THERE IS ONLY ONE ANSWER—GET RID OF DAVID!

NO MAN CAN TAKE MY KINGDOM FROM ME!

THE KING'S INSANE!

LET'S CALL DAVID—HIS MUSIC HELPED THE KING BEFORE!

DAVID COMES AT ONCE AND PLAYS FOR THE KING. SAUL GLARES AT HIM STRANGELY. TOYS WITH HIS SPEAR...

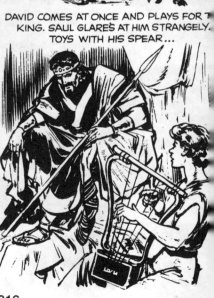

...THEN HURLS IT STRAIGHT AT DAVID. BUT DAVID IS TOO QUICK... HE DODGES THE SPEAR AND ESCAPES.

A FEW DAYS LATER SAUL MAKES ANOTHER ATTEMPT TO KILL DAVID. BUT AGAIN HE MISSES. FINALLY HE HAS A NEW IDEA...

MAYBE IT'S BEST THAT I DON'T KILL DAVID. THE PEOPLE MIGHT TURN AGAINST ME. I MUST MAKE HIS DEATH LOOK ACCIDENTAL—OR IN BATTLE. THAT'S IT— IN BATTLE!

SAUL'S CHANCE COMES SOONER THAN HE EXPECTS...

PRINCESS MICHAL IS IN LOVE WITH DAVID, BUT DAVID SAYS HE IS TOO POOR TO MARRY THE DAUGHTER OF A KING.

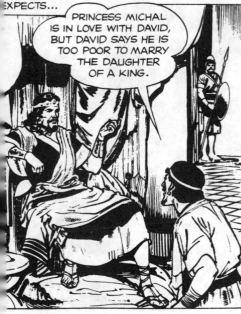

TELL DAVID THAT THE ONLY GIFT I WANT FROM HIM IS ONE HUNDRED DEAD PHILISTINES.

THIS IS BETTER THAN I HAD HOPED.

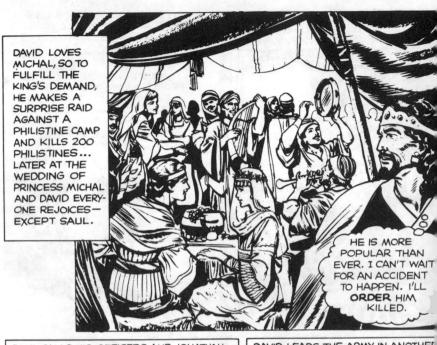

DAVID LOVES MICHAL, SO TO FULFILL THE KING'S DEMAND, HE MAKES A SURPRISE RAID AGAINST A PHILISTINE CAMP AND KILLS 200 PHILISTINES... LATER AT THE WEDDING OF PRINCESS MICHAL AND DAVID EVERYONE REJOICES— EXCEPT SAUL.

HE IS MORE POPULAR THAN EVER. I CAN'T WAIT FOR AN ACCIDENT TO HAPPEN. I'LL **ORDER** HIM KILLED.

SAUL CALLS HIS OFFICERS AND JONATHAN TO HIM AND ORDERS THEM TO PUT DAVID TO DEATH.

BUT, FATHER, HE RISKED HIS LIFE TO SAVE US. WHY DO YOU WANT TO KILL AN INNOCENT MAN?

YOU ARE RIGHT. AS THE LORD LIVES, DAVID SHALL NOT BE KILLED.

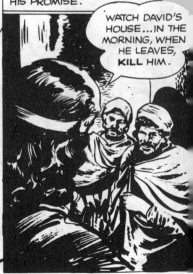

DAVID LEADS THE ARMY IN ANOTHER SUCCESSFUL BATTLE AGAINST THE PHILISTINES. SAUL'S JEALOUSY INCREASES... AND IN ANGER HE BREAKS HIS PROMISE.

WATCH DAVID'S HOUSE... IN THE MORNING, WHEN HE LEAVES, **KILL** HIM.

scape in the Night

OM I SAMUEL 19: 11-22

KING SAUL IS AFRAID THAT DAVID MIGHT SOME DAY TAKE HIS KINGDOM FROM HIM. SEVERAL TIMES SAUL ATTEMPTS TO KILL DAVID, BUT EACH TIME HE FAILS. NOW HE ORDERS TWO OF HIS MEN TO GO TO DAVID'S HOUSE, AND KILL HIM.

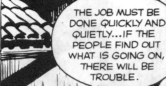

THE JOB MUST BE DONE QUICKLY AND QUIETLY... IF THE PEOPLE FIND OUT WHAT IS GOING ON, THERE WILL BE TROUBLE.

YOU'RE RIGHT— DAVID GETS MORE POPULAR EVERY DAY.

BUT EVEN AS SAUL'S MEN PLAN THEIR EVIL WORK, MICHAL WARNS HER HUSBAND...

HAVE LEARNED THAT Y FATHER PLANS TO ILL YOU. YOU MUST SCAPE BEFORE DAYLIGHT.

BUT HE PROMISED JONATHAN HE WOULDN'T HARM ME.

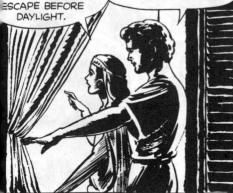

THEN HE HAS CHANGED HIS MIND AGAIN—HIS MEN ARE ON THEIR WAY HERE RIGHT NOW. YOU MUST LEAVE BY THE BACK WINDOW. PLEASE—DAVID— BEFORE IT IS TOO LATE.

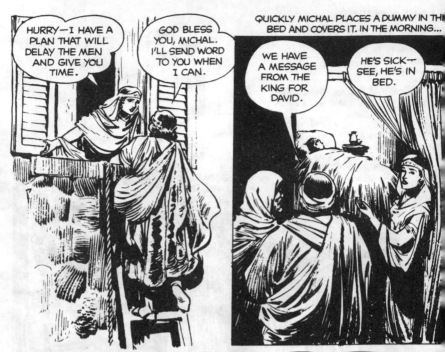

HURRY—I HAVE A PLAN THAT WILL DELAY THE MEN AND GIVE YOU TIME.

GOD BLESS YOU, MICHAL. I'LL SEND WORD TO YOU WHEN I CAN.

QUICKLY MICHAL PLACES A DUMMY IN THE BED AND COVERS IT. IN THE MORNING...

WE HAVE A MESSAGE FROM THE KING FOR DAVID.

HE'S SICK— SEE, HE'S IN BED.

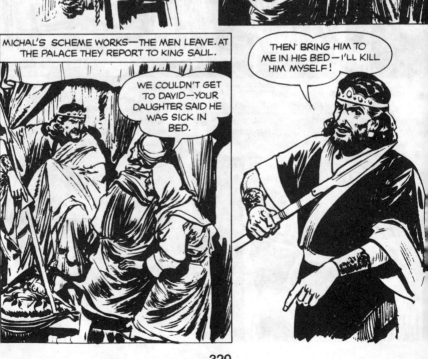

MICHAL'S SCHEME WORKS—THE MEN LEAVE. AT THE PALACE THEY REPORT TO KING SAUL.

WE COULDN'T GET TO DAVID—YOUR DAUGHTER SAID HE WAS SICK IN BED.

THEN BRING HIM TO ME IN HIS BED—I'LL KILL HIM MYSELF!

320

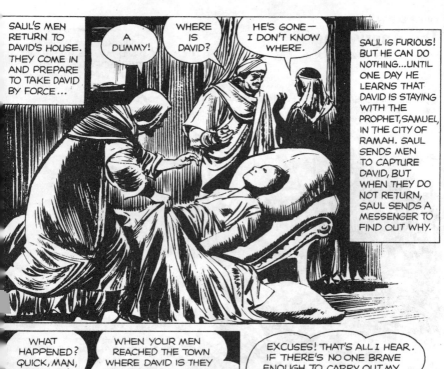

SAUL'S MEN RETURN TO DAVID'S HOUSE. THEY COME IN AND PREPARE TO TAKE DAVID BY FORCE...

A DUMMY!

WHERE IS DAVID?

HE'S GONE— I DON'T KNOW WHERE.

SAUL IS FURIOUS! BUT HE CAN DO NOTHING...UNTIL ONE DAY HE LEARNS THAT DAVID IS STAYING WITH THE PROPHET, SAMUEL, IN THE CITY OF RAMAH. SAUL SENDS MEN TO CAPTURE DAVID, BUT WHEN THEY DO NOT RETURN, SAUL SENDS A MESSENGER TO FIND OUT WHY.

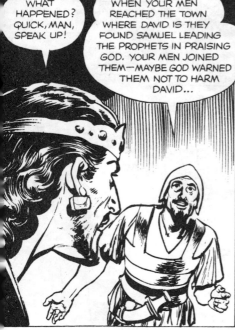

WHAT HAPPENED? QUICK, MAN, SPEAK UP!

WHEN YOUR MEN REACHED THE TOWN WHERE DAVID IS THEY FOUND SAMUEL LEADING THE PROPHETS IN PRAISING GOD. YOUR MEN JOINED THEM—MAYBE GOD WARNED THEM NOT TO HARM DAVID...

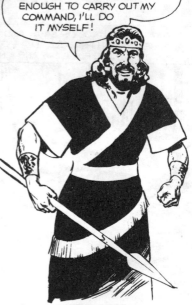

EXCUSES! THAT'S ALL I HEAR. IF THERE'S NO ONE BRAVE ENOUGH TO CARRY OUT MY COMMAND, I'LL DO IT MYSELF!

The Angry King

FROM I SAMUEL 19: 22—20: 33

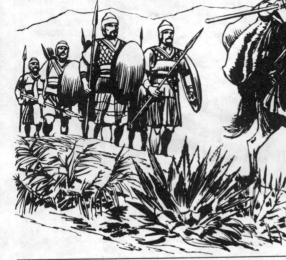

I'LL KILL HIM MYSELF! DAVID MAY BE A HERO TO THE PEOPLE, BUT HE WON'T LIVE TO TAKE _MY_ KINGDOM FROM ME!

THREE TIMES SAUL SENDS MEN TO RAMAH TO CAPTURE DAVID. BUT EACH TIME THE MEN FAIL. IN A FIT OF RAGE, SAUL SETS OUT...

—BUT ON THE WAY A STRANGE THING HAPPENS...

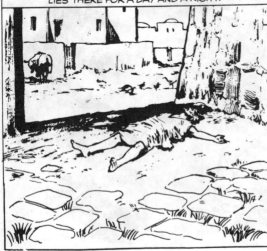

GOD TAKES CONTROL OF SAUL. AND WHEN SAUL REACHES RAMAH HE FALLS TO THE GROUND AND LIES THERE FOR A DAY AND A NIGHT.

WHILE SAUL IS IN RAMAH, DAVID HURRIES BACK TO THE PALACE TO SEE HIS FRIEND, PRINCE JONATHAN.

322

INSIDE THE PALACE DAVID SEEKS OUT HIS FRIEND.

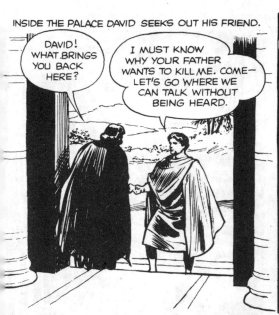

DAVID! WHAT BRINGS YOU BACK HERE?

I MUST KNOW WHY YOUR FATHER WANTS TO KILL ME. COME— LET'S GO WHERE WE CAN TALK WITHOUT BEING HEARD.

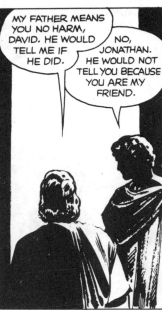

MY FATHER MEANS YOU NO HARM, DAVID. HE WOULD TELL ME IF HE DID.

NO, JONATHAN. HE WOULD NOT TELL YOU BECAUSE YOU ARE MY FRIEND.

TOMORROW STARTS THE KING'S FEAST OF THE NEW MOON—BUT I WON'T ATTEND. IF YOUR FATHER ASKS ABOUT ME, TELL HIM I HAVE GONE TO BETHLEHEM TO SEE MY FAMILY. IF HE IS NOT ANGRY, THEN ALL IS WELL. BUT IF HE IS—REMEMBER THE AGREEMENT WE MADE BEFORE GOD TO BE FRIENDS, ALWAYS.

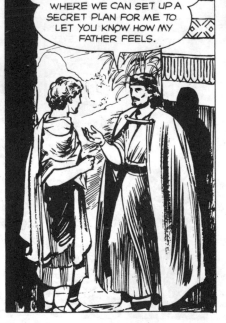

I'LL FIND OUT THE TRUTH. NOW, LET'S GO OUT IN THE FIELD WHERE WE CAN SET UP A SECRET PLAN FOR ME TO LET YOU KNOW HOW MY FATHER FEELS.

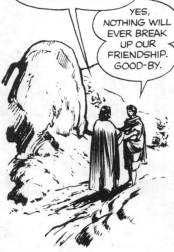

WHATEVER HAPPENS, DAVID, THE LORD IS A WITNESS TO OUR AGREEMENT THAT WE WILL BE LOYAL TO EACH OTHER—AND TO EACH OTHER'S CHILDREN.

YES, NOTHING WILL EVER BREAK UP OUR FRIENDSHIP. GOOD-BY.

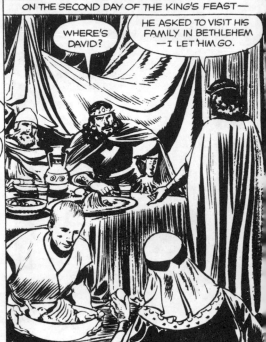

ON THE SECOND DAY OF THE KING'S FEAST—

WHERE'S DAVID?

HE ASKED TO VISIT HIS FAMILY IN BETHLEHEM —I LET 'HIM GO.

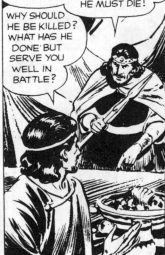

DON'T YOU KNOW THAT AS LONG AS DAVID LIVES YOU WILL NEVER BE KING? BRING HIM HERE, FOR HE MUST DIE!

WHY SHOULD HE BE KILLED? WHAT HAS HE DONE' BUT SERVE YOU WELL IN BATTLE?

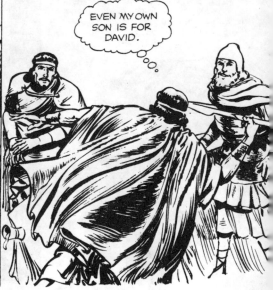

EVEN MY OWN SON IS FOR DAVID.

In Enemy Country

FROM I SAMUEL 20: 33—21: 11

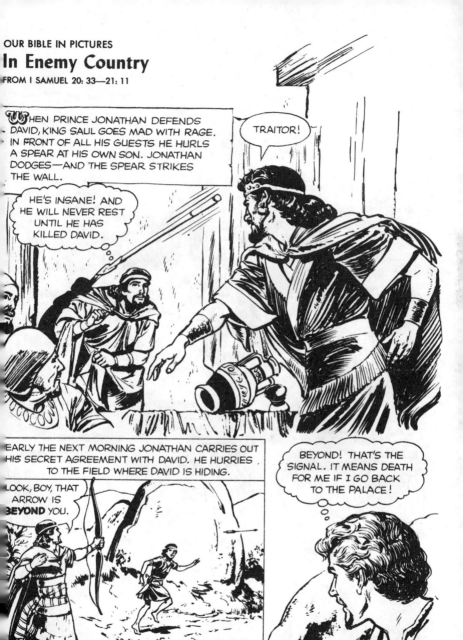

WHEN PRINCE JONATHAN DEFENDS DAVID, KING SAUL GOES MAD WITH RAGE. IN FRONT OF ALL HIS GUESTS HE HURLS A SPEAR AT HIS OWN SON. JONATHAN DODGES—AND THE SPEAR STRIKES THE WALL.

TRAITOR!

HE'S INSANE! AND HE WILL NEVER REST UNTIL HE HAS KILLED DAVID.

EARLY THE NEXT MORNING JONATHAN CARRIES OUT HIS SECRET AGREEMENT WITH DAVID. HE HURRIES TO THE FIELD WHERE DAVID IS HIDING.

LOOK, BOY, THAT ARROW IS BEYOND YOU.

BEYOND! THAT'S THE SIGNAL. IT MEANS DEATH FOR ME IF I GO BACK TO THE PALACE!

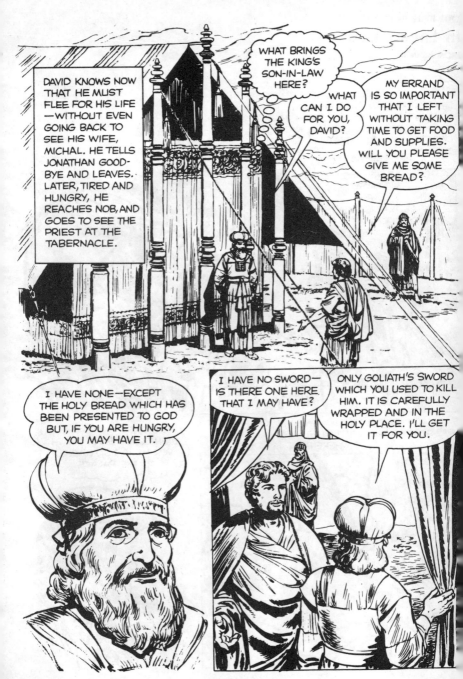

326

GOD HELPED ME WHEN I KILLED GOLIATH. HE WILL HELP ME NOW IF I TRUST AND OBEY HIM.

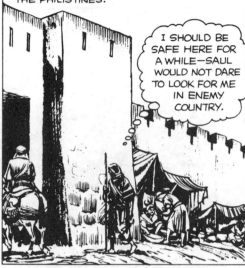

AFRAID THAT HE HAS BEEN SEEN AT THE TABERNACLE, DAVID KEEPS ON THE MOVE. HE CROSSES THE BORDER INTO THE LAND OF THE PHILISTINES.

I SHOULD BE SAFE HERE FOR A WHILE—SAUL WOULD NOT DARE TO LOOK FOR ME IN ENEMY COUNTRY.

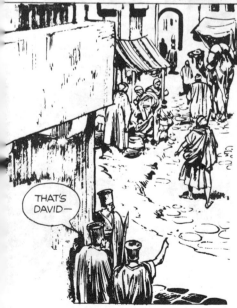

BUT THE PHILISTINES HAVEN'T FORGOTTEN THE MAN WHO KILLED THEIR CHAMPION, GOLIATH.

THAT'S DAVID—

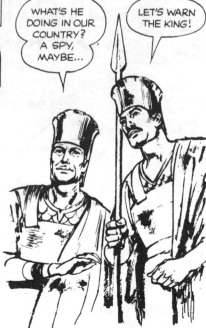

WHAT'S HE DOING IN OUR COUNTRY? A SPY, MAYBE...

LET'S WARN THE KING!

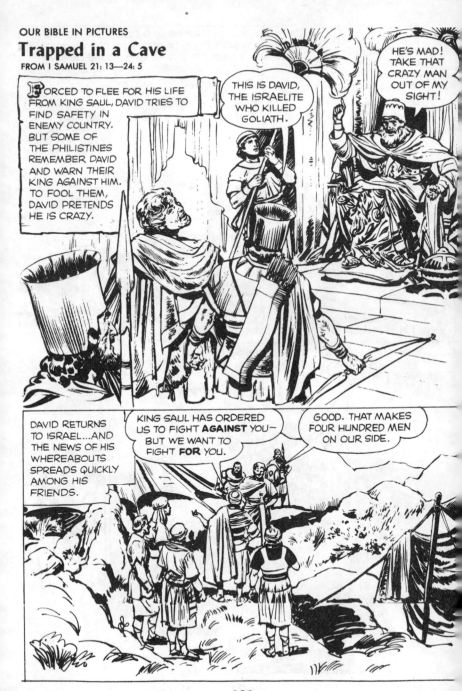

BUT NEWS ABOUT DAVID ALSO REACHES SAUL.

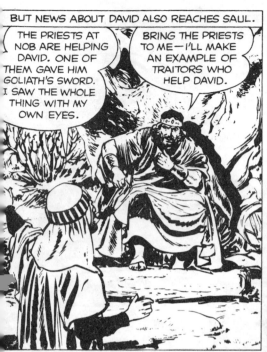

THE PRIESTS AT NOB ARE HELPING DAVID. ONE OF THEM GAVE HIM GOLIATH'S SWORD. I SAW THE WHOLE THING WITH MY OWN EYES.

BRING THE PRIESTS TO ME—I'LL MAKE AN EXAMPLE OF TRAITORS WHO HELP DAVID.

THE PRIESTS OF NOB PLEAD INNOCENT TO THE CHARGE OF PLOTTING AGAINST SAUL—BUT HE WILL NOT LISTEN!

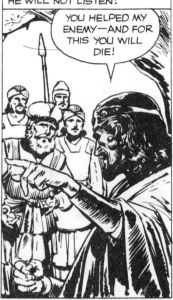

YOU HELPED MY ENEMY—AND FOR THIS YOU WILL DIE!

IN HIS INSANE DESIRE FOR REVENGE, SAUL ORDERS THE DEATH OF NOT ONLY THE PRIESTS OF NOB, BUT OF EVERY MAN, WOMAN AND CHILD IN THEIR CITY. ONLY ONE MAN ESCAPES, ABIATHAR...

...WHO CARRIES THE TRAGIC NEWS TO DAVID.

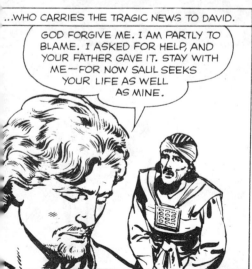

GOD FORGIVE ME. I AM PARTLY TO BLAME. I ASKED FOR HELP, AND YOUR FATHER GAVE IT. STAY WITH ME—FOR NOW SAUL SEEKS YOUR LIFE AS WELL AS MINE.

REPORTS OF DAVID'S MOVEMENTS ARE AGAIN BROUGHT TO SAUL—AND THIS TIME THE JEALOUS KING SETS OUT WITH THREE THOUSAND MEN.

BUT DAVID'S SCOUTS ARE ON THE ALERT...

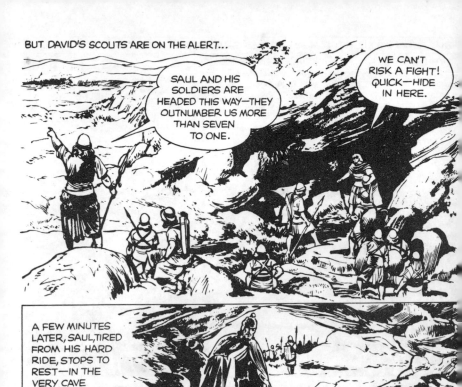

SAUL AND HIS SOLDIERS ARE HEADED THIS WAY—THEY OUTNUMBER US MORE THAN SEVEN TO ONE.

WE CAN'T RISK A FIGHT! QUICK—HIDE IN HERE.

A FEW MINUTES LATER, SAUL, TIRED FROM HIS HARD RIDE, STOPS TO REST—IN THE VERY CAVE WHERE DAVID AND HIS MEN ARE HIDING!

INSIDE, EAGER EYES WATCH THE KING'S EVERY MOVEMENT.

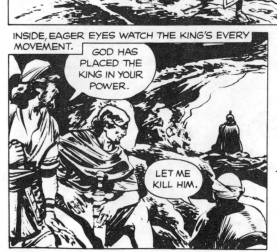

GOD HAS PLACED THE KING IN YOUR POWER.

LET ME KILL HIM.

STAY BACK— I'LL TAKE CARE OF THIS.

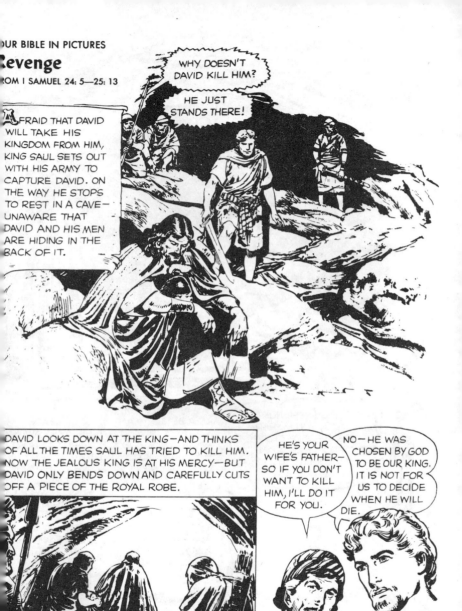

Revenge

FROM I SAMUEL 24: 5—25: 13

AFRAID THAT DAVID WILL TAKE HIS KINGDOM FROM HIM, KING SAUL SETS OUT WITH HIS ARMY TO CAPTURE DAVID. ON THE WAY HE STOPS TO REST IN A CAVE—UNAWARE THAT DAVID AND HIS MEN ARE HIDING IN THE BACK OF IT.

WHY DOESN'T DAVID KILL HIM?

HE JUST STANDS THERE!

DAVID LOOKS DOWN AT THE KING—AND THINKS OF ALL THE TIMES SAUL HAS TRIED TO KILL HIM. NOW THE JEALOUS KING IS AT HIS MERCY—BUT DAVID ONLY BENDS DOWN AND CAREFULLY CUTS OFF A PIECE OF THE ROYAL ROBE.

HE'S YOUR WIFE'S FATHER—SO IF YOU DON'T WANT TO KILL HIM, I'LL DO IT FOR YOU.

NO—HE WAS CHOSEN BY GOD TO BE OUR KING. IT IS NOT FOR US TO DECIDE WHEN HE WILL DIE.

331

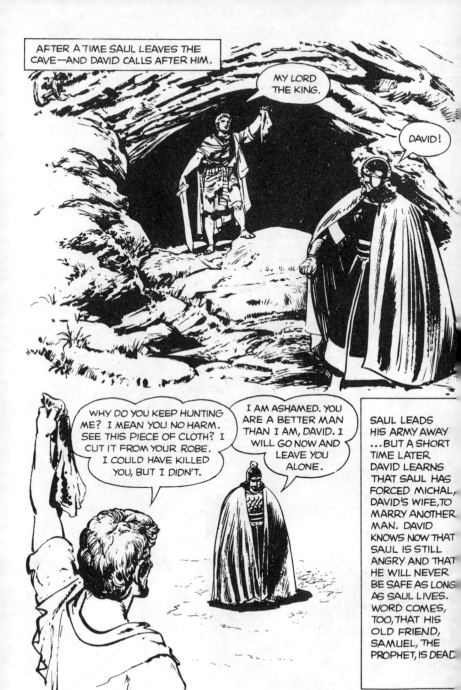

332

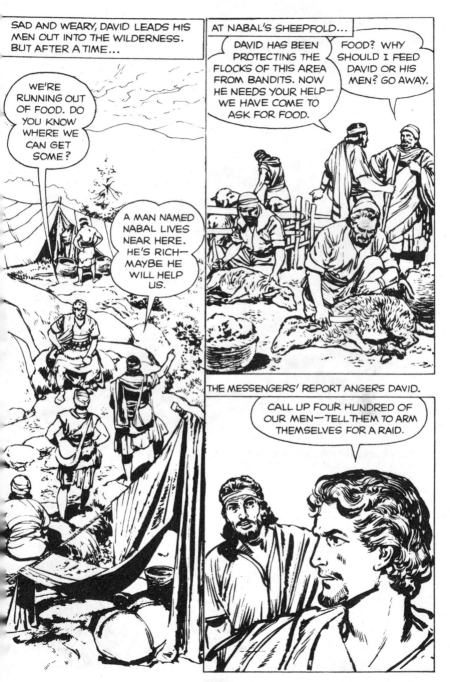

333

Spies in the Night

FROM I SAMUEL 25: 13—26: 6

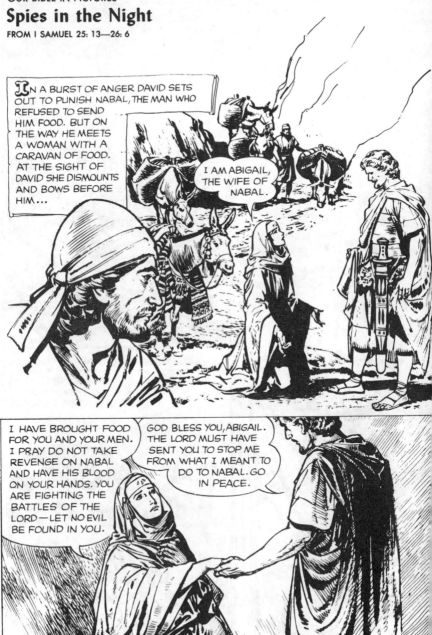

IN A BURST OF ANGER DAVID SETS OUT TO PUNISH NABAL, THE MAN WHO REFUSED TO SEND HIM FOOD. BUT ON THE WAY HE MEETS A WOMAN WITH A CARAVAN OF FOOD. AT THE SIGHT OF DAVID SHE DISMOUNTS AND BOWS BEFORE HIM...

I AM ABIGAIL, THE WIFE OF NABAL.

I HAVE BROUGHT FOOD FOR YOU AND YOUR MEN. I PRAY DO NOT TAKE REVENGE ON NABAL AND HAVE HIS BLOOD ON YOUR HANDS. YOU ARE FIGHTING THE BATTLES OF THE LORD—LET NO EVIL BE FOUND IN YOU.

GOD BLESS YOU, ABIGAIL. THE LORD MUST HAVE SENT YOU TO STOP ME FROM WHAT I MEANT TO DO TO NABAL. GO IN PEACE.

ABIGAIL RETURNS HOME TO FIND NABAL CELEBRATING THE END OF THE SHEARING OF THE SHEEP. HE IS SO DRUNK THAT ABIGAIL DOES NOT TELL HIM WHAT SHE HAS DONE...

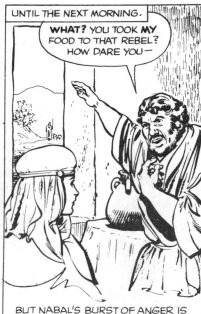

UNTIL THE NEXT MORNING.

WHAT? YOU TOOK **MY** FOOD TO THAT REBEL? HOW DARE YOU—

BUT NABAL'S BURST OF ANGER IS CUT SHORT. HE HAS A STROKE— AND TEN DAYS LATER HE DIES.

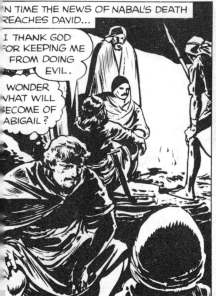

IN TIME THE NEWS OF NABAL'S DEATH REACHES DAVID...

I THANK GOD FOR KEEPING ME FROM DOING EVIL.

I WONDER WHAT WILL BECOME OF ABIGAIL?

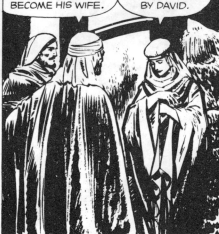

DAVID CONTINUES TO THINK OF ABIGAIL— OF HER BEAUTY AND HER KINDNESS TO HIM. HE SENDS MESSENGERS TO HER...

DAVID HAS SENT US TO ASK YOU TO BECOME HIS WIFE.

I AM HONORED TO BE CHOSEN BY DAVID.

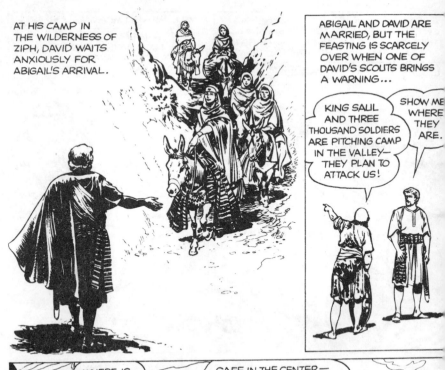

AT HIS CAMP IN THE WILDERNESS OF ZIPH, DAVID WAITS ANXIOUSLY FOR ABIGAIL'S ARRIVAL.

ABIGAIL AND DAVID ARE MARRIED, BUT THE FEASTING IS SCARCELY OVER WHEN ONE OF DAVID'S SCOUTS BRINGS A WARNING...

KING SAUL AND THREE THOUSAND SOLDIERS ARE PITCHING CAMP IN THE VALLEY— THEY PLAN TO ATTACK US!

SHOW ME WHERE THEY ARE.

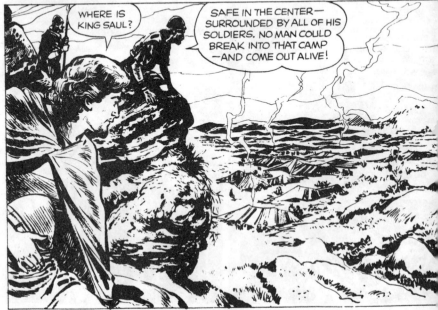

WHERE IS KING SAUL?

SAFE IN THE CENTER— SURROUNDED BY ALL OF HIS SOLDIERS. NO MAN COULD BREAK INTO THAT CAMP —AND COME OUT ALIVE!

David's Dilemma

FROM I SAMUEL 26: 6—28: 2

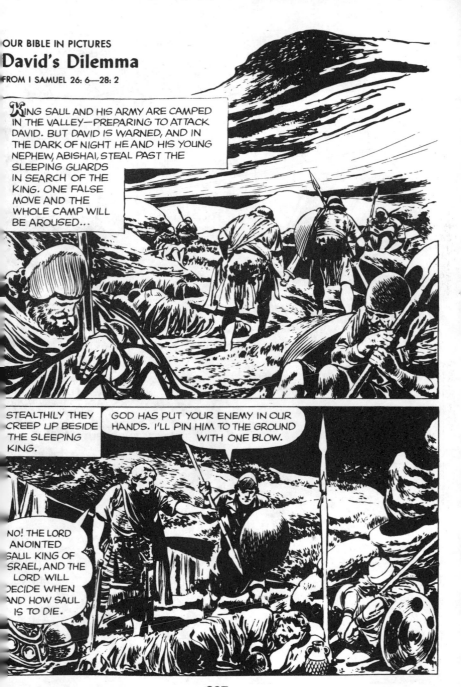

KING SAUL AND HIS ARMY ARE CAMPED IN THE VALLEY—PREPARING TO ATTACK DAVID. BUT DAVID IS WARNED, AND IN THE DARK OF NIGHT HE AND HIS YOUNG NEPHEW, ABISHAI, STEAL PAST THE SLEEPING GUARDS IN SEARCH OF THE KING. ONE FALSE MOVE AND THE WHOLE CAMP WILL BE AROUSED...

STEALTHILY THEY CREEP UP BESIDE THE SLEEPING KING.

GOD HAS PUT YOUR ENEMY IN OUR HANDS. I'LL PIN HIM TO THE GROUND WITH ONE BLOW.

NO! THE LORD ANOINTED SAUL KING OF ISRAEL, AND THE LORD WILL DECIDE WHEN AND HOW SAUL IS TO DIE.

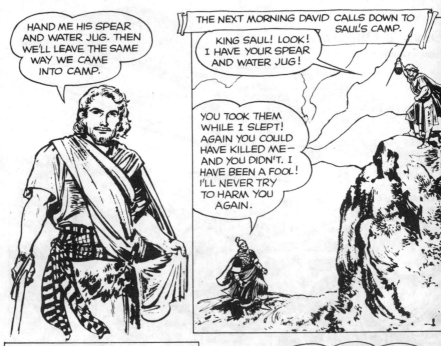

HAND ME HIS SPEAR AND WATER JUG. THEN WE'LL LEAVE THE SAME WAY WE CAME INTO CAMP.

THE NEXT MORNING DAVID CALLS DOWN TO SAUL'S CAMP.

KING SAUL! LOOK! I HAVE YOUR SPEAR AND WATER JUG!

YOU TOOK THEM WHILE I SLEPT! AGAIN YOU COULD HAVE KILLED ME— AND YOU DIDN'T. I HAVE BEEN A FOOL! I'LL NEVER TRY TO HARM YOU AGAIN.

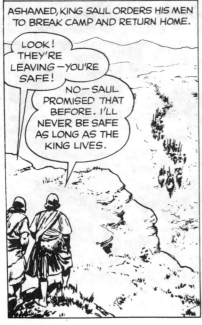

ASHAMED, KING SAUL ORDERS HIS MEN TO BREAK CAMP AND RETURN HOME.

LOOK! THEY'RE LEAVING—YOU'RE SAFE!

NO—SAUL PROMISED THAT BEFORE. I'LL NEVER BE SAFE AS LONG AS THE KING LIVES.

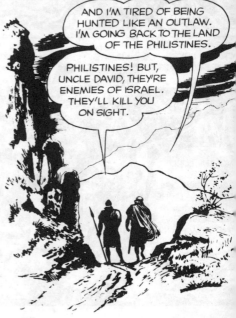

AND I'M TIRED OF BEING HUNTED LIKE AN OUTLAW. I'M GOING BACK TO THE LAND OF THE PHILISTINES.

PHILISTINES! BUT, UNCLE DAVID, THEY'RE ENEMIES OF ISRAEL. THEY'LL KILL YOU ON SIGHT.

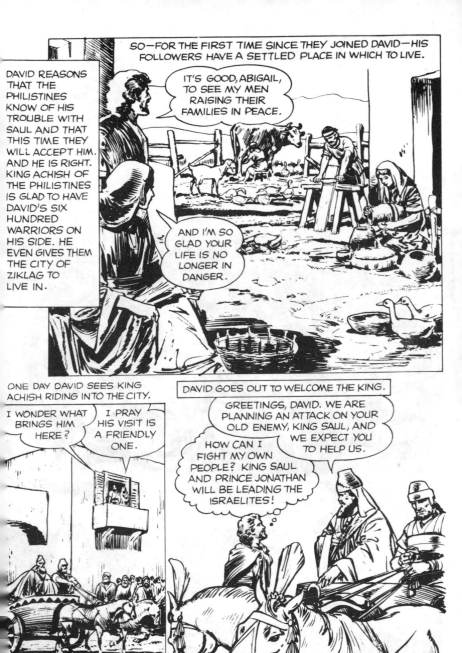

SO—FOR THE FIRST TIME SINCE THEY JOINED DAVID—HIS FOLLOWERS HAVE A SETTLED PLACE IN WHICH TO LIVE.

DAVID REASONS THAT THE PHILISTINES KNOW OF HIS TROUBLE WITH SAUL AND THAT THIS TIME THEY WILL ACCEPT HIM. AND HE IS RIGHT. KING ACHISH OF THE PHILISTINES IS GLAD TO HAVE DAVID'S SIX HUNDRED WARRIORS ON HIS SIDE. HE EVEN GIVES THEM THE CITY OF ZIKLAG TO LIVE IN.

IT'S GOOD, ABIGAIL, TO SEE MY MEN RAISING THEIR FAMILIES IN PEACE.

AND I'M SO GLAD YOUR LIFE IS NO LONGER IN DANGER.

ONE DAY DAVID SEES KING ACHISH RIDING INTO THE CITY.

I WONDER WHAT BRINGS HIM HERE?

I PRAY HIS VISIT IS A FRIENDLY ONE.

DAVID GOES OUT TO WELCOME THE KING.

GREETINGS, DAVID. WE ARE PLANNING AN ATTACK ON YOUR OLD ENEMY, KING SAUL, AND WE EXPECT YOU TO HELP US.

HOW CAN I FIGHT MY OWN PEOPLE? KING SAUL AND PRINCE JONATHAN WILL BE LEADING THE ISRAELITES!

At the Witch's House

FROM I SAMUEL 28: 5-11; 29

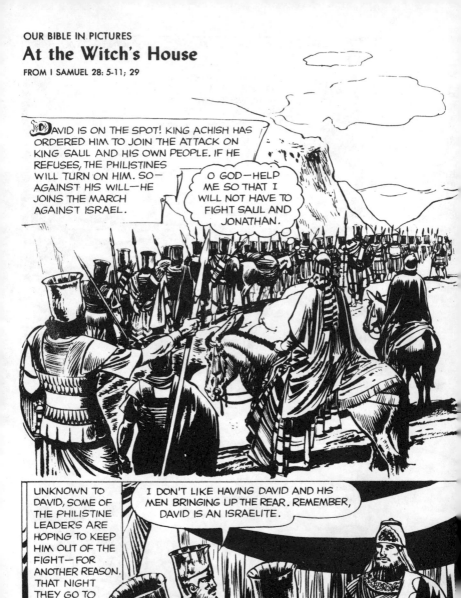

DAVID IS ON THE SPOT! KING ACHISH HAS ORDERED HIM TO JOIN THE ATTACK ON KING SAUL AND HIS OWN PEOPLE. IF HE REFUSES, THE PHILISTINES WILL TURN ON HIM. SO— AGAINST HIS WILL—HE JOINS THE MARCH AGAINST ISRAEL.

O GOD—HELP ME SO THAT I WILL NOT HAVE TO FIGHT SAUL AND JONATHAN.

UNKNOWN TO DAVID, SOME OF THE PHILISTINE LEADERS ARE HOPING TO KEEP HIM OUT OF THE FIGHT— FOR ANOTHER REASON. THAT NIGHT THEY GO TO KING ACHISH'S TENT.

I DON'T LIKE HAVING DAVID AND HIS MEN BRINGING UP THE REAR. REMEMBER, DAVID IS AN ISRAELITE.

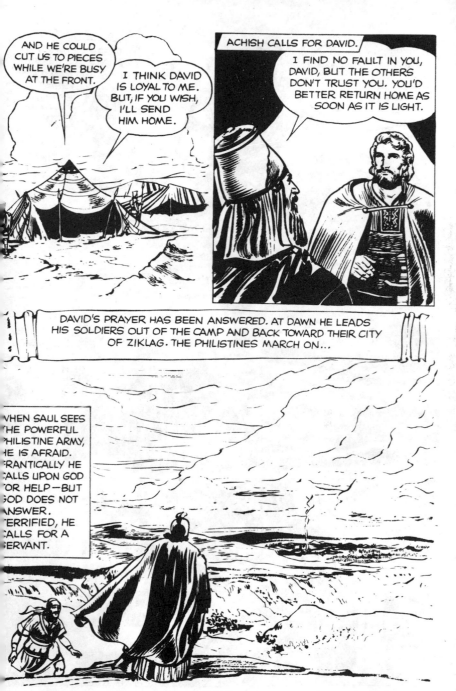

AND HE COULD CUT US TO PIECES WHILE WE'RE BUSY AT THE FRONT.

I THINK DAVID IS LOYAL TO ME. BUT, IF YOU WISH, I'LL SEND HIM HOME.

ACHISH CALLS FOR DAVID.

I FIND NO FAULT IN YOU, DAVID, BUT THE OTHERS DON'T TRUST YOU. YOU'D BETTER RETURN HOME AS SOON AS IT IS LIGHT.

DAVID'S PRAYER HAS BEEN ANSWERED. AT DAWN HE LEADS HIS SOLDIERS OUT OF THE CAMP AND BACK TOWARD THEIR CITY OF ZIKLAG. THE PHILISTINES MARCH ON...

WHEN SAUL SEES THE POWERFUL PHILISTINE ARMY, HE IS AFRAID. FRANTICALLY HE CALLS UPON GOD FOR HELP—BUT GOD DOES NOT ANSWER. TERRIFIED, HE CALLS FOR A SERVANT.

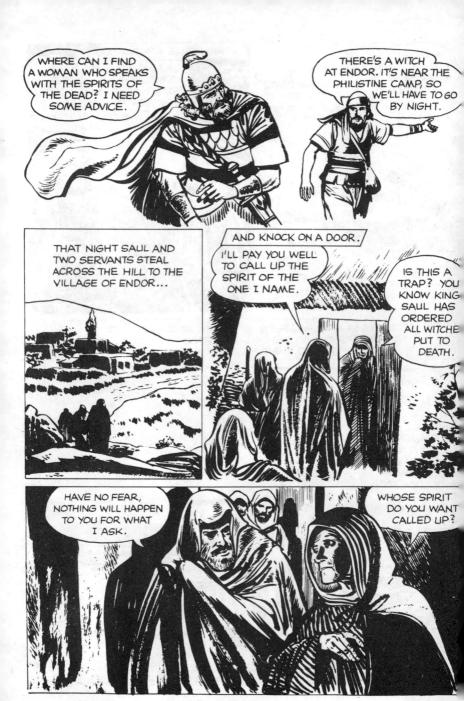

342

Voice from the Dead

OM I SAMUEL 28: 11-25; 30: 1-3; 31: 1-6

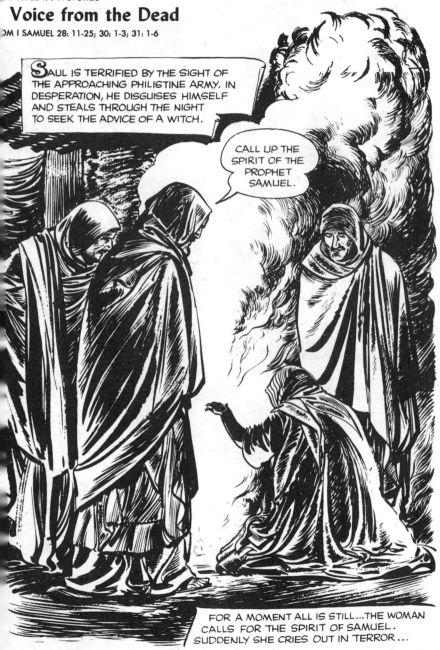

SAUL IS TERRIFIED BY THE SIGHT OF THE APPROACHING PHILISTINE ARMY. IN DESPERATION, HE DISGUISES HIMSELF AND STEALS THROUGH THE NIGHT TO SEEK THE ADVICE OF A WITCH.

CALL UP THE SPIRIT OF THE PROPHET SAMUEL.

FOR A MOMENT ALL IS STILL...THE WOMAN CALLS FOR THE SPIRIT OF SAMUEL. SUDDENLY SHE CRIES OUT IN TERROR...

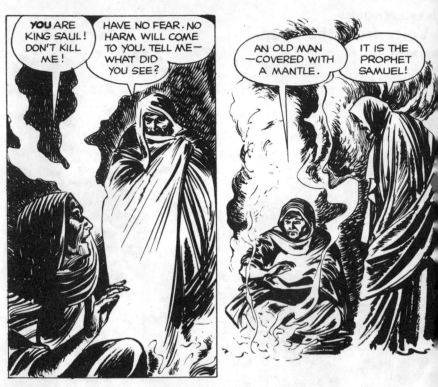

THEN SAUL HEARS THE VOICE OF SAMUEL: BECAUSE YOU DISOBEYED GOD, THE LORD WILL DELIVER ISRAEL INTO THE HANDS OF THE PHILISTINES. TOMORROW YOU AND YOUR SONS WILL BE DEAD.

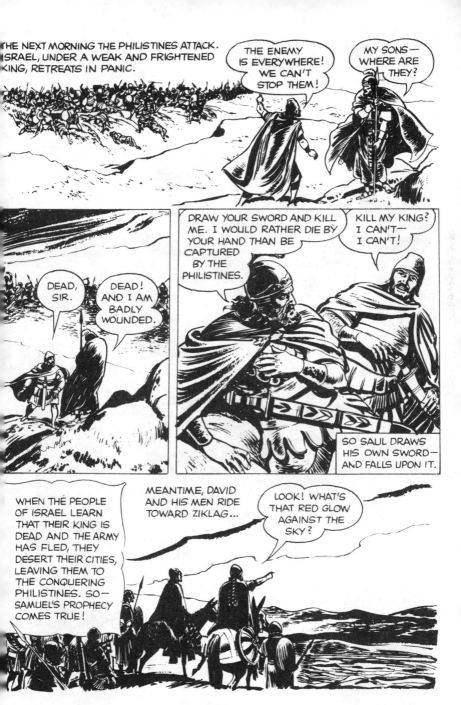

On the Robbers' Trail

FROM I SAMUEL 30: 1-11

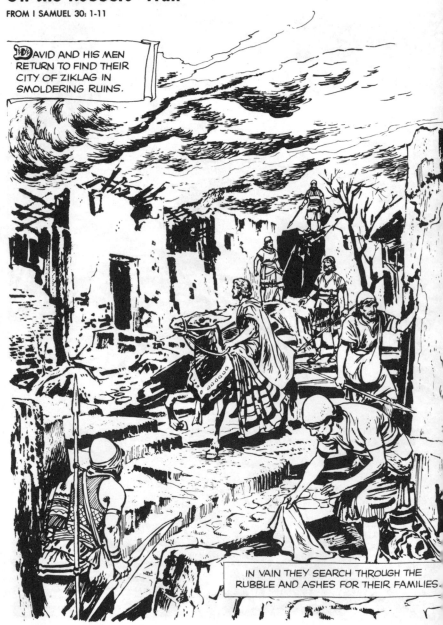

DAVID AND HIS MEN RETURN TO FIND THEIR CITY OF ZIKLAG IN SMOLDERING RUINS.

IN VAIN THEY SEARCH THROUGH THE RUBBLE AND ASHES FOR THEIR FAMILIES.

347

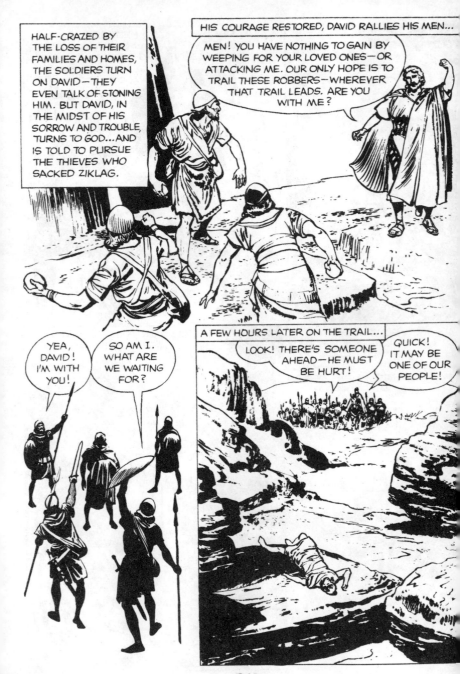

HALF-CRAZED BY THE LOSS OF THEIR FAMILIES AND HOMES, THE SOLDIERS TURN ON DAVID—THEY EVEN TALK OF STONING HIM. BUT DAVID, IN THE MIDST OF HIS SORROW AND TROUBLE, TURNS TO GOD...AND IS TOLD TO PURSUE THE THIEVES WHO SACKED ZIKLAG.

HIS COURAGE RESTORED, DAVID RALLIES HIS MEN...

MEN! YOU HAVE NOTHING TO GAIN BY WEEPING FOR YOUR LOVED ONES—OR ATTACKING ME. OUR ONLY HOPE IS TO TRAIL THESE ROBBERS—WHEREVER THAT TRAIL LEADS. ARE YOU WITH ME?

YEA, DAVID! I'M WITH YOU!

SO AM I. WHAT ARE WE WAITING FOR?

A FEW HOURS LATER ON THE TRAIL...

LOOK! THERE'S SOMEONE AHEAD—HE MUST BE HURT!

QUICK! IT MAY BE ONE OF OUR PEOPLE!

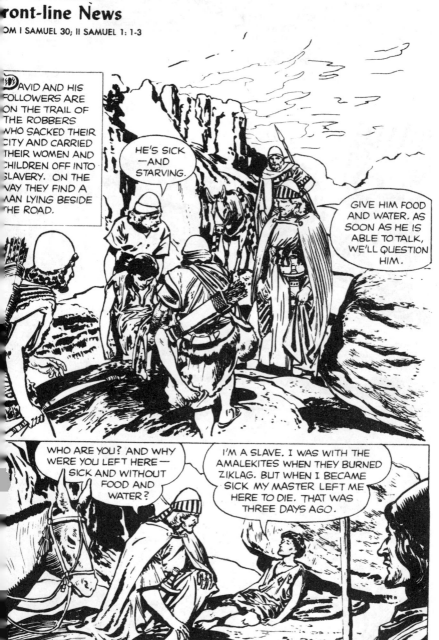

ront-line News

DAVID AND HIS FOLLOWERS ARE ON THE TRAIL OF THE ROBBERS WHO SACKED THEIR CITY AND CARRIED THEIR WOMEN AND CHILDREN OFF INTO SLAVERY. ON THE WAY THEY FIND A MAN LYING BESIDE THE ROAD.

HE'S SICK —AND STARVING.

GIVE HIM FOOD AND WATER. AS SOON AS HE IS ABLE TO TALK, WE'LL QUESTION HIM.

WHO ARE YOU? AND WHY WERE YOU LEFT HERE — SICK AND WITHOUT FOOD AND WATER?

I'M A SLAVE. I WAS WITH THE AMALEKITES WHEN THEY BURNED ZIKLAG. BUT WHEN I BECAME SICK MY MASTER LEFT ME HERE TO DIE. THAT WAS THREE DAYS AGO.

349

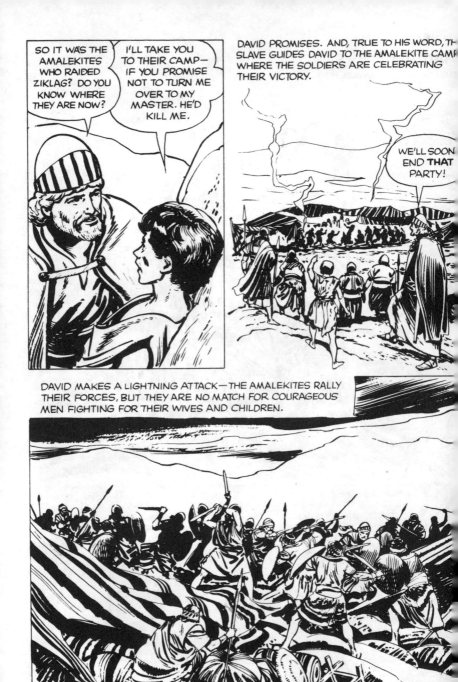

SO IT WAS THE AMALEKITES WHO RAIDED ZIKLAG? DO YOU KNOW WHERE THEY ARE NOW?

I'LL TAKE YOU TO THEIR CAMP— IF YOU PROMISE NOT TO TURN ME OVER TO MY MASTER. HE'D KILL ME.

DAVID PROMISES. AND, TRUE TO HIS WORD, TH SLAVE GUIDES DAVID TO THE AMALEKITE CAMP WHERE THE SOLDIERS ARE CELEBRATING THEIR VICTORY.

WE'LL SOON END **THAT** PARTY!

DAVID MAKES A LIGHTNING ATTACK—THE AMALEKITES RALLY THEIR FORCES, BUT THEY ARE NO MATCH FOR COURAGEOUS MEN FIGHTING FOR THEIR WIVES AND CHILDREN.

350

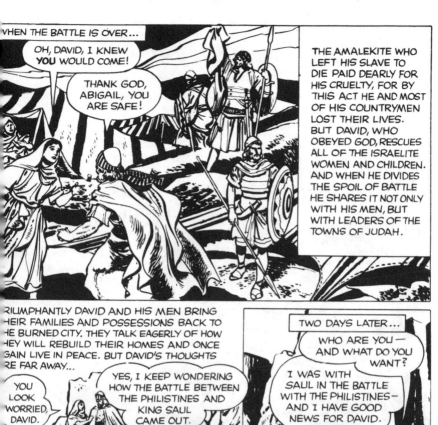

WHEN THE BATTLE IS OVER...

OH, DAVID, I KNEW **YOU** WOULD COME!

THANK GOD, ABIGAIL, YOU ARE SAFE!

THE AMALEKITE WHO LEFT HIS SLAVE TO DIE PAID DEARLY FOR HIS CRUELTY, FOR BY THIS ACT HE AND MOST OF HIS COUNTRYMEN LOST THEIR LIVES. BUT DAVID, WHO OBEYED GOD, RESCUES ALL OF THE ISRAELITE WOMEN AND CHILDREN. AND WHEN HE DIVIDES THE SPOIL OF BATTLE HE SHARES IT NOT ONLY WITH HIS MEN, BUT WITH LEADERS OF THE TOWNS OF JUDAH.

TRIUMPHANTLY DAVID AND HIS MEN BRING THEIR FAMILIES AND POSSESSIONS BACK TO THE BURNED CITY. THEY TALK EAGERLY OF HOW THEY WILL REBUILD THEIR HOMES AND ONCE AGAIN LIVE IN PEACE. BUT DAVID'S THOUGHTS ARE FAR AWAY...

YOU LOOK WORRIED, DAVID.

YES, I KEEP WONDERING HOW THE BATTLE BETWEEN THE PHILISTINES AND KING SAUL CAME OUT.

TWO DAYS LATER...

WHO ARE YOU— AND WHAT DO YOU WANT?

I WAS WITH SAUL IN THE BATTLE WITH THE PHILISTINES— AND I HAVE GOOD NEWS FOR DAVID.

Rival Kings!

FROM II SAMUEL 1: 2—2: 9

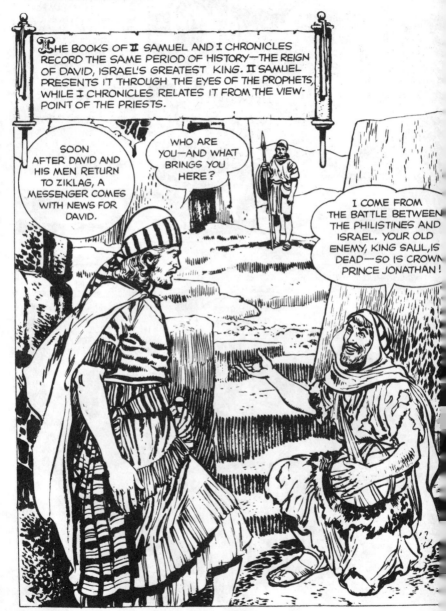

THE BOOKS OF II SAMUEL AND I CHRONICLES RECORD THE SAME PERIOD OF HISTORY—THE REIGN OF DAVID, ISRAEL'S GREATEST KING. II SAMUEL PRESENTS IT THROUGH THE EYES OF THE PROPHETS, WHILE I CHRONICLES RELATES IT FROM THE VIEWPOINT OF THE PRIESTS.

SOON AFTER DAVID AND HIS MEN RETURN TO ZIKLAG, A MESSENGER COMES WITH NEWS FOR DAVID.

WHO ARE YOU—AND WHAT BRINGS YOU HERE?

I COME FROM THE BATTLE BETWEEN THE PHILISTINES AND ISRAEL. YOUR OLD ENEMY, KING SAUL, IS DEAD—SO IS CROWN PRINCE JONATHAN!

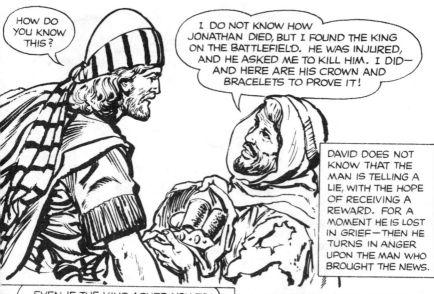

HOW DO YOU KNOW THIS?

I DO NOT KNOW HOW JONATHAN DIED, BUT I FOUND THE KING ON THE BATTLEFIELD. HE WAS INJURED, AND HE ASKED ME TO KILL HIM. I DID—AND HERE ARE HIS CROWN AND BRACELETS TO PROVE IT!

DAVID DOES NOT KNOW THAT THE MAN IS TELLING A LIE, WITH THE HOPE OF RECEIVING A REWARD. FOR A MOMENT HE IS LOST IN GRIEF—THEN HE TURNS IN ANGER UPON THE MAN WHO BROUGHT THE NEWS.

EVEN IF THE KING ASKED YOU TO KILL HIM, YOU HAD NO RIGHT TO TAKE THE LIFE OF THE MAN CHOSEN BY GOD TO BE KING OF ISRAEL. FOR THIS CRIME YOU WILL PAY—WITH YOUR LIFE!

SO THE MAN WHO LIED TO WIN FAVOR WITH DAVID LOSES NOT ONLY THE FAVOR—BUT HIS LIFE!

THEN, BEFORE ALL OF HIS FAITHFUL FOLLOWERS, DAVID SINGS A MEMORIAL SONG FOR JONATHAN AND THE KING.

Song of the Bow

...How are the mighty fallen!...
The bow of Jonathan turned not back,
And the sword of Saul returned not empty....
In their death they were not divided:
They were swifter than eagles,
They were stronger than lions....
I am distressed for thee, my brother Jonathan:
Very pleasant hast thou been unto me:
Thy love to me was wonderful,
Passing the love of women.
How are the mighty fallen,
And the weapons of war perished!

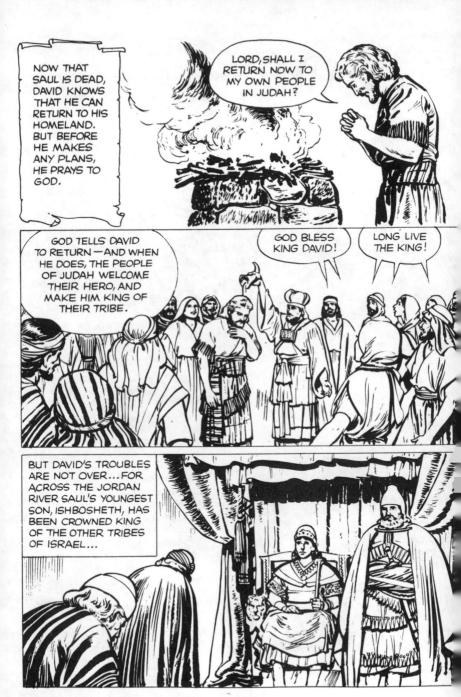

NOW THAT SAUL IS DEAD, DAVID KNOWS THAT HE CAN RETURN TO HIS HOMELAND. BUT BEFORE HE MAKES ANY PLANS, HE PRAYS TO GOD.

LORD, SHALL I RETURN NOW TO MY OWN PEOPLE IN JUDAH?

GOD TELLS DAVID TO RETURN—AND WHEN HE DOES, THE PEOPLE OF JUDAH WELCOME THEIR HERO, AND MAKE HIM KING OF THEIR TRIBE.

GOD BLESS KING DAVID!

LONG LIVE THE KING!

BUT DAVID'S TROUBLES ARE NOT OVER...FOR ACROSS THE JORDAN RIVER SAUL'S YOUNGEST SON, ISHBOSHETH, HAS BEEN CROWNED KING OF THE OTHER TRIBES OF ISRAEL...

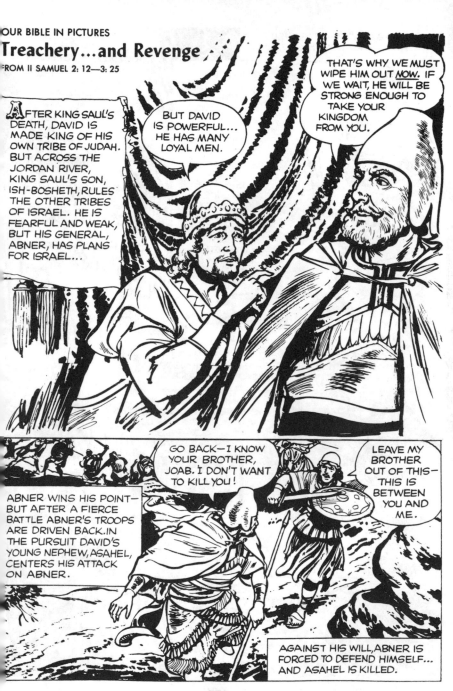

355

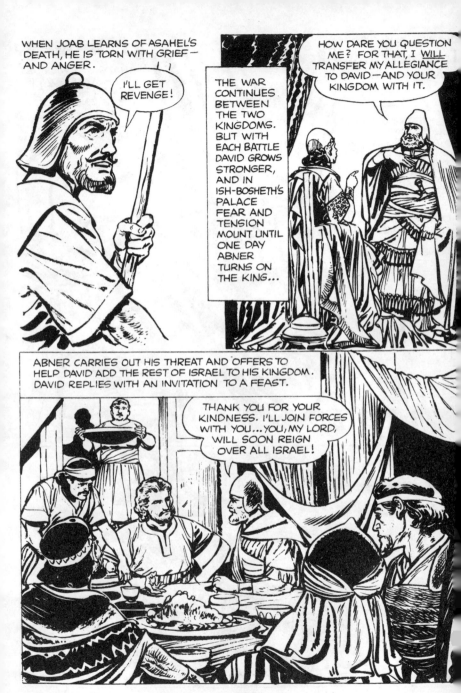

356

ABNER IS SCARCELY OUT OF THE CITY WHEN JOAB RETURNS...

ABNER JUST LEFT—DAVID HAD A BIG FEAST FOR HIM.

ABNER _HERE_? AND DAVID LET HIM GO?

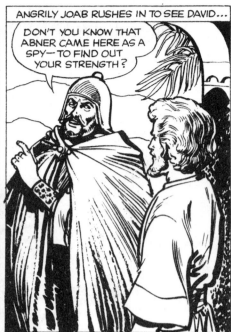

ANGRILY JOAB RUSHES IN TO SEE DAVID...

DON'T YOU KNOW THAT ABNER _CAME_ HERE AS A SPY—TO FIND OUT YOUR STRENGTH?

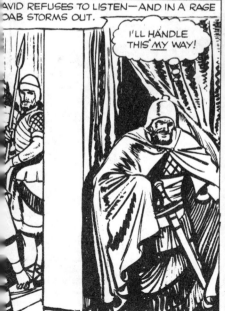

DAVID REFUSES TO LISTEN—AND IN A RAGE JOAB STORMS OUT.

I'LL HANDLE THIS _MY_ WAY!

JOAB IS FURIOUS! THIS COULD MEAN TROUBLE!

HE WOULDN'T DARE DEFY THE KING!

Plot Against the King

FROM II SAMUEL 3: 26—4: 5

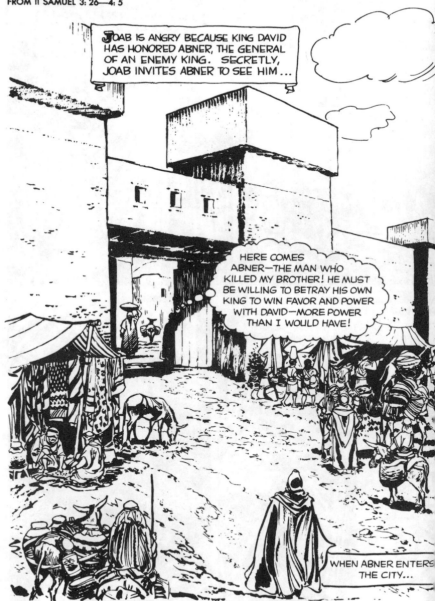

JOAB IS ANGRY BECAUSE KING DAVID HAS HONORED ABNER, THE GENERAL OF AN ENEMY KING. SECRETLY, JOAB INVITES ABNER TO SEE HIM ...

HERE COMES ABNER—THE MAN WHO KILLED MY BROTHER! HE MUST BE WILLING TO BETRAY HIS OWN KING TO WIN FAVOR AND POWER WITH DAVID—MORE POWER THAN I WOULD HAVE!

WHEN ABNER ENTERS THE CITY...

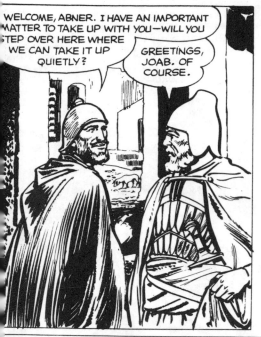

WELCOME, ABNER. I HAVE AN IMPORTANT MATTER TO TAKE UP WITH YOU—WILL YOU STEP OVER HERE WHERE WE CAN TAKE IT UP QUIETLY?

GREETINGS, JOAB. OF COURSE.

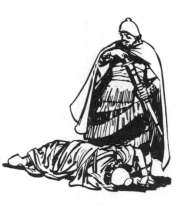

JOAB LEADS ABNER TO A QUIET CORNER OF THE BUSY GATE. AND THERE, BEFORE ABNER CAN SUSPECT WHAT IS GOING ON— JOAB STABS HIM.'

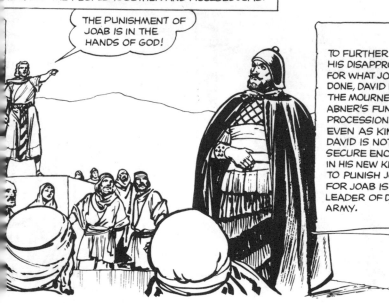

DAVID IS ANGRY WHEN HE LEARNS OF ABNER'S MURDER. HE CALLS THE PEOPLE TOGETHER AND ACCUSES JOAB.

THE PUNISHMENT OF JOAB IS IN THE HANDS OF GOD!

TO FURTHER SHOW HIS DISAPPROVAL FOR WHAT JOAB HAS DONE, DAVID LEADS THE MOURNERS IN ABNER'S FUNERAL PROCESSION. BUT EVEN AS KING, DAVID IS NOT SECURE ENOUGH IN HIS NEW KINGDOM TO PUNISH JOAB, FOR JOAB IS THE LEADER OF DAVID'S ARMY.

DAVID MOURNS THE DEATH OF ABNER, BUT ABNER'S MASTER, KING ISH-BOSHETH, IS SHAKEN WITH FRIGHT.

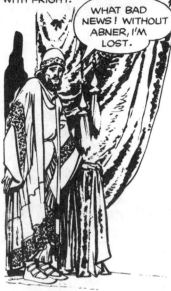

WHAT BAD NEWS! WITHOUT ABNER, I'M LOST.

KING ISH-BOSHETH'S FEARS ARE WELL GROUNDED FOR EVEN AS HE RECEIVES THE NEWS OF ABNER'S DEATH, TWO OF HIS OWN ARMY OFFICERS ARE PLOTTING...

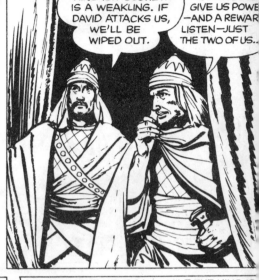

WITHOUT ABNER, KING ISH-BOSHETH IS A WEAKLING. IF DAVID ATTACKS US, WE'LL BE WIPED OUT.

I HAVE AN IDE[A] THAT COULD GIVE US POWE[R] —AND A REWAR[D] LISTEN—JUST THE TWO OF US..

WONDERFUL! LET'S DO IT NOW WHILE IT'S DARK.

NO—IT WILL BE EASIER IF WE JUST WALK INTO THE PALACE IN BROAD DAYLIGHT— AS IF WE WERE GETTING GRAIN. THEN NO ONE WOULD SUSPECT.

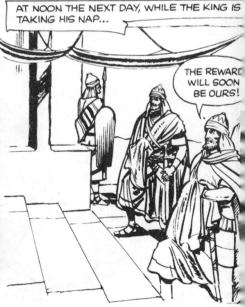

AT NOON THE NEXT DAY, WHILE THE KING IS TAKING HIS NAP...

THE REWAR[D] WILL SOON BE OURS!

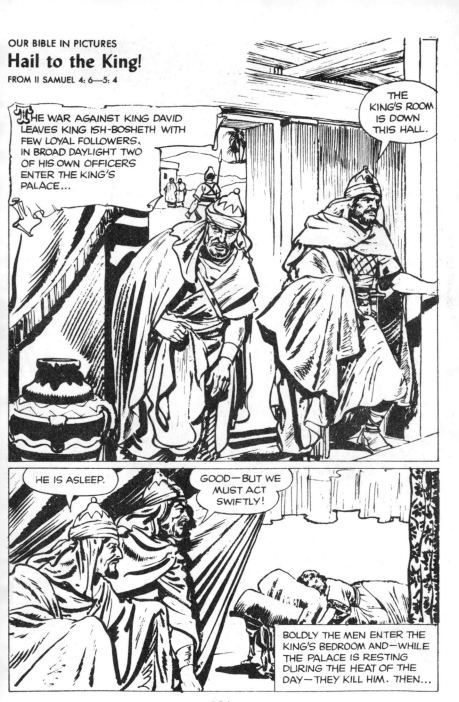

QUIETLY, SO THAT NO ONE WILL SUSPECT THEIR ERRAND...THEY WALK OUT OF THE PALACE AND INTO THE STREET. NIGHT FINDS THEM TRAVELING DOWN THE PLAIN TOWARD DAVID'S CAPITAL IN HEBRON.

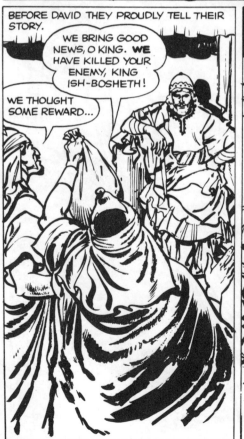

BEFORE DAVID THEY PROUDLY TELL THEIR STORY.

WE BRING GOOD NEWS, O KING. **WE** HAVE KILLED YOUR ENEMY, KING ISH-BOSHETH!

WE THOUGHT SOME REWARD...

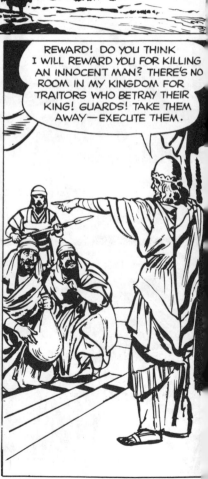

REWARD! DO YOU THINK I WILL REWARD YOU FOR KILLING AN INNOCENT MAN? THERE'S NO ROOM IN MY KINGDOM FOR TRAITORS WHO BETRAY THEIR KING! GUARDS! TAKE THEM AWAY—EXECUTE THEM.

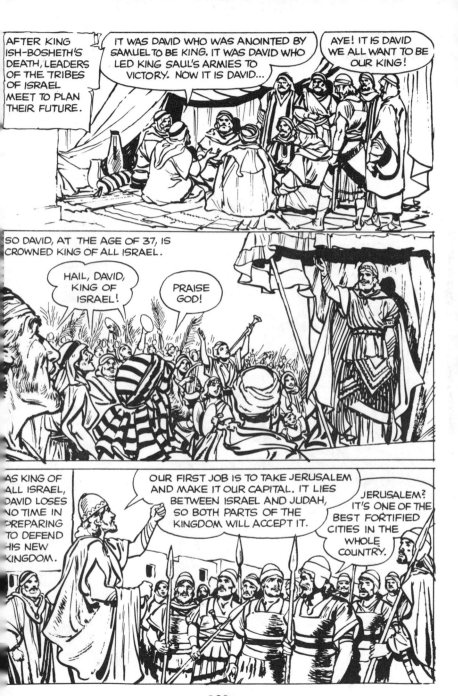

AFTER KING ISH-BOSHETH'S DEATH, LEADERS OF THE TRIBES OF ISRAEL MEET TO PLAN THEIR FUTURE.

IT WAS DAVID WHO WAS ANOINTED BY SAMUEL TO BE KING. IT WAS DAVID WHO LED KING SAUL'S ARMIES TO VICTORY. NOW IT IS DAVID...

AYE! IT IS DAVID WE ALL WANT TO BE OUR KING!

SO DAVID, AT THE AGE OF 37, IS CROWNED KING OF ALL ISRAEL.

HAIL, DAVID, KING OF ISRAEL!

PRAISE GOD!

AS KING OF ALL ISRAEL, DAVID LOSES NO TIME IN PREPARING TO DEFEND HIS NEW KINGDOM.

OUR FIRST JOB IS TO TAKE JERUSALEM AND MAKE IT OUR CAPITAL. IT LIES BETWEEN ISRAEL AND JUDAH, SO BOTH PARTS OF THE KINGDOM WILL ACCEPT IT.

JERUSALEM? IT'S ONE OF THE BEST FORTIFIED CITIES IN THE WHOLE COUNTRY.

363

Underground Attack

FROM II SAMUEL 5: 5-9

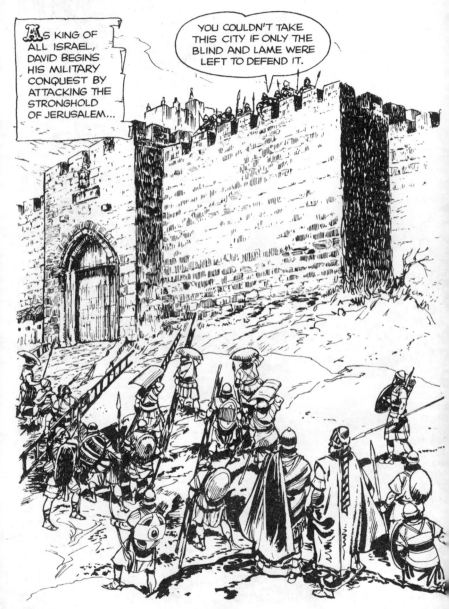

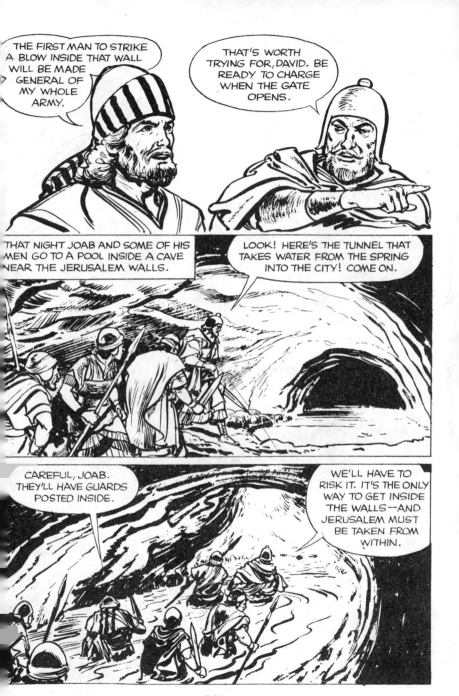

365

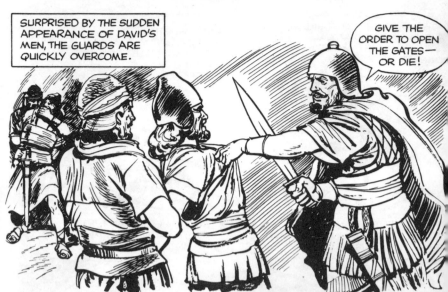

SURPRISED BY THE SUDDEN APPEARANCE OF DAVID'S MEN, THE GUARDS ARE QUICKLY OVERCOME.

GIVE THE ORDER TO OPEN THE GATES— OR DIE!

THE TERRIFIED OFFICER SHOUTS THE ORDER. THE HUGE GATES SWING OPEN...

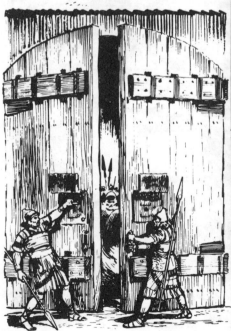

AND DAVID'S ARMY CHARGES THROUGH.

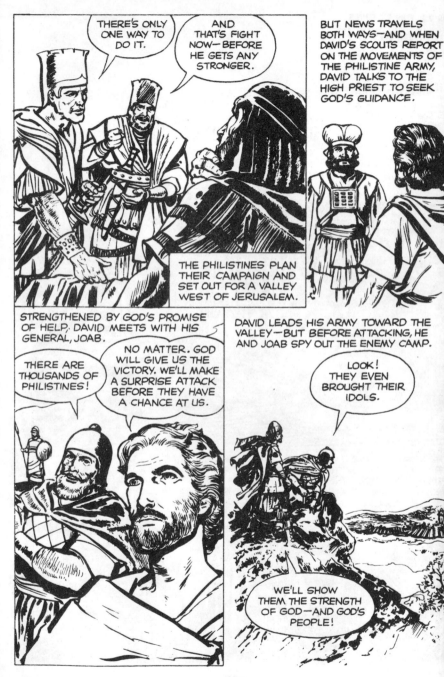

368

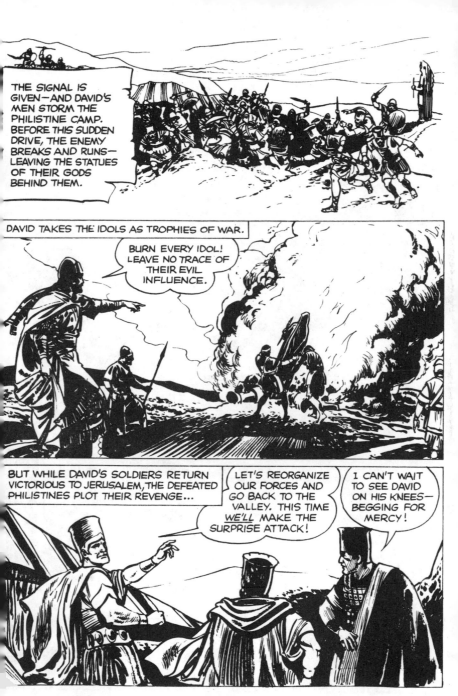

THE SIGNAL IS GIVEN—AND DAVID'S MEN STORM THE PHILISTINE CAMP. BEFORE THIS SUDDEN DRIVE, THE ENEMY BREAKS AND RUNS—LEAVING THE STATUES OF THEIR GODS BEHIND THEM.

DAVID TAKES THE IDOLS AS TROPHIES OF WAR.

BURN EVERY IDOL! LEAVE NO TRACE OF THEIR EVIL INFLUENCE.

BUT WHILE DAVID'S SOLDIERS RETURN VICTORIOUS TO JERUSALEM, THE DEFEATED PHILISTINES PLOT THEIR REVENGE...

LET'S REORGANIZE OUR FORCES AND GO BACK TO THE VALLEY. THIS TIME _WE'LL_ MAKE THE SURPRISE ATTACK!

I CAN'T WAIT TO SEE DAVID ON HIS KNEES— BEGGING FOR MERCY!

The Mighty City

FROM II SAMUEL 5: 22-25; 5: 10, 11

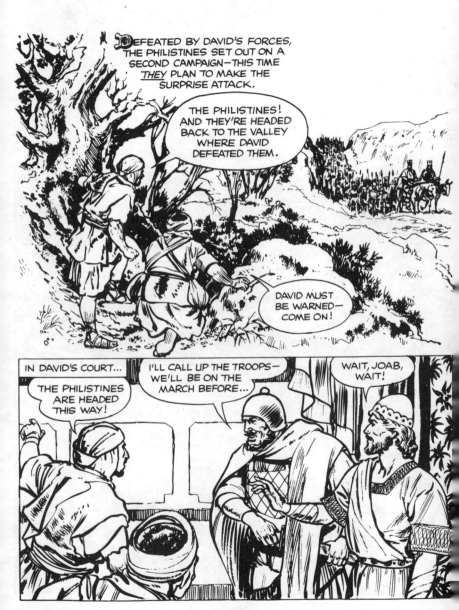

DEFEATED BY DAVID'S FORCES, THE PHILISTINES SET OUT ON A SECOND CAMPAIGN—THIS TIME *THEY* PLAN TO MAKE THE SURPRISE ATTACK.

THE PHILISTINES! AND THEY'RE HEADED BACK TO THE VALLEY WHERE DAVID DEFEATED THEM.

DAVID MUST BE WARNED—COME ON!

IN DAVID'S COURT...

THE PHILISTINES ARE HEADED THIS WAY!

I'LL CALL UP THE TROOPS— WE'LL BE ON THE MARCH BEFORE...

WAIT, JOAB, WAIT!

BEFORE MAKING ANY MOVE AGAINST THE ENEMY, DAVID AGAIN SEEKS GOD'S HELP. GOD GIVES HIM TWO ORDERS...

FOLLOWING GOD'S DIRECTION, DAVID LEADS HIS ARMY IN A LARGE SEMICIRCLE UNTIL IT COMES UP *BEHIND* THE ENEMY CAMP. THEN HE WAITS FOR THE SECOND SIGN...

SUDDENLY THEY HEAR A SOUND IN THE TREE TOPS— AS OF A MIGHTY ARMY ON THE MARCH.

IT IS THE SIGN—FROM GOD. ATTACK!

OBEDIENT TO GOD, DAVID ATTACKS FROM THE REAR AND DRIVES THE PHILISTINES OUT OF ISRAEL. THE KINGS OF NEIGHBORING COUNTRIES REALIZE THEY CANNOT DEFEAT DAVID— AND AGREE TO LIVE IN PEACE.

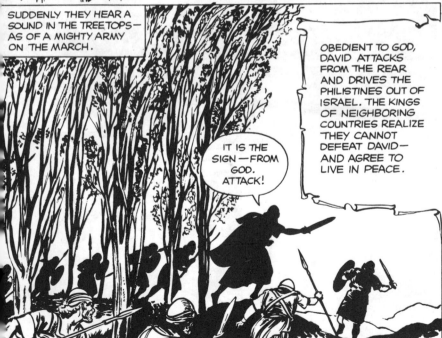

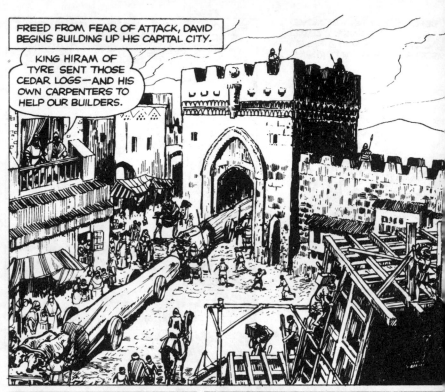

FREED FROM FEAR OF ATTACK, DAVID BEGINS BUILDING UP HIS CAPITAL CITY.

KING HIRAM OF TYRE SENT THOSE CEDAR LOGS—AND HIS OWN CARPENTERS TO HELP OUR BUILDERS.

WORK BEGINS ON A BEAUTIFUL PALACE FOR DAVID...

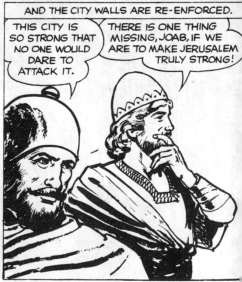

AND THE CITY WALLS ARE RE-ENFORCED.

THIS CITY IS SO STRONG THAT NO ONE WOULD DARE TO ATTACK IT.

THERE IS ONE THING MISSING, JOAB, IF WE ARE TO MAKE JERUSALEM TRULY STRONG!

God's Promises to David

FROM II SAMUEL 6, 7, 8, 9: 5; I CHRONICLES 13, 15, 16

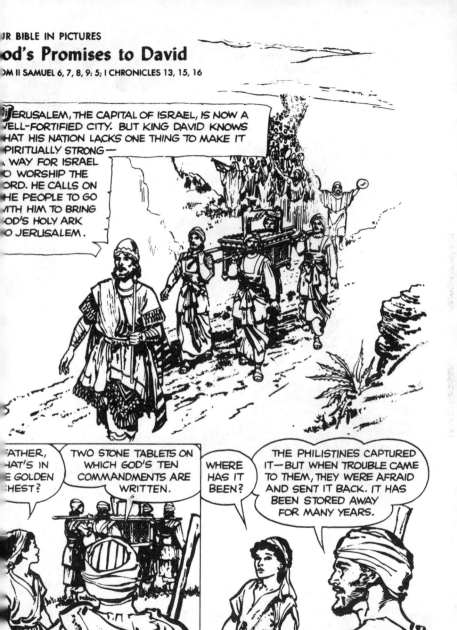

JERUSALEM, THE CAPITAL OF ISRAEL, IS NOW A WELL-FORTIFIED CITY. BUT KING DAVID KNOWS THAT HIS NATION LACKS ONE THING TO MAKE IT SPIRITUALLY STRONG— A WAY FOR ISRAEL TO WORSHIP THE LORD. HE CALLS ON THE PEOPLE TO GO WITH HIM TO BRING GOD'S HOLY ARK TO JERUSALEM.

FATHER, WHAT'S IN THE GOLDEN CHEST?

TWO STONE TABLETS ON WHICH GOD'S TEN COMMANDMENTS ARE WRITTEN.

WHERE HAS IT BEEN?

THE PHILISTINES CAPTURED IT—BUT WHEN TROUBLE CAME TO THEM, THEY WERE AFRAID AND SENT IT BACK. IT HAS BEEN STORED AWAY FOR MANY YEARS.

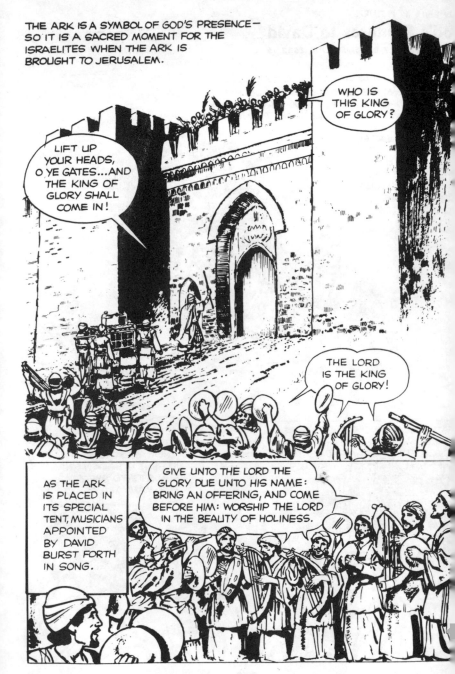

374

BUT ONE DAY DAVID LOOKS AT THE TENT AND CALLS NATHAN, THE PROPHET OF GOD, TO HIM.

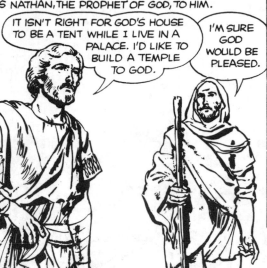

IT ISN'T RIGHT FOR GOD'S HOUSE TO BE A TENT WHILE I LIVE IN A PALACE. I'D LIKE TO BUILD A TEMPLE TO GOD.

I'M SURE GOD WOULD BE PLEASED.

THAT NIGHT GOD SPEAKS TO NATHAN—AND THE NEXT DAY NATHAN TELLS DAVID THAT GOD DOES NOT WANT HIM TO BUILD THE TEMPLE. BUT GOD PROMISES TO GIVE DAVID A SON WHO WILL BUILD A HOUSE FOR GOD—AND THAT HIS ROYAL LINE WILL LAST FOREVER. THIS SECOND PROMISE WAS FULFILLED IN JESUS, WHO WAS BORN OF THE ROYAL LINE OF DAVID AND REIGNS FOREVER.

THEN DAVID REMEMBERS A PROMISE HE HIMSELF MADE YEARS BEFORE TO HIS BEST FRIEND, JONATHAN. EACH HAD VOWED TO BE KIND TO THE OTHER'S CHILDREN. DAVID INQUIRES ABOUT JONATHAN'S FAMILY.

SEND FOR HIM.

REMEMBER, HE IS ALSO KING SAUL'S GRANDSON. BUT FOR YOU HE MIGHT BE SITTING ON THE THRONE OF ISRAEL. HE MAY HATE YOU...

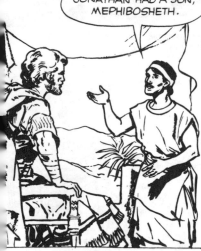

YES, PRINCE JONATHAN HAD A SON, MEPHIBOSHETH.

375

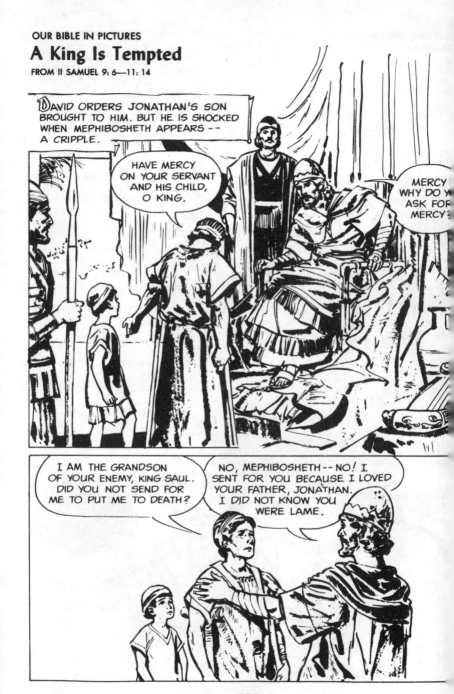

OUR BIBLE IN PICTURES

A King Is Tempted

FROM II SAMUEL 9: 6—11: 14

DAVID ORDERS JONATHAN'S SON BROUGHT TO HIM. BUT HE IS SHOCKED WHEN MEPHIBOSHETH APPEARS -- A CRIPPLE.

HAVE MERCY ON YOUR SERVANT AND HIS CHILD, O KING.

MERCY! WHY DO Y ASK FOR MERCY?

I AM THE GRANDSON OF YOUR ENEMY, KING SAUL. DID YOU NOT SEND FOR ME TO PUT ME TO DEATH?

NO, MEPHIBOSHETH -- NO! I SENT FOR YOU BECAUSE I LOVED YOUR FATHER, JONATHAN. I DID NOT KNOW YOU WERE LAME.

I WAS ONLY FIVE WHEN THE NEWS OF MY FATHER'S DEATH CAME. AS MY NURSE RAN IN FRIGHT, SHE DROPPED ME. I HAVE BEEN CRIPPLED EVER SINCE.

I AM SORRY -- AND I REGRET THAT YOUR GRANDFATHER'S LAND WAS NOT RESTORED TO YOU BEFORE. IT IS NOW YOURS -- AND I INVITE YOU TO EAT EVERY DAY AT MY TABLE.

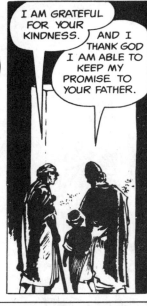

I AM GRATEFUL FOR YOUR KINDNESS.

AND I THANK GOD I AM ABLE TO KEEP MY PROMISE TO YOUR FATHER.

UNDER DAVID'S LEADERSHIP, ISRAEL GROWS STRONGER EVERY DAY. BUT RULERS OF THE COUNTRIES AROUND GROW WORRIED.

WORD HAS COME THAT THE SYRIANS AND AMMONITES ARE JOINING FORCES AGAINST US.

I CAN'T LEAVE JERUSALEM NOW, JOAB. CALL UP THE ARMY AND GO OUT TO MEET THEM.

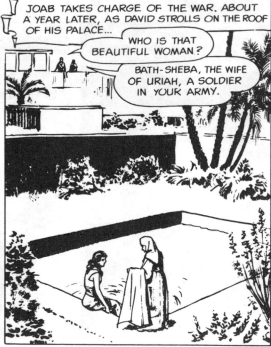

JOAB TAKES CHARGE OF THE WAR. ABOUT A YEAR LATER, AS DAVID STROLLS ON THE ROOF OF HIS PALACE...

WHO IS THAT BEAUTIFUL WOMAN?

BATH-SHEBA, THE WIFE OF URIAH, A SOLDIER IN YOUR ARMY.

377

DAVID SENDS A MESSENGER TO BRING BATH-SHEBA TO HIS COURT.

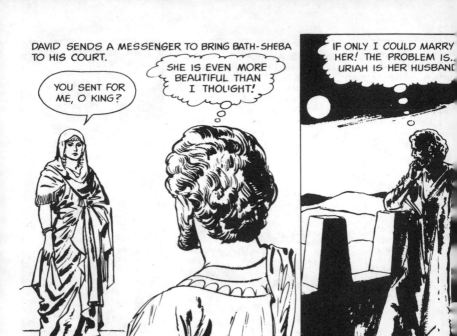

YOU SENT FOR ME, O KING?

SHE IS EVEN MORE BEAUTIFUL THAN I THOUGHT!

IF ONLY I COULD MARRY HER! THE PROBLEM IS... URIAH IS HER HUSBAND

BUT SOLDIERS SOMETIMES DIE IN BATTLE. THAT'S IT!

THINKING ONLY OF HIS LOVE FOR BATH-SHE[BA], DAVID SENDS FOR URIAH ON THE EXCUSE [OF] ASKING ABOUT THE WAR.

THE ENEMY IS STRONG. BUT JOAB THINKS WE CAN FORCE THEIR SURRENDER SOON.

I AM SURE OF IT. PREPARE TO RETU[RN] TO THE FRONT-- AN[D] TAKE THIS MESSAG[E] TO JOAB.

ing David's Sin

URIAH, THE HUSBAND OF BATH-SHEBA, RETURNS TO THE BATTLEFRONT WITH A MESSAGE FROM KING DAVID TO JOAB, GENERAL OF THE ISRAELITE FORCES

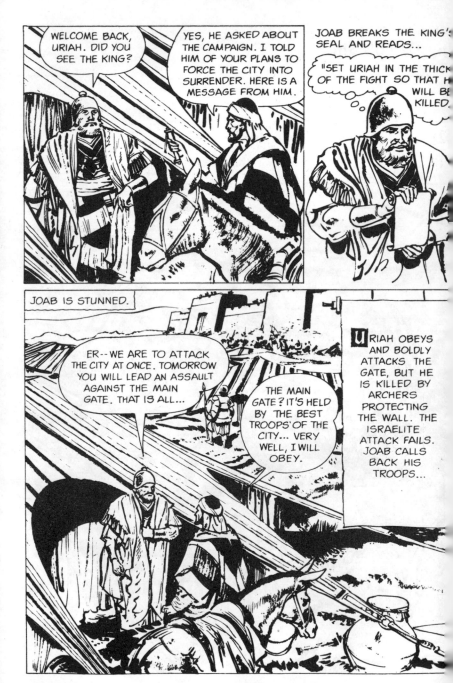

380

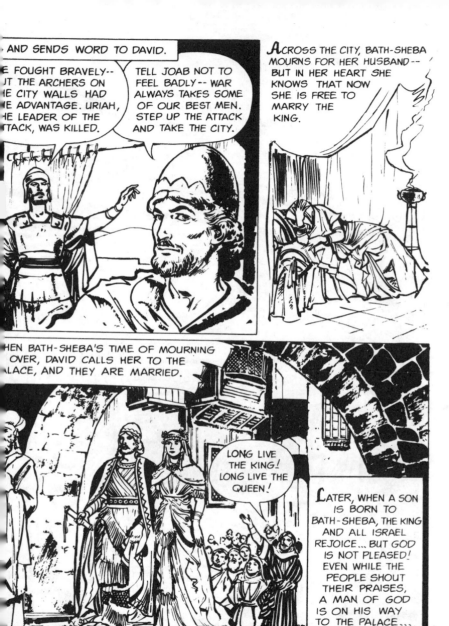

... AND SENDS WORD TO DAVID.

...E FOUGHT BRAVELY-- ...UT THE ARCHERS ON ...E CITY WALLS HAD ...E ADVANTAGE. URIAH, ...E LEADER OF THE ...TACK, WAS KILLED.

TELL JOAB NOT TO FEEL BADLY-- WAR ALWAYS TAKES SOME OF OUR BEST MEN. STEP UP THE ATTACK AND TAKE THE CITY.

ACROSS THE CITY, BATH-SHEBA MOURNS FOR HER HUSBAND-- BUT IN HER HEART SHE KNOWS THAT NOW SHE IS FREE TO MARRY THE KING.

...HEN BATH-SHEBA'S TIME OF MOURNING ...OVER, DAVID CALLS HER TO THE ...LACE, AND THEY ARE MARRIED.

LONG LIVE THE KING! LONG LIVE THE QUEEN!

LATER, WHEN A SON IS BORN TO BATH-SHEBA, THE KING AND ALL ISRAEL REJOICE... BUT GOD IS NOT PLEASED! EVEN WHILE THE PEOPLE SHOUT THEIR PRAISES, A MAN OF GOD IS ON HIS WAY TO THE PALACE...

The King's Punishment

FROM II SAMUEL 12: 1-14

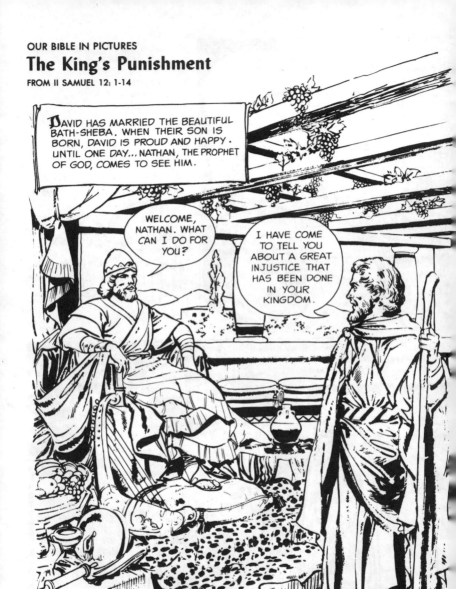

DAVID HAS MARRIED THE BEAUTIFUL BATH-SHEBA. WHEN THEIR SON IS BORN, DAVID IS PROUD AND HAPPY. UNTIL ONE DAY... NATHAN, THE PROPHET OF GOD, COMES TO SEE HIM.

WELCOME, NATHAN. WHAT CAN I DO FOR YOU?

I HAVE COME TO TELL YOU ABOUT A GREAT INJUSTICE THAT HAS BEEN DONE IN YOUR KINGDOM.

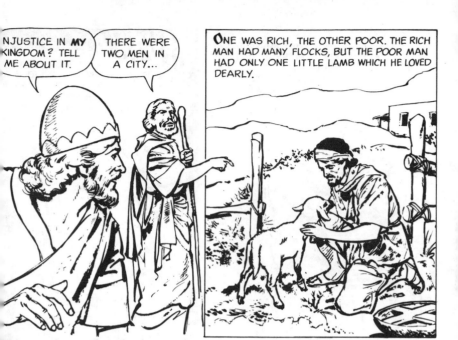

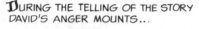

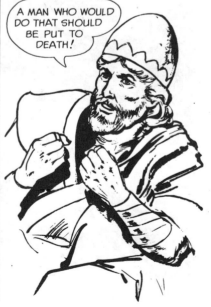

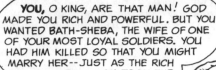

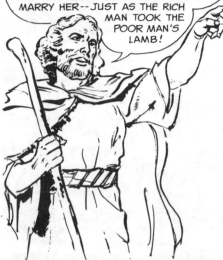

YOU, O KING, ARE THAT MAN! GOD MADE YOU RICH AND POWERFUL. BUT YOU WANTED BATH-SHEBA, THE WIFE OF ONE OF YOUR MOST LOYAL SOLDIERS. YOU HAD HIM KILLED SO THAT YOU MIGHT MARRY HER--JUST AS THE RICH MAN TOOK THE POOR MAN'S LAMB!

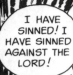

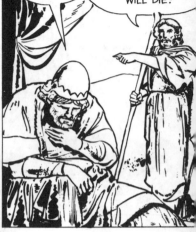

I HAVE SINNED! I HAVE SINNED AGAINST THE LORD!

AND YOUR SIN WILL BRING TROUBLE TO YOU AND YOUR FAMILY. THE CHILD WHICH HAS BEEN BORN TO YOU AND BATH-SHEBA WILL DIE!

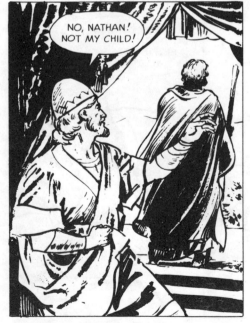

NO, NATHAN! NOT MY CHILD!

HE'S GONE!

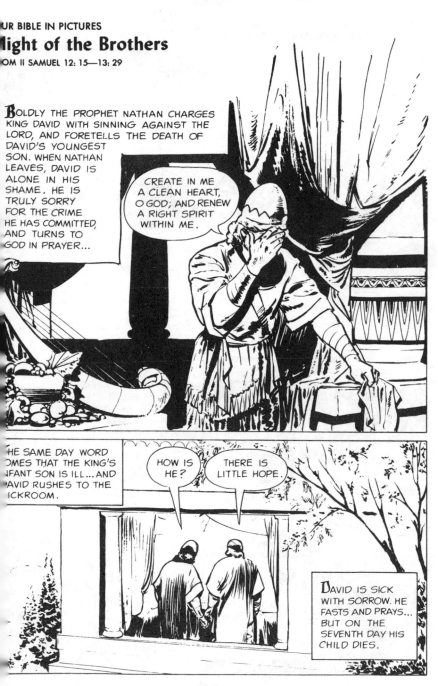

light of the Brothers

BOLDLY THE PROPHET NATHAN CHARGES KING DAVID WITH SINNING AGAINST THE LORD, AND FORETELLS THE DEATH OF DAVID'S YOUNGEST SON. WHEN NATHAN LEAVES, DAVID IS ALONE IN HIS SHAME. HE IS TRULY SORRY FOR THE CRIME HE HAS COMMITTED, AND TURNS TO GOD IN PRAYER...

CREATE IN ME A CLEAN HEART, O GOD; AND RENEW A RIGHT SPIRIT WITHIN ME.

THE SAME DAY WORD COMES THAT THE KING'S INFANT SON IS ILL...AND DAVID RUSHES TO THE SICKROOM.

HOW IS HE?

THERE IS LITTLE HOPE.

DAVID IS SICK WITH SORROW. HE FASTS AND PRAYS... BUT ON THE SEVENTH DAY HIS CHILD DIES.

385

MEANWHILE JOAB, DAVID'S GENERAL, CONTINUES THE SIEGE AGAINST THE CITY OF RABBAH. TO HONOR DAVID, HE SENDS WORD FOR THE KING TO COME AND MAKE THE FINAL ATTACK. DAVID LEADS THE CHARGE -- AND THE CITY SURRENDERS.

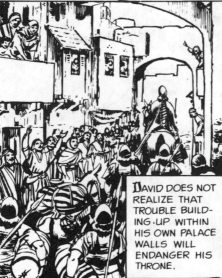

RETURNING VICTORIOUS INTO JERUSALEM, DAVID IS GREETED WITH SHOUTS OF PRAISE. HE IS PLEASED AND PROUD -- ISRAEL IS STRONG, AND NO NATION WOULD DARE ATTACK IT, BUT...

DAVID DOES NOT REALIZE THAT TROUBLE BUILD-ING-UP WITHIN HIS OWN PALACE WALLS WILL ENDANGER HIS THRONE.

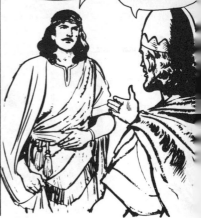

SOON AFTER DAVID'S TRIUMPHAL RETURN, PRINCE ABSALOM MAKES A SPECIAL VISIT TO HIS FATHER.

IT'S SHEEPSHEARING TIME, AND I'M HAVING A BIG FEAST IN THE COUNTRY. WILL YOU HONOR MY GUESTS WITH YOUR PRESENCE?

THANK YOU, ABSALOM, BUT IF YOU ARE HAVING A BIG FEAST, I DON'T WANT TO ADD TO YOUR EXPENSES.

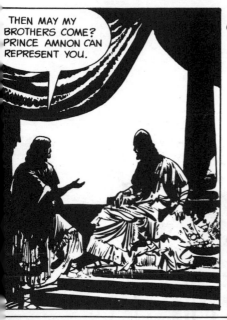

THEN MAY MY BROTHERS COME? PRINCE AMNON CAN REPRESENT YOU.

AMNON? I THOUGHT ABSALOM HATED HIM.

YES, I'M PLEASED THAT YOU WANT TO HONOR YOUR BROTHERS THIS WAY.

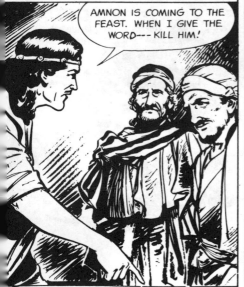

ABSALOM DOES HATE HIS OLDER HALF-BROTHER, AMNON, WHO HAS FIRST RIGHT TO DAVID'S THRONE. WHEN AMNON ACCEPTS THE INVITATION, ABSALOM CALLS IN HIS SERVANTS.

AMNON IS COMING TO THE FEAST. WHEN I GIVE THE WORD--- KILL HIM!

AT THE HEIGHT OF THE FEAST, AMNON IS KILLED... AFRAID FOR THEIR LIVES, THE REST OF THE BROTHERS FLEE INTO THE NIGHT...

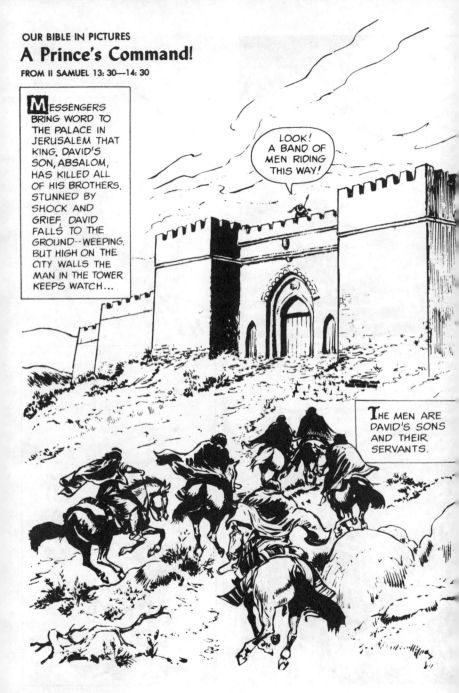

OUR BIBLE IN PICTURES

A Prince's Command!

FROM II SAMUEL 13: 30—14: 30

MESSENGERS BRING WORD TO THE PALACE IN JERUSALEM THAT KING DAVID'S SON, ABSALOM, HAS KILLED ALL OF HIS BROTHERS. STUNNED BY SHOCK AND GRIEF, DAVID FALLS TO THE GROUND--WEEPING. BUT HIGH ON THE CITY WALLS THE MAN IN THE TOWER KEEPS WATCH...

LOOK! A BAND OF MEN RIDING THIS WAY!

THE MEN ARE DAVID'S SONS AND THEIR SERVANTS.

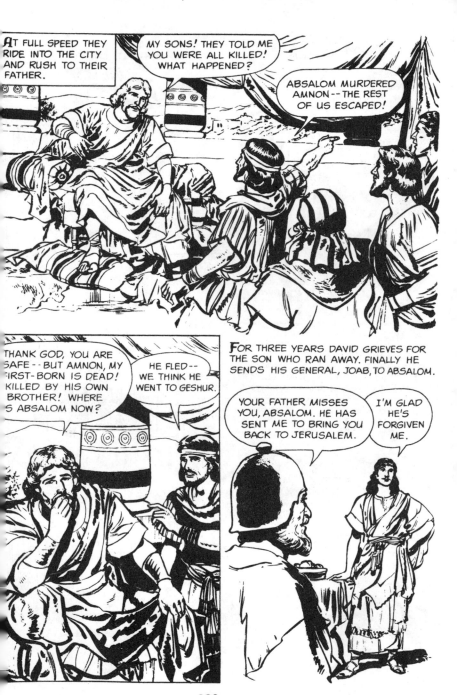

389

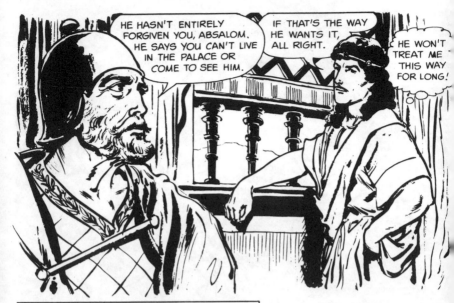

FOR TWO YEARS ABSALOM LIVES IN JERUSALEM WITHOUT SEEING HIS FATHER. HE RESENTS THIS TREATMENT AND HIS ANGER GROWS UNTIL AT LAST HE CAN STAND IT NO LONGER. HE SENDS FOR JOAB. JOAB REFUSES TO COME. ABSALOM SENDS A SECOND TIME.

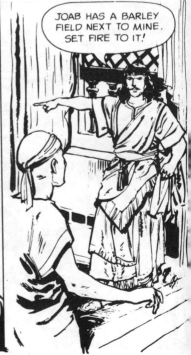

Treason?

FROM II SAMUEL 14: 31—15: 4

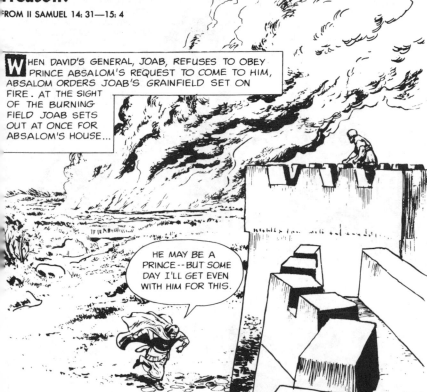

WHEN DAVID'S GENERAL, JOAB, REFUSES TO OBEY PRINCE ABSALOM'S REQUEST TO COME TO HIM, ABSALOM ORDERS JOAB'S GRAINFIELD SET ON FIRE. AT THE SIGHT OF THE BURNING FIELD JOAB SETS OUT AT ONCE FOR ABSALOM'S HOUSE...

HE MAY BE A PRINCE--BUT SOME DAY I'LL GET EVEN WITH HIM FOR THIS.

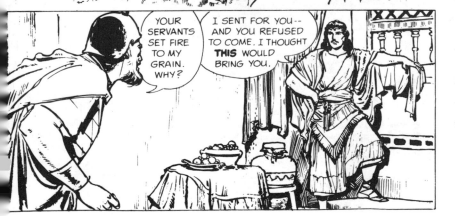

YOUR SERVANTS SET FIRE TO MY GRAIN. WHY?

I SENT FOR YOU-- AND YOU REFUSED TO COME. I THOUGHT **THIS** WOULD BRING YOU.

I'M A PRINCE, AND I SHOULD BE TREATED LIKE MY BROTHERS. GO TO MY FATHER AND ASK HIM IF HE WILL SEE ME.

BUT... HE ASKED ME TO COME BACK TO JERUSALEM. IF HE WANTS TO PUNISH ME FOR WHAT I DID, LET HIM DO IT. IF NOT, THEN LET HIM TREAT ME LIKE A SON AGAIN.

JOAB CARRIES ABSALOM'S MESSAGE TO KING DAVID.

YOUR SON MISSES YOU — HE WISHES TO BE FORGIVEN AND WELCOMED BACK INTO THE FAMILY.

HE MISSES ME? NO MORE THAN I MISS HIM. TELL HIM TO COME TO ME.

ABSALOM PRETENDS TO BE HUMBLE AS HE BOWS BEFORE HIS FATHER--ASKING FORGIVENESS. BUT IN HIS HEART HE HAS AN EVIL PLAN.

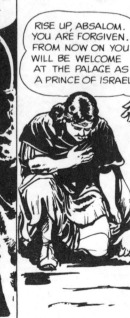

RISE UP, ABSALOM. YOU ARE FORGIVEN. FROM NOW ON YOU WILL BE WELCOME AT THE PALACE AS A PRINCE OF ISRAEL.

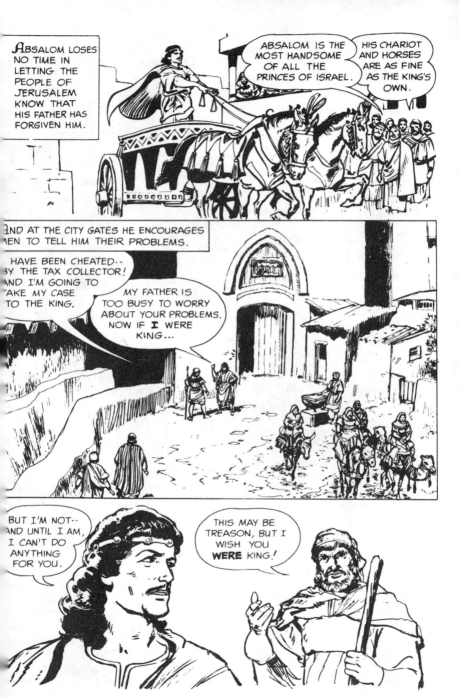

393

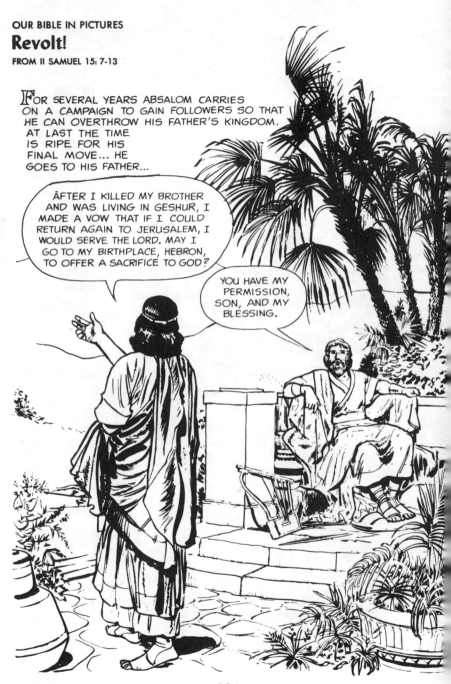

OUR BIBLE IN PICTURES
Revolt!
FROM II SAMUEL 15: 7-13

FOR SEVERAL YEARS ABSALOM CARRIES ON A CAMPAIGN TO GAIN FOLLOWERS SO THAT HE CAN OVERTHROW HIS FATHER'S KINGDOM. AT LAST THE TIME IS RIPE FOR HIS FINAL MOVE... HE GOES TO HIS FATHER...

AFTER I KILLED MY BROTHER AND WAS LIVING IN GESHUR, I MADE A VOW THAT IF I COULD RETURN AGAIN TO JERUSALEM, I WOULD SERVE THE LORD. MAY I GO TO MY BIRTHPLACE, HEBRON, TO OFFER A SACRIFICE TO GOD?

YOU HAVE MY PERMISSION, SON, AND MY BLESSING.

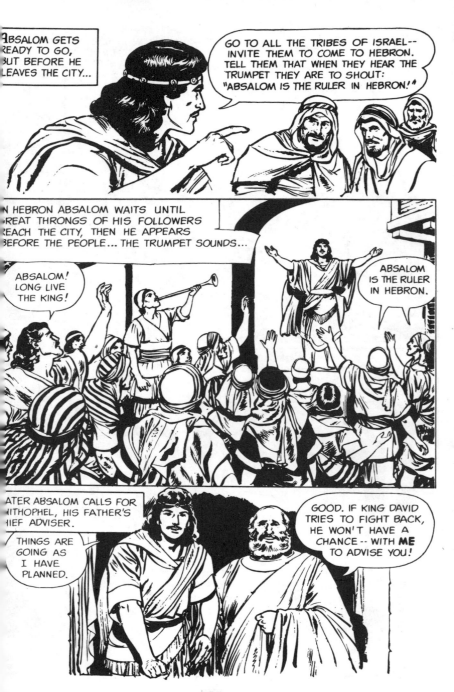

ABSALOM GETS READY TO GO, BUT BEFORE HE LEAVES THE CITY...

GO TO ALL THE TRIBES OF ISRAEL-- INVITE THEM TO COME TO HEBRON. TELL THEM THAT WHEN THEY HEAR THE TRUMPET THEY ARE TO SHOUT: "ABSALOM IS THE RULER IN HEBRON!"

IN HEBRON ABSALOM WAITS UNTIL GREAT THRONGS OF HIS FOLLOWERS REACH THE CITY, THEN HE APPEARS BEFORE THE PEOPLE... THE TRUMPET SOUNDS...

ABSALOM! LONG LIVE THE KING!

ABSALOM IS THE RULER IN HEBRON.

LATER ABSALOM CALLS FOR AHITHOPHEL, HIS FATHER'S CHIEF ADVISER.

THINGS ARE GOING AS I HAVE PLANNED.

GOOD. IF KING DAVID TRIES TO FIGHT BACK, HE WON'T HAVE A CHANCE -- WITH **ME** TO ADVISE YOU!

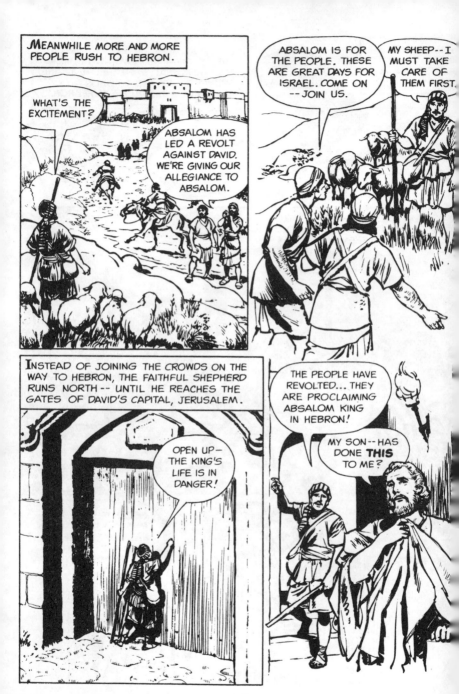

396

Council of War

THE NEWS THAT HIS OWN SON, ABSALOM, HAS LED A REVOLT AGAINST HIM LEAVES DAVID IN A STATE OF SHOCK.

ABSALOM! HOW CAN I FIGHT MY OWN SON--MY OWN PEOPLE? WHOM CAN I COUNT ON TO STAND WITH ME?

YOUR FRIENDS WILL MAKE THEMSELVES KNOWN.

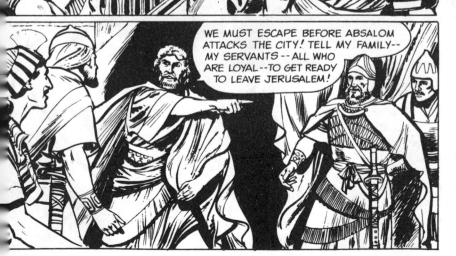

WE MUST ESCAPE BEFORE ABSALOM ATTACKS THE CITY! TELL MY FAMILY-- MY SERVANTS -- ALL WHO ARE LOYAL--TO GET READY TO LEAVE JERUSALEM!

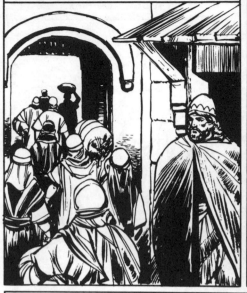

AT DAWN DAVID LEADS HIS PEOPLE OUT OF THE CITY--AT THE LAST HOUSE HE STOPS TO WATCH HIS FOLLOWERS PASS BY.

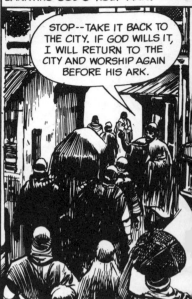

IN THE PROCESSION ARE THE PRIESTS CARRYING GOD'S HOLY ARK.

STOP--TAKE IT BACK TO THE CITY. IF GOD WILLS IT, I WILL RETURN TO THE CITY AND WORSHIP AGAIN BEFORE HIS ARK.

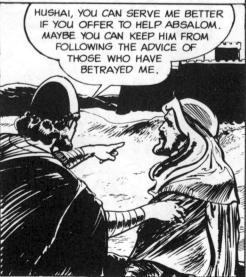

THE NUMBER WHO CHOOSE TO JOIN DAVID GROWS WITH EACH PASSING HOUR. BUT DAVID SENDS ONE OF THEM BACK...

HUSHAI, YOU CAN SERVE ME BETTER IF YOU OFFER TO HELP ABSALOM. MAYBE YOU CAN KEEP HIM FROM FOLLOWING THE ADVICE OF THOSE WHO HAVE BETRAYED ME.

YOU ARE MY KING, AND I WILL SERVE IN ANY WAY YOU ASK.

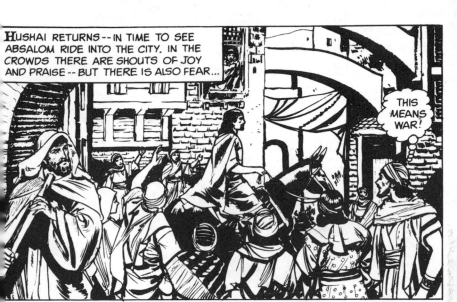

HUSHAI RETURNS -- IN TIME TO SEE ABSALOM RIDE INTO THE CITY. IN THE CROWDS THERE ARE SHOUTS OF JOY AND PRAISE -- BUT THERE IS ALSO FEAR...

THIS MEANS WAR!

LIKE THE MAN IN THE CROWD, HUSHAI KNOWS THAT WAR WILL SOON BE UPON THEM. HE OFFERS HIS SERVICES TO ABSALOM -- AND ALONG WITH AHITHOPHEL IS CALLED TO THE FIRST COUNCIL OF WAR. AHITHOPHEL SPEAKS FIRST.

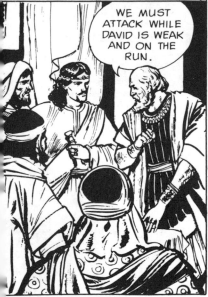

WE MUST ATTACK WHILE DAVID IS WEAK AND ON THE RUN.

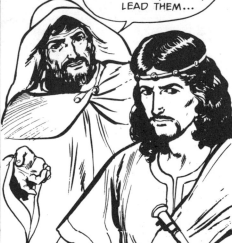

NO, AHITHOPHEL'S ADVICE IS NOT GOOD. DAVID AND HIS MEN ARE ISRAEL'S BEST FIGHTERS. AND RIGHT NOW THEY ARE ANGRY AS BEARS ROBBED OF THEIR YOUNG. IF YOU ATTACK AND SUFFER ANY DEFEAT, THE PEOPLE WILL TURN AGAINST YOU. WAIT UNTIL YOU CAN CALL UP THOUSANDS OF MEN... THEN IF YOU, O KING, LEAD THEM...

Hide-out in a Well

FROM II SAMUEL 17: 14-23

AHITHOPHEL HAS ADVISED ABSALOM TO ATTACK KING DAVID WHILE HE IS FLEEING FOR HIS LIFE. BUT HUSHAI -- SECRETLY WORKING FOR DAVID -- TELLS ABSALOM TO WAIT UNTIL HIS OWN FORCES ARE BETTER PREPARED.

NO! NO! HUSHAI'S ADVICE WILL HELP YOUR FATHER MORE THAN YOU. GIVE DAVID TIME TO GET HIS FORCES PREPARED, AND THE BATTLE IS HIS. REMEMBER -- DEFEAT MEANS DEATH TO ALL OF US!

BUT ABSALOM WILL NOT LISTEN. AHITHOPHEL IS SO SURE THE REBELLION WILL FAIL -- AND HE WILL DIE A TRAITOR'S DEATH -- THAT HE GOES HOME AND COMMITS SUICIDE.

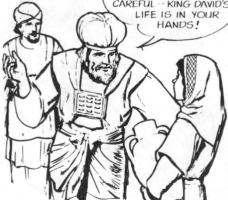

MEANWHILE, BACK IN JERUSALEM, HUSHAI'S WELL-ORGANIZED PLAN IS BEING CARRIED OUT.

TWO OF OUR MEN ARE WAITING AT THE KIDRON FOUNTAIN. TELL THEM WHAT WE HAVE TOLD YOU. BE CAREFUL -- KING DAVID'S LIFE IS IN YOUR HANDS!

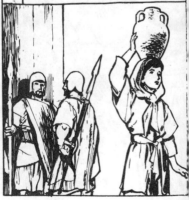

WITH A WATER JUG ON HER HEAD, THE GIRL WALKS BOLDLY OUT OF THE CITY GATE...

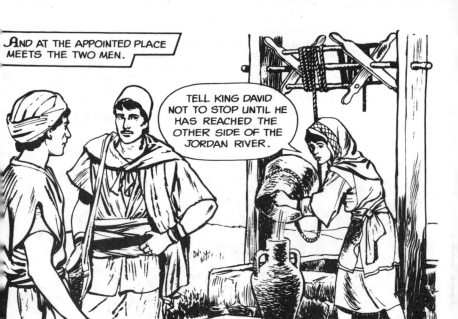

AND AT THE APPOINTED PLACE MEETS THE TWO MEN.

TELL KING DAVID NOT TO STOP UNTIL HE HAS REACHED THE OTHER SIDE OF THE JORDAN RIVER.

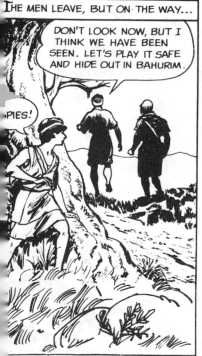

THE MEN LEAVE, BUT ON THE WAY...

DON'T LOOK NOW, BUT I THINK WE HAVE BEEN SEEN. LET'S PLAY IT SAFE AND HIDE OUT IN BAHURIM.

PIES!

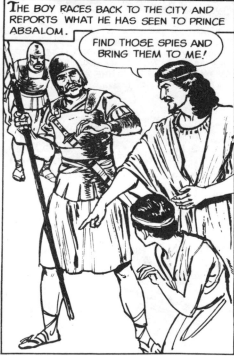

THE BOY RACES BACK TO THE CITY AND REPORTS WHAT HE HAS SEEN TO PRINCE ABSALOM.

FIND THOSE SPIES AND BRING THEM TO ME!

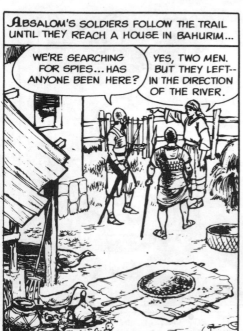

ABSALOM'S SOLDIERS FOLLOW THE TRAIL UNTIL THEY REACH A HOUSE IN BAHURIM...

WE'RE SEARCHING FOR SPIES...HAS ANYONE BEEN HERE?

YES, TWO MEN. BUT THEY LEFT-- IN THE DIRECTION OF THE RIVER.

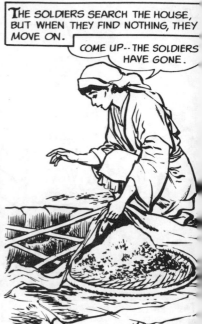

THE SOLDIERS SEARCH THE HOUSE, BUT WHEN THEY FIND NOTHING, THEY MOVE ON.

COME UP-- THE SOLDIERS HAVE GONE.

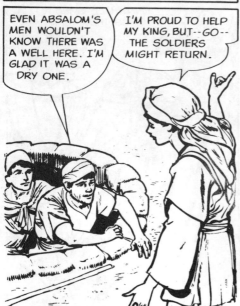

EVEN ABSALOM'S MEN WOULDN'T KNOW THERE WAS A WELL HERE. I'M GLAD IT WAS A DRY ONE.

I'M PROUD TO HELP MY KING, BUT--GO-- THE SOLDIERS MIGHT RETURN.

THE MESSENGERS HURRY ON... AND THAT NIGHT DAVID AND HIS FOLLOWERS CROSS OVER THE JORDAN.

ather Against Son

FROM II SAMUEL 17: 24—18: 9

ABSALOM'S SOLDIERS SEARCH FOR THE MESSENGERS WHO HAVE BEEN SENT TO WARN DAVID. WHEN THEY CANNOT FIND THEM, THEY RETURN TO JERUSALEM. MEANWHILE, DAVID AND HIS FOLLOWERS REACH THE CITY OF MAHANAIM.

HERE'S SOME FOOD AND BEDDING MY MASTER HAS SENT FOR KING DAVID AND HIS FRIENDS.

GOD BLESS YOU. TELL YOUR MASTER I WILL NOT FORGET HIS KINDNESS.

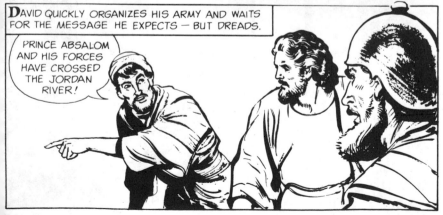

DAVID QUICKLY ORGANIZES HIS ARMY AND WAITS FOR THE MESSAGE HE EXPECTS — BUT DREADS.

PRINCE ABSALOM AND HIS FORCES HAVE CROSSED THE JORDAN RIVER!

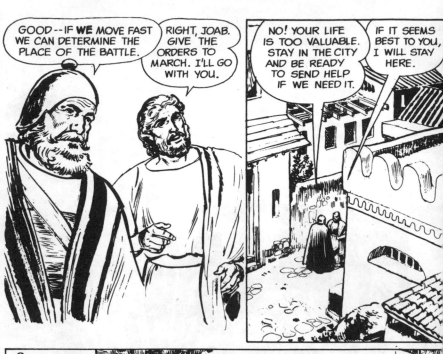

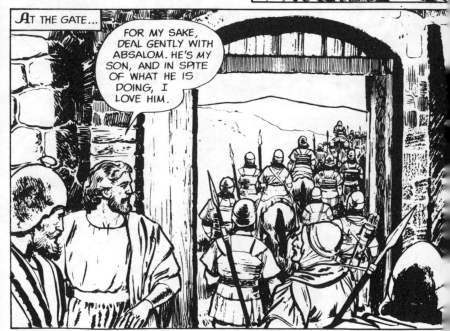

404

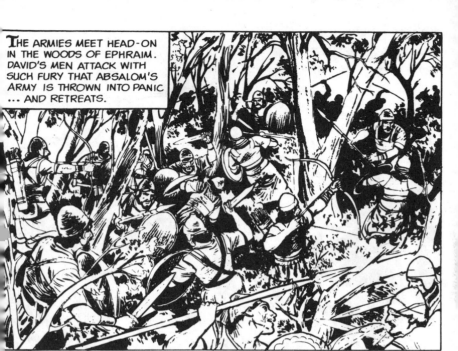

THE ARMIES MEET HEAD-ON IN THE WOODS OF EPHRAIM. DAVID'S MEN ATTACK WITH SUCH FURY THAT ABSALOM'S ARMY IS THROWN INTO PANIC ... AND RETREATS.

THE BATTLE IS LOST. ABSALOM IS AFRAID THAT IF HE IS CAUGHT HE WILL SUFFER A TRAITOR'S DEATH. HE TRIES TO ESCAPE...

AND IS CAUGHT IN THE LOW HANGING BRANCH OF AN OAK!

OUR BIBLE IN PICTURES

The King Returns

FROM II SAMUEL 18—24; I KINGS 1: 1-9

PRINCE ABSALOM'S REVOLT AGAINST HIS FATHER, KING DAVID, LEADS TO A TERRIBLE BATTLE IN THE WOODS OF EPHRAIM. WHEN ABSALOM SEES THAT THE FIGHT IS GOING AGAINST HIM, HE TRIES TO ESCAPE, BUT...

GENERAL JOAB! ABSALOM IS CAUGHT-- BACK THERE-- IN A TREE!

ABSALOM? WHY DIDN'T YOU KILL HIM ON THE SPOT!

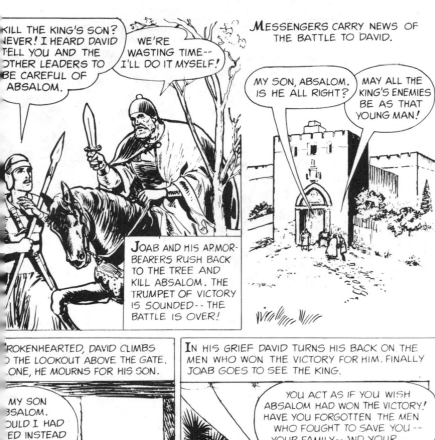

KILL THE KING'S SON? NEVER! I HEARD DAVID TELL YOU AND THE OTHER LEADERS TO BE CAREFUL OF ABSALOM.

WE'RE WASTING TIME-- I'LL DO IT MYSELF!

MESSENGERS CARRY NEWS OF THE BATTLE TO DAVID.

MY SON, ABSALOM. IS HE ALL RIGHT?

MAY ALL THE KING'S ENEMIES BE AS THAT YOUNG MAN!

JOAB AND HIS ARMOR-BEARERS RUSH BACK TO THE TREE AND KILL ABSALOM. THE TRUMPET OF VICTORY IS SOUNDED-- THE BATTLE IS OVER!

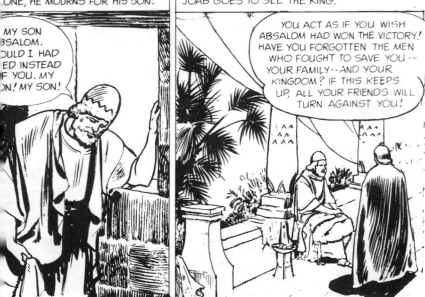

BROKENHEARTED, DAVID CLIMBS TO THE LOOKOUT ABOVE THE GATE. ALONE, HE MOURNS FOR HIS SON.

MY SON ABSALOM. WOULD I HAD DIED INSTEAD OF YOU. MY SON! MY SON!

IN HIS GRIEF DAVID TURNS HIS BACK ON THE MEN WHO WON THE VICTORY FOR HIM. FINALLY JOAB GOES TO SEE THE KING.

YOU ACT AS IF YOU WISH ABSALOM HAD WON THE VICTORY! HAVE YOU FORGOTTEN THE MEN WHO FOUGHT TO SAVE YOU-- YOUR FAMILY--AND YOUR KINGDOM? IF THIS KEEPS UP, ALL YOUR FRIENDS WILL TURN AGAINST YOU!

407

DAVID SEES THE TRUTH OF JOAB'S WORDS. HE MAKES PEACE WITH THE TRIBES THAT HAD SIDED WITH ABSALOM... AND GOES BACK TO JERUSALEM.

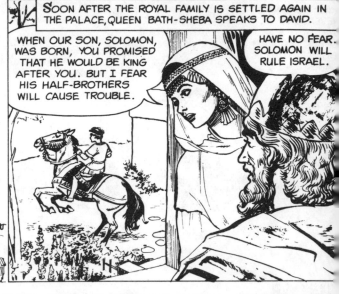

SOON AFTER THE ROYAL FAMILY IS SETTLED AGAIN IN THE PALACE, QUEEN BATH-SHEBA SPEAKS TO DAVID.

WHEN OUR SON, SOLOMON, WAS BORN, YOU PROMISED THAT HE WOULD BE KING AFTER YOU. BUT I FEAR HIS HALF-BROTHERS WILL CAUSE TROUBLE.

HAVE NO FEAR. SOLOMON WILL RULE ISRAEL.

YEARS PASS -- AND DAVID GROWS OLD. FINALLY WORD SPREADS THROUGHOUT JERUSALEM THAT THE KING'S HEALTH IS FAILING FAST. THE PEOPLE KNOW THAT DAVID HAS CHOSEN SOLOMON TO BE KING AND TO BUILD THE TEMPLE OF GOD. BUT THERE ARE RUMORS...

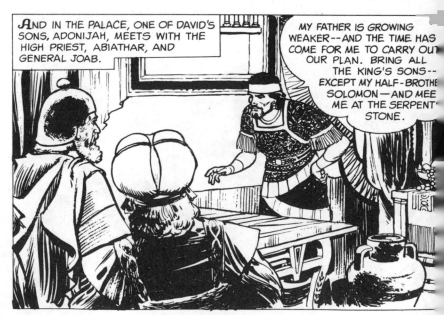

AND IN THE PALACE, ONE OF DAVID'S SONS, ADONIJAH, MEETS WITH THE HIGH PRIEST, ABIATHAR, AND GENERAL JOAB.

MY FATHER IS GROWING WEAKER -- AND THE TIME HAS COME FOR ME TO CARRY OUT OUR PLAN. BRING ALL THE KING'S SONS -- EXCEPT MY HALF-BROTHER SOLOMON — AND MEET ME AT THE SERPENT' STONE.

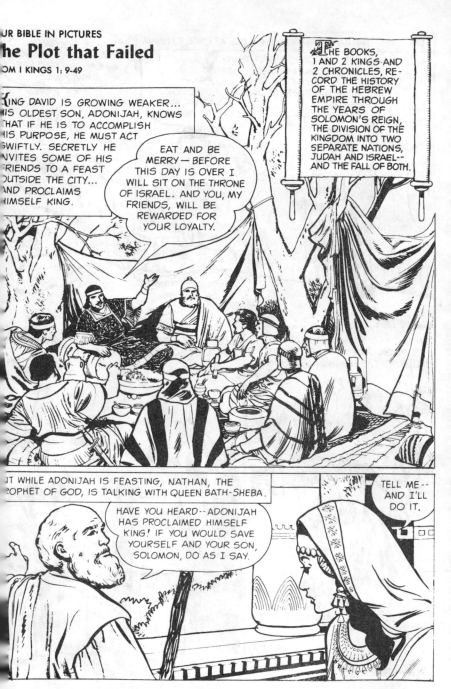

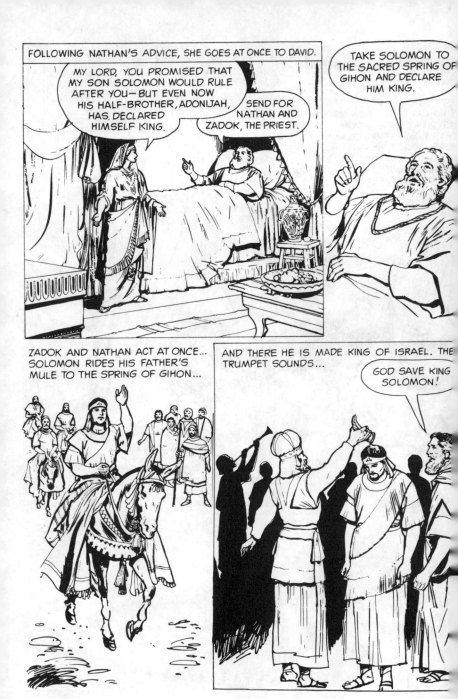

FOLLOWING NATHAN'S ADVICE, SHE GOES AT ONCE TO DAVID.

MY LORD, YOU PROMISED THAT MY SON SOLOMON WOULD RULE AFTER YOU — BUT EVEN NOW HIS HALF-BROTHER, ADONIJAH, HAS DECLARED HIMSELF KING.

SEND FOR NATHAN AND ZADOK, THE PRIEST.

TAKE SOLOMON TO THE SACRED SPRING OF GIHON AND DECLARE HIM KING.

ZADOK AND NATHAN ACT AT ONCE... SOLOMON RIDES HIS FATHER'S MULE TO THE SPRING OF GIHON...

AND THERE HE IS MADE KING OF ISRAEL. THE TRUMPET SOUNDS...

GOD SAVE KING SOLOMON!

AS SOLOMON RETURNS TO THE CITY, THE PEOPLE GREET THEIR NEW KING WITH SHOUTS OF JOY.

SO GREAT IS THE NOISE OF THE CELEBRATION THAT IT REACHES ADONIJAH'S FEAST.

WHAT'S GOING ON IN THE CITY?

...THAT MOMENT A MESSENGER ...NTERS...

WHAT ...OOD NEWS ...O YOU ...VE FOR US?

THE NOISE YOU HEAR IS THE SHOUTING OF ALL JERUSALEM! DAVID HAS MADE SOLOMON KING.

KNOWING THAT THEY MAY BE BRANDED AS TRAITORS, ADONIJAH'S GUESTS FLEE IN TERROR.

THERE'S ONLY ONE CHANCE TO SAVE MY LIFE.

411

Death of a King

FROM I KINGS 1: 49—2: 46

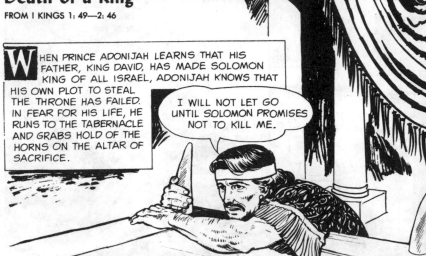

WHEN PRINCE ADONIJAH LEARNS THAT HIS FATHER, KING DAVID, HAS MADE SOLOMON KING OF ALL ISRAEL, ADONIJAH KNOWS THAT HIS OWN PLOT TO STEAL THE THRONE HAS FAILED. IN FEAR FOR HIS LIFE, HE RUNS TO THE TABERNACLE AND GRABS HOLD OF THE HORNS ON THE ALTAR OF SACRIFICE.

I WILL NOT LET GO UNTIL SOLOMON PROMISES NOT TO KILL ME.

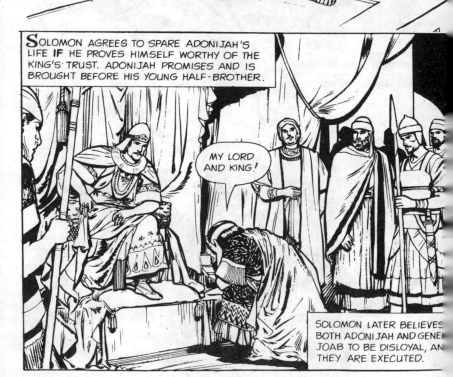

SOLOMON AGREES TO SPARE ADONIJAH'S LIFE **IF** HE PROVES HIMSELF WORTHY OF THE KING'S TRUST. ADONIJAH PROMISES AND IS BROUGHT BEFORE HIS YOUNG HALF-BROTHER.

MY LORD AND KING!

SOLOMON LATER BELIEVES BOTH ADONIJAH AND GENERAL JOAB TO BE DISLOYAL, AND THEY ARE EXECUTED.

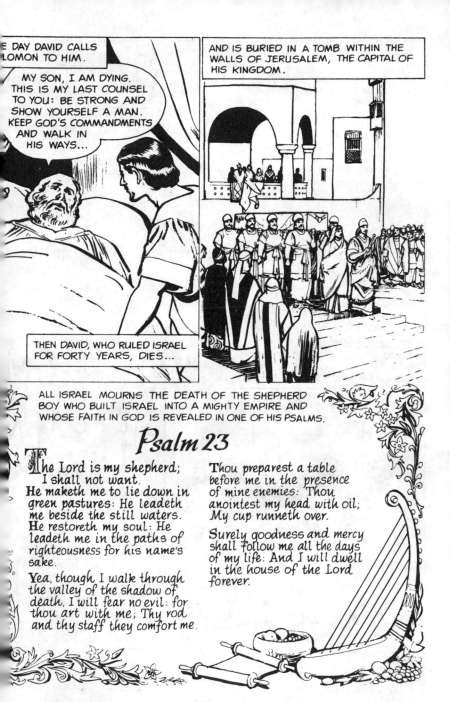

E DAY DAVID CALLS
LOMON TO HIM.

MY SON, I AM DYING. THIS IS MY LAST COUNSEL TO YOU: BE STRONG AND SHOW YOURSELF A MAN. KEEP GOD'S COMMANDMENTS AND WALK IN HIS WAYS...

AND IS BURIED IN A TOMB WITHIN THE WALLS OF JERUSALEM, THE CAPITAL OF HIS KINGDOM.

THEN DAVID, WHO RULED ISRAEL FOR FORTY YEARS, DIES...

ALL ISRAEL MOURNS THE DEATH OF THE SHEPHERD BOY WHO BUILT ISRAEL INTO A MIGHTY EMPIRE AND WHOSE FAITH IN GOD IS REVEALED IN ONE OF HIS PSALMS.

Psalm 23

The Lord is my shepherd; I shall not want. He maketh me to lie down in green pastures: He leadeth me beside the still waters. He restoreth my soul: He leadeth me in the paths of righteousness for his name's sake.

Yea, though I walk through the valley of the shadow of death, I will fear no evil: for thou art with me; Thy rod and thy staff they comfort me.

Thou preparest a table before me in the presence of mine enemies: Thou anointest my head with oil; My cup runneth over.

Surely goodness and mercy shall follow me all the days of my life: And I will dwell in the house of the Lord forever.

413

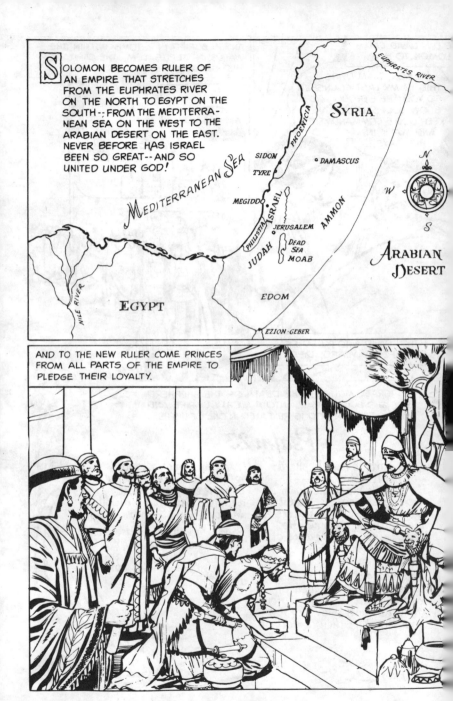

SOLOMON BECOMES RULER OF AN EMPIRE THAT STRETCHES FROM THE EUPHRATES RIVER ON THE NORTH TO EGYPT ON THE SOUTH--; FROM THE MEDITERRANEAN SEA ON THE WEST TO THE ARABIAN DESERT ON THE EAST. NEVER BEFORE HAS ISRAEL BEEN SO GREAT-- AND SO UNITED UNDER GOD!

EUPHRATES RIVER

SYRIA

MEDITERRANEAN SEA

SIDON
TYRE
PHOENICIA
DAMASCUS

MEGIDDO
ISRAEL
PHILISTIA
JERUSALEM
JUDAH
DEAD SEA
MOAB
AMMON

N
W S

ARABIAN DESERT

EDOM

NILE RIVER

EGYPT

EZION-GEBER

AND TO THE NEW RULER COME PRINCES FROM ALL PARTS OF THE EMPIRE TO PLEDGE THEIR LOYALTY.

414

God's Promise to a King

FROM I KINGS 3: 1-27

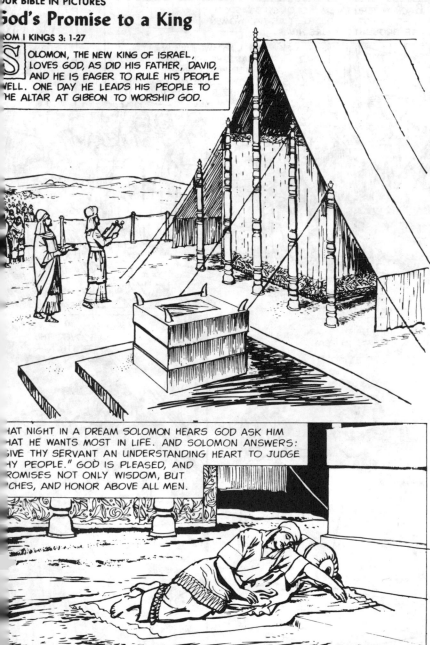

SOLOMON, THE NEW KING OF ISRAEL, LOVES GOD, AS DID HIS FATHER, DAVID, AND HE IS EAGER TO RULE HIS PEOPLE WELL. ONE DAY HE LEADS HIS PEOPLE TO THE ALTAR AT GIBEON TO WORSHIP GOD.

THAT NIGHT IN A DREAM SOLOMON HEARS GOD ASK HIM WHAT HE WANTS MOST IN LIFE. AND SOLOMON ANSWERS: "GIVE THY SERVANT AN UNDERSTANDING HEART TO JUDGE THY PEOPLE." GOD IS PLEASED, AND PROMISES NOT ONLY WISDOM, BUT RICHES, AND HONOR ABOVE ALL MEN.

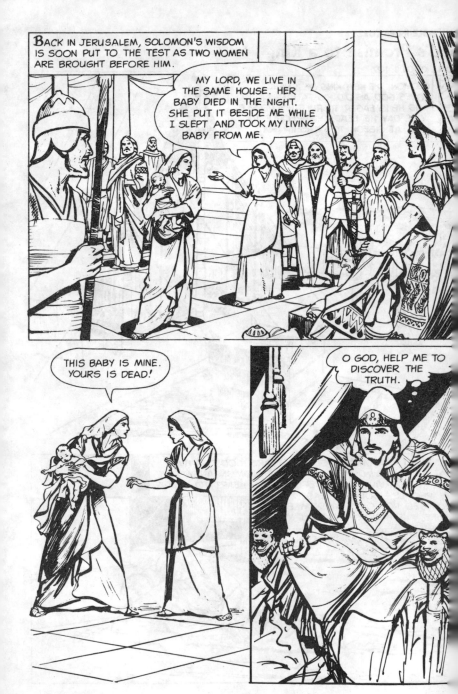

416

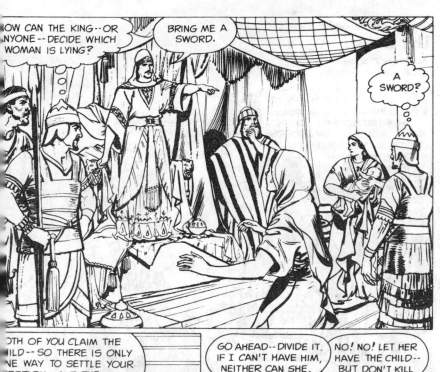

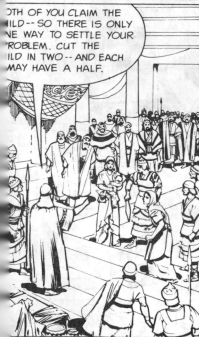

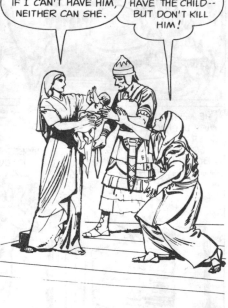

417

The Golden Age

FROM I KINGS 3: 25—7: 51

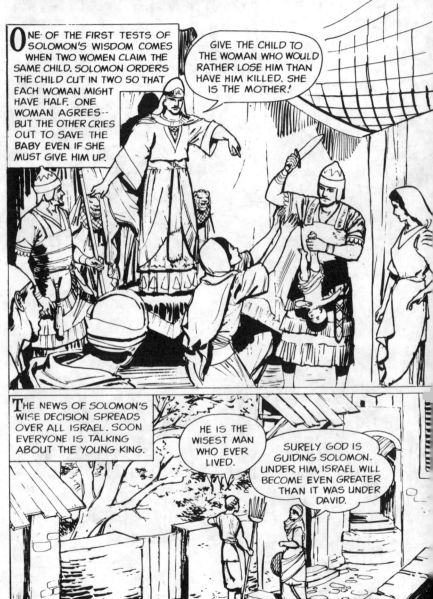

ONE OF THE FIRST TESTS OF SOLOMON'S WISDOM COMES WHEN TWO WOMEN CLAIM THE SAME CHILD. SOLOMON ORDERS THE CHILD CUT IN TWO SO THAT EACH WOMAN MIGHT HAVE HALF. ONE WOMAN AGREES-- BUT THE OTHER CRIES OUT TO SAVE THE BABY EVEN IF SHE MUST GIVE HIM UP.

GIVE THE CHILD TO THE WOMAN WHO WOULD RATHER LOSE HIM THAN HAVE HIM KILLED. SHE IS THE MOTHER!

THE NEWS OF SOLOMON'S WISE DECISION SPREADS OVER ALL ISRAEL. SOON EVERYONE IS TALKING ABOUT THE YOUNG KING.

HE IS THE WISEST MAN WHO EVER LIVED.

SURELY GOD IS GUIDING SOLOMON. UNDER HIM, ISRAEL WILL BECOME EVEN GREATER THAN IT WAS UNDER DAVID.

THE PEOPLE ARE HAPPY. ISRAEL IS AT PEACE. SOLOMON ESTABLISHES GOOD RELATIONS WITH MANY OF THE NEIGHBORING COUNTRIES BY MARRYING PRINCESSES OF THOSE NATIONS. RULERS OF THE COUNTRIES CONQUERED BY DAVID PAY TRIBUTE MONEY TO SOLOMON'S TREASURY. SO BEGINS THE GOLDEN AGE OF ISRAEL.

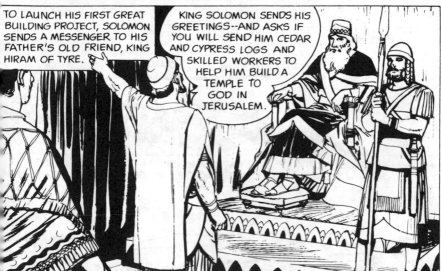

TO LAUNCH HIS FIRST GREAT BUILDING PROJECT, SOLOMON SENDS A MESSENGER TO HIS FATHER'S OLD FRIEND, KING HIRAM OF TYRE.

KING SOLOMON SENDS HIS GREETINGS--AND ASKS IF YOU WILL SEND HIM CEDAR AND CYPRESS LOGS AND SKILLED WORKERS TO HELP HIM BUILD A TEMPLE TO GOD IN JERUSALEM.

BLESSED BE THE LORD FOR GIVING MY FRIEND DAVID SUCH A WISE SON. TELL YOUR KING I WILL GIVE HIM WHAT HE ASKS IN EXCHANGE FOR WHEAT AND OIL, WHICH ARE SCARCE IN OUR COUNTRY.

THE DEAL IS MADE--AND SOON MEN BY THE THOUSANDS ARE ORDERED TO WORK IN THE FORESTS OF LEBANON, CUTTING CEDAR TREES FOR SOLOMON'S TEMPLE.

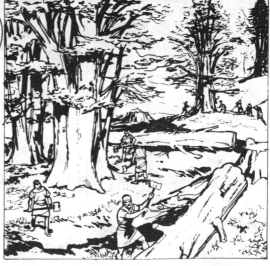

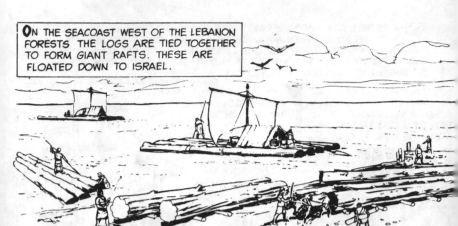

ON THE SEACOAST WEST OF THE LEBANON FORESTS THE LOGS ARE TIED TOGETHER TO FORM GIANT RAFTS. THESE ARE FLOATED DOWN TO ISRAEL.

AT THE SEAPORT OF JOPPA THE LOG RAFTS ARE BROKEN UP, AND THE TIMBERS ARE DRAGGED MORE THAN THIRTY MILES ACROSS RUGGED COUNTRY TO JERUSALEM

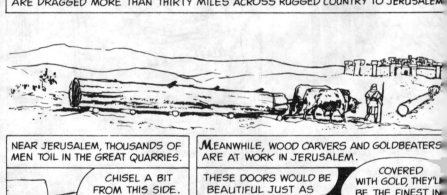

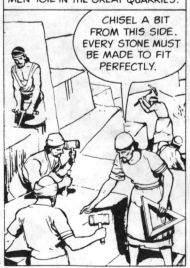

NEAR JERUSALEM, THOUSANDS OF MEN TOIL IN THE GREAT QUARRIES.

CHISEL A BIT FROM THIS SIDE. EVERY STONE MUST BE MADE TO FIT PERFECTLY.

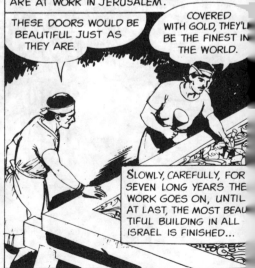

MEANWHILE, WOOD CARVERS AND GOLDBEATERS ARE AT WORK IN JERUSALEM.

THESE DOORS WOULD BE BEAUTIFUL JUST AS THEY ARE.

COVERED WITH GOLD, THEY'LL BE THE FINEST IN THE WORLD.

SLOWLY, CAREFULLY, FOR SEVEN LONG YEARS THE WORK GOES ON, UNTIL AT LAST, THE MOST BEAUTIFUL BUILDING IN ALL ISRAEL IS FINISHED...

420

he Temple of God

OM I KINGS 8: 1—10: 1

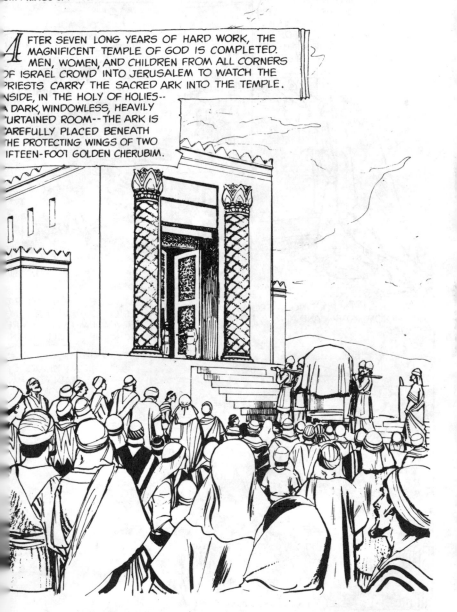

AFTER SEVEN LONG YEARS OF HARD WORK, THE MAGNIFICENT TEMPLE OF GOD IS COMPLETED. MEN, WOMEN, AND CHILDREN FROM ALL CORNERS OF ISRAEL CROWD INTO JERUSALEM TO WATCH THE PRIESTS CARRY THE SACRED ARK INTO THE TEMPLE. INSIDE, IN THE HOLY OF HOLIES-- A DARK, WINDOWLESS, HEAVILY CURTAINED ROOM--THE ARK IS CAREFULLY PLACED BENEATH THE PROTECTING WINGS OF TWO FIFTEEN-FOOT GOLDEN CHERUBIM.

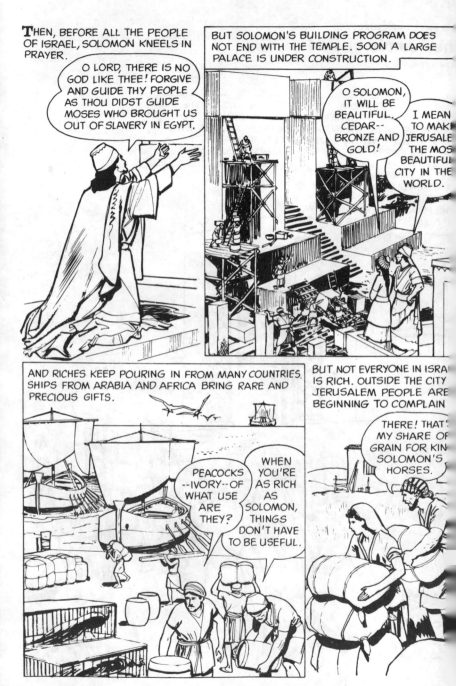

THEN, BEFORE ALL THE PEOPLE OF ISRAEL, SOLOMON KNEELS IN PRAYER.

O LORD, THERE IS NO GOD LIKE THEE! FORGIVE AND GUIDE THY PEOPLE AS THOU DIDST GUIDE MOSES WHO BROUGHT US OUT OF SLAVERY IN EGYPT.

BUT SOLOMON'S BUILDING PROGRAM DOES NOT END WITH THE TEMPLE. SOON A LARGE PALACE IS UNDER CONSTRUCTION.

O SOLOMON, IT WILL BE BEAUTIFUL. CEDAR-- BRONZE AND GOLD!

I MEAN TO MAK[E] JERUSALE[M] THE MOS[T] BEAUTIFU[L] CITY IN THE WORLD.

AND RICHES KEEP POURING IN FROM MANY COUNTRIES. SHIPS FROM ARABIA AND AFRICA BRING RARE AND PRECIOUS GIFTS.

PEACOCKS --IVORY-- OF WHAT USE ARE THEY?

WHEN YOU'RE AS RICH AS SOLOMON, THINGS DON'T HAVE TO BE USEFUL.

BUT NOT EVERYONE IN ISRA[EL] IS RICH. OUTSIDE THE CITY [OF] JERUSALEM PEOPLE ARE BEGINNING TO COMPLAIN.

THERE! THAT'[S] MY SHARE OF GRAIN FOR KIN[G] SOLOMON'S HORSES.

422

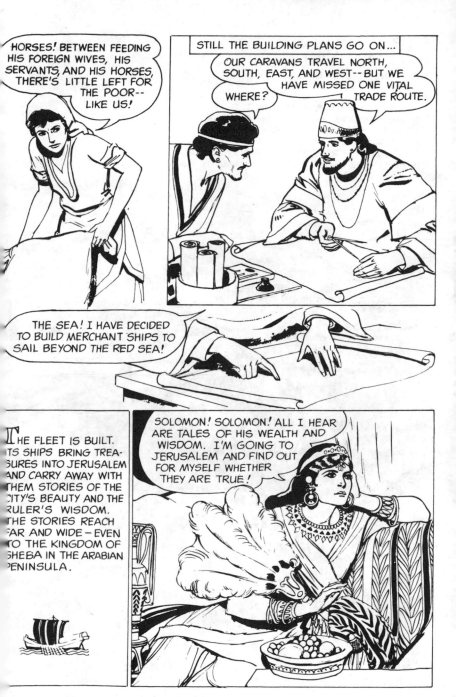

423

A Queen's Visit
FROM I KINGS 10: 2—11: 8

THE FAME OF SOLOMON'S WEALTH AND WISDOM SPREADS FAR AND WIDE. IN THE ARABIAN PENINSULA, THE QUEEN OF SHEBA IS SO CURIOUS THAT SHE SETS OUT ON A TRIP TO JERUSALEM TO SEE FOR HERSELF WHETHER THE STORIES ARE TRUE.

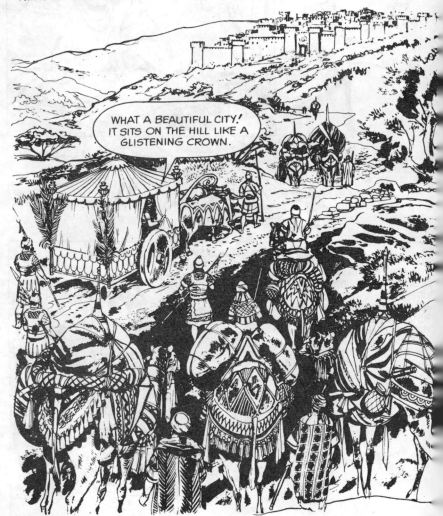

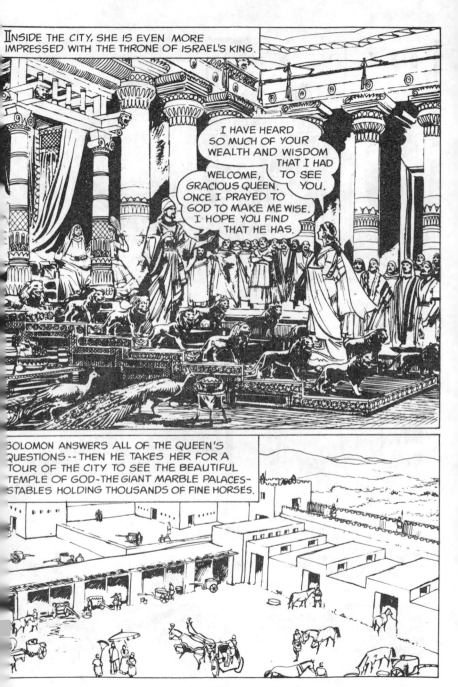

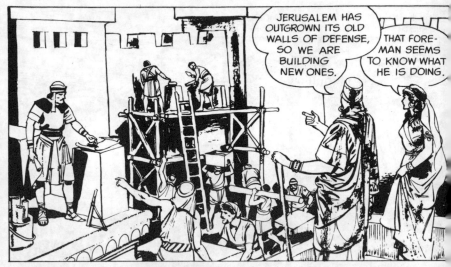

JERUSALEM HAS OUTGROWN ITS OLD WALLS OF DEFENSE, SO WE ARE BUILDING NEW ONES.

THAT FOREMAN SEEMS TO KNOW WHAT HE IS DOING.

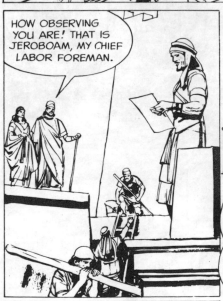

HOW OBSERVING YOU ARE! THAT IS JEROBOAM, MY CHIEF LABOR FOREMAN.

WHEN HER CURIOSITY IS SATISFIED, THE QUEEN OF SHEBA PRESENTS SOLOMON WITH GIFTS OF GOLD, RARE SPICES, PRECIOUS STONES — AND DEPARTS FOR HER HOME.

SOLOMON CONTINUES TO BUILD -- BUT NOW THE PEOPLE ARE WORRIED AND SHOCKED BY WHAT THEY SEE.

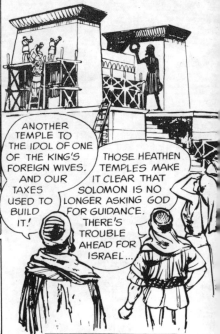

ANOTHER TEMPLE TO THE IDOL OF ONE OF THE KING'S FOREIGN WIVES. AND OUR TAXES USED TO BUILD IT!

THOSE HEATHEN TEMPLES MAKE IT CLEAR THAT SOLOMON IS NO LONGER ASKING GOD FOR GUIDANCE. THERE'S TROUBLE AHEAD FOR ISRAEL...

The King Is Dead

FROM I KINGS 11: 29—12: 3

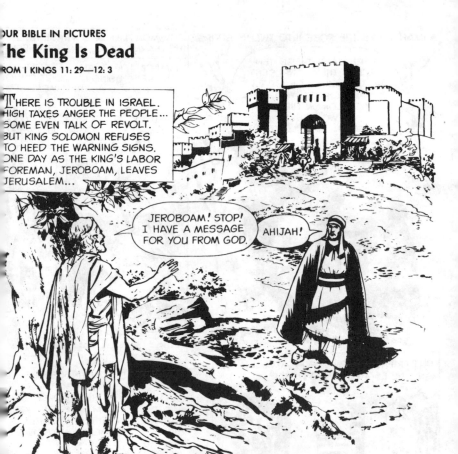

THERE IS TROUBLE IN ISRAEL. HIGH TAXES ANGER THE PEOPLE... SOME EVEN TALK OF REVOLT. BUT KING SOLOMON REFUSES TO HEED THE WARNING SIGNS. ONE DAY AS THE KING'S LABOR FOREMAN, JEROBOAM, LEAVES JERUSALEM...

JEROBOAM! STOP! I HAVE A MESSAGE FOR YOU FROM GOD.

AHIJAH!

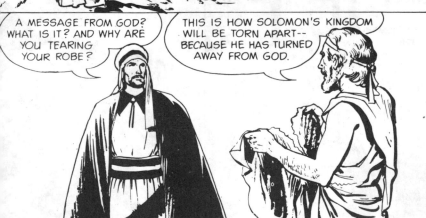

A MESSAGE FROM GOD? WHAT IS IT? AND WHY ARE YOU TEARING YOUR ROBE?

THIS IS HOW SOLOMON'S KINGDOM WILL BE TORN APART-- BECAUSE HE HAS TURNED AWAY FROM GOD.

AHIJAH TEARS THE ROBE INTO TWELVE STRIPS.

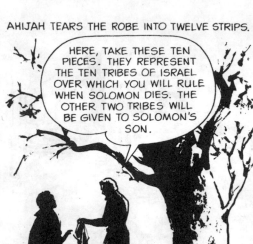

HERE, TAKE THESE TEN PIECES. THEY REPRESENT THE TEN TRIBES OF ISRAEL OVER WHICH YOU WILL RULE WHEN SOLOMON DIES. THE OTHER TWO TRIBES WILL BE GIVEN TO SOLOMON'S SON.

SOLOMON FLIES INTO A RAGE WHEN HE LEARNS OF AHIJAH'S PROPHECY.

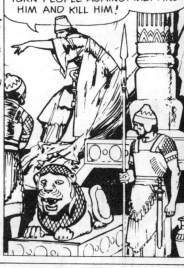

I MADE JEROBOAM A LEADER-- NOW HE IS USING HIS POSITION TO TURN PEOPLE AGAINST ME! FIND HIM AND KILL HIM!

BUT FRIENDS WARN JEROBOAM-- AND HE ESCAPES INTO EGYPT.

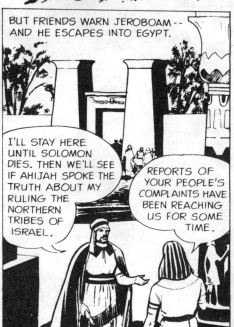

I'LL STAY HERE UNTIL SOLOMON DIES. THEN WE'LL SEE IF AHIJAH SPOKE THE TRUTH ABOUT MY RULING THE NORTHERN TRIBES OF ISRAEL.

REPORTS OF YOUR PEOPLE'S COMPLAINTS HAVE BEEN REACHING US FOR SOME TIME.

BUT SOLOMON CONTINUES TO LIVE IN LUXURY -- AND SO FAR REMOVED FROM HIS PEOPLE THAT THEIR COMPLAINTS DO NOT REACH HIM. HE EVEN IGNORES AHIJAH'S PROPHECY AND GOD'S WARNING THAT THE KINGDOM WILL BE DIVIDED BECAUSE HE WORSHIPS FALSE GODS.

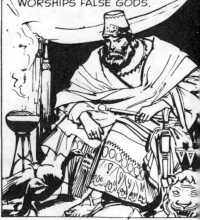

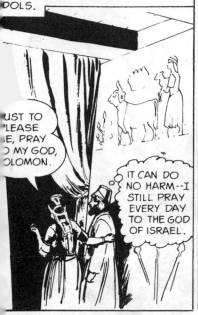

AT LAST HE EVEN JOINS HIS FOREIGN WIVES IN THEIR WORSHIP OF HEATHEN IDOLS.

JUST TO PLEASE ...E, PRAY ...O MY GOD, ...OLOMON.

IT CAN DO NO HARM--I STILL PRAY EVERY DAY TO THE GOD OF ISRAEL.

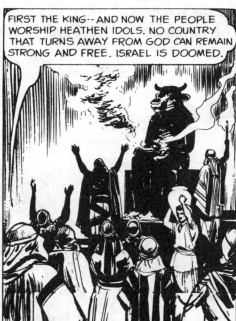

FIRST THE KING--AND NOW THE PEOPLE WORSHIP HEATHEN IDOLS. NO COUNTRY THAT TURNS AWAY FROM GOD CAN REMAIN STRONG AND FREE. ISRAEL IS DOOMED.

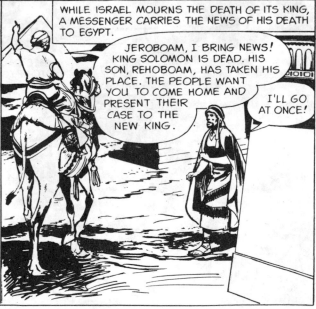

...HEN SOLOMON DIES! ...ITH GOD'S HELP HE ...AD BUILT ISRAEL ...NTO A STRONG NATION. ...UT IN HIS GREED ...OR MORE WEALTH ...ND POWER HE HAD ...URNED AWAY FROM ...OD--AND HIS ...IGHTY KINGDOM ...EGINS TO CRUMBLE...

WHILE ISRAEL MOURNS THE DEATH OF ITS KING, A MESSENGER CARRIES THE NEWS OF HIS DEATH TO EGYPT.

JEROBOAM, I BRING NEWS! KING SOLOMON IS DEAD. HIS SON, REHOBOAM, HAS TAKEN HIS PLACE. THE PEOPLE WANT YOU TO COME HOME AND PRESENT THEIR CASE TO THE NEW KING.

I'LL GO AT ONCE!

429

The Kingdom Is Divided

FROM I KINGS 12: 4-27

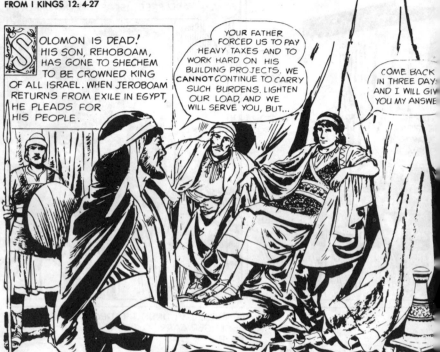

SOLOMON IS DEAD! HIS SON, REHOBOAM, HAS GONE TO SHECHEM TO BE CROWNED KING OF ALL ISRAEL. WHEN JEROBOAM RETURNS FROM EXILE IN EGYPT, HE PLEADS FOR HIS PEOPLE.

YOUR FATHER FORCED US TO PAY HEAVY TAXES AND TO WORK HARD ON HIS BUILDING PROJECTS. WE **CANNOT** CONTINUE TO CARRY SUCH BURDENS. LIGHTEN OUR LOAD, AND WE WILL SERVE YOU, BUT...

COME BACK IN THREE DAYS AND I WILL GIVE YOU MY ANSWER.

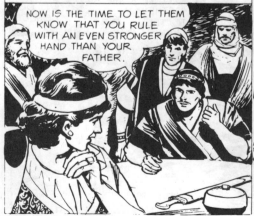

REHOBOAM CONSULTS HIS ADVISERS. THE OLDER MEN TELL HIM TO HEED THE CRIES OF HIS PEOPLE, BUT HIS YOUNG FRIENDS...

NOW IS THE TIME TO LET THEM KNOW THAT YOU RULE WITH AN EVEN STRONGER HAND THAN YOUR FATHER.

THREE DAYS LATER THE PEOPLE RETURN FOR THE KING'S ANSWER

MY FATHER MADE YOUR YOKE HEAVY. I'LL MAKE IT HEAVIER. MY FATHER BEAT YOU WITH LEATHER WHIPS. I'LL STING YOU WITH LEADED LASHES

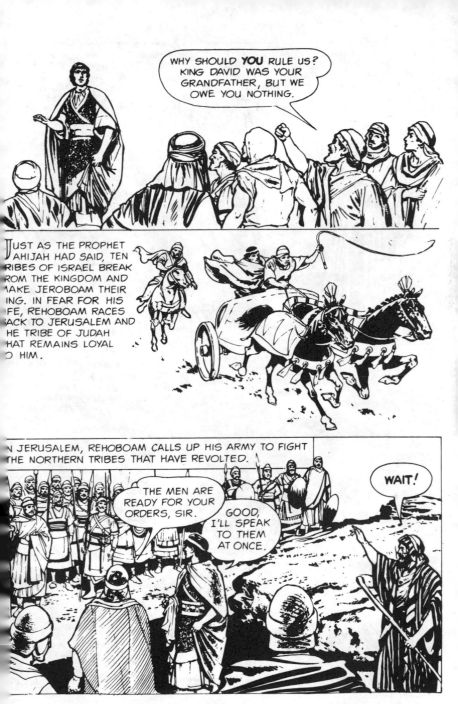

431

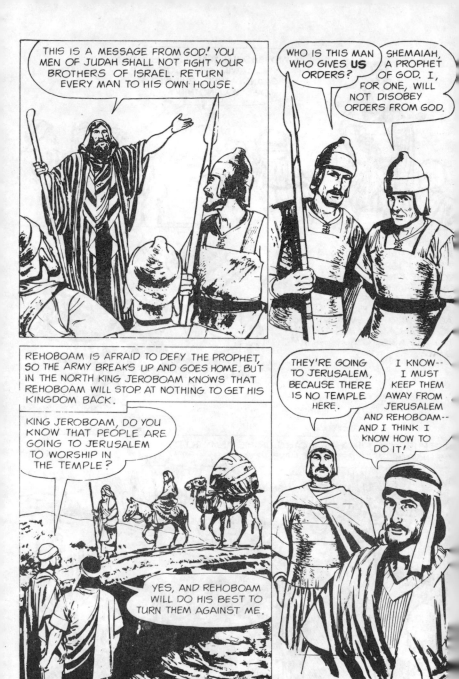

432

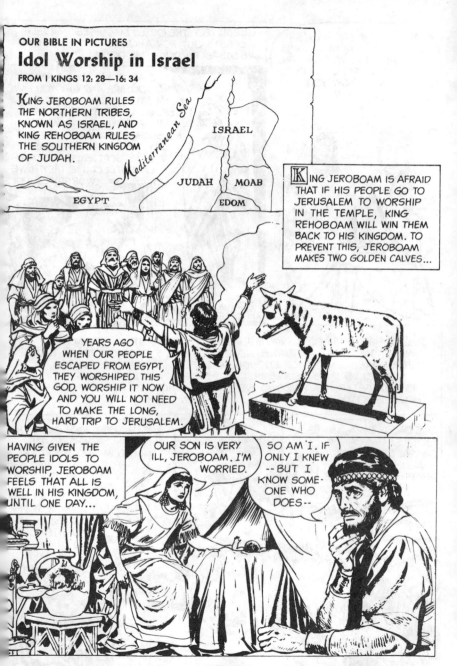

433

AHIJAH, THE PROPHET! HE TOLD ME I WOULD BE KING. HE KNOWS WHAT WILL HAPPEN. DISGUISE YOURSELF SO THAT HE WILL NOT KNOW YOU AND GO TO HIM.

IMMEDIATELY THE QUEEN DISGUISES HERSELF AND SETS OUT FOR AHIJAH'S HOUSE. BUT AS SHE STEPS THROUGH THE DOOR...

I AM BLIND -- BUT I KNOW WHO YOU ARE AND WHY YOU HAVE COME! TELL YOUR HUSBAND, JEROBOAM, THAT HE HAS DONE EVIL -- AND EVIL WILL COME TO HIM. HIS CHILD WILL DIE -- AND ONE DAY THE PEOPLE OF ISRAEL WILL BE SCATTERED IN OTHER LANDS BECAUSE THEY HAVE WORSHIPED IDOLS.

THE FIRST PART OF AHIJAH'S PROPHECY COMES TRUE AT ONCE -- WHEN THE QUEEN RETURNS HOME SHE FINDS HER SON DEAD! BUT JEROBOAM IS NOT WISE ENOUGH TO HEED THIS WARNING. HE CONTINUES TO LEAD HIS PEOPLE IN IDOL WORSHIP, AND EVERY KING OF ISRAEL AFTER HIM FOLLOWS HIS EVIL PRACTICE. AT LAST KING AHAB COMES TO THE THRONE, AND...

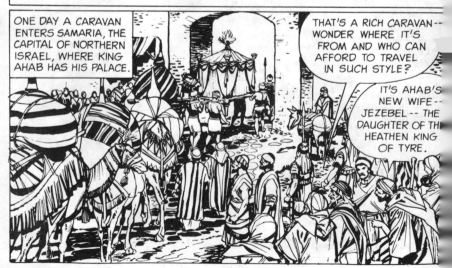

ONE DAY A CARAVAN ENTERS SAMARIA, THE CAPITAL OF NORTHERN ISRAEL, WHERE KING AHAB HAS HIS PALACE.

THAT'S A RICH CARAVAN -- WONDER WHERE IT'S FROM AND WHO CAN AFFORD TO TRAVEL IN SUCH STYLE?

IT'S AHAB'S NEW WIFE -- JEZEBEL -- THE DAUGHTER OF THE HEATHEN KING OF TYRE.

434

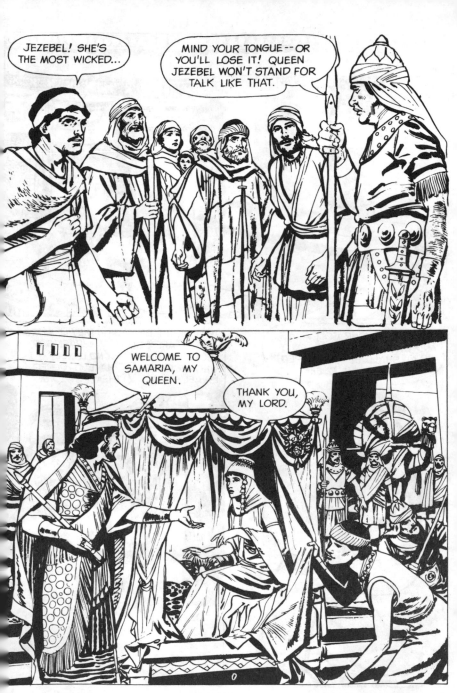

435

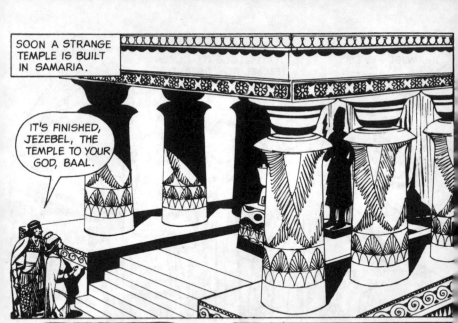

SOON A STRANGE TEMPLE IS BUILT IN SAMARIA.

IT'S FINISHED, JEZEBEL, THE TEMPLE TO YOUR GOD, BAAL.

MY GOD? YOUR GOD, AHAB, AND EVERYBODY'S GOD. ONLY BAAL SHALL BE WORSHIPED WHERE I AM QUEEN.

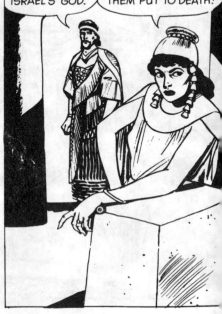

THAT WON'T BE EASY --THERE ARE STILL PEOPLE IN ISRAEL WHO WORSHIP ISRAEL'S GOD.

THEY'LL WORSHIP ISRAEL'S GOD NO LONGER-- I HAVE ORDERED THEM PUT TO DEATH!

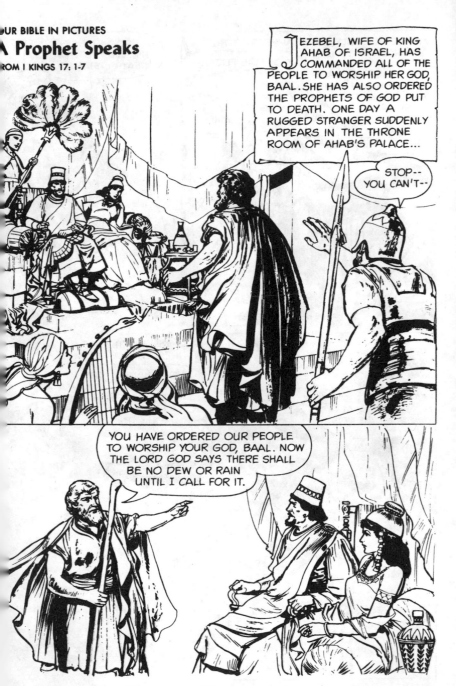

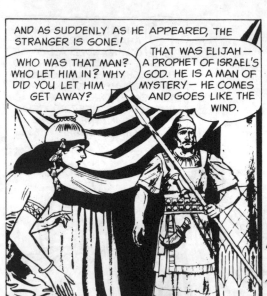

AND AS SUDDENLY AS HE APPEARED, THE STRANGER IS GONE!

WHO WAS THAT MAN? WHO LET HIM IN? WHY DID YOU LET HIM GET AWAY?

THAT WAS ELIJAH— A PROPHET OF ISRAEL'S GOD. HE IS A MAN OF MYSTERY— HE COMES AND GOES LIKE THE WIND.

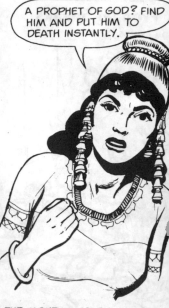

A PROPHET OF GOD? FIND HIM AND PUT HIM TO DEATH INSTANTLY.

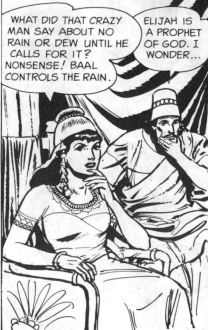

WHAT DID THAT CRAZY MAN SAY ABOUT NO RAIN OR DEW UNTIL HE CALLS FOR IT? NONSENSE! BAAL CONTROLS THE RAIN.

ELIJAH IS A PROPHET OF GOD. I WONDER...

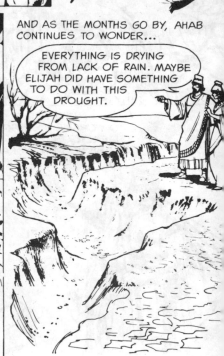

AND AS THE MONTHS GO BY, AHAB CONTINUES TO WONDER...

EVERYTHING IS DRYING FROM LACK OF RAIN. MAYBE ELIJAH DID HAVE SOMETHING TO DO WITH THIS DROUGHT.

438

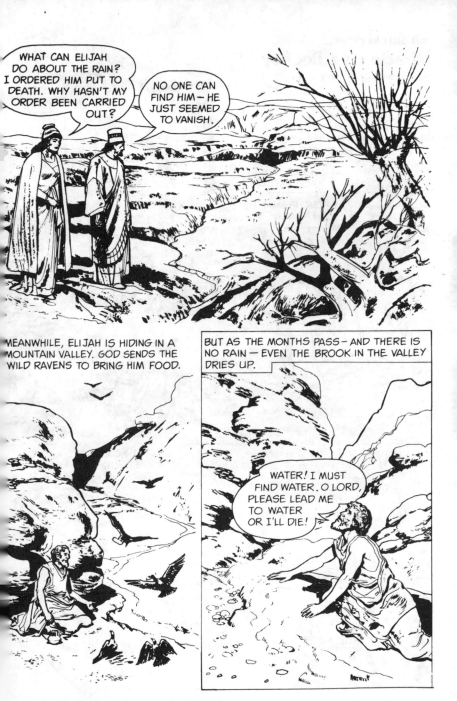

439

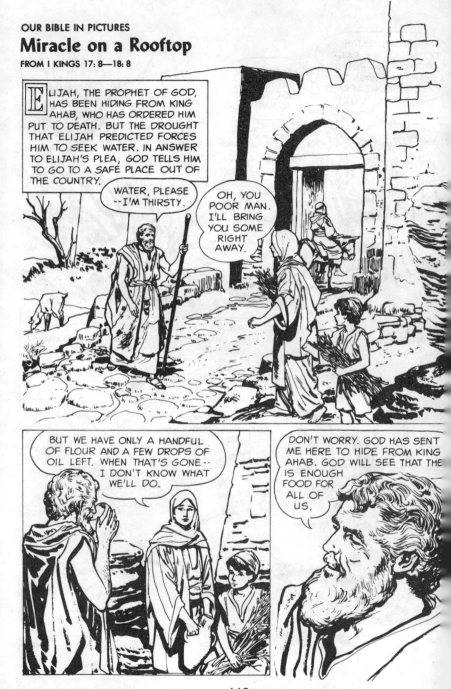
440

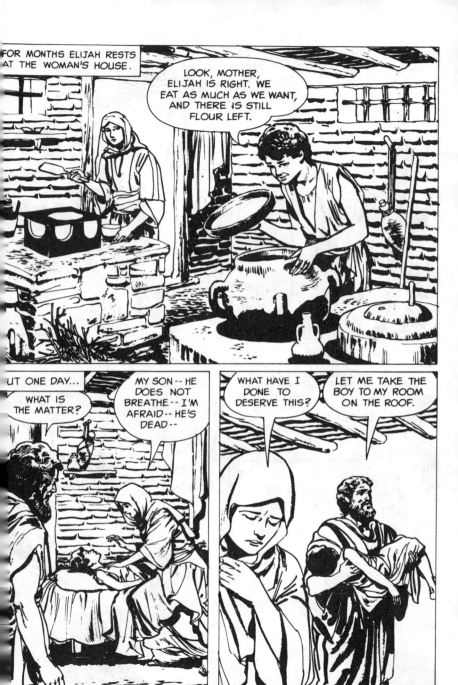

441

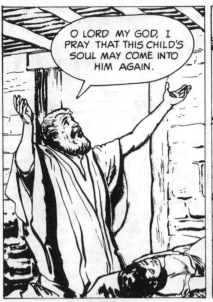

O LORD MY GOD, I PRAY THAT THIS CHILD'S SOUL MAY COME INTO HIM AGAIN.

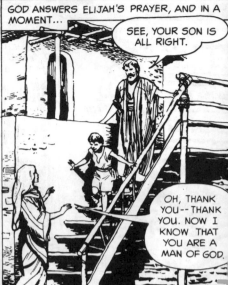

GOD ANSWERS ELIJAH'S PRAYER, AND IN A MOMENT...

SEE, YOUR SON IS ALL RIGHT.

OH, THANK YOU-- THANK YOU. NOW I KNOW THAT YOU ARE A MAN OF GOD.

WHILE ELIJAH IS IN HIDING, KING AHAB BECOMES FRANTIC BECAUSE OF THE DROUGHT. HE FINALLY CALLS FOR OBADIAH, A MAN WHO HAS REMAINED TRUE TO GOD.

WE MUST FIND WATER-- BEFORE ALL OF OUR ANIMALS DIE. YOU SEARCH IN ONE DIRECTION, AND I'LL SEARCH THE OTHER.

OBADIAH SETS OUT-- AND ON THE WAY HE IS SURPRISED TO SEE ELIJAH COMING.

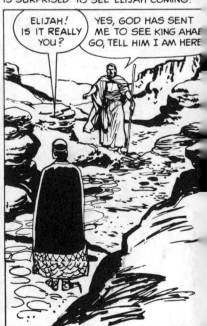

ELIJAH! IS IT REALLY YOU?

YES, GOD HAS SENT ME TO SEE KING AHAB. GO, TELL HIM I AM HERE.

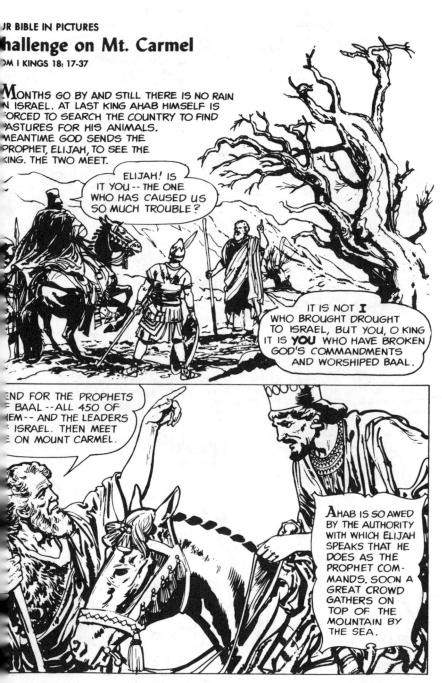

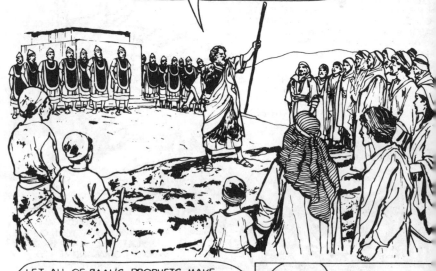

PEOPLE OF ISRAEL! HOW LONG WILL YOU WANDER BACK AND FORTH BETWEEN THE LORD AND BAAL? IF BAAL IS GOD, WORSHIP HIM. IF THE LORD IS GOD, WORSHIP HIM AND HIM ONLY. BUT TODAY, YOU MUST CHOOSE.

LET ALL OF BAAL'S PROPHETS MAKE AN OFFERING AND PRAY TO HIM. I, ALONE, WILL PRAY TO THE LORD. THE GOD WHO ANSWERS WITH FIRE IS THE REAL GOD.

THAT'S A REAL TEST.

FAIR ENOUGH-- BUT IF ELIJAH FAILS, HE' LOSE HIS LIFE. AHA WILL SEE TO THAT

THE PROPHETS OF BAAL ARE FORCED TO ACCEPT THE CHALLENGE. WITH GREAT CEREMONY THEY PREPARE THE SACRIFICE... AND BEGIN TO CHANT AND CALL UPON THEIR GOD.

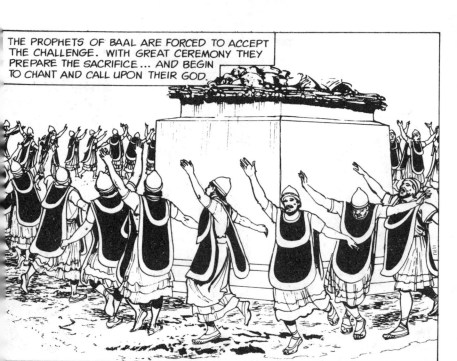

AS THE HOURS PASS THEY SING LOUDER AND LOUDER.

CALL A LITTLE LOUDER-- PERHAPS BAAL IS TALKING --OR OFF ON A JOURNEY-- OR ASLEEP.

BY MIDAFTERNOON THE PROPHETS ARE STILL CALLING UPON BAAL TO SEND DOWN FIRE-- BUT THERE IS NO ANSWER. AT LAST THEY GIVE UP.

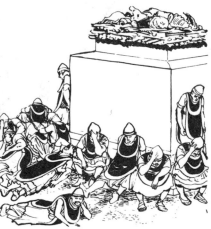

445

THEN ELIJAH BUILDS AN ALTAR TO GOD.

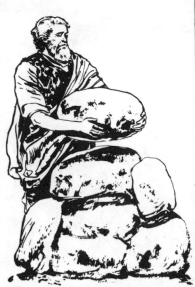

WHEN IT IS FINISHED, AND THE SACRIFICE PREPARED, ELIJAH ORDERS MEN TO POUR WATER OVER IT.

POUR ON MORE WATER. FILL THE TRENCH WITH IT.

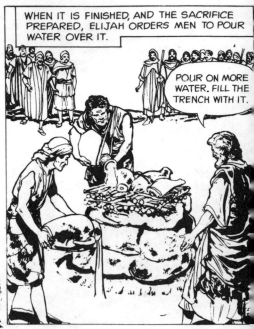

THEN--BEFORE THE WATER-SOAKED ALTAR--ELIJAH PRAYS.

HEAR ME, O LORD, HEAR ME, THAT THE PEOPLE OF ISRAEL MAY KNOW THAT THOU ART THE LORD GOD.

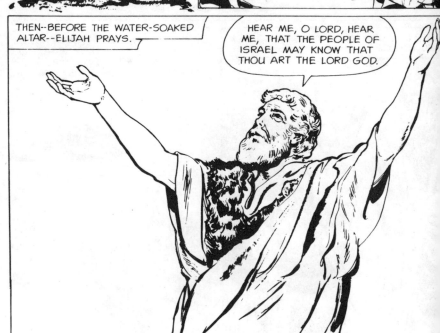

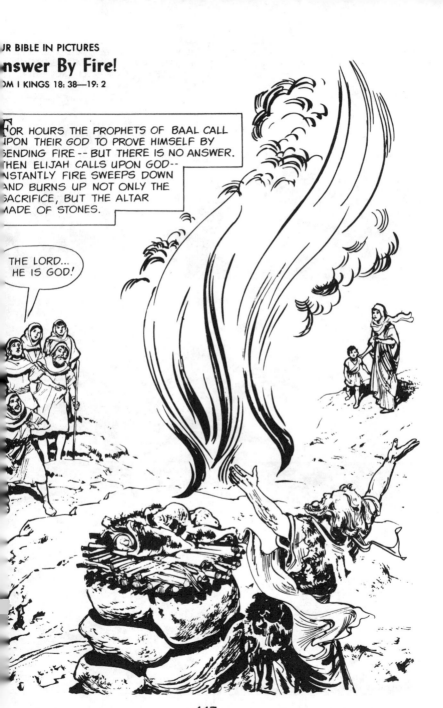

nswer By Fire!

FOR HOURS THE PROPHETS OF BAAL CALL UPON THEIR GOD TO PROVE HIMSELF BY SENDING FIRE -- BUT THERE IS NO ANSWER. THEN ELIJAH CALLS UPON GOD-- INSTANTLY FIRE SWEEPS DOWN AND BURNS UP NOT ONLY THE SACRIFICE, BUT THE ALTAR MADE OF STONES.

THE LORD... HE IS GOD!

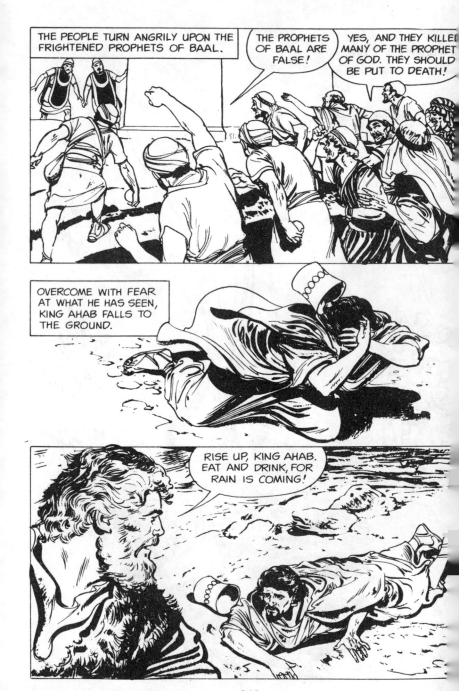

THE PEOPLE TURN ANGRILY UPON THE FRIGHTENED PROPHETS OF BAAL.

THE PROPHETS OF BAAL ARE FALSE!

YES, AND THEY KILLED MANY OF THE PROPHET OF GOD. THEY SHOULD BE PUT TO DEATH!

OVERCOME WITH FEAR AT WHAT HE HAS SEEN, KING AHAB FALLS TO THE GROUND.

RISE UP, KING AHAB. EAT AND DRINK, FOR RAIN IS COMING!

448

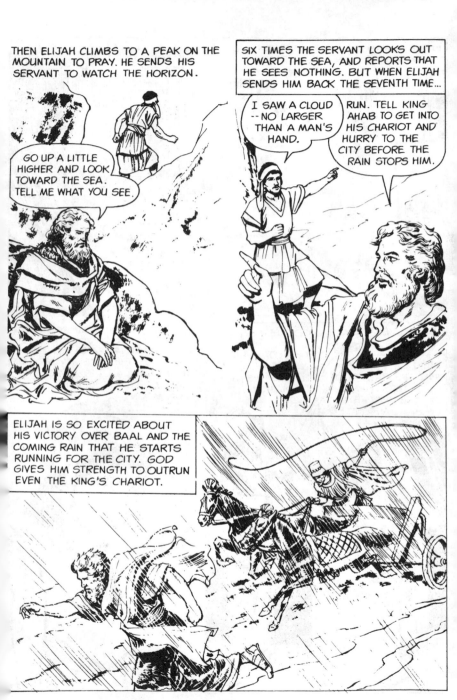

THEN ELIJAH CLIMBS TO A PEAK ON THE MOUNTAIN TO PRAY. HE SENDS HIS SERVANT TO WATCH THE HORIZON.

GO UP A LITTLE HIGHER AND LOOK TOWARD THE SEA. TELL ME WHAT YOU SEE.

SIX TIMES THE SERVANT LOOKS OUT TOWARD THE SEA, AND REPORTS THAT HE SEES NOTHING. BUT WHEN ELIJAH SENDS HIM BACK THE SEVENTH TIME...

I SAW A CLOUD --NO LARGER THAN A MAN'S HAND.

RUN. TELL KING AHAB TO GET INTO HIS CHARIOT AND HURRY TO THE CITY BEFORE THE RAIN STOPS HIM.

ELIJAH IS SO EXCITED ABOUT HIS VICTORY OVER BAAL AND THE COMING RAIN THAT HE STARTS RUNNING FOR THE CITY. GOD GIVES HIM STRENGTH TO OUTRUN EVEN THE KING'S CHARIOT.

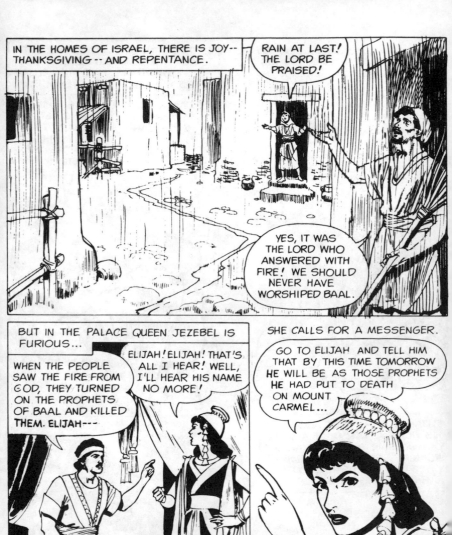

IN THE HOMES OF ISRAEL, THERE IS JOY-- THANKSGIVING -- AND REPENTANCE.

RAIN AT LAST! THE LORD BE PRAISED!

YES, IT WAS THE LORD WHO ANSWERED WITH FIRE! WE SHOULD NEVER HAVE WORSHIPED BAAL.

BUT IN THE PALACE QUEEN JEZEBEL IS FURIOUS...

WHEN THE PEOPLE SAW THE FIRE FROM GOD, THEY TURNED ON THE PROPHETS OF BAAL AND KILLED THEM. ELIJAH---

ELIJAH! ELIJAH! THAT'S ALL I HEAR! WELL, I'LL HEAR HIS NAME NO MORE!

SHE CALLS FOR A MESSENGER.

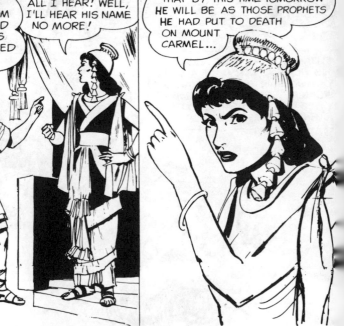

GO TO ELIJAH AND TELL HIM THAT BY THIS TIME TOMORROW HE WILL BE AS THOSE PROPHETS HE HAD PUT TO DEATH ON MOUNT CARMEL...

450

Voice in the Mountain

OM I KINGS 19: 3-18

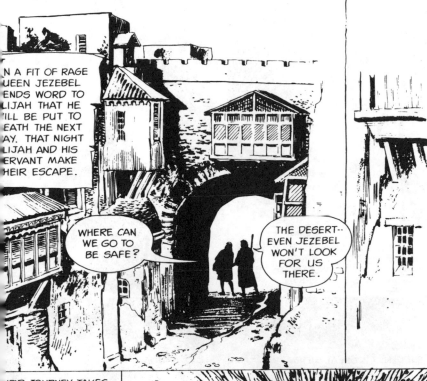

N A FIT OF RAGE UEEN JEZEBEL ENDS WORD TO LIJAH THAT HE 'ILL BE PUT TO EATH THE NEXT AY. THAT NIGHT LIJAH AND HIS ERVANT MAKE HEIR ESCAPE.

WHERE CAN WE GO TO BE SAFE?

THE DESERT-- EVEN JEZEBEL WON'T LOOK FOR US THERE.

HEIR JOURNEY TAKES HEM SOUTH THROUGH RAEL AND JUDAH. HE SERVANT STAYS THE CITY OF BEER- HEBA, WHILE ELIJAH ONTINUES ALONE INTO HE WILDERNESS. BUT FTER A DAY'S TRAVEL..

O LORD, TAKE MY LIFE. I HAVE DONE MY BEST TO BRING ISRAEL BACK TO THEE, BUT IT'S NO USE. THE PEOPLE WON'T LISTEN!

451

THEN, HUNGRY AND TIRED, ELIJAH FALLS ASLEEP. WHILE HE IS SLEEPING AN ANGEL APPEARS WITH BREAD AND WATER.

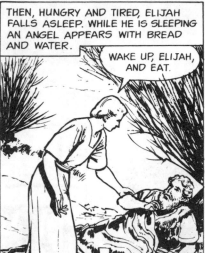

WAKE UP, ELIJAH, AND EAT.

ELIJAH IS ENCOURAGED BY THE FACT THAT GOD IS TAKING CARE OF HIM. AFTER HE EATS AND RESTS, HE CONTINUES HIS JOURNEY...

AND FORTY DAYS LATER HE REACHES MOUNT SINAI WHERE GOD TALKED TO MOSES.

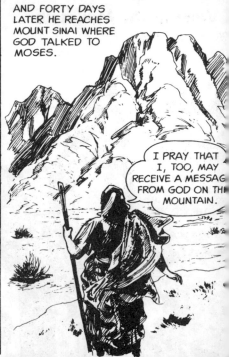

I PRAY THAT I, TOO, MAY RECEIVE A MESSAGE FROM GOD ON THE MOUNTAIN.

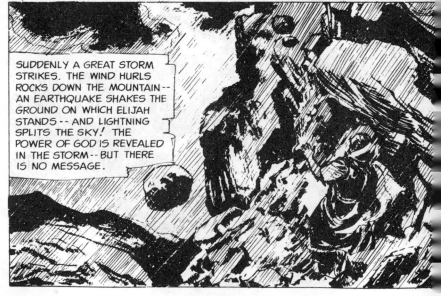

SUDDENLY A GREAT STORM STRIKES. THE WIND HURLS ROCKS DOWN THE MOUNTAIN -- AN EARTHQUAKE SHAKES THE GROUND ON WHICH ELIJAH STANDS -- AND LIGHTNING SPLITS THE SKY! THE POWER OF GOD IS REVEALED IN THE STORM -- BUT THERE IS NO MESSAGE.

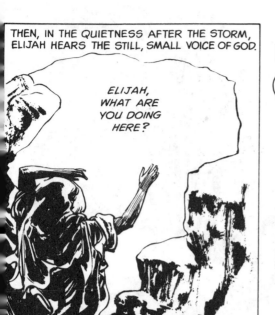

THEN, IN THE QUIETNESS AFTER THE STORM, ELIJAH HEARS THE STILL, SMALL VOICE OF GOD.

ELIJAH, WHAT ARE YOU DOING HERE?

O LORD, THE PEOPLE OF ISRAEL DO NOT SERVE THEE. THEY WORSHIP IDOLS. THEY HAVE KILLED ALL OF YOUR OTHER PROPHETS--AND NOW THEY WANT TO KILL ME.

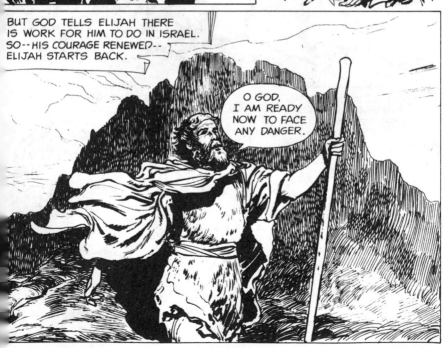

BUT GOD TELLS ELIJAH THERE IS WORK FOR HIM TO DO IN ISRAEL. SO--HIS COURAGE RENEWED-- ELIJAH STARTS BACK.

O GOD, I AM READY NOW TO FACE ANY DANGER.

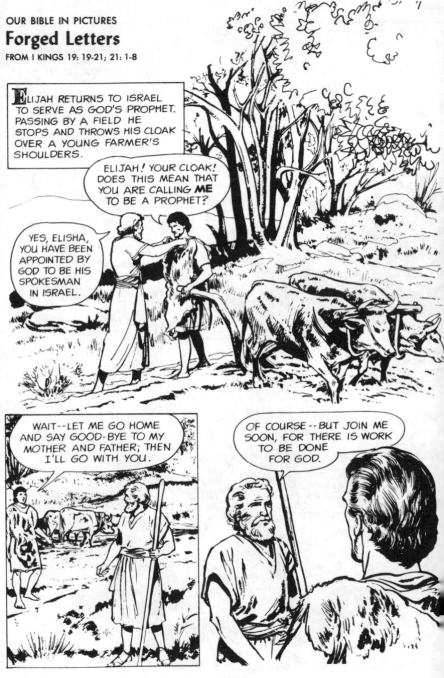

OUR BIBLE IN PICTURES
Forged Letters
FROM I KINGS 19: 19-21; 21: 1-8

ELIJAH RETURNS TO ISRAEL TO SERVE AS GOD'S PROPHET. PASSING BY A FIELD HE STOPS AND THROWS HIS CLOAK OVER A YOUNG FARMER'S SHOULDERS.

ELIJAH! YOUR CLOAK! DOES THIS MEAN THAT YOU ARE CALLING **ME** TO BE A PROPHET?

YES, ELISHA, YOU HAVE BEEN APPOINTED BY GOD TO BE HIS SPOKESMAN IN ISRAEL.

WAIT--LET ME GO HOME AND SAY GOOD-BYE TO MY MOTHER AND FATHER; THEN I'LL GO WITH YOU.

OF COURSE--BUT JOIN ME SOON, FOR THERE IS WORK TO BE DONE FOR GOD.

454

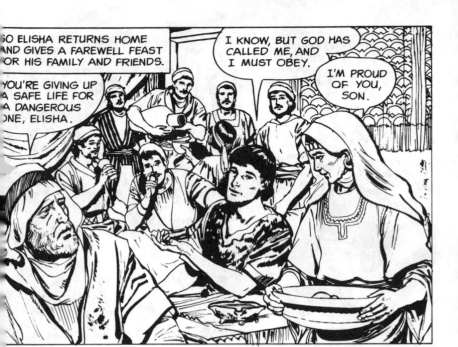

SO ELISHA RETURNS HOME AND GIVES A FAREWELL FEAST FOR HIS FAMILY AND FRIENDS.

YOU'RE GIVING UP A SAFE LIFE FOR A DANGEROUS ONE, ELISHA.

I KNOW, BUT GOD HAS CALLED ME, AND I MUST OBEY.

I'M PROUD OF YOU, SON.

ELISHA GOES TO WORK WITH ELIJAH, AND WHILE THEY ARE TRAINING OTHER PROPHETS, KING AHAB MAKES A SURPRISE VISIT TO ONE OF HIS SUBJECTS.

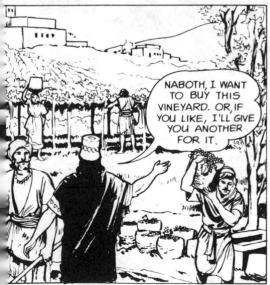

NABOTH, I WANT TO BUY THIS VINEYARD. OR, IF YOU LIKE, I'LL GIVE YOU ANOTHER FOR IT.

I'M SORRY, O KING, BUT OUR FAMILY HAS OWNED THIS VINEYARD FOR MANY YEARS. IT WOULD NOT BE RIGHT TO SELL IT TO SOMEONE OUTSIDE THE FAMILY.

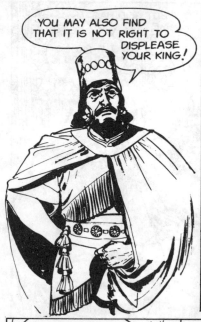

YOU MAY ALSO FIND THAT IT IS NOT RIGHT TO DISPLEASE YOUR KING!

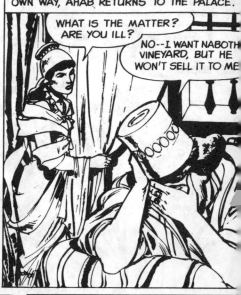

LIKE A SPOILED CHILD WHO CANNOT HAVE HIS OWN WAY, AHAB RETURNS TO THE PALACE.

WHAT IS THE MATTER? ARE YOU ILL?

NO--I WANT NABOTH'S VINEYARD, BUT HE WON'T SELL IT TO ME!

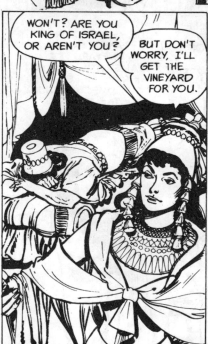

WON'T? ARE YOU KING OF ISRAEL, OR AREN'T YOU?

BUT DON'T WORRY, I'LL GET THE VINEYARD FOR YOU.

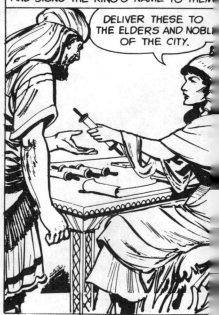

QUICKLY JEZEBEL WRITES SOME LETTERS AND SIGNS THE KING'S NAME TO THEM.

DELIVER THESE TO THE ELDERS AND NOBLES OF THE CITY.

The Price of a Vineyard

FROM I KINGS 21: 9—22: 29

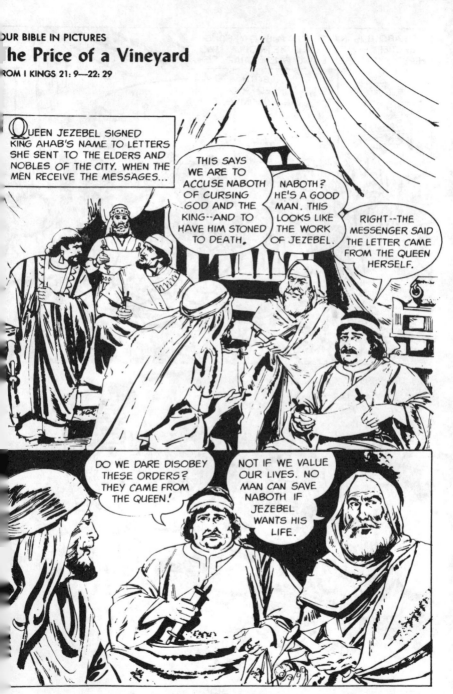

QUEEN JEZEBEL SIGNED KING AHAB'S NAME TO LETTERS SHE SENT TO THE ELDERS AND NOBLES OF THE CITY. WHEN THE MEN RECEIVE THE MESSAGES...

THIS SAYS WE ARE TO ACCUSE NABOTH OF CURSING GOD AND THE KING--AND TO HAVE HIM STONED TO DEATH.

NABOTH? HE'S A GOOD MAN. THIS LOOKS LIKE THE WORK OF JEZEBEL.

RIGHT--THE MESSENGER SAID THE LETTER CAME FROM THE QUEEN HERSELF.

DO WE DARE DISOBEY THESE ORDERS? THEY CAME FROM THE QUEEN!

NOT IF WE VALUE OUR LIVES. NO MAN CAN SAVE NABOTH IF JEZEBEL WANTS HIS LIFE.

457

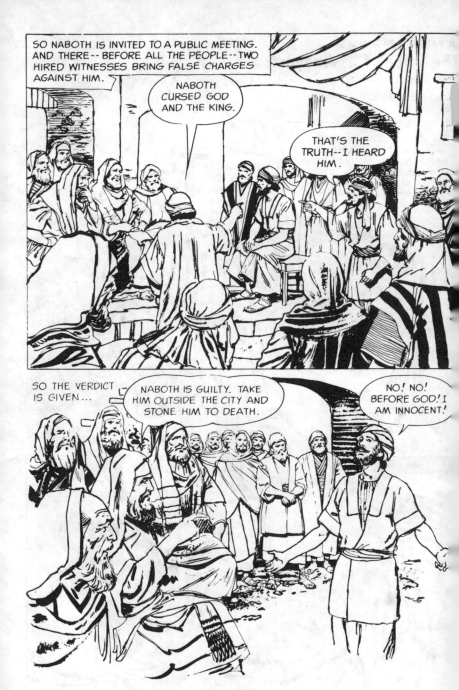

458

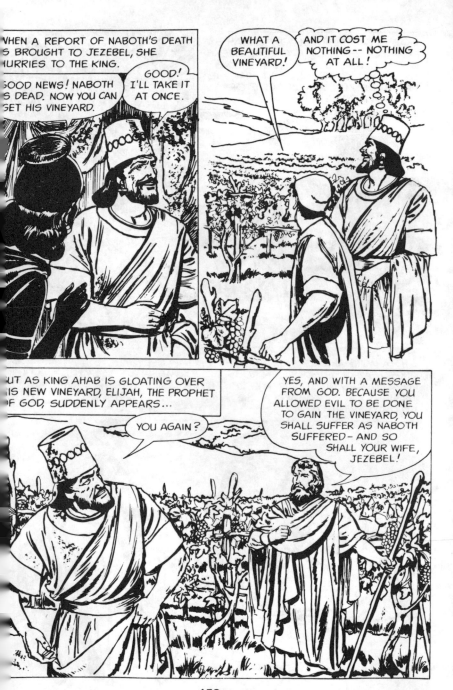

459

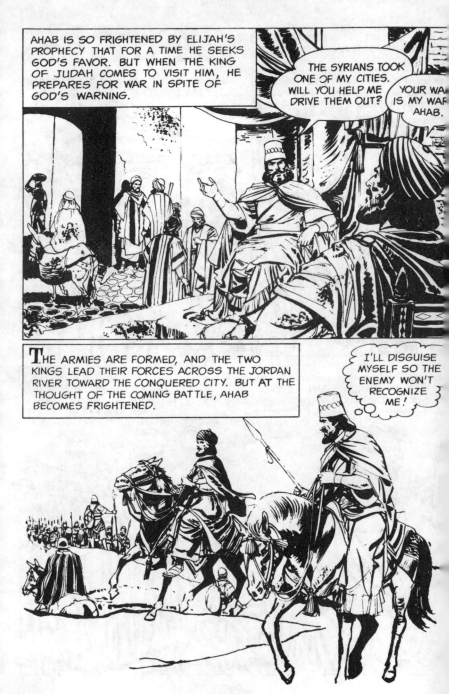

460

The Last Journey

FROM I KINGS 22: 30—II KINGS 2: 10

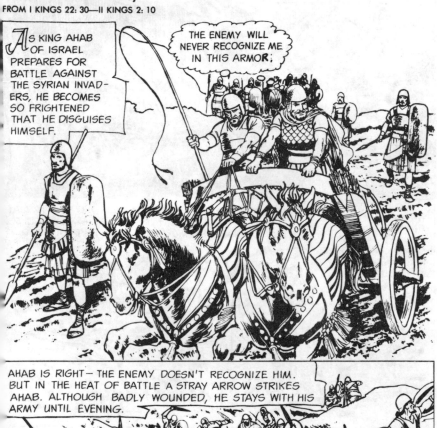

As KING AHAB OF ISRAEL PREPARES FOR BATTLE AGAINST THE SYRIAN INVADERS, HE BECOMES SO FRIGHTENED THAT HE DISGUISES HIMSELF.

THE ENEMY WILL NEVER RECOGNIZE ME IN THIS ARMOR;

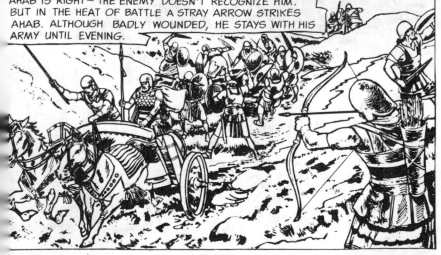

AHAB IS RIGHT—THE ENEMY DOESN'T RECOGNIZE HIM. BUT IN THE HEAT OF BATTLE A STRAY ARROW STRIKES AHAB. ALTHOUGH BADLY WOUNDED, HE STAYS WITH HIS ARMY UNTIL EVENING.

461

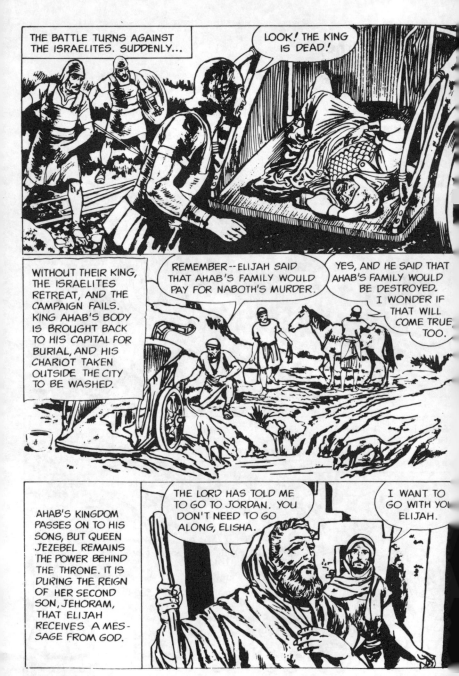

THE BATTLE TURNS AGAINST THE ISRAELITES. SUDDENLY...

LOOK! THE KING IS DEAD!

WITHOUT THEIR KING, THE ISRAELITES RETREAT, AND THE CAMPAIGN FAILS. KING AHAB'S BODY IS BROUGHT BACK TO HIS CAPITAL FOR BURIAL, AND HIS CHARIOT TAKEN OUTSIDE THE CITY TO BE WASHED.

REMEMBER -- ELIJAH SAID THAT AHAB'S FAMILY WOULD PAY FOR NABOTH'S MURDER.

YES, AND HE SAID THAT AHAB'S FAMILY WOULD BE DESTROYED. I WONDER IF THAT WILL COME TRUE TOO.

AHAB'S KINGDOM PASSES ON TO HIS SONS, BUT QUEEN JEZEBEL REMAINS THE POWER BEHIND THE THRONE. IT IS DURING THE REIGN OF HER SECOND SON, JEHORAM, THAT ELIJAH RECEIVES A MESSAGE FROM GOD.

THE LORD HAS TOLD ME TO GO TO JORDAN. YOU DON'T NEED TO GO ALONG, ELISHA.

I WANT TO GO WITH YOU, ELIJAH.

462

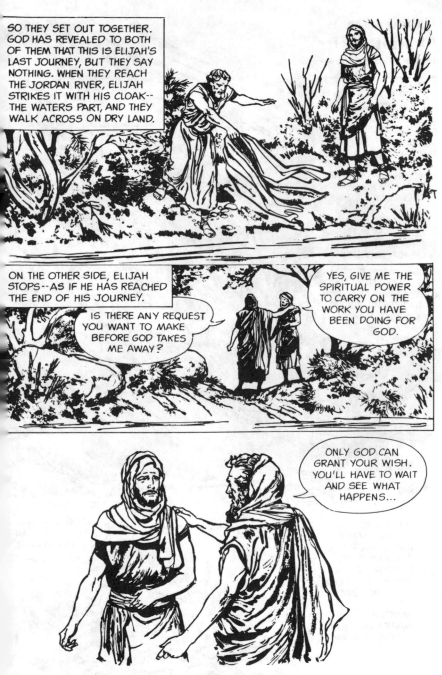

SO THEY SET OUT TOGETHER. GOD HAS REVEALED TO BOTH OF THEM THAT THIS IS ELIJAH'S LAST JOURNEY, BUT THEY SAY NOTHING. WHEN THEY REACH THE JORDAN RIVER, ELIJAH STRIKES IT WITH HIS CLOAK-- THE WATERS PART, AND THEY WALK ACROSS ON DRY LAND.

ON THE OTHER SIDE, ELIJAH STOPS -- AS IF HE HAS REACHED THE END OF HIS JOURNEY.

IS THERE ANY REQUEST YOU WANT TO MAKE BEFORE GOD TAKES ME AWAY?

YES, GIVE ME THE SPIRITUAL POWER TO CARRY ON THE WORK YOU HAVE BEEN DOING FOR GOD.

ONLY GOD CAN GRANT YOUR WISH. YOU'LL HAVE TO WAIT AND SEE WHAT HAPPENS...

463

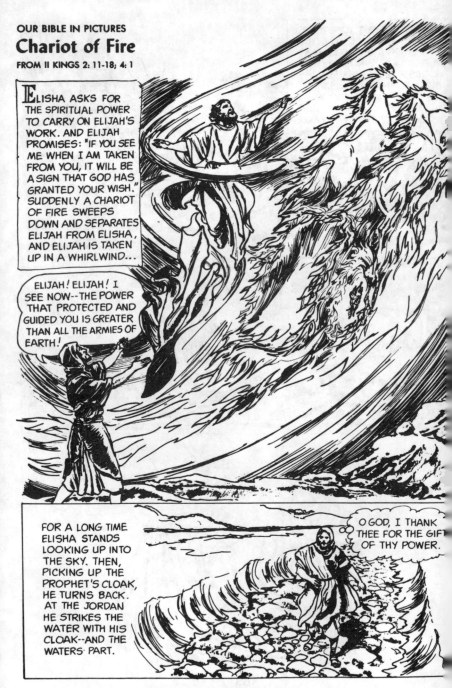

OUR BIBLE IN PICTURES
Chariot of Fire
FROM II KINGS 2: 11-18; 4: 1

ELISHA ASKS FOR THE SPIRITUAL POWER TO CARRY ON ELIJAH'S WORK. AND ELIJAH PROMISES: "IF YOU SEE ME WHEN I AM TAKEN FROM YOU, IT WILL BE A SIGN THAT GOD HAS GRANTED YOUR WISH." SUDDENLY A CHARIOT OF FIRE SWEEPS DOWN AND SEPARATES ELIJAH FROM ELISHA, AND ELIJAH IS TAKEN UP IN A WHIRLWIND...

ELIJAH! ELIJAH! I SEE NOW--THE POWER THAT PROTECTED AND GUIDED YOU IS GREATER THAN ALL THE ARMIES OF EARTH!

FOR A LONG TIME ELISHA STANDS LOOKING UP INTO THE SKY. THEN, PICKING UP THE PROPHET'S CLOAK, HE TURNS BACK. AT THE JORDAN HE STRIKES THE WATER WITH HIS CLOAK--AND THE WATERS· PART.

O GOD, I THANK THEE FOR THE GIFT OF THY POWER.

464

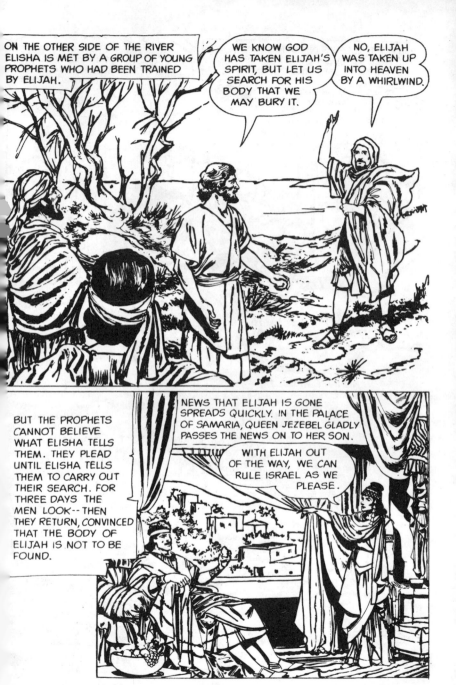

465

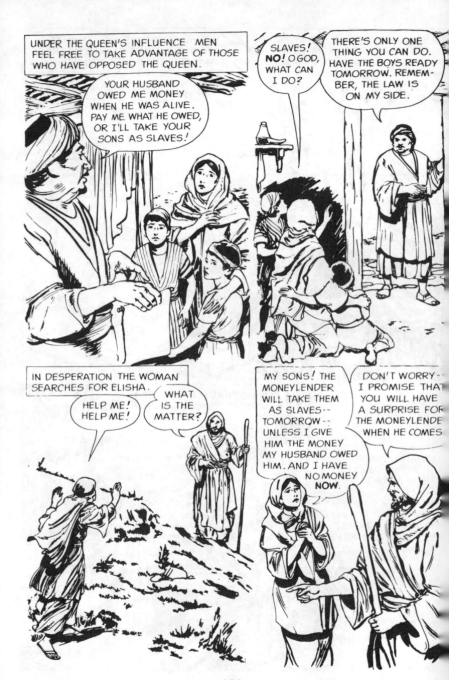

466

A Miracle of Oil

FROM II KINGS 4: 2-7

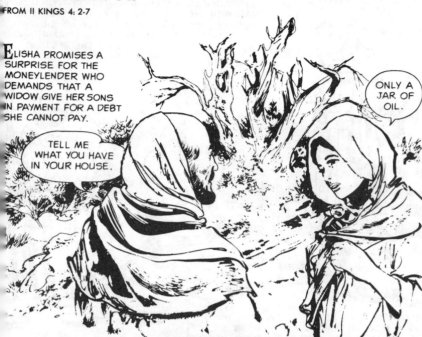

Elisha promises a surprise for the moneylender who demands that a widow give her sons in payment for a debt she cannot pay.

TELL ME WHAT YOU HAVE IN YOUR HOUSE.

ONLY A JAR OF OIL.

BORROW ALL THE EMPTY JARS YOU CAN FROM THE NEIGHBORS. POUR THE OIL INTO THE JARS, AND TRUST GOD TO HELP YOU.

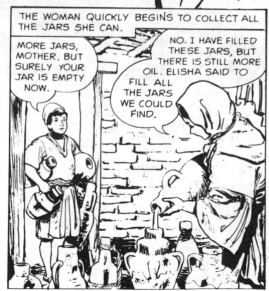

THE WOMAN QUICKLY BEGINS TO COLLECT ALL THE JARS SHE CAN.

MORE JARS, MOTHER. BUT SURELY YOUR JAR IS EMPTY NOW.

NO. I HAVE FILLED THESE JARS, BUT THERE IS STILL MORE OIL. ELISHA SAID TO FILL ALL THE JARS WE COULD FIND.

467

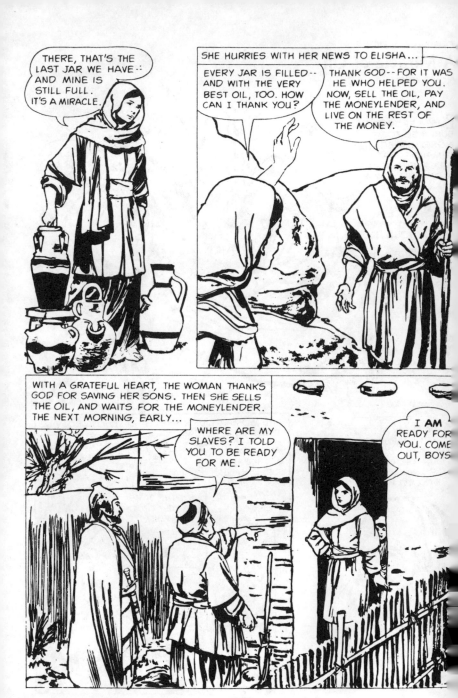

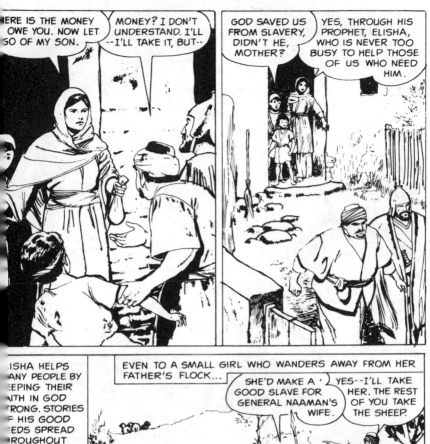

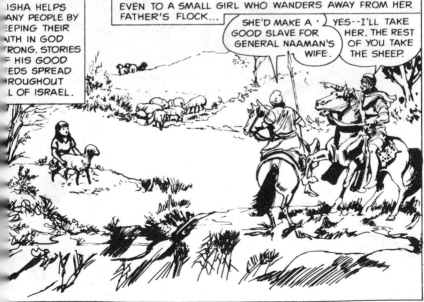

A Prophet's Prescription

FROM II KINGS 5: 1-14a

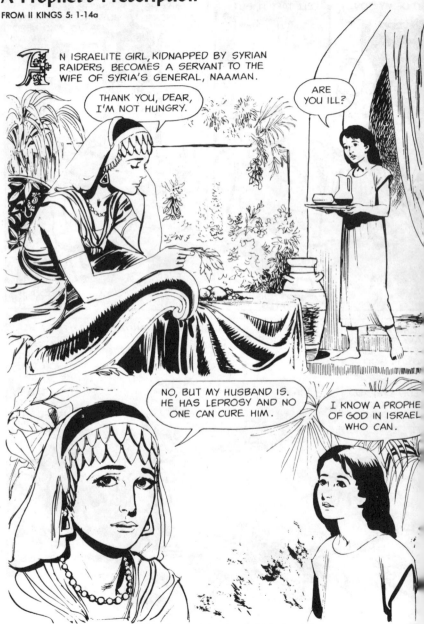

AN ISRAELITE GIRL, KIDNAPPED BY SYRIAN RAIDERS, BECOMES A SERVANT TO THE WIFE OF SYRIA'S GENERAL, NAAMAN.

THANK YOU, DEAR, I'M NOT HUNGRY.

ARE YOU ILL?

NO, BUT MY HUSBAND IS. HE HAS LEPROSY AND NO ONE CAN CURE HIM.

I KNOW A PROPHET OF GOD IN ISRAEL WHO CAN.

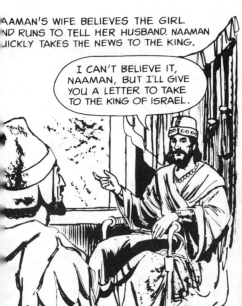

NAAMAN'S WIFE BELIEVES THE GIRL AND RUNS TO TELL HER HUSBAND. NAAMAN QUICKLY TAKES THE NEWS TO THE KING.

I CAN'T BELIEVE IT, NAAMAN, BUT I'LL GIVE YOU A LETTER TO TAKE TO THE KING OF ISRAEL.

IN SAMARIA, THE CAPITAL OF ISRAEL, NAAMAN HAS THE LETTER DELIVERED TO KING JEHORAM. THE LETTER DOES NOT MENTION ELISHA, SO THE KING MISINTERPRETS IT.

WHAT'S THIS -- THE KING OF SYRIA ASKS **ME** TO CURE HIS GENERAL?

AM I A GOD THAT I CAN CURE AN INCURABLE DISEASE? IS THE KING OF SAMARIA TRYING TO PICK A QUARREL WITH ME?

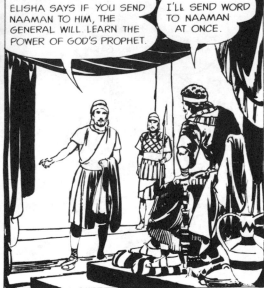

REPORTS OF KING JEHORAM'S PROBLEM SPREAD THROUGHOUT THE CITY. WHEN ELISHA HEARS THEM HE SENDS HIS SERVANT TO THE KING.

ELISHA SAYS IF YOU SEND NAAMAN TO HIM, THE GENERAL WILL LEARN THE POWER OF GOD'S PROPHET.

I'LL SEND WORD TO NAAMAN AT ONCE.

471

NAAMAN LOSES NO TIME IN GOING TO ELISHA'S HOUSE WHERE HE IS MET BY A SERVANT.

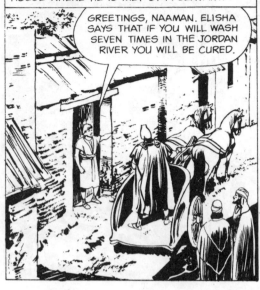

GREETINGS, NAAMAN. ELISHA SAYS THAT IF YOU WILL WASH SEVEN TIMES IN THE JORDAN RIVER YOU WILL BE CURED.

WASH IN THE JORDAN? THAT'S SILLY! I THOUGHT ELISHA WOULD CALL ON HIS GOD TO CURE ME.

NAAMAN THINKS HE HAS BEEN MADE A FOOL OF -- AND IN A RAGE HE DRIVES AWAY.

THE GENERAL TAKES HIS SERVANT'S ADVICE AND GOES TO TH JORDAN RIVER.

THINK AGAIN, NAAMAN. IF ELISHA HAD ASKED YOU TO DO SOMETHING HARD, YOU WOULD HAVE DONE IT. WHY NOT DO THIS EASY THING HE ASKS?

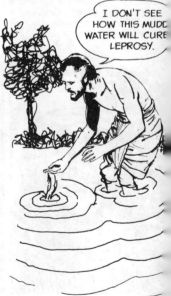

I DON'T SEE HOW THIS MUDD WATER WILL CURE LEPROSY.

Surrounded

FROM II KINGS 5: 14-16; 6: 8-16

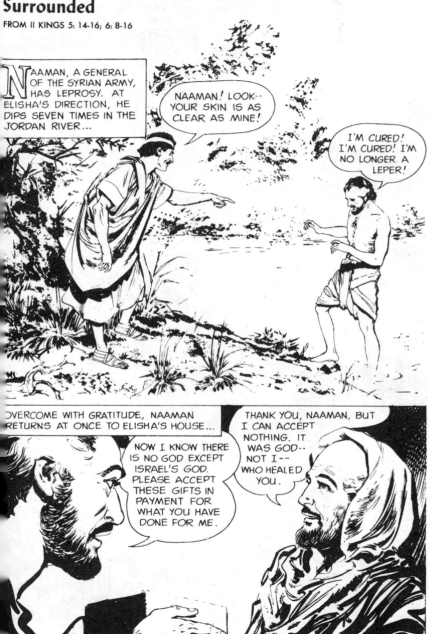

NAAMAN, A GENERAL OF THE SYRIAN ARMY, HAS LEPROSY. AT ELISHA'S DIRECTION, HE DIPS SEVEN TIMES IN THE JORDAN RIVER...

NAAMAN! LOOK-- YOUR SKIN IS AS CLEAR AS MINE!

I'M CURED! I'M CURED! I'M NO LONGER A LEPER!

OVERCOME WITH GRATITUDE, NAAMAN RETURNS AT ONCE TO ELISHA'S HOUSE...

NOW I KNOW THERE IS NO GOD EXCEPT ISRAEL'S GOD. PLEASE ACCEPT THESE GIFTS IN PAYMENT FOR WHAT YOU HAVE DONE FOR ME.

THANK YOU, NAAMAN, BUT I CAN ACCEPT NOTHING. IT WAS GOD-- NOT I-- WHO HEALED YOU.

THEN NAAMAN RETURNS TO HIS HOME IN SYRIA.

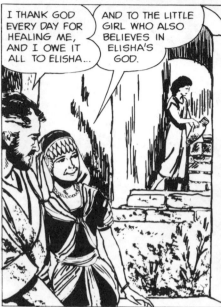

I THANK GOD EVERY DAY FOR HEALING ME, AND I OWE IT ALL TO ELISHA...

AND TO THE LITTLE GIRL WHO ALSO BELIEVES IN ELISHA'S GOD.

BUT THE HEALING OF NAAMAN DOES NOT KEEP THE KING OF SYRIA FROM PLOTTING AGAINST ISRAEL.

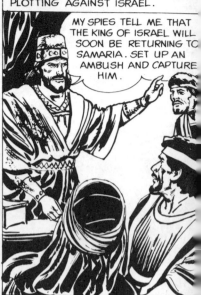

MY SPIES TELL ME THAT THE KING OF ISRAEL WILL SOON BE RETURNING TO SAMARIA. SET UP AN AMBUSH AND CAPTURE HIM.

A FEW DAYS LATER ON THE ROAD TO SAMARIA...

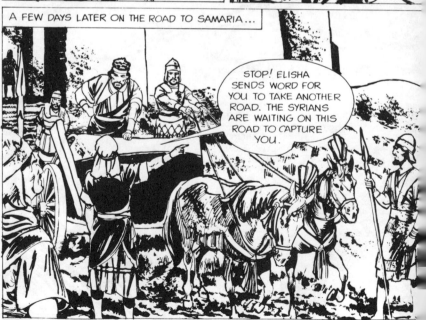

STOP! ELISHA SENDS WORD FOR YOU TO TAKE ANOTHER ROAD. THE SYRIANS ARE WAITING ON THIS ROAD TO CAPTURE YOU.

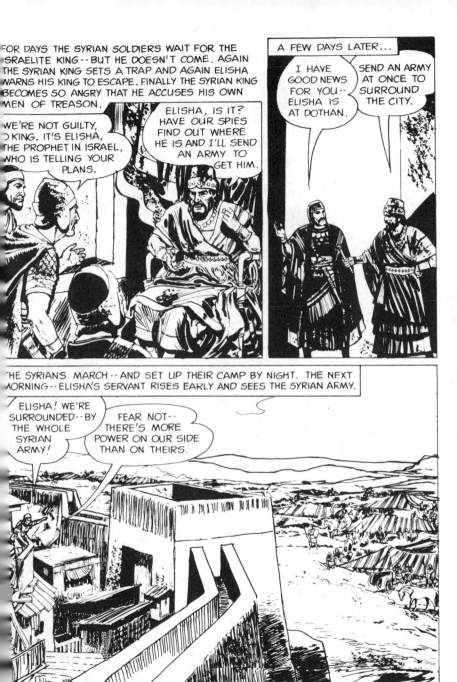

One Against an Army

FROM II KINGS 6: 17-24

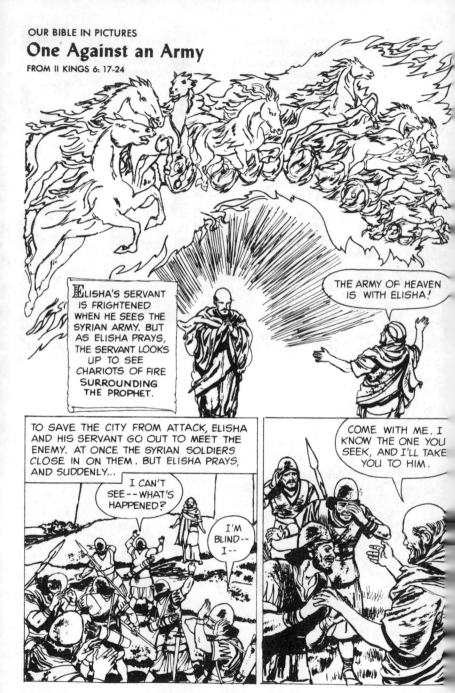

ELISHA'S SERVANT IS FRIGHTENED WHEN HE SEES THE SYRIAN ARMY. BUT AS ELISHA PRAYS, THE SERVANT LOOKS UP TO SEE CHARIOTS OF FIRE SURROUNDING THE PROPHET.

THE ARMY OF HEAVEN IS WITH ELISHA!

TO SAVE THE CITY FROM ATTACK, ELISHA AND HIS SERVANT GO OUT TO MEET THE ENEMY. AT ONCE THE SYRIAN SOLDIERS CLOSE IN ON THEM. BUT ELISHA PRAYS, AND SUDDENLY...

I CAN'T SEE -- WHAT'S HAPPENED?

I'M BLIND -- I --

COME WITH ME. I KNOW THE ONE YOU SEEK, AND I'LL TAKE YOU TO HIM.

476

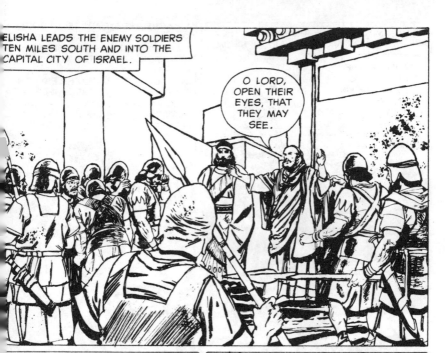

ELISHA LEADS THE ENEMY SOLDIERS TEN MILES SOUTH AND INTO THE CAPITAL CITY OF ISRAEL.

O LORD, OPEN THEIR EYES, THAT THEY MAY SEE.

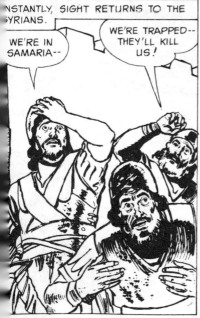

INSTANTLY, SIGHT RETURNS TO THE SYRIANS.

WE'RE IN SAMARIA--

WE'RE TRAPPED-- THEY'LL KILL US!

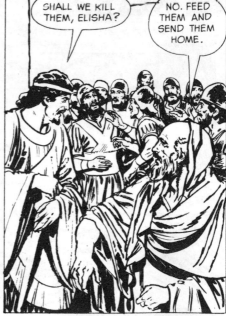

SHALL WE KILL THEM, ELISHA?

NO. FEED THEM AND SEND THEM HOME.

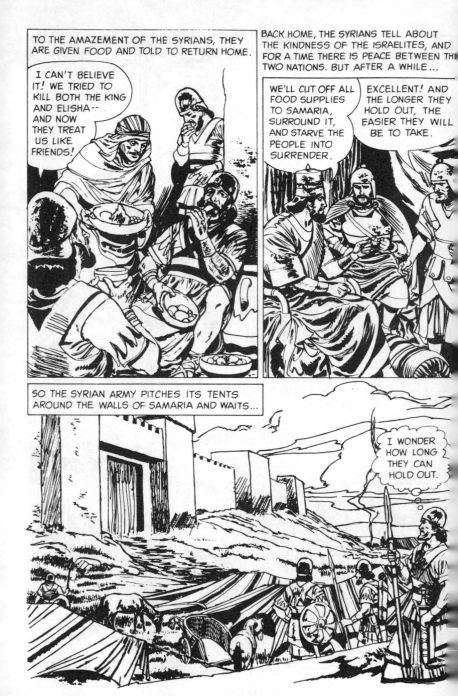

478

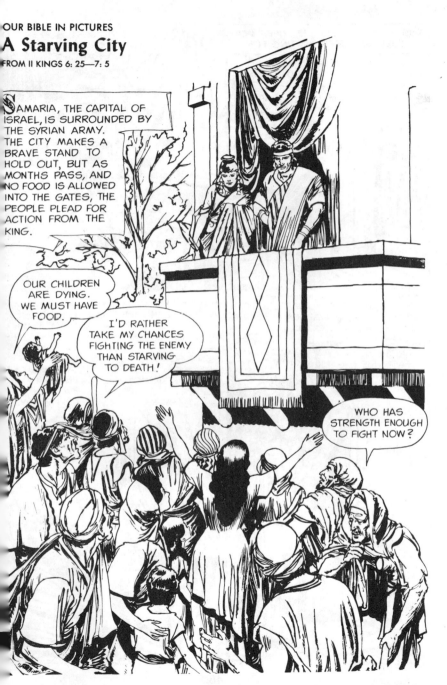

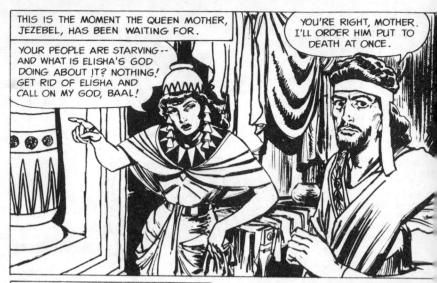

THIS IS THE MOMENT THE QUEEN MOTHER, JEZEBEL, HAS BEEN WAITING FOR.

YOUR PEOPLE ARE STARVING-- AND WHAT IS ELISHA'S GOD DOING ABOUT IT? NOTHING! GET RID OF ELISHA AND CALL ON MY GOD, BAAL!

YOU'RE RIGHT, MOTHER. I'LL ORDER HIM PUT TO DEATH AT ONCE.

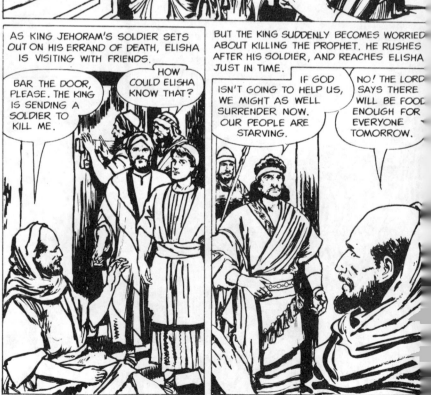

AS KING JEHORAM'S SOLDIER SETS OUT ON HIS ERRAND OF DEATH, ELISHA IS VISITING WITH FRIENDS.

BAR THE DOOR, PLEASE. THE KING IS SENDING A SOLDIER TO KILL ME.

HOW COULD ELISHA KNOW THAT?

BUT THE KING SUDDENLY BECOMES WORRIED ABOUT KILLING THE PROPHET. HE RUSHES AFTER HIS SOLDIER, AND REACHES ELISHA JUST IN TIME.

IF GOD ISN'T GOING TO HELP US, WE MIGHT AS WELL SURRENDER NOW. OUR PEOPLE ARE STARVING.

NO! THE LORD SAYS THERE WILL BE FOOD ENOUGH FOR EVERYONE TOMORROW.

THE ANXIOUS KING IS WILLING TO WAIT UNTIL THE NEXT DAY, BUT OUTSIDE THE CITY FOUR LEPERS HAVE NOT HEARD ELISHA'S PROPHECY...

I'M STARVING. I'M GOING TO TRY TO BREAK INTO THE CITY AND GET SOME FOOD.

WHY DO THAT? THERE'S NO FOOD IN THERE.

THEN LET'S GO OVER TO THE SYRIAN CAMP. MAYBE THEY'LL GIVE US SOMETHING TO EAT. MAYBE THEY'LL KILL US. EITHER WAY, THERE'S NOTHING TO LOSE-- WE'LL STARVE IF WE STAY HERE.

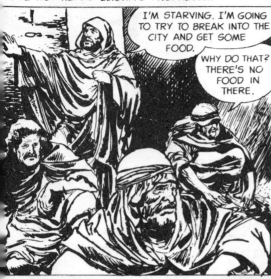

IN DESPERATION THE FOUR HUNGRY LEPERS APPROACH THE SYRIAN CAMP.

SOMETHING STRANGE IS GOING ON. THERE'S NOT A GUARD IN SIGHT. MAYBE IT'S A TRAP--

MAYBE IT IS-- BUT I'D RATHER DIE QUICKLY THAN STARVE TO DEATH. COME ON--

THERE'S NOBODY HERE!

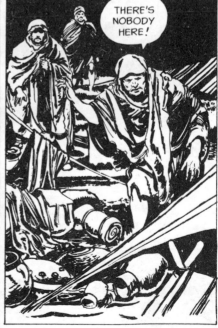

The Missing Enemy

FROM II KINGS 7: 6-15

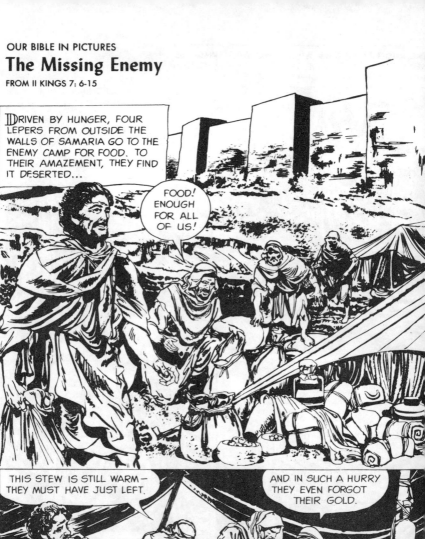

DRIVEN BY HUNGER, FOUR LEPERS FROM OUTSIDE THE WALLS OF SAMARIA GO TO THE ENEMY CAMP FOR FOOD. TO THEIR AMAZEMENT, THEY FIND IT DESERTED...

FOOD! ENOUGH FOR ALL OF US!

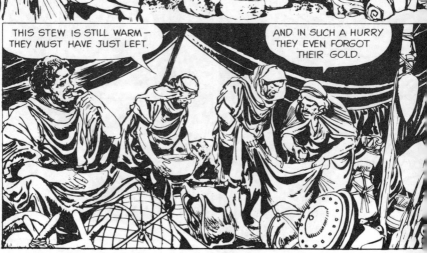

THIS STEW IS STILL WARM — THEY MUST HAVE JUST LEFT.

AND IN SUCH A HURRY THEY EVEN FORGOT THEIR GOLD.

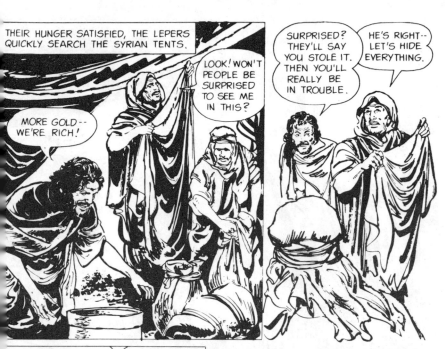

THEIR HUNGER SATISFIED, THE LEPERS QUICKLY SEARCH THE SYRIAN TENTS.

MORE GOLD-- WE'RE RICH!

LOOK! WON'T PEOPLE BE SURPRISED TO SEE ME IN THIS?

SURPRISED? THEY'LL SAY YOU STOLE IT. THEN YOU'LL REALLY BE IN TROUBLE.

HE'S RIGHT-- LET'S HIDE EVERYTHING.

T ISN'T RIGHT FOR S TO KEEP ALL OF HIS FOOD FROM THE TARVING PEOPLE IN THE CITY.

IF WE DON'T TELL THE GOOD NEWS, SOME PUNISHMENT MAY COME UPON US.

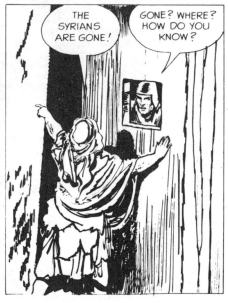

THE MEN GO BACK TO THE CITY AND POUND ON THE GATES UNTIL A GUARD ANSWERS.

THE SYRIANS ARE GONE!

GONE? WHERE? HOW DO YOU KNOW?

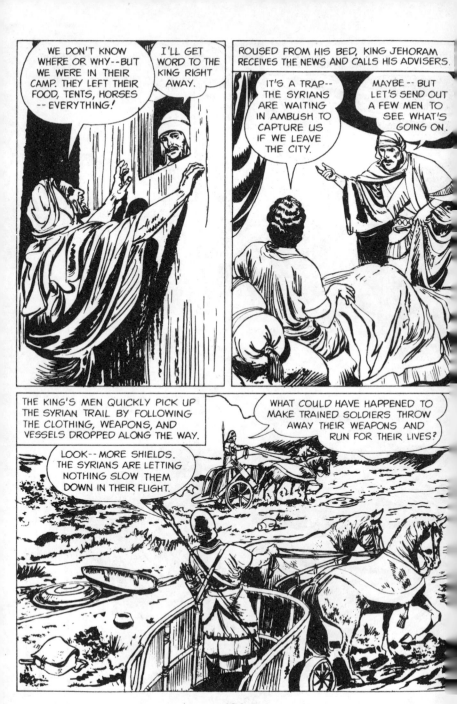

The Sound of Marching Men

FROM II KINGS 7: 14—9: 12

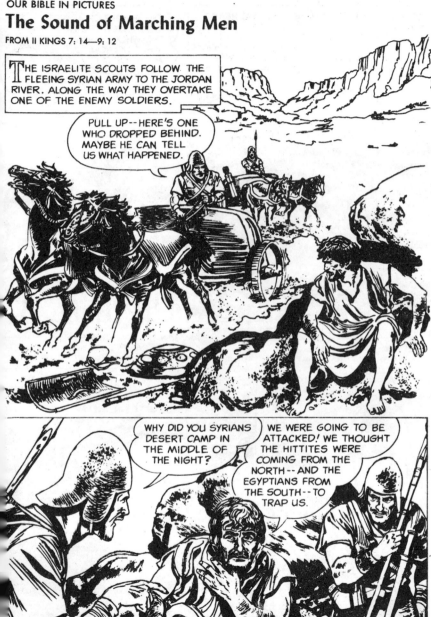

THE ISRAELITE SCOUTS FOLLOW THE FLEEING SYRIAN ARMY TO THE JORDAN RIVER. ALONG THE WAY THEY OVERTAKE ONE OF THE ENEMY SOLDIERS.

PULL UP--HERE'S ONE WHO DROPPED BEHIND. MAYBE HE CAN TELL US WHAT HAPPENED.

WHY DID YOU SYRIANS DESERT CAMP IN THE MIDDLE OF THE NIGHT?

WE WERE GOING TO BE ATTACKED! WE THOUGHT THE HITTITES WERE COMING FROM THE NORTH--AND THE EGYPTIANS FROM THE SOUTH--TO TRAP US.

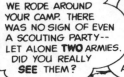

WE RODE AROUND YOUR CAMP. THERE WAS NO SIGN OF EVEN A SCOUTING PARTY-- LET ALONE **TWO** ARMIES. DID YOU REALLY **SEE** THEM?

NO--BUT WE HEARD THEM! THOUSANDS OF SOLDIERS, HORSES AND CHARIOTS --WE WOULDN'T HAVE HAD A CHANCE AGAINST SUCH MIGHT.

THE **SOUND** OF ARMIES-- REAL ENOUGH TO FRIGHTEN THE WHOLE SYRIAN CAMP. WHAT DO YOU MAKE OF IT?

IT WAS A MIRACLE --USED BY ELISHA'S GOD TO FRIGHTEN THE SYRIANS AWAY.

ELISHA'S GOD -- YES. THAT FITS IN WITH THE PROMISE THAT BY TODAY THERE WOULD BE FOOD FOR EVERYONE!

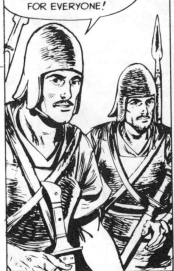

BACK IN SAMARIA THE STARVING ISRAELITES RUSH OUT TO THE SYRIAN CAMP, EAT THEIR FILL, AND HAUL THE REST OF THE FOOD BACK TO THE CITY.

YOU SAID THERE WOULD BE FOOD, ELISHA, BUT I DIDN'T BELIEVE YOU.

IT WAS THE LORD WHO PROMISED THE FOOD-- AND YOU CAN ALWAYS COUNT ON THE PROMISES OF GOD!

IN SPITE OF THE FACT THAT GOD HAS SAVED ISRAEL, KING JEHORAM AND HIS MOTHER KEEP ON WORSHIPPING BAAL. WHEN ONE OF HIS BORDER CITIES IS ATTACKED BY THE KING OF SYRIA, JEHORAM GOES TO ITS DEFENSE. WOUNDED IN THE BATTLE, HE LEAVES CAPTAIN JEHU IN CHARGE AND RETURNS HOME.

WHILE THE KING IS AWAY FROM THE ARMY, ELISHA CALLS FOR A YOUNG PROPHET TO MAKE A QUICK JOURNEY FOR HIM.

TAKE THIS OIL -- GO OUT TO WHERE OUR ARMY IS CAMPED, AND DO WHAT I TELL YOU.

AT THE CAMP THE YOUNG PROPHET SEARCHES UNTIL HE FINDS A GROUP OF OFFICERS.

CAPTAIN JEHU! PLEASE COME WITH ME -- I MUST SPEAK TO YOU ALONE.

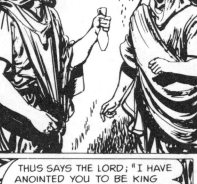

THUS SAYS THE LORD; "I HAVE ANOINTED YOU TO BE KING OVER ISRAEL, TO FIGHT FOR THOSE WHO WORSHIP ME, AND AGAINST THOSE WHO WORSHIP BAAL."

WHAT DID THAT FELLOW WANT?

HE WAS A MESSENGER FROM GOD -- AND HE ANOINTED **ME** KING -- **KING OF ISRAEL!**

WHAT'S GOING TO HAPPEN WHEN KING JEHORAM LEARNS OF THIS?

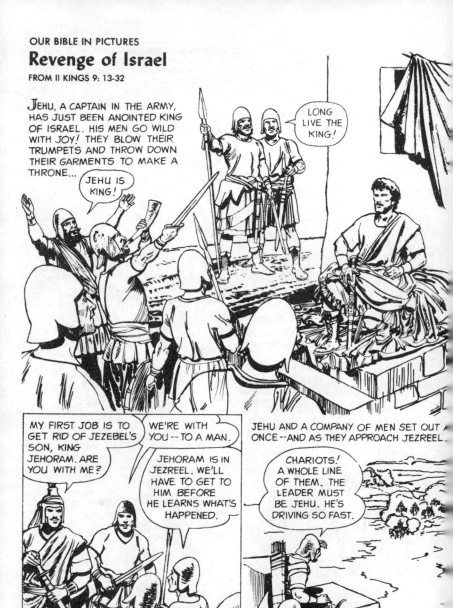

OUR BIBLE IN PICTURES

Revenge of Israel

FROM II KINGS 9: 13-32

JEHU, A CAPTAIN IN THE ARMY, HAS JUST BEEN ANOINTED KING OF ISRAEL. HIS MEN GO WILD WITH JOY! THEY BLOW THEIR TRUMPETS AND THROW DOWN THEIR GARMENTS TO MAKE A THRONE...

LONG LIVE THE KING!

JEHU IS KING!

MY FIRST JOB IS TO GET RID OF JEZEBEL'S SON, KING JEHORAM. ARE YOU WITH ME?

WE'RE WITH YOU -- TO A MAN.

JEHORAM IS IN JEZREEL. WE'LL HAVE TO GET TO HIM BEFORE HE LEARNS WHAT'S HAPPENED.

JEHU AND A COMPANY OF MEN SET OUT AT ONCE -- AND AS THEY APPROACH JEZREEL.

CHARIOTS! A WHOLE LINE OF THEM. THE LEADER MUST BE JEHU. HE'S DRIVING SO FAST.

WHEN THE NEWS REACHES KING JEHORAM, HE BELIEVES JEHU IS BRINGING NEWS OF THE WAR. SO, WITH HIS VISITOR, KING AHAZIAH OF JUDAH, HE RIDES OUT TO MEET JEHU.

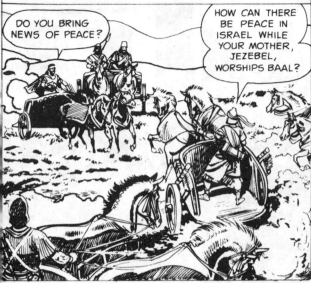

DO YOU BRING NEWS OF PEACE?

HOW CAN THERE BE PEACE IN ISRAEL WHILE YOUR MOTHER, JEZEBEL, WORSHIPS BAAL?

TOO LATE, JEHORAM SEES THAT JEHU HAS COME TO OVERTHROW THE KINGDOM. HE TRIES TO ESCAPE, BUT JEHU'S ARROW STRIKES HIM DOWN.

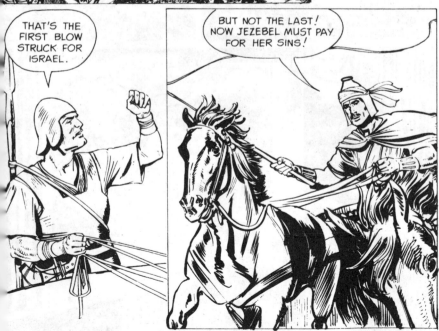

THAT'S THE FIRST BLOW STRUCK FOR ISRAEL.

BUT NOT THE LAST! NOW JEZEBEL MUST PAY FOR HER SINS!

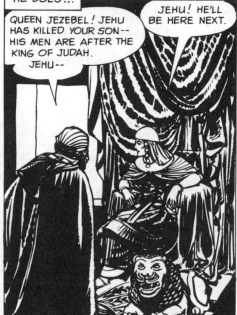

IN SPITE OF JEHU'S SURPRISE ATTACK, THE NEWS REACHES THE PALACE BEFORE HE DOES...

QUEEN JEZEBEL! JEHU HAS KILLED YOUR SON-- HIS MEN ARE AFTER THE KING OF JUDAH. JEHU--

JEHU! HE'LL BE HERE NEXT.

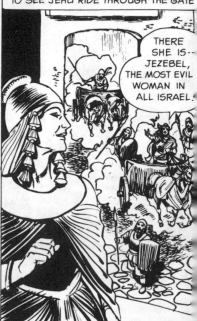

QUICKLY SHE PUTS ON HER CROWN-- AND GOES TO THE WINDOW IN TIME TO SEE JEHU RIDE THROUGH THE GATE

THERE SHE IS-- JEZEBEL, THE MOST EVIL WOMAN IN ALL ISRAEL!

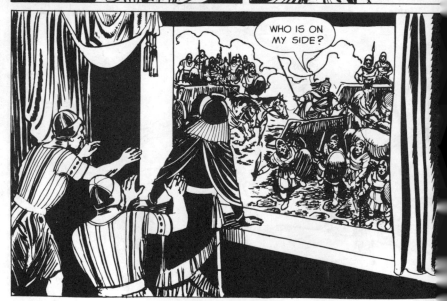

WHO IS ON MY SIDE?

490

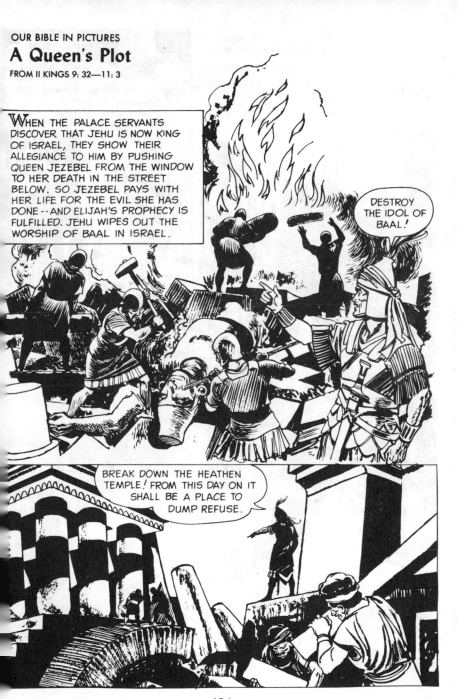

TO THE SOUTH, IN THE KINGDOM OF JUDAH, JEZEBEL'S DAUGHTER, ATHALIAH, RECEIVES THE NEWS...

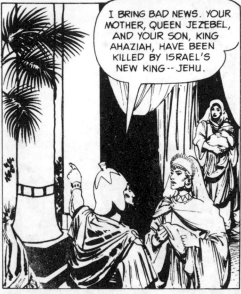

I BRING BAD NEWS. YOUR MOTHER, QUEEN JEZEBEL, AND YOUR SON, KING AHAZIAH, HAVE BEEN KILLED BY ISRAEL'S NEW KING -- JEHU.

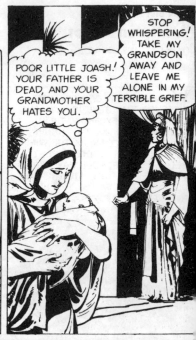

POOR LITTLE JOASH! YOUR FATHER IS DEAD, AND YOUR GRANDMOTHER HATES YOU.

STOP WHISPERING! TAKE MY GRANDSON AWAY AND LEAVE ME ALONE IN MY TERRIBLE GRIEF.

BUT ATHALIAH'S GRIEF IS ONLY A COVER FOR HER PLAN.

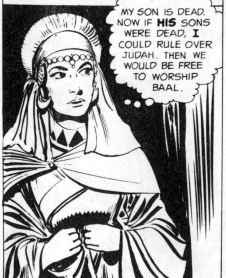

MY SON IS DEAD. NOW IF **HIS** SONS WERE DEAD, **I** COULD RULE OVER JUDAH. THEN WE WOULD BE FREE TO WORSHIP BAAL.

SHE ACTS AT ONCE TO CARRY OUT HER BOLD PLOT.

ORDER YOUR SOLDIERS TO KILL ALL OF THE KING'S MALE RELATIVES. DON'T LET ONE OF THEM ESCAPE -- NOT ONE!

492

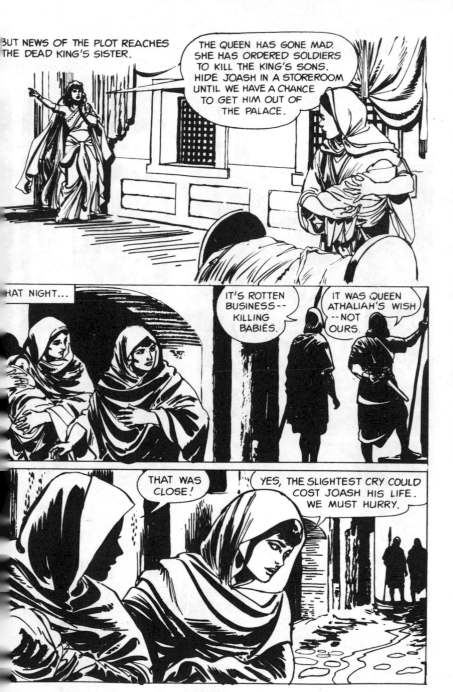

493

The Temple Secret

FROM II KINGS 11: 1-12

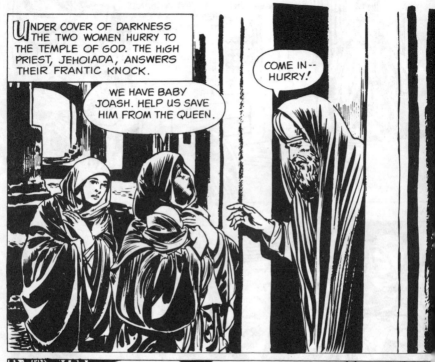

UNDER COVER OF DARKNESS THE TWO WOMEN HURRY TO THE TEMPLE OF GOD. THE HIGH PRIEST, JEHOIADA, ANSWERS THEIR FRANTIC KNOCK.

WE HAVE BABY JOASH. HELP US SAVE HIM FROM THE QUEEN.

COME IN-- HURRY!

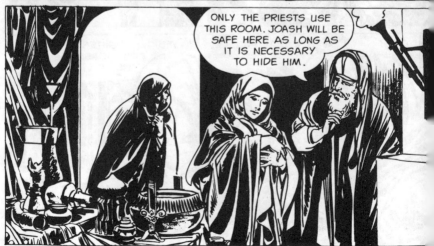

ONLY THE PRIESTS USE THIS ROOM. JOASH WILL BE SAFE HERE AS LONG AS IT IS NECESSARY TO HIDE HIM.

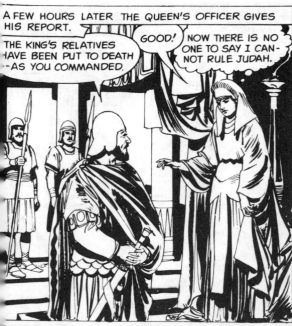

A FEW HOURS LATER THE QUEEN'S OFFICER GIVES HIS REPORT.

THE KING'S RELATIVES HAVE BEEN PUT TO DEATH -- AS YOU COMMANDED.

GOOD! NOW THERE IS NO ONE TO SAY I CANNOT RULE JUDAH.

FOR SIX YEARS ATHALIAH RULES JUDAH WITH A CRUEL HAND UNTIL AT LAST THE PEOPLE BEGIN TO COMPLAIN. UNKNOWN TO THEM -- IN A SECRET ROOM OF THE TEMPLE -- YOUNG PRINCE JOASH IS BEING TRAINED BY THE HIGH PRIEST.

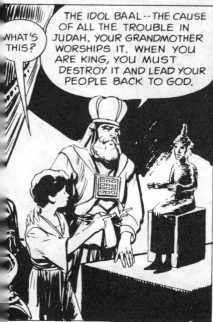

WHAT'S THIS?

THE IDOL BAAL -- THE CAUSE OF ALL THE TROUBLE IN JUDAH. YOUR GRANDMOTHER WORSHIPS IT. WHEN YOU ARE KING, YOU MUST DESTROY IT AND LEAD YOUR PEOPLE BACK TO GOD.

NOW, TELL ME THE WORD OF GOD YOU HAVE LEARNED TODAY.

THOU SHALT LOVE THE LORD THY GOD WITH ALL THINE HEART, AND WITH ALL THY SOUL, AND WITH ALL THY MIGHT!

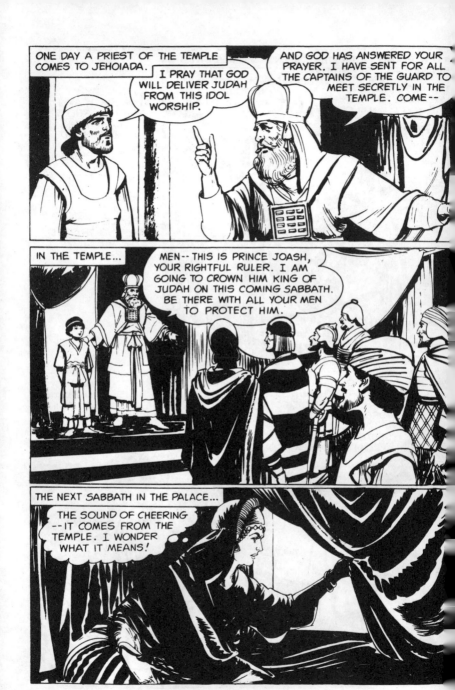

496

497

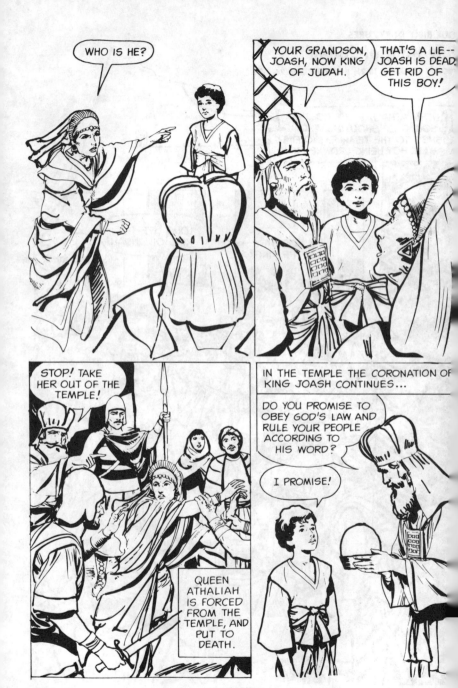

498

UNDER THE GUIDANCE OF JEHOIADA, THE HIGH PRIEST, JOASH DESTROYS THE TEMPLE OF BAAL AND LEADS HIS PEOPLE BACK TO THE WORSHIP OF GOD. THE HOUSE OF GOD IS REPAIRED, AND FOR YEARS JUDAH PROSPERS. BUT WHEN JEHOIADA DIES, JOASH IS TOO WEAK TO STAND UP UNDER THE PRESSURE OF THOSE WHO WOULD TURN HIM AWAY FROM GOD. FINALLY, JEHOIADA'S SON, ZECHARIAH, GOES TO THE KING...

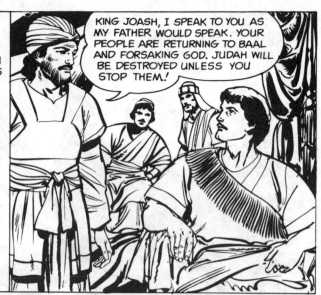

KING JOASH, I SPEAK TO YOU AS MY FATHER WOULD SPEAK. YOUR PEOPLE ARE RETURNING TO BAAL AND FORSAKING GOD. JUDAH WILL BE DESTROYED UNLESS YOU STOP THEM!

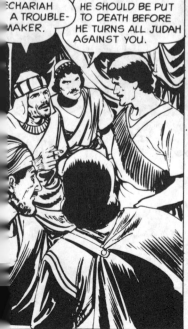

AS SOON AS ZECHARIAH LEAVES, THE WORSHIPERS OF BAAL GIVE **THEIR** ADVICE.

ZECHARIAH IS A TROUBLE-MAKER.

HE SHOULD BE PUT TO DEATH BEFORE HE TURNS ALL JUDAH AGAINST YOU.

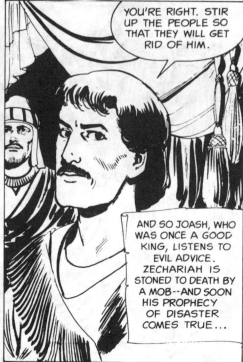

YOU'RE RIGHT. STIR UP THE PEOPLE SO THAT THEY WILL GET RID OF HIM.

AND SO JOASH, WHO WAS ONCE A GOOD KING, LISTENS TO EVIL ADVICE. ZECHARIAH IS STONED TO DEATH BY A MOB--AND SOON HIS PROPHECY OF DISASTER COMES TRUE...

OUR BIBLE IN PICTURES

Dagger in the Night

FROM II KINGS 12—18: 10

WHEN KING JOASH TURNED AWAY FROM GOD, ZECHARIAH PREDICTED DISASTER. IT COMES SOON-- IN AN ATTACK BY THE KING OF SYRIA WHO IS ON A CAMPAIGN OF CONQUEST. DURING THE ATTACK THE MEN WHO HAD ADVISED JOASH AGAINST ZECHARIAH ARE KILLED. IN AN ATTEMPT TO SAVE JERUSALEM, JOASH TRIES TO BUY OFF THE ENEMY.

GIFTS FROM MY LORD, KING JOASH OF JUDAH. HE ASKS THAT YOU ACCEPT THEM AND LEAVE JERUSALEM IN PEACE.

TELL YOUR KING I ACCEPT HIS OFFER.

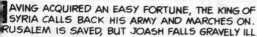
HAVING ACQUIRED AN EASY FORTUNE, THE KING OF SYRIA CALLS BACK HIS ARMY AND MARCHES ON. JERUSALEM IS SAVED, BUT JOASH FALLS GRAVELY ILL.

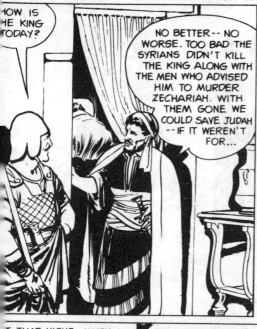

HOW IS THE KING TODAY?

NO BETTER-- NO WORSE. TOO BAD THE SYRIANS DIDN'T KILL THE KING ALONG WITH THE MEN WHO ADVISED HIM TO MURDER ZECHARIAH. WITH THEM GONE WE COULD SAVE JUDAH --IF IT WEREN'T FOR...

IF YOU'RE THINKING WHAT I AM--

SH! THIS ISN'T THE TIME.

THAT NIGHT-- WHEN ALL THE PALACE IS ASLEEP...

REMEMBER-- WE'RE DOING THIS TO SAVE OUR COUNTRY.

SO KING JOASH IS MURDERED-- BY HIS OWN MEN. FOR ALMOST A HUNDRED YEARS JUDAH IS RULED BY KINGS WHO WAVER BETWEEN WORSHIPING GOD AND HEATHEN IDOLS. THEN HEZEKIAH COMES TO THE THRONE...

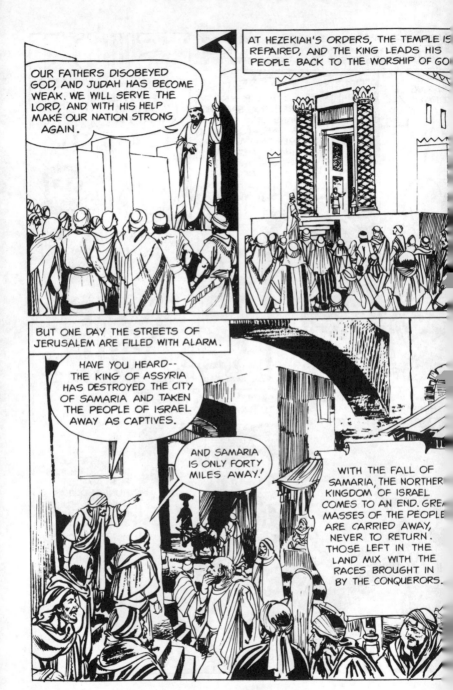

502

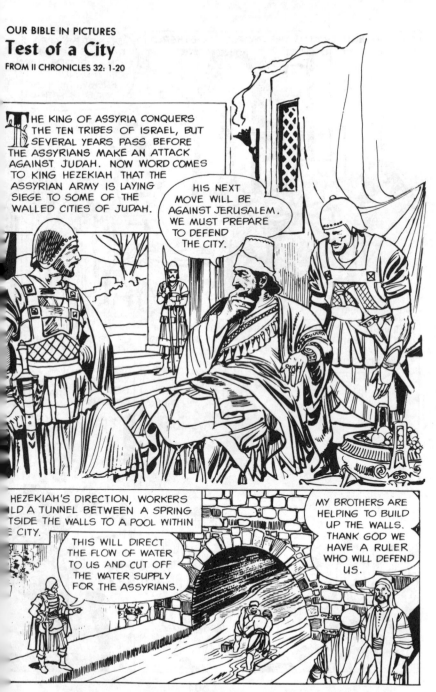

OUR BIBLE IN PICTURES
Test of a City
FROM II CHRONICLES 32: 1-20

THE KING OF ASSYRIA CONQUERS THE TEN TRIBES OF ISRAEL, BUT SEVERAL YEARS PASS BEFORE THE ASSYRIANS MAKE AN ATTACK AGAINST JUDAH. NOW WORD COMES TO KING HEZEKIAH THAT THE ASSYRIAN ARMY IS LAYING SIEGE TO SOME OF THE WALLED CITIES OF JUDAH.

HIS NEXT MOVE WILL BE AGAINST JERUSALEM. WE MUST PREPARE TO DEFEND THE CITY.

HEZEKIAH'S DIRECTION, WORKERS [BUI]LD A TUNNEL BETWEEN A SPRING [OU]TSIDE THE WALLS TO A POOL WITHIN [TH]E CITY.

THIS WILL DIRECT THE FLOW OF WATER TO US AND CUT OFF THE WATER SUPPLY FOR THE ASSYRIANS.

MY BROTHERS ARE HELPING TO BUILD UP THE WALLS. THANK GOD WE HAVE A RULER WHO WILL DEFEND US.

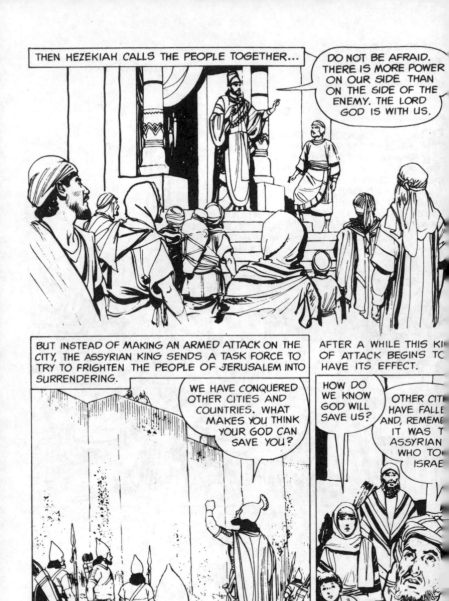

THEN HEZEKIAH CALLS THE PEOPLE TOGETHER...

DO NOT BE AFRAID. THERE IS MORE POWER ON OUR SIDE THAN ON THE SIDE OF THE ENEMY. THE LORD GOD IS WITH US.

BUT INSTEAD OF MAKING AN ARMED ATTACK ON THE CITY, THE ASSYRIAN KING SENDS A TASK FORCE TO TRY TO FRIGHTEN THE PEOPLE OF JERUSALEM INTO SURRENDERING.

WE HAVE CONQUERED OTHER CITIES AND COUNTRIES. WHAT MAKES YOU THINK YOUR GOD CAN SAVE YOU?

AFTER A WHILE THIS KI OF ATTACK BEGINS TO HAVE ITS EFFECT.

HOW DO WE KNOW GOD WILL SAVE US?

OTHER CIT HAVE FALLE AND, REMEMB IT WAS T ASSYRIAN WHO TO ISRAE

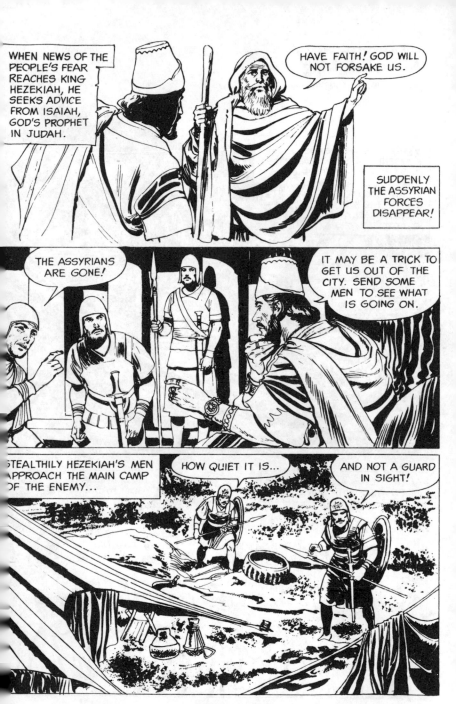

A Foolish King
FROM II CHRONICLES 32: 21—33: 12

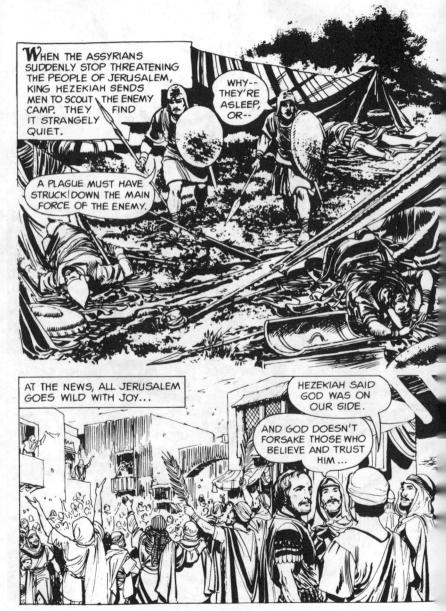

WHEN THE ASSYRIANS SUDDENLY STOP THREATENING THE PEOPLE OF JERUSALEM, KING HEZEKIAH SENDS MEN TO SCOUT THE ENEMY CAMP. THEY FIND IT STRANGELY QUIET.

WHY-- THEY'RE ASLEEP, OR--

A PLAGUE MUST HAVE STRUCK DOWN THE MAIN FORCE OF THE ENEMY.

AT THE NEWS, ALL JERUSALEM GOES WILD WITH JOY...

HEZEKIAH SAID GOD WAS ON OUR SIDE.

AND GOD DOESN'T FORSAKE THOSE WHO BELIEVE AND TRUST HIM ...

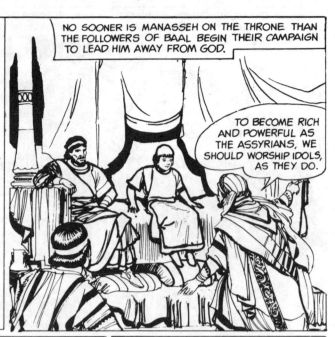

NO SOONER IS MANASSEH ON THE THRONE THAN THE FOLLOWERS OF BAAL BEGIN THEIR CAMPAIGN TO LEAD HIM AWAY FROM GOD.

NEVER AGAIN WHILE HEZEKIAH LIVES DO THE ASSYRIANS TRY TO TAKE JERUSALEM. HEZEKIAH CONTINUES TO LEAD HIS PEOPLE IN THEIR WORSHIP OF GOD, AND THEY ARE HAPPY. AT HIS DEATH, HIS YOUNG SON, MANASSEH, IS CROWNED KING.

TO BECOME RICH AND POWERFUL AS THE ASSYRIANS, WE SHOULD WORSHIP IDOLS, AS THEY DO.

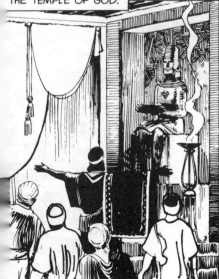

MANASSEH LISTENS TO THEIR ADVICE, AND RESTORES IDOL WORSHIP IN ISRAEL. HE EVEN DARES TO PLACE AN IDOL IN THE TEMPLE OF GOD.

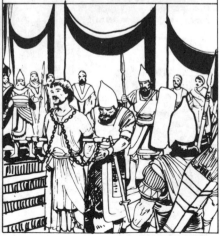

BUT WORSHIPING THE IDOLS OF THE SURROUNDING NATIONS DOES NOT SAVE MANASSEH. THE ASSYRIAN KING SUSPECTS MANASSEH IS PLOTTING AGAINST HIM AND SENDS TROOPS TO JERUSALEM. IN A SURPRISE MOVE THE ASSYRIANS OVERCOME MANASSEH'S FORCES AND TAKE THE KING PRISONER.

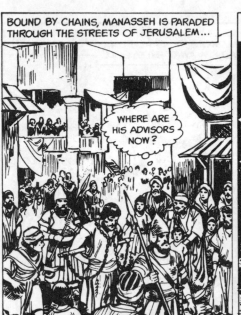

BOUND BY CHAINS, MANASSEH IS PARADED THROUGH THE STREETS OF JERUSALEM...

WHERE ARE HIS ADVISORS NOW?

AND IN BABYLON, WHICH IS CONTROLLED BY ASSYRIA, HE IS CAST INTO PRISON.

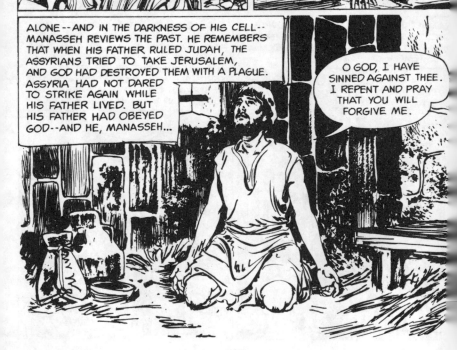

ALONE--AND IN THE DARKNESS OF HIS CELL-- MANASSEH REVIEWS THE PAST. HE REMEMBERS THAT WHEN HIS FATHER RULED JUDAH, THE ASSYRIANS TRIED TO TAKE JERUSALEM, AND GOD HAD DESTROYED THEM WITH A PLAGUE. ASSYRIA HAD NOT DARED TO STRIKE AGAIN WHILE HIS FATHER LIVED. BUT HIS FATHER HAD OBEYED GOD--AND HE, MANASSEH...

O GOD, I HAVE SINNED AGAINST THEE. I REPENT AND PRAY THAT YOU WILL FORGIVE ME.

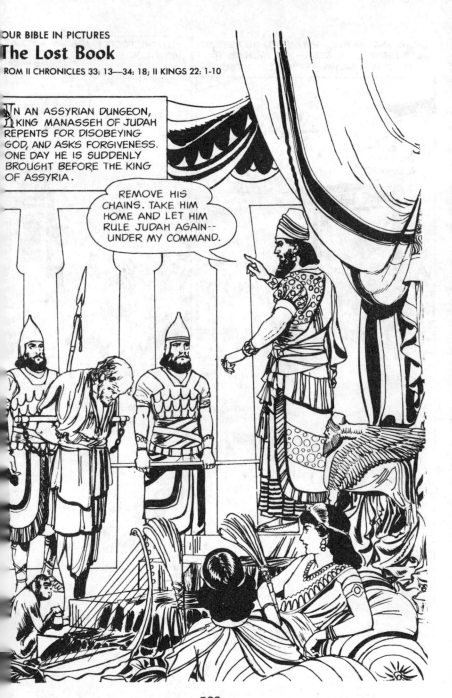

The Lost Book

FROM II CHRONICLES 33: 13—34: 18; II KINGS 22: 1-10

IN AN ASSYRIAN DUNGEON, KING MANASSEH OF JUDAH REPENTS FOR DISOBEYING GOD, AND ASKS FORGIVENESS. ONE DAY HE IS SUDDENLY BROUGHT BEFORE THE KING OF ASSYRIA.

REMOVE HIS CHAINS. TAKE HIM HOME AND LET HIM RULE JUDAH AGAIN-- UNDER MY COMMAND.

NO ONE KNOWS WHAT PROMPTED THE ASSYRIAN KING TO FREE MANASSEH--BUT WHEN HE RETURNS TO JERUSALEM HIS PEOPLE WELCOME HIM...

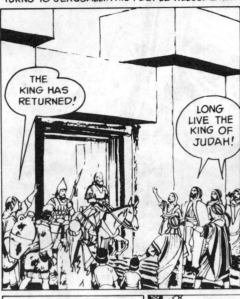

THE KING HAS RETURNED!

LONG LIVE THE KING OF JUDAH!

BUT THE PEOPLE ARE AMAZED AT HIS FIRST SPEECH...

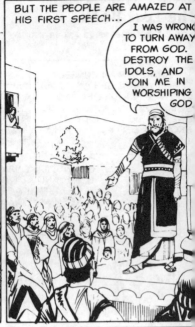

I WAS WRONG TO TURN AWAY FROM GOD. DESTROY THE IDOLS, AND JOIN ME IN WORSHIPING GOD.

MANASSEH TRIES TO SAVE HIS NATION, BUT IT IS TOO LATE. MOST OF THE PEOPLE CONTINUE TO WORSHIP IDOLS. MANASSEH DIES, AND AFTER TWO YEARS, HIS EIGHT-YEAR-OLD GRANDSON, JOSIAH, COMES TO THE THRONE.

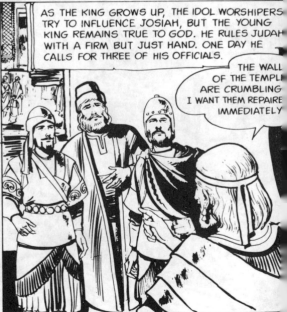

AS THE KING GROWS UP, THE IDOL WORSHIPERS TRY TO INFLUENCE JOSIAH, BUT THE YOUNG KING REMAINS TRUE TO GOD. HE RULES JUDAH WITH A FIRM BUT JUST HAND. ONE DAY HE CALLS FOR THREE OF HIS OFFICIALS.

THE WALLS OF THE TEMPLE ARE CRUMBLING. I WANT THEM REPAIRED IMMEDIATELY!

WORKMEN BEGIN AT ONCE. AFTER A WHILE THE HIGH PRIEST COMES TO CHECK THEIR PROGRESS...

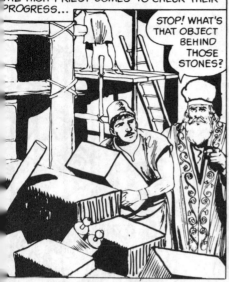

STOP! WHAT'S THAT OBJECT BEHIND THOSE STONES?

HE TAKES HIS DISCOVERY TO THE KING'S SCRIBE.

LOOK WHAT I HAVE FOUND! THE BOOK OF THE LAW!

IT HAS BEEN LOST FOR YEARS! LET ME READ IT!

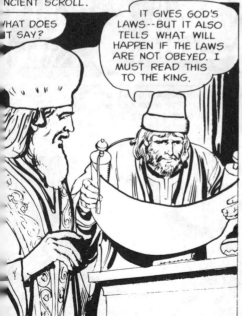

LOWLY, CAREFULLY, THE SCRIBE READS THE ANCIENT SCROLL.

WHAT DOES IT SAY?

IT GIVES GOD'S LAWS--BUT IT ALSO TELLS WHAT WILL HAPPEN IF THE LAWS ARE NOT OBEYED. I MUST READ THIS TO THE KING.

BUT I'M AFRAID THERE'S NOTHING HE--OR ANYBODY ELSE--CAN DO TO SAVE JUDAH!

511

A Prophetess Speaks

FROM II KINGS 22. 11—24: 20; II CHRONICLES 34: 19—36: 16

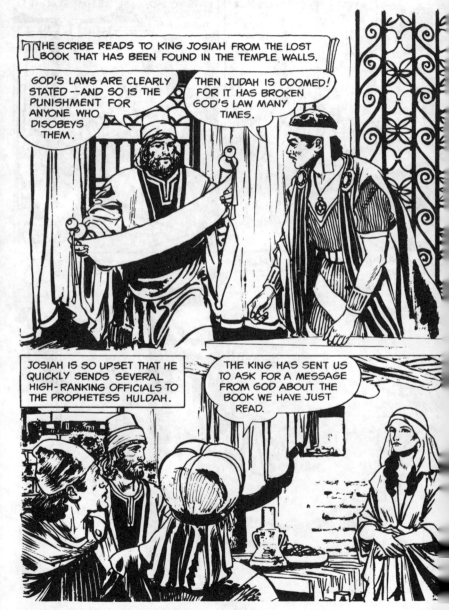

THE SCRIBE READS TO KING JOSIAH FROM THE LOST BOOK THAT HAS BEEN FOUND IN THE TEMPLE WALLS.

GOD'S LAWS ARE CLEARLY STATED --AND SO IS THE PUNISHMENT FOR ANYONE WHO DISOBEYS THEM.

THEN JUDAH IS DOOMED! FOR IT HAS BROKEN GOD'S LAW MANY TIMES.

JOSIAH IS SO UPSET THAT HE QUICKLY SENDS SEVERAL HIGH-RANKING OFFICIALS TO THE PROPHETESS HULDAH.

THE KING HAS SENT US TO ASK FOR A MESSAGE FROM GOD ABOUT THE BOOK WE HAVE JUST READ.

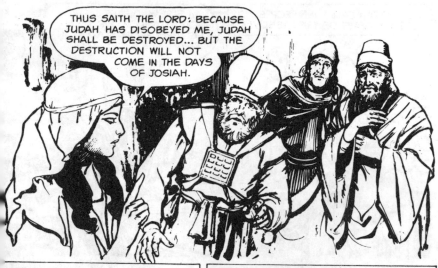

THUS SAITH THE LORD: BECAUSE JUDAH HAS DISOBEYED ME, JUDAH SHALL BE DESTROYED... BUT THE DESTRUCTION WILL NOT COME IN THE DAYS OF JOSIAH.

HOPING HE MAY YET WIN GOD'S FORGIVENESS FOR HIS NATION, JOSIAH CALLS A MEETING OF THE PEOPLE.

AT JOSIAH'S COMMAND PAGAN WORSHIP IS WIPED OUT IN ALL THE LAND. OBJECTS USED IN IDOL WORSHIP ARE REMOVED FROM GOD'S TEMPLE IN JERUSALEM, TAKEN OUTSIDE THE CITY, AND BURNED.

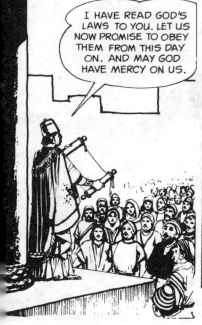

I HAVE READ GOD'S LAWS TO YOU. LET US NOW PROMISE TO OBEY THEM FROM THIS DAY ON. AND MAY GOD HAVE MERCY ON US.

513

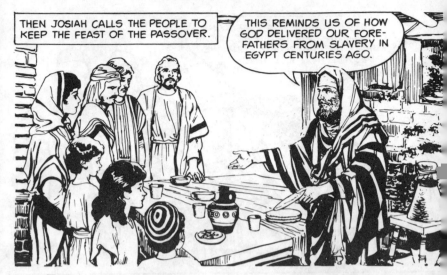

THEN JOSIAH CALLS THE PEOPLE TO KEEP THE FEAST OF THE PASSOVER.

THIS REMINDS US OF HOW GOD DELIVERED OUR FORE-FATHERS FROM SLAVERY IN EGYPT CENTURIES AGO.

WHILE JOSIAH LIVES, JUDAH OBEYS THE LAWS OF GOD. BUT AFTER HIS DEATH, ONE KING AFTER ANOTHER TURNS BACK TO THE WORSHIP OF IDOLS. LACKING GOD'S HELP, JUDAH COMES UNDER THE CONTROL OF A NEW WORLD POWER, BABYLONIA.

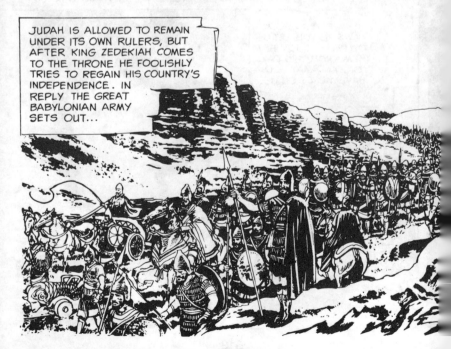

JUDAH IS ALLOWED TO REMAIN UNDER ITS OWN RULERS, BUT AFTER KING ZEDEKIAH COMES TO THE THRONE HE FOOLISHLY TRIES TO REGAIN HIS COUNTRY'S INDEPENDENCE. IN REPLY THE GREAT BABYLONIAN ARMY SETS OUT...

The Fall of Jerusalem

FROM II CHRONICLES 36: 17-20; II KINGS 25: 1-11

FOR TWO YEARS AND A HALF, FORCES FROM THE GREAT BABYLONIAN ARMY BESIEGE THE CITY OF JERUSALEM. AT LAST THEY BREAK THROUGH THE WALL...

THAT NIGHT KING ZEDEKIAH AND HIS ARMY TRY TO ESCAPE.

IF WE CAN MAKE IT TO THE HILL REGION EAST OF THE JORDAN, THEY'LL NEVER FIND US.

IT'S OUR ONLY CHANCE --IF THEY CAPTURE US...

BUT THE BABYLONIANS PURSUE THEM, AND ZEDEKIAH IS CAPTURED BEFORE HE CAN REACH THE RIVER. HE IS BLINDED AND TAKEN TO BABYLON.

HUNGRY, WEARY, AND AFRAID, THE PEOPLE OF JERUSALEM ARE FORCED TO BEGIN THE LONG MARCH OF 900 MILES FROM JERUSALEM TO BABYLON--AS CAPTIVES.

GOD HAS FORSAKEN US.

NO. GOD WARNED US, BUT WE WOULD NOT LISTEN. IT IS WE WHO HAVE FORSAKEN GOD!

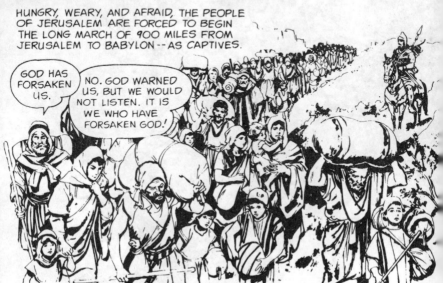

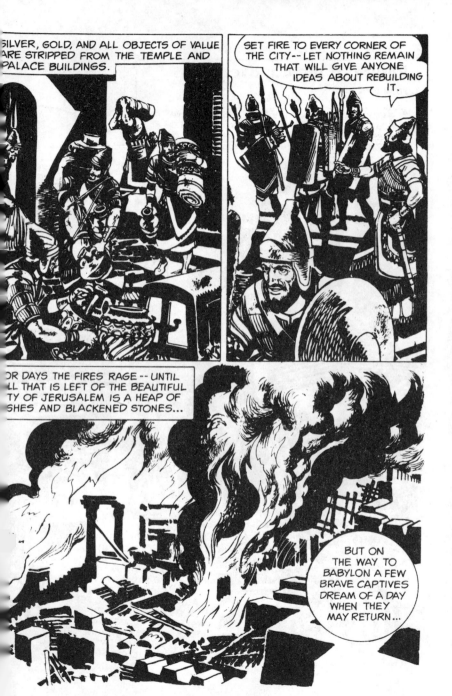

517

Return of the Captives

FROM EZRA 1, 2

FROM THE MOMENT THEY ARE CARRIED AWAY AS CAPTIVES TO BABYLON, THE JEWS DREAM OF RETURNING TO THEIR HOMELAND, JUDAH. THE BOOK OF **EZRA** TELLS WHAT HAPPENS TO THAT DREAM.

FOR MANY YEARS THE JEWS LIVE AS CAPTIVES OF THE GREAT BABYLONIAN EMPIRE. THEY WATCH ANXIOUSLY AS PERSIA, A STRONG COUNTRY TO THE EAST, RISES UP TO CHALLENGE BABYLON.

WHEN THE PERSIAN ARMY APPEARS OUTSIDE THE CITY WALLS, KING BELSHAZZAR IS SO SURE OF BABYLON'S STRENGTH THAT HE SPENDS THE NIGHT IN A DRUNKEN FEAST WITH HIS COURT. PERSIAN TROOPS STEAL INTO THE CITY-- INVADE THE PALACE--AND SLAY BELSHAZZAR. WITHIN HOURS THE BABYLONIAN EMPIRE FALLS TO PERSIA.

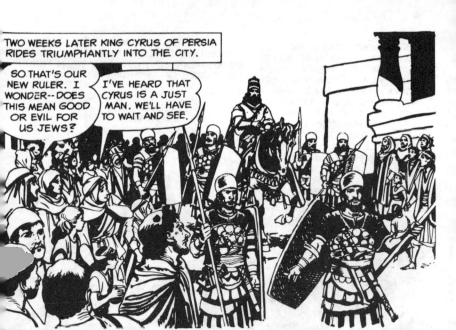

TWO WEEKS LATER KING CYRUS OF PERSIA RIDES TRIUMPHANTLY INTO THE CITY.

SO THAT'S OUR NEW RULER. I WONDER--DOES THIS MEAN GOOD OR EVIL FOR US JEWS?

I'VE HEARD THAT CYRUS IS A JUST MAN. WE'LL HAVE TO WAIT AND SEE.

SOON AFTER CYRUS TAKES OVER THE BABYLONIAN EMPIRE, AN OFFICIAL ANNOUNCEMENT IS READ.

THESE ARE THE WORDS OF KING CYRUS: THE GOD OF ISRAEL COMMANDS THAT A HOUSE BE BUILT FOR HIM IN JERUSALEM. ANY OF HIS PEOPLE WHO WANT TO DO SO MAY RETURN. THOSE WHO DO NOT GO BACK SHOULD GIVE OF THEIR POSSESSIONS TO HELP THOSE WHO RETURN TO JUDAH.

GIFTS OF MONEY, HORSES, MULES, CAMELS, GOLD AND SILVER, FOOD AND CLOTHING POUR IN. AT LAST THE DAY COMES WHEN THE GREAT CARAVAN IS READY TO LEAVE.

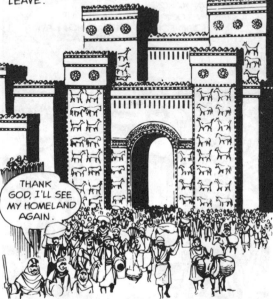

THANK GOD, I'LL SEE MY HOMELAND AGAIN.

ON THE LONG ROAD HOME, THEY FOLLOW MUCH THE SAME ROUTE THAT ABRAHAM, THE FATHER OF THE JEWISH NATION, TRAVELED 1,500 YEARS BEFORE WHEN HE OBEYED GOD'S COMMAND TO LEAVE UR AND MAKE A NEW NATION IN PALESTINE.

WHEN WE LEFT JERUSALEM IT WAS IN FLAMES-- I WONDER WHAT IT LOOKS LIKE NOW.

BUT NO MATTER HOW MUCH THEY PREPARE THEMSELVES FOR THE RUINED CITY, THEY ARE BROKENHEARTED WHEN THEY WALK THROUGH THE RUBBLE OF JERUSALEM.

SOLOMON'S BEAUTIFUL TEMPLE STOOD OVER THERE.

OUR HOME-- LET'S TRY TO FIND IT.

HOW PROUD WE WERE WHEN WE BUILT IT-- WITH OUR OWN HANDS, TOO. NOW LOOK AT IT-- A HOME FOR WILD DOGS.

MAYBE WE SHOULD NOT HAVE COME BACK. MAYBE...

OUR FOREFATHERS BUILT MUCH OF THIS CITY. WE'LL REBUILD IT-- JERUSALEM WILL RISE AGAIN. YOU'LL SEE...

A City Rises Again

FROM EZRA 3—10

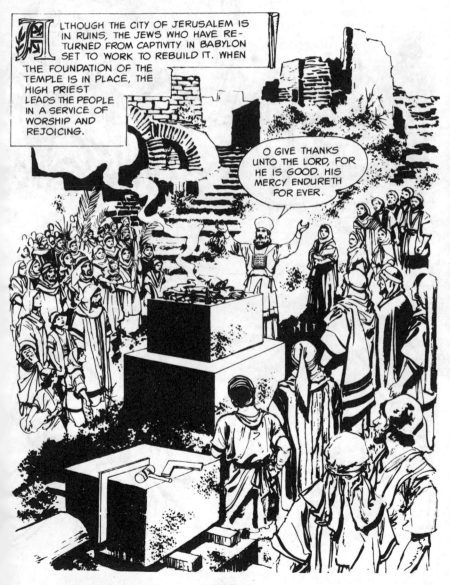

ALTHOUGH THE CITY OF JERUSALEM IS IN RUINS, THE JEWS WHO HAVE RETURNED FROM CAPTIVITY IN BABYLON SET TO WORK TO REBUILD IT. WHEN THE FOUNDATION OF THE TEMPLE IS IN PLACE, THE HIGH PRIEST LEADS THE PEOPLE IN A SERVICE OF WORSHIP AND REJOICING.

O GIVE THANKS UNTO THE LORD, FOR HE IS GOOD. HIS MERCY ENDURETH FOR EVER.

BUT THE SOUND OF REJOICING BRINGS TROUBLE. THE SAMARITANS WHO LIVE NEAR JERUSALEM COME WITH A REQUEST TO HELP BUILD THE TEMPLE.

WE'RE SORRY-- BUT YOU DO NOT WORSHIP AS WE DO, SO WE CANNOT LET YOU HELP US BUILD OUR TEMPLE TO GOD.

SO THEY "CAN'T" LET US HELP THEM BUILD THE TEMPLE! WELL, WE'LL MAKE THEM SORRY THEY EVER CAME BACK TO JERUSALEM TO BUILD ANYTHING.

WHAT DO YOU MEAN?

THE JEWS SOON LEARN WHAT THE SAMARITAN MEANT. ONE DAY WHILE THEY ARE AT WORK AN OFFICER OF KING CYRUS RIDES UP.

BY ORDER OF THE KING, THIS WORK IS TO STOP!

STOP? WHY? IT WAS KING CYRUS HIMSELF WHO TOLD US WE SHOULD RETURN TO JERUSALEM TO REBUILD THE TEMPLE!

UNHAPPILY, THE WORKMEN LAY DOWN THEIR TOOLS AND GO HOME.

FATHER, WHAT COULD HAVE HAPPENED? KING CYRUS SAID...

YES, BUT THE SAMARITANS WROTE HIM THAT WE WERE TRYING TO DESTROY HIS POWER HERE. THE KING IS INVESTIGATING THE CHARGES AND HAS ORDERED WORK ON THE TEMPLE STOPPED.

522

FORCED TO OBEY, THE JEWS TURN TO WORK ON THEIR HOMES AND GARDENS. SEVERAL YEARS PASS -- CYRUS DIES AND NEW KINGS COME TO THE THRONE IN PERSIA, BUT STILL THE TEMPLE IN JERUSALEM IS NOT COMPLETED. THEN, ONE DAY, THE JEWS ARE APPROACHED BY TWO PROPHETS OF GOD.

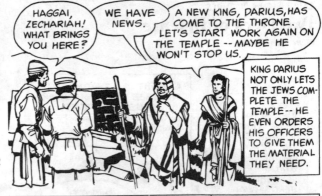

HAGGAI, ZECHARIAH! WHAT BRINGS YOU HERE?

WE HAVE NEWS.

A NEW KING, DARIUS, HAS COME TO THE THRONE. LET'S START WORK AGAIN ON THE TEMPLE -- MAYBE HE WON'T STOP US.

KING DARIUS NOT ONLY LETS THE JEWS COMPLETE THE TEMPLE -- HE EVEN ORDERS HIS OFFICERS TO GIVE THEM THE MATERIAL THEY NEED.

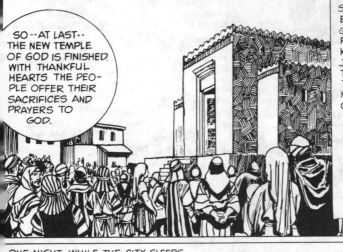

SO -- AT LAST -- THE NEW TEMPLE OF GOD IS FINISHED. WITH THANKFUL HEARTS THE PEOPLE OFFER THEIR SACRIFICES AND PRAYERS TO GOD.

SOME YEARS LATER, EZRA, A PRIEST, GAINS PERMISSION FROM THE PERSIAN KING TO GO TO JERUSALEM TO TEACH THE PEOPLE THE LAWS OF GOD. HE TAKES A GROUP OF JEWS WITH HIM. UNDER EZRA JERUSALEM GROWS IN SIZE AND SPIRITUAL STRENGTH, BUT IS STILL WITHOUT WALLS AND SURROUNDED BY HOSTILE NEIGHBORS.

ONE NIGHT, WHILE THE CITY SLEEPS, A STRANGER AND HIS GUARDS RIDE TOWARD JERUSALEM ...

Two Lines of Defense

FROM NEHEMIAH

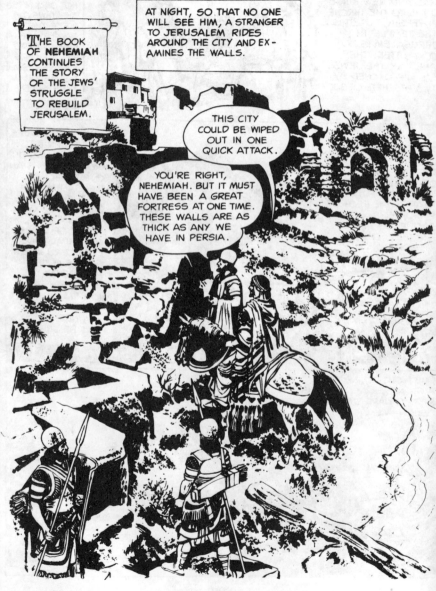

THE BOOK OF **NEHEMIAH** CONTINUES THE STORY OF THE JEWS' STRUGGLE TO REBUILD JERUSALEM.

AT NIGHT, SO THAT NO ONE WILL SEE HIM, A STRANGER TO JERUSALEM RIDES AROUND THE CITY AND EXAMINES THE WALLS.

THIS CITY COULD BE WIPED OUT IN ONE QUICK ATTACK.

YOU'RE RIGHT, NEHEMIAH. BUT IT MUST HAVE BEEN A GREAT FORTRESS AT ONE TIME. THESE WALLS ARE AS THICK AS ANY WE HAVE IN PERSIA.

THE NEXT DAY NEHEMIAH CALLS ON THE PRIESTS AND RULERS OF THE CITY.

I HAVE EXAMINED THE WALLS OF JERUSALEM. THEY ARE JUST HEAPS OF BROKEN STONE. THE CITY IS DEFENSELESS.

YOU ARE RIGHT, BUT WHY--

WHY HAVE I COME? BECAUSE I, TOO, AM A JEW. AND WHILE I WAS SERVING THE KING OF PERSIA AS HIS CUPBEARER, I LEARNED THAT JERUSALEM WAS WITHOUT ANY DEFENSE. I PRAYED TO GOD-- AND THE KING GAVE ME HIS PERMISSION TO COME HERE AND BUILD UP THE WALLS. ARE YOU WITH ME?

WE ARE-- AND WE'LL START AT ONCE.

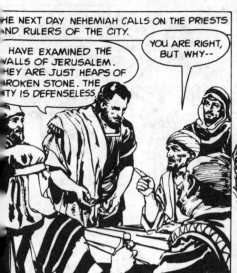

THE WORK BEGINS. EVERY ABLE-BODIED MAN AND BOY DOES HIS PART. THE WOMEN HELP... AND SLOWLY THE WALLS BEGIN TO RISE.

BUT SOME OF THE NEIGHBORING COUNTRIES DO NOT WANT TO SEE JERUSALEM PROTECTED.

IF THOSE WALLS ARE FINISHED, THE CITY WILL BE TOO STRONG TO ATTACK. WE MUST STOP IT **NOW**.

DOWN WITH THE WALLS!

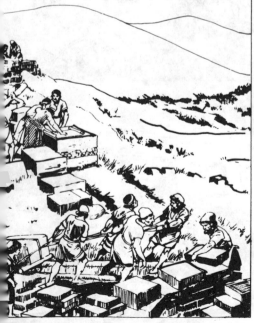

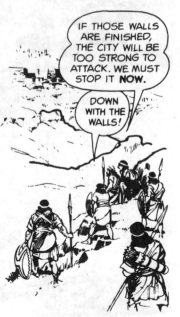

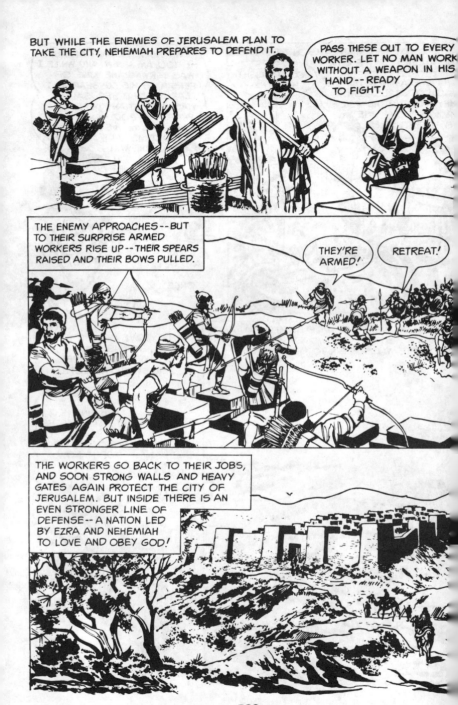

BUT WHILE THE ENEMIES OF JERUSALEM PLAN TO TAKE THE CITY, NEHEMIAH PREPARES TO DEFEND IT.

PASS THESE OUT TO EVERY WORKER. LET NO MAN WORK WITHOUT A WEAPON IN HIS HAND -- READY TO FIGHT!

THE ENEMY APPROACHES -- BUT TO THEIR SURPRISE ARMED WORKERS RISE UP -- THEIR SPEARS RAISED AND THEIR BOWS PULLED.

THEY'RE ARMED!

RETREAT!

THE WORKERS GO BACK TO THEIR JOBS, AND SOON STRONG WALLS AND HEAVY GATES AGAIN PROTECT THE CITY OF JERUSALEM. BUT INSIDE THERE IS AN EVEN STRONGER LINE OF DEFENSE -- A NATION LED BY EZRA AND NEHEMIAH TO LOVE AND OBEY GOD!

526

arch for a Queen

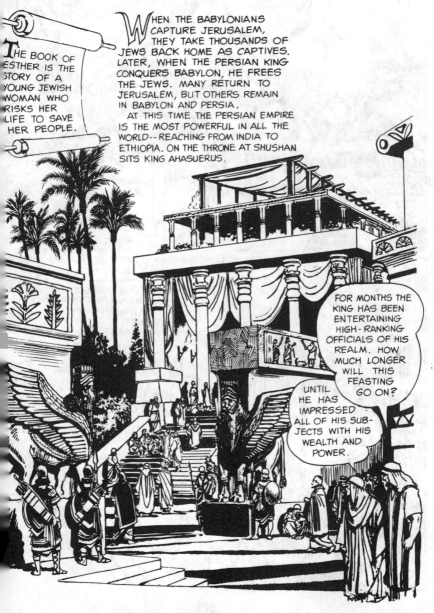

THE BOOK OF ESTHER IS THE STORY OF A YOUNG JEWISH WOMAN WHO RISKS HER LIFE TO SAVE HER PEOPLE.

WHEN THE BABYLONIANS CAPTURE JERUSALEM, THEY TAKE THOUSANDS OF JEWS BACK HOME AS CAPTIVES. LATER, WHEN THE PERSIAN KING CONQUERS BABYLON, HE FREES THE JEWS. MANY RETURN TO JERUSALEM, BUT OTHERS REMAIN IN BABYLON AND PERSIA.

AT THIS TIME THE PERSIAN EMPIRE IS THE MOST POWERFUL IN ALL THE WORLD--REACHING FROM INDIA TO ETHIOPIA. ON THE THRONE AT SHUSHAN SITS KING AHASUERUS.

FOR MONTHS THE KING HAS BEEN ENTERTAINING HIGH-RANKING OFFICIALS OF HIS REALM. HOW MUCH LONGER WILL THIS FEASTING GO ON?

UNTIL HE HAS IMPRESSED ALL OF HIS SUBJECTS WITH HIS WEALTH AND POWER.

527

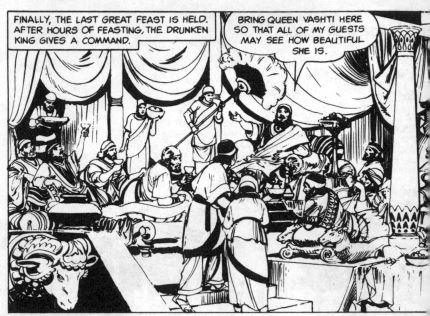

FINALLY, THE LAST GREAT FEAST IS HELD. AFTER HOURS OF FEASTING, THE DRUNKEN KING GIVES A COMMAND.

BRING QUEEN VASHTI HERE SO THAT ALL OF MY GUESTS MAY SEE HOW BEAUTIFUL SHE IS.

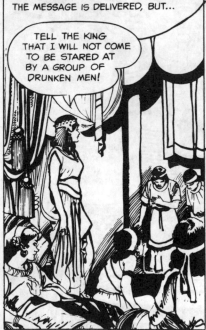

THE MESSAGE IS DELIVERED, BUT...

TELL THE KING THAT I WILL NOT COME TO BE STARED AT BY A GROUP OF DRUNKEN MEN!

SHOCKED BY HIS WIFE'S REFUSAL TO OBEY HI THE KING CALLS ON HIS WISE MEN FOR ADV

THIS COULD START TROUBLE THROUGHOUT YOUR WHOLE REALM. IF OTHER WOMEN HE OF THIS, THEY WILL THINK THEY CAN DISOB THEIR HUSBANDS, TOO. YOUR NOBLES MIGHT TURN AGAINST YOU.

528

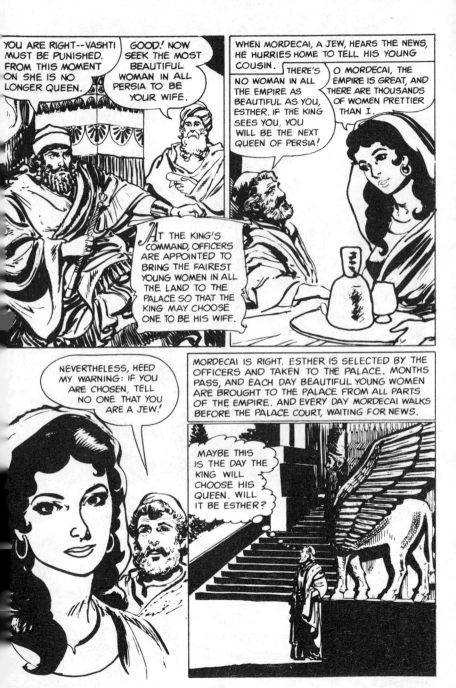

529

Plot Against the King

FROM ESTHER 2: 11—3: 6

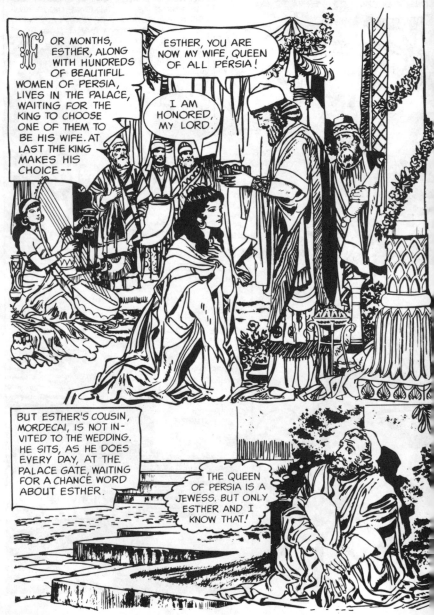

FOR MONTHS, ESTHER, ALONG WITH HUNDREDS OF BEAUTIFUL WOMEN OF PERSIA, LIVES IN THE PALACE, WAITING FOR THE KING TO CHOOSE ONE OF THEM TO BE HIS WIFE. AT LAST THE KING MAKES HIS CHOICE--

ESTHER, YOU ARE NOW MY WIFE, QUEEN OF ALL PERSIA!

I AM HONORED, MY LORD.

BUT ESTHER'S COUSIN, MORDECAI, IS NOT IN-VITED TO THE WEDDING. HE SITS, AS HE DOES EVERY DAY, AT THE PALACE GATE, WAITING FOR A CHANCE WORD ABOUT ESTHER.

THE QUEEN OF PERSIA IS A JEWESS. BUT ONLY ESTHER AND I KNOW THAT!

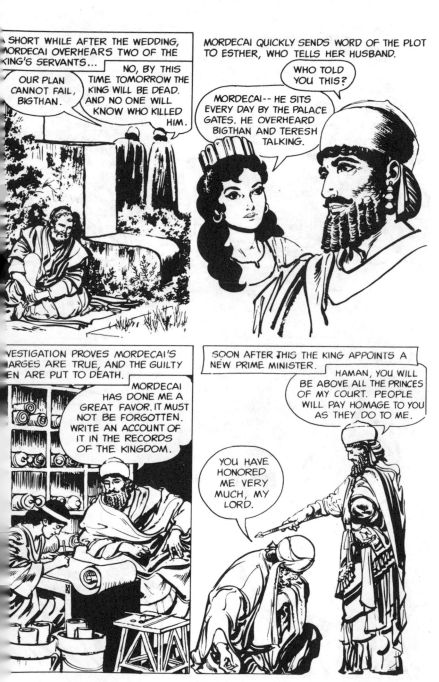

A SHORT WHILE AFTER THE WEDDING, MORDECAI OVERHEARS TWO OF THE KING'S SERVANTS...

OUR PLAN CANNOT FAIL, BIGTHAN.

NO, BY THIS TIME TOMORROW THE KING WILL BE DEAD. AND NO ONE WILL KNOW WHO KILLED HIM.

MORDECAI QUICKLY SENDS WORD OF THE PLOT TO ESTHER, WHO TELLS HER HUSBAND.

WHO TOLD YOU THIS?

MORDECAI-- HE SITS EVERY DAY BY THE PALACE GATES. HE OVERHEARD BIGTHAN AND TERESH TALKING.

INVESTIGATION PROVES MORDECAI'S CHARGES ARE TRUE, AND THE GUILTY MEN ARE PUT TO DEATH.

MORDECAI HAS DONE ME A GREAT FAVOR. IT MUST NOT BE FORGOTTEN. WRITE AN ACCOUNT OF IT IN THE RECORDS OF THE KINGDOM.

SOON AFTER THIS THE KING APPOINTS A NEW PRIME MINISTER.

HAMAN, YOU WILL BE ABOVE ALL THE PRINCES OF MY COURT. PEOPLE WILL PAY HOMAGE TO YOU AS THEY DO TO ME.

YOU HAVE HONORED ME VERY MUCH, MY LORD.

531

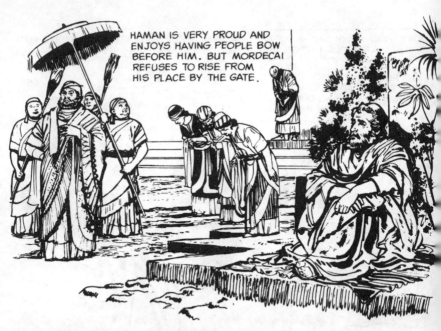

HAMAN IS VERY PROUD AND ENJOYS HAVING PEOPLE BOW BEFORE HIM. BUT MORDECAI REFUSES TO RISE FROM HIS PLACE BY THE GATE.

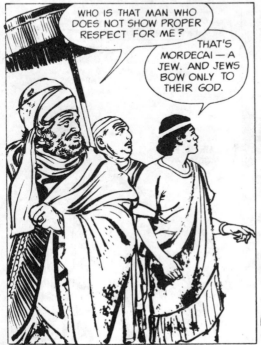

WHO IS THAT MAN WHO DOES NOT SHOW PROPER RESPECT FOR ME?

THAT'S MORDECAI — A JEW. AND JEWS BOW ONLY TO THEIR GOD.

MORDECAI WILL PAY FOR THIS -- AND SO WILL EVERY JEW IN PERSIA!

NGERED BECAUSE MORDECAI WILL NOT BOW BEFORE HIM, HAMAN PREPARES HIS REVENGE...

THERE'S A RACE OF PEOPLE IN OUR KINGDOM, SIR, WHO DO NOT OBEY YOU. FOR YOUR SAFETY, THEY SHOULD BE DESTROYED. GIVE ME PERMISSION TO MAKE A LAW THAT WILL RID PERSIA OF THEM.

YOU ARE A LOYAL MAN, HAMAN. HERE IS MY RING. USE ITS SEAL TO SHOW THAT YOUR LAW IS MY LAW.

MAN ACTS AT ONCE...

WRITE THIS DOWN AND SEE THAT EACH GOVERNOR IN THE KINGDOM RECEIVES A COPY OF IT: "EVERY JEW IN PERSIA IS TO BE DESTROYED ON THE 13TH DAY OF THE 12TH MONTH. THOSE WHO KILL THE JEWS MAY KEEP AS REWARDS ALL THE MONEY AND GOODS OF THE JEWS THEY KILL."

533

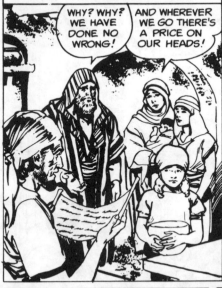

THE ORDERS ARE WRITTEN AND DELIVERED. THROUGHOUT THE KINGDOM JEWISH FAMILIES ARE TERRIFIED...

WHY? WHY? WE HAVE DONE NO WRONG!

AND WHEREVER WE GO THERE'S A PRICE ON OUR HEADS!

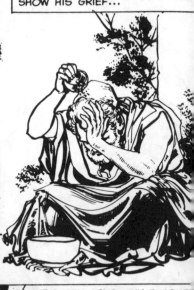

WHEN MORDECAI HEARS THE ORDE... HE DRESSES IN CLOTHES OF MOURN... AND POURS ASHES OVER HIS HEAD... SHOW HIS GRIEF...

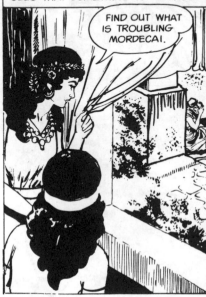

FROM HER PALACE WINDOW ESTHER SEES THAT SOMETHING IS WRONG.

FIND OUT WHAT IS TROUBLING MORDECAI.

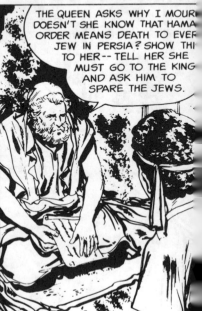

THE QUEEN ASKS WHY I MOURN DOESN'T SHE KNOW THAT HAMA... ORDER MEANS DEATH TO EVER... JEW IN PERSIA? SHOW THI... TO HER-- TELL HER SHE MUST GO TO THE KING AND ASK HIM TO SPARE THE JEWS.

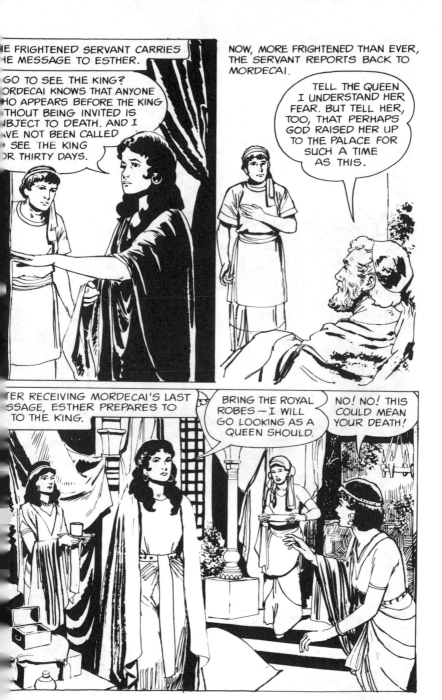

535

OUR BIBLE IN PICTURES
A Queen Risks Her Life
FROM ESTHER 5: 1—6: 10

QUEEN ESTHER BREAKS A LAW BY APPEARING UNINVITED BEFORE THE KING--AN ACT PUNISHABLE BY DEATH. BUT THE LIVES OF HER PEOPLE, THE JEWS, ARE IN DANGER, AND SHE IS THE ONLY ONE WHO MAY BE ABLE TO SAVE THEM.

ESTHER! WHAT DOES SHE WANT THAT SHE WOULD RISK HER LIFE TO GET?

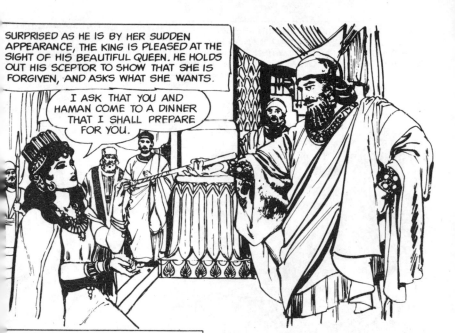

SURPRISED AS HE IS BY HER SUDDEN APPEARANCE, THE KING IS PLEASED AT THE SIGHT OF HIS BEAUTIFUL QUEEN. HE HOLDS OUT HIS SCEPTER TO SHOW THAT SHE IS FORGIVEN, AND ASKS WHAT SHE WANTS.

I ASK THAT YOU AND HAMAN COME TO A DINNER THAT I SHALL PREPARE FOR YOU.

THE KING ACCEPTS. SO DOES HAMAN -- WHO IS OVERJOYED UNTIL HE LEAVES THE PALACE.

THAT STUBBORN JEW -- HE STILL WON'T BOW BEFORE ME! WELL, HE'LL SOON BE DEAD WITH ALL THE OTHER JEWS.

AT HOME HAMAN COMPLAINS THAT MORDECAI HAS INSULTED HIM.

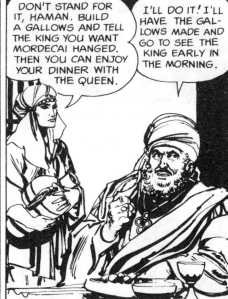

DON'T STAND FOR IT, HAMAN. BUILD A GALLOWS AND TELL THE KING YOU WANT MORDECAI HANGED. THEN YOU CAN ENJOY YOUR DINNER WITH THE QUEEN.

I'LL DO IT! I'LL HAVE THE GALLOWS MADE AND GO TO SEE THE KING EARLY IN THE MORNING.

BUT THAT NIGHT THE KING CANNOT SLEEP. HE CALLS FOR A SCRIBE TO READ TO HIM FROM THE RECORDS OF THE KINGDOM. WHEN THE READING REACHES THE STORY OF MORDECAI, THE KING INTERRUPTS.

AT THAT MOMENT HAMAN ENTER THE COURT AND IS BROUGHT BEFORE THE KING.

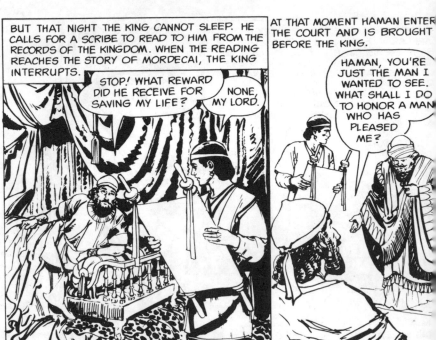

STOP! WHAT REWARD DID HE RECEIVE FOR SAVING MY LIFE?

NONE, MY LORD.

HAMAN, YOU'RE JUST THE MAN I WANTED TO SEE. WHAT SHALL I DO TO HONOR A MAN WHO HAS PLEASED ME?

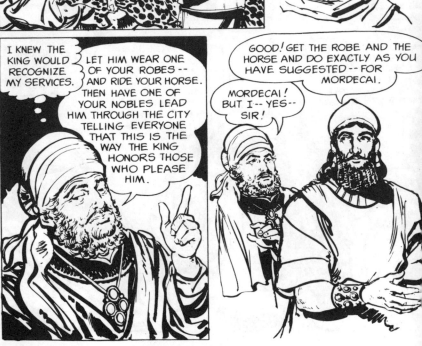

I KNEW THE KING WOULD RECOGNIZE MY SERVICES.

LET HIM WEAR ONE OF YOUR ROBES -- AND RIDE YOUR HORSE. THEN HAVE ONE OF YOUR NOBLES LEAD HIM THROUGH THE CITY TELLING EVERYONE THAT THIS IS THE WAY THE KING HONORS THOSE WHO PLEASE HIM.

GOOD! GET THE ROBE AND THE HORSE AND DO EXACTLY AS YOU HAVE SUGGESTED -- FOR MORDECAI.

MORDECAI! BUT I -- YES-- SIR!

The Unchangeable Law

FROM ESTHER 6: 11—10

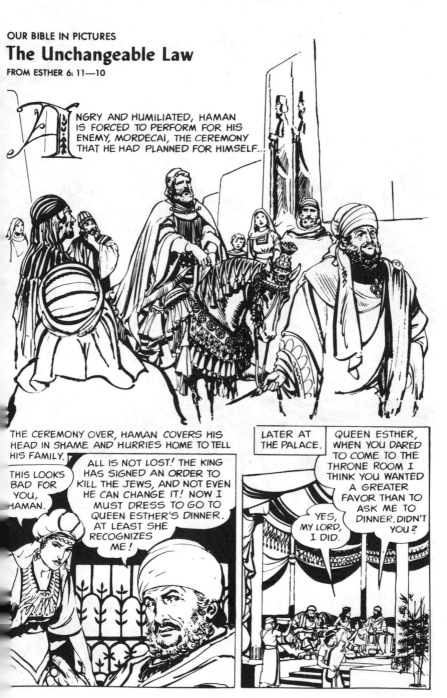

NGRY AND HUMILIATED, HAMAN IS FORCED TO PERFORM FOR HIS ENEMY, MORDECAI, THE CEREMONY THAT HE HAD PLANNED FOR HIMSELF...

THE CEREMONY OVER, HAMAN COVERS HIS HEAD IN SHAME AND HURRIES HOME TO TELL HIS FAMILY.

THIS LOOKS BAD FOR YOU, HAMAN.

ALL IS NOT LOST! THE KING HAS SIGNED AN ORDER TO KILL THE JEWS, AND NOT EVEN HE CAN CHANGE IT! NOW I MUST DRESS TO GO TO QUEEN ESTHER'S DINNER. AT LEAST SHE RECOGNIZES ME!

LATER AT THE PALACE.

QUEEN ESTHER, WHEN YOU DARED TO COME TO THE THRONE ROOM I THINK YOU WANTED A GREATER FAVOR THAN TO ASK ME TO DINNER. DIDN'T YOU?

YES, MY LORD, I DID.

539

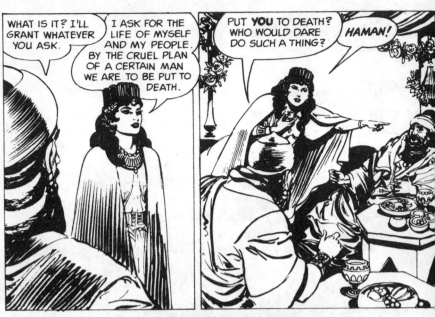

WHAT IS IT? I'LL GRANT WHATEVER YOU ASK.

I ASK FOR THE LIFE OF MYSELF AND MY PEOPLE. BY THE CRUEL PLAN OF A CERTAIN MAN WE ARE TO BE PUT TO DEATH.

PUT **YOU** TO DEATH? WHO WOULD DARE DO SUCH A THING?

HAMAN!

Now, FOR THE FIRST TIME THE KING KNOWS THAT HIS WIFE IS JEWISH, AND THAT HAMAN TRICKED HIM INTO SIGNING HER DEATH WARRANT. IN ANGER THE KING LEAVES THE ROOM.

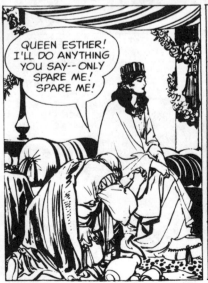

QUEEN ESTHER! I'LL DO ANYTHING YOU SAY-- ONLY SPARE ME! SPARE ME!

THE KING'S SERVANT KNOWS THAT HAMAN IS DOOMED TO DIE AND HE COVERS THE MAN'S HEAD WITH A CLOTH.

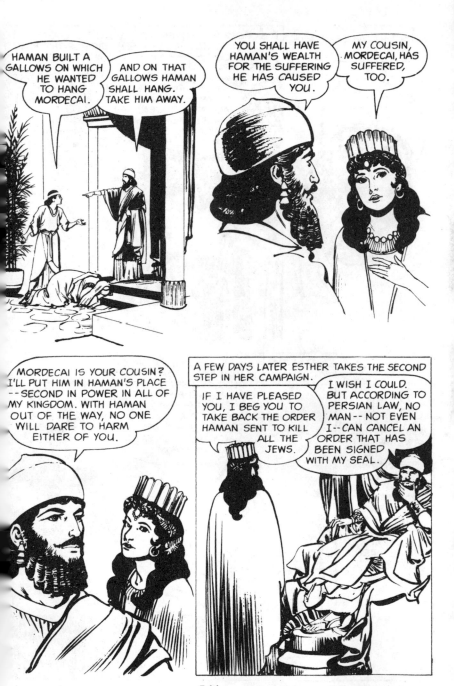

541

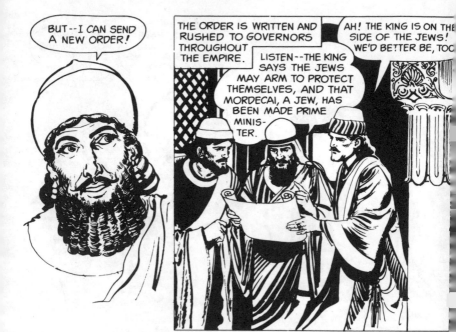

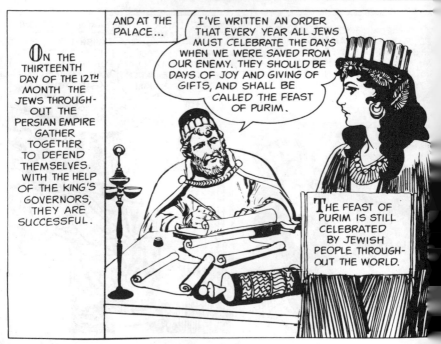

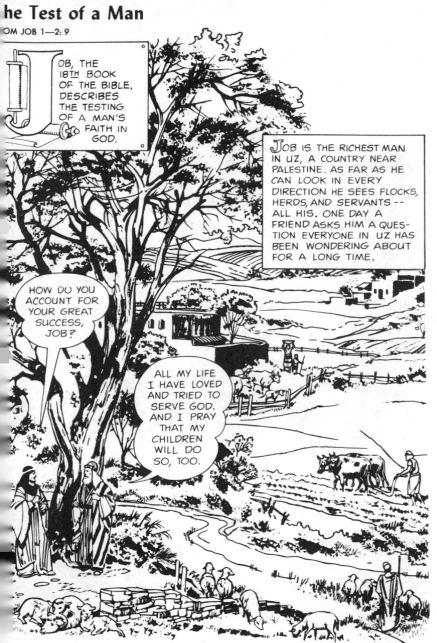

JOB, THE 18TH BOOK OF THE BIBLE, DESCRIBES THE TESTING OF A MAN'S FAITH IN GOD.

JOB IS THE RICHEST MAN IN UZ, A COUNTRY NEAR PALESTINE. AS FAR AS HE CAN LOOK IN EVERY DIRECTION HE SEES FLOCKS, HERDS, AND SERVANTS -- ALL HIS. ONE DAY A FRIEND ASKS HIM A QUESTION EVERYONE IN UZ HAS BEEN WONDERING ABOUT FOR A LONG TIME.

HOW DO YOU ACCOUNT FOR YOUR GREAT SUCCESS, JOB?

ALL MY LIFE I HAVE LOVED AND TRIED TO SERVE GOD. AND I PRAY THAT MY CHILDREN WILL DO SO, TOO.

543

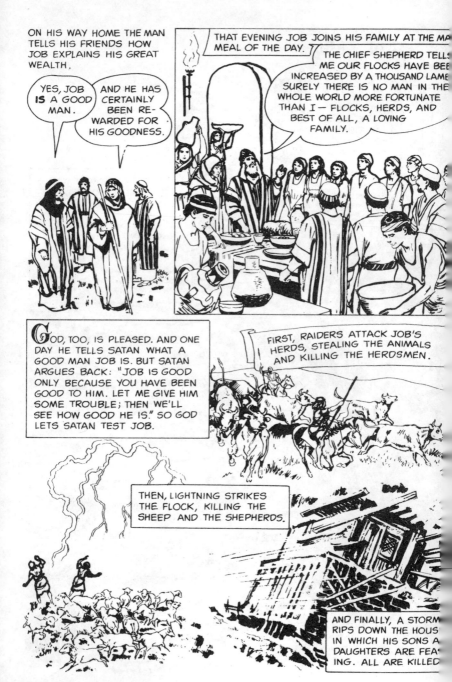

ON HIS WAY HOME THE MAN TELLS HIS FRIENDS HOW JOB EXPLAINS HIS GREAT WEALTH.

YES, JOB **IS** A GOOD MAN.

AND HE HAS CERTAINLY BEEN REWARDED FOR HIS GOODNESS.

THAT EVENING JOB JOINS HIS FAMILY AT THE MA[IN] MEAL OF THE DAY.

THE CHIEF SHEPHERD TELLS ME OUR FLOCKS HAVE BEE[N] INCREASED BY A THOUSAND LAMB[S] SURELY THERE IS NO MAN IN THE WHOLE WORLD MORE FORTUNATE THAN I — FLOCKS, HERDS, AND BEST OF ALL, A LOVING FAMILY.

GOD, TOO, IS PLEASED. AND ONE DAY HE TELLS SATAN WHAT A GOOD MAN JOB IS. BUT SATAN ARGUES BACK: "JOB IS GOOD ONLY BECAUSE YOU HAVE BEEN GOOD TO HIM. LET ME GIVE HIM SOME TROUBLE; THEN WE'LL SEE HOW GOOD HE IS." SO GOD LETS SATAN TEST JOB.

FIRST, RAIDERS ATTACK JOB'S HERDS, STEALING THE ANIMALS AND KILLING THE HERDSMEN.

THEN, LIGHTNING STRIKES THE FLOCK, KILLING THE SHEEP AND THE SHEPHERDS.

AND FINALLY, A STORM RIPS DOWN THE HOUS[E] IN WHICH HIS SONS A[ND] DAUGHTERS ARE FEA[ST]ING. ALL ARE KILLED

544

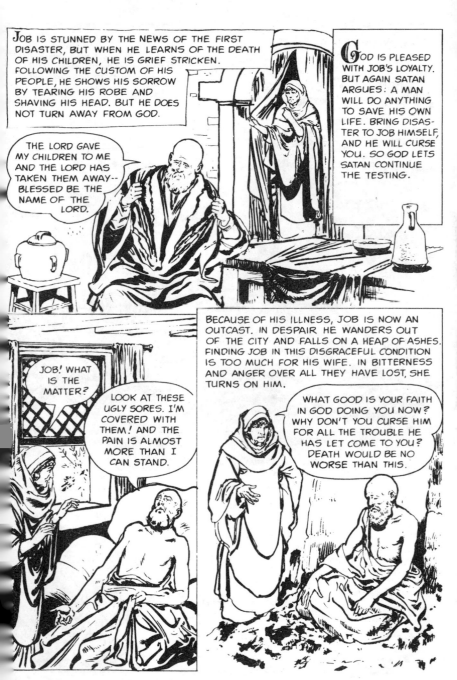

JOB IS STUNNED BY THE NEWS OF THE FIRST DISASTER, BUT WHEN HE LEARNS OF THE DEATH OF HIS CHILDREN, HE IS GRIEF STRICKEN. FOLLOWING THE CUSTOM OF HIS PEOPLE, HE SHOWS HIS SORROW BY TEARING HIS ROBE AND SHAVING HIS HEAD. BUT HE DOES NOT TURN AWAY FROM GOD.

THE LORD GAVE MY CHILDREN TO ME AND THE LORD HAS TAKEN THEM AWAY-- BLESSED BE THE NAME OF THE LORD.

GOD IS PLEASED WITH JOB'S LOYALTY. BUT AGAIN SATAN ARGUES: A MAN WILL DO ANYTHING TO SAVE HIS OWN LIFE. BRING DISASTER TO JOB HIMSELF, AND HE WILL CURSE YOU. SO GOD LETS SATAN CONTINUE THE TESTING.

JOB! WHAT IS THE MATTER?

LOOK AT THESE UGLY SORES. I'M COVERED WITH THEM! AND THE PAIN IS ALMOST MORE THAN I CAN STAND.

BECAUSE OF HIS ILLNESS, JOB IS NOW AN OUTCAST. IN DESPAIR HE WANDERS OUT OF THE CITY AND FALLS ON A HEAP OF ASHES. FINDING JOB IN THIS DISGRACEFUL CONDITION IS TOO MUCH FOR HIS WIFE. IN BITTERNESS AND ANGER OVER ALL THEY HAVE LOST, SHE TURNS ON HIM.

WHAT GOOD IS YOUR FAITH IN GOD DOING YOU NOW? WHY DON'T YOU CURSE HIM FOR ALL THE TROUBLE HE HAS LET COME TO YOU? DEATH WOULD BE NO WORSE THAN THIS.

God's Answer

FROM JOB 2: 10— 42

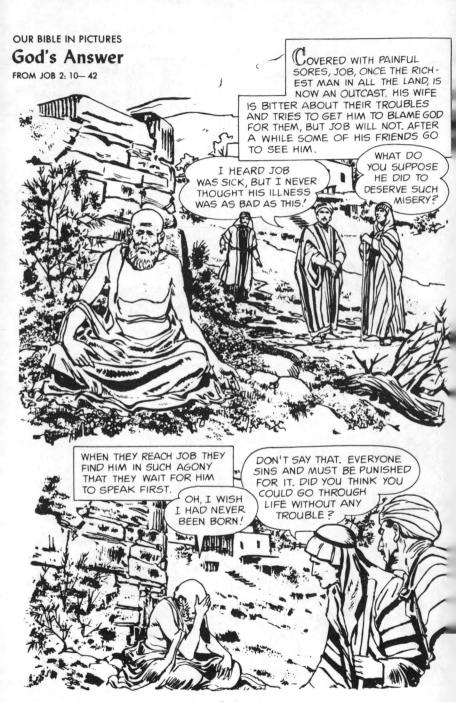

COVERED WITH PAINFUL SORES, JOB, ONCE THE RICHEST MAN IN ALL THE LAND, IS NOW AN OUTCAST. HIS WIFE IS BITTER ABOUT THEIR TROUBLES AND TRIES TO GET HIM TO BLAME GOD FOR THEM, BUT JOB WILL NOT. AFTER A WHILE SOME OF HIS FRIENDS GO TO SEE HIM.

I HEARD JOB WAS SICK, BUT I NEVER THOUGHT HIS ILLNESS WAS AS BAD AS THIS!

WHAT DO YOU SUPPOSE HE DID TO DESERVE SUCH MISERY?

WHEN THEY REACH JOB THEY FIND HIM IN SUCH AGONY THAT THEY WAIT FOR HIM TO SPEAK FIRST.

OH, I WISH I HAD NEVER BEEN BORN!

DON'T SAY THAT. EVERYONE SINS AND MUST BE PUNISHED FOR IT. DID YOU THINK YOU COULD GO THROUGH LIFE WITHOUT ANY TROUBLE?

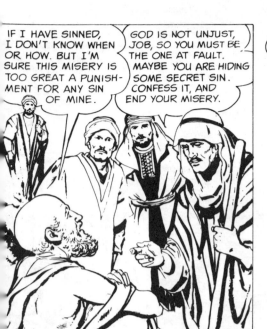

IF I HAVE SINNED, I DON'T KNOW WHEN OR HOW. BUT I'M SURE THIS MISERY IS TOO GREAT A PUNISHMENT FOR ANY SIN OF MINE.

GOD IS NOT UNJUST, JOB, SO YOU MUST BE THE ONE AT FAULT. MAYBE YOU ARE HIDING SOME SECRET SIN. CONFESS IT, AND END YOUR MISERY.

I HAVE DONE NO WRONG --AND SOMEDAY GOD WILL DECLARE MY INNOCENCE.

T THIS POINT ANOTHER RIEND SPEAKS UP.

SUFFERING IS NOT JUST A PUNISHMENT. OFTEN GOD SENDS IT AS A MEANS OF STRENGTHENING A MAN.

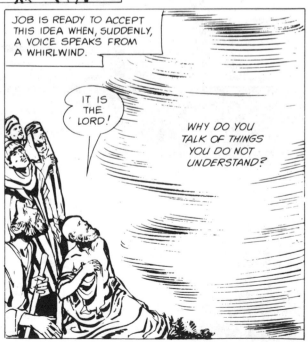

JOB IS READY TO ACCEPT THIS IDEA WHEN, SUDDENLY, A VOICE SPEAKS FROM A WHIRLWIND.

IT IS THE LORD!

WHY DO YOU TALK OF THINGS YOU DO NOT UNDERSTAND?

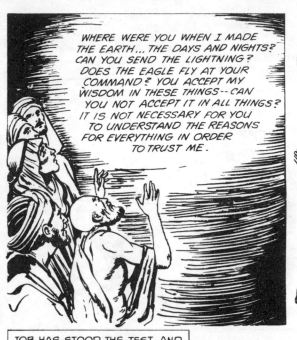

WHERE WERE YOU WHEN I MADE THE EARTH... THE DAYS AND NIGHTS? CAN YOU SEND THE LIGHTNING? DOES THE EAGLE FLY AT YOUR COMMAND? YOU ACCEPT MY WISDOM IN THESE THINGS--CAN YOU NOT ACCEPT IT IN ALL THINGS? IT IS NOT NECESSARY FOR YOU TO UNDERSTAND THE REASONS FOR EVERYTHING IN ORDER TO TRUST ME.

O GOD, FORGIVE ME FOR THINKING ONLY OF MYSELF. NOW I SEE THAT YOU ARE ALL POWERFUL. I TRUST YOU IN ALL THINGS.

JOB HAS STOOD THE TEST, AND GOD IS PLEASED WITH HIM. HIS HEALTH IS RESTORED; IN TIME HE IS FURTHER REWARDED BY HAVING CHILDREN AND TWICE THE WEALTH HE PREVIOUSLY HAD.

JOB NEVER UNDERSTANDS ALL OF THE MYSTERIES OF GOD, BUT HE KNOWS THAT GOD IS WISE AND GREAT ENOUGH TO DO WHAT IS BEST. AND JOB IS HAPPY!

he World's Greatest Poetry

ROM PSALMS, PROVERBS, ECCLESIASTES, SONG OF SOLOMON

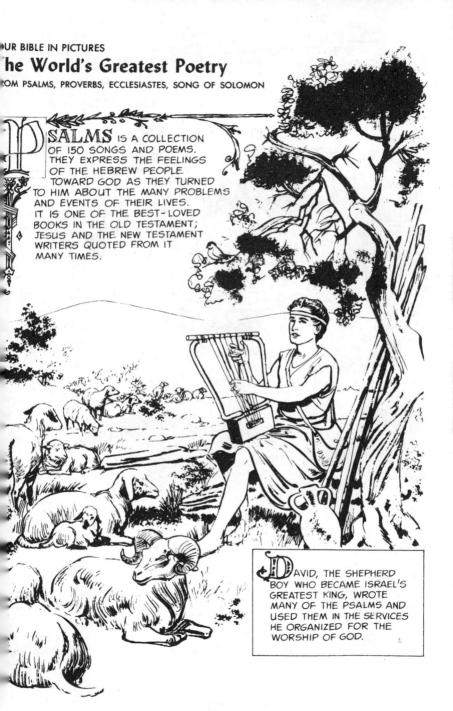

PSALMS IS A COLLECTION OF 150 SONGS AND POEMS. THEY EXPRESS THE FEELINGS OF THE HEBREW PEOPLE TOWARD GOD AS THEY TURNED TO HIM ABOUT THE MANY PROBLEMS AND EVENTS OF THEIR LIVES. IT IS ONE OF THE BEST-LOVED BOOKS IN THE OLD TESTAMENT; JESUS AND THE NEW TESTAMENT WRITERS QUOTED FROM IT MANY TIMES.

DAVID, THE SHEPHERD BOY WHO BECAME ISRAEL'S GREATEST KING, WROTE MANY OF THE PSALMS AND USED THEM IN THE SERVICES HE ORGANIZED FOR THE WORSHIP OF GOD.

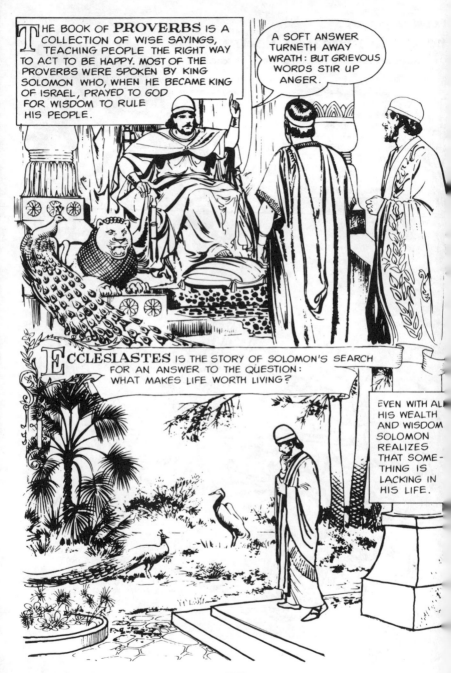

THE BOOK OF **PROVERBS** IS A COLLECTION OF WISE SAYINGS, TEACHING PEOPLE THE RIGHT WAY TO ACT TO BE HAPPY. MOST OF THE PROVERBS WERE SPOKEN BY KING SOLOMON WHO, WHEN HE BECAME KING OF ISRAEL, PRAYED TO GOD FOR WISDOM TO RULE HIS PEOPLE.

A SOFT ANSWER TURNETH AWAY WRATH: BUT GRIEVOUS WORDS STIR UP ANGER.

ECCLESIASTES IS THE STORY OF SOLOMON'S SEARCH FOR AN ANSWER TO THE QUESTION: WHAT MAKES LIFE WORTH LIVING?

EVEN WITH ALL HIS WEALTH AND WISDOM SOLOMON REALIZES THAT SOMETHING IS LACKING IN HIS LIFE.

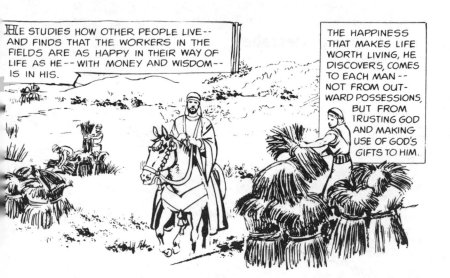

HE STUDIES HOW OTHER PEOPLE LIVE-- AND FINDS THAT THE WORKERS IN THE FIELDS ARE AS HAPPY IN THEIR WAY OF LIFE AS HE--WITH MONEY AND WISDOM-- IS IN HIS.

THE HAPPINESS THAT MAKES LIFE WORTH LIVING, HE DISCOVERS, COMES TO EACH MAN-- NOT FROM OUT-WARD POSSESSIONS, BUT FROM TRUSTING GOD AND MAKING USE OF GOD'S GIFTS TO HIM.

THE BOOK ENDS WITH THIS ADVICE TO YOUNG PEOPLE: REMEMBER NOW THY CREATOR IN THE DAYS OF THY YOUTH...FEAR GOD, AND KEEP HIS COMMANDMENTS.

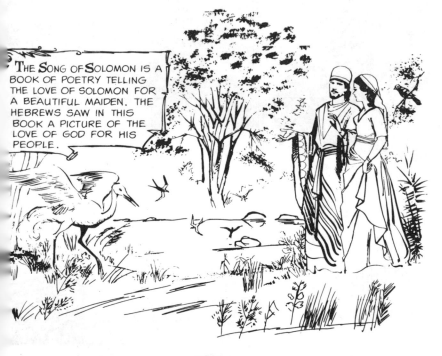

THE SONG OF SOLOMON IS A BOOK OF POETRY TELLING THE LOVE OF SOLOMON FOR A BEAUTIFUL MAIDEN. THE HEBREWS SAW IN THIS BOOK A PICTURE OF THE LOVE OF GOD FOR HIS PEOPLE.

A Man with a Message

FROM THE BOOK OF ISAIAH

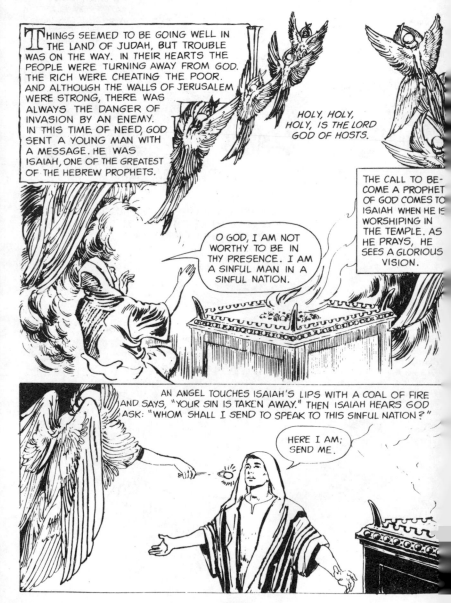

THINGS SEEMED TO BE GOING WELL IN THE LAND OF JUDAH, BUT TROUBLE WAS ON THE WAY. IN THEIR HEARTS THE PEOPLE WERE TURNING AWAY FROM GOD. THE RICH WERE CHEATING THE POOR. AND ALTHOUGH THE WALLS OF JERUSALEM WERE STRONG, THERE WAS ALWAYS THE DANGER OF INVASION BY AN ENEMY. IN THIS TIME OF NEED, GOD SENT A YOUNG MAN WITH A MESSAGE. HE WAS ISAIAH, ONE OF THE GREATEST OF THE HEBREW PROPHETS.

HOLY, HOLY, HOLY, IS THE LORD GOD OF HOSTS.

THE CALL TO BE-COME A PROPHET OF GOD COMES TO ISAIAH WHEN HE IS WORSHIPING IN THE TEMPLE. AS HE PRAYS, HE SEES A GLORIOUS VISION.

O GOD, I AM NOT WORTHY TO BE IN THY PRESENCE. I AM A SINFUL MAN IN A SINFUL NATION.

AN ANGEL TOUCHES ISAIAH'S LIPS WITH A COAL OF FIRE AND SAYS, "YOUR SIN IS TAKEN AWAY." THEN ISAIAH HEARS GOD ASK: "WHOM SHALL I SEND TO SPEAK TO THIS SINFUL NATION?"

HERE I AM; SEND ME.

GOD GIVES ISAIAH INSTRUCTIONS ABOUT CARRYING ON HIS WORK, AND ISAIAH BEGINS AT ONCE AMONG THE PEOPLE OF JERUSALEM.

WHAT A BEAUTIFUL IDOL. WHERE DID YOU GET IT?

I MADE IT... TO CARRY WITH ME FOR GOOD LUCK.

HOW CAN YOU WORSHIP SOMETHING YOU YOURSELF HAVE MADE?

A LOT OF PEOPLE ARE WORSHIPING IDOLS THESE DAYS -- AND GETTING ALONG ALL RIGHT, TOO. BESIDES, ISAIAH, HOW DO YOU KNOW THAT YOUR GOD IS THE TRUE ONE?

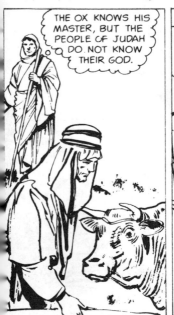

THE OX KNOWS HIS MASTER, BUT THE PEOPLE OF JUDAH DO NOT KNOW THEIR GOD.

HE SEES RICH MEN TAKING ADVANTAGE OF THE POOR.

THE INTEREST YOU'RE CHARGING IS WRONG. YOU'RE GETTING RICH AT THIS MAN'S EXPENSE. SOMEDAY YOU'LL HAVE TO SETTLE YOUR ACCOUNTS WITH GOD.

THE ONLY ACCOUNTS I'M INTERESTED IN ARE THE ONES THAT GIVE ME A PROFIT.

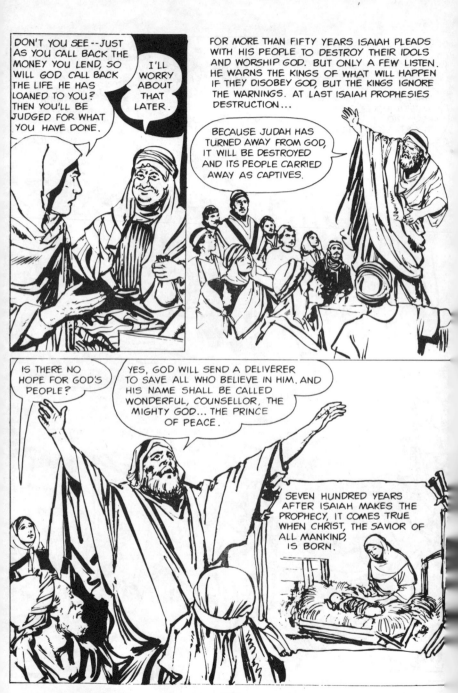

554

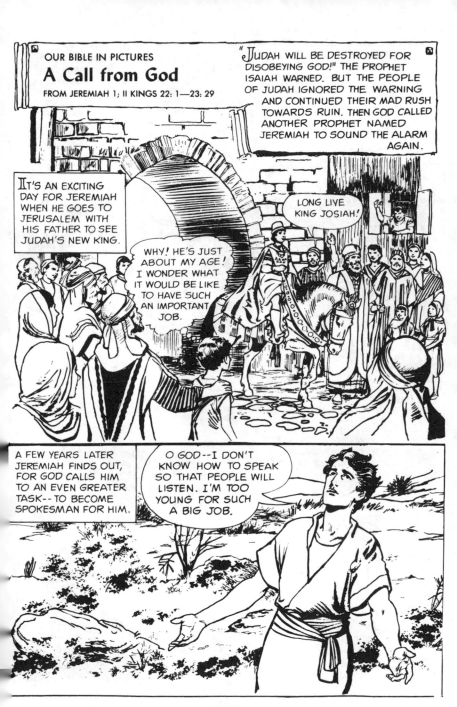

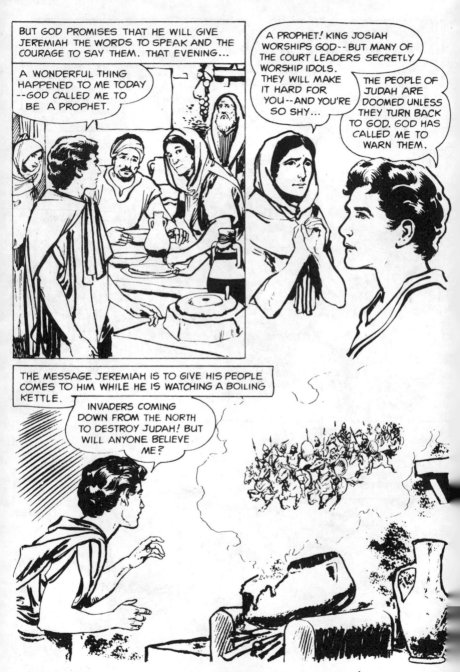

556

E SOON FINDS OUT -- WHEN HE TELLS THE PRIESTS N HIS OWN TOWN THAT JUDAH WILL BE DESTROYED BECAUSE THE PEOPLE HAVE TURNED FROM GOD TO WORSHIP IDOLS.

WHO IS THIS YOUNG UPSTART TO TELL US HOW TO LIVE?

LET'S GET RID OF HIM BEFORE HE STARTS TROUBLE.

SO, TO SAVE HIS LIFE, JEREMIAH IS FORCED TO LEAVE HIS HOME TOWN AND GO TO JERUSALEM.

KING JOSIAH LOVES AND WORSHIPS GOD; HE WILL HELP ME TRY TO SAVE JUDAH.

OR SEVERAL YEARS JEREMIAH AND THE KING ORK TOGETHER TO DESTROY IDOL WORSHIP. THEN, NE DAY, JEREMIAH HEARS SOME FRIGHTENING NEWS.

HE ASSYRIAN EMPIRE CRACKING UP. EGYPT MARCHING NORTH TO RAB WHAT'S LEFT. KING OSIAH DECLARES HE ILL STOP THE EGYPTIAN RMY FROM MARCHING HROUGH JUDAH.

STOP EGYPT? WHY, IT'S ONE OF THE STRONG- EST COUNTRIES IN THE WORLD! THE KING IS MAKING A BIG MISTAKE.

BUT KING JOSIAH LEADS HIS SOLDIERS OUT OF THE GATES OF JERUSALEM — AND INTO THE PATH OF THE ONCOMING EGYPTIAN ARMY.

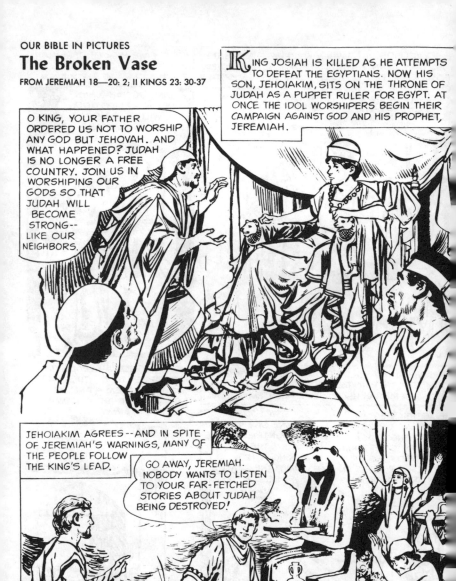

OUR BIBLE IN PICTURES

The Broken Vase

FROM JEREMIAH 18—20: 2; II KINGS 23: 30-37

KING JOSIAH IS KILLED AS HE ATTEMPTS TO DEFEAT THE EGYPTIANS. NOW HIS SON, JEHOIAKIM, SITS ON THE THRONE OF JUDAH AS A PUPPET RULER FOR EGYPT. AT ONCE THE IDOL WORSHIPERS BEGIN THEIR CAMPAIGN AGAINST GOD AND HIS PROPHET, JEREMIAH.

O KING, YOUR FATHER ORDERED US NOT TO WORSHIP ANY GOD BUT JEHOVAH. AND WHAT HAPPENED? JUDAH IS NO LONGER A FREE COUNTRY. JOIN US IN WORSHIPING OUR GODS SO THAT JUDAH WILL BECOME STRONG-- LIKE OUR NEIGHBORS.

JEHOIAKIM AGREES --AND IN SPITE OF JEREMIAH'S WARNINGS, MANY OF THE PEOPLE FOLLOW THE KING'S LEAD.

GO AWAY, JEREMIAH. NOBODY WANTS TO LISTEN TO YOUR FAR-FETCHED STORIES ABOUT JUDAH BEING DESTROYED!

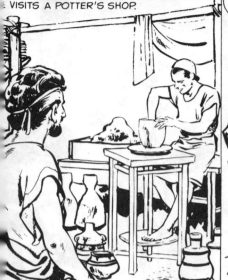

REMIAH SEARCHES FOR A WAY TO SHOW HIS OPLE WHAT WILL HAPPEN TO JUDAH--AND HY. HE FINDS HIS ANSWER ONE DAY WHEN E VISITS A POTTER'S SHOP.

THE VASE-- YOU'RE TURNING IT BACK INTO A LUMP OF CLAY!

YES, IT DIDN'T TURN OUT TO BE A GOOD VASE. THE ONLY WAY I CAN MAKE A GOOD VASE NOW IS TO START OVER.

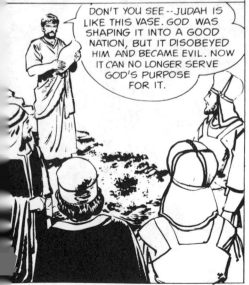

EMIAH CALLS THE PRIESTS AND THE CHIEF MEN JERUSALEM TO GO TO THE CITY DUMP WITH HIM.

DON'T YOU SEE--JUDAH IS LIKE THIS VASE. GOD WAS SHAPING IT INTO A GOOD NATION, BUT IT DISOBEYED HIM AND BECAME EVIL. NOW IT CAN NO LONGER SERVE GOD'S PURPOSE FOR IT.

SO JUDAH WILL BE DESTROYED JUST LIKE THIS VASE.

559

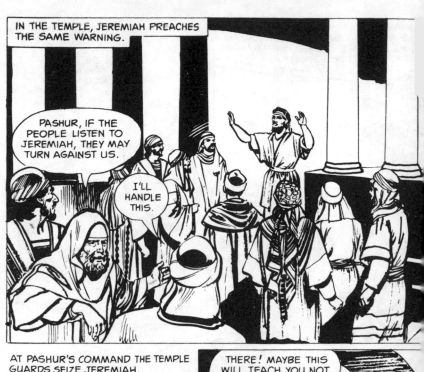

IN THE TEMPLE, JEREMIAH PREACHES THE SAME WARNING.

PASHUR, IF THE PEOPLE LISTEN TO JEREMIAH, THEY MAY TURN AGAINST US.

I'LL HANDLE THIS.

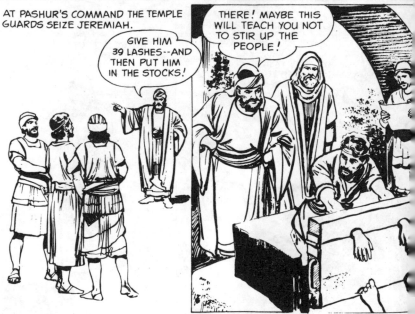

AT PASHUR'S COMMAND THE TEMPLE GUARDS SEIZE JEREMIAH.

GIVE HIM 39 LASHES--AND THEN PUT HIM IN THE STOCKS!

THERE! MAYBE THIS WILL TEACH YOU NOT TO STIR UP THE PEOPLE!

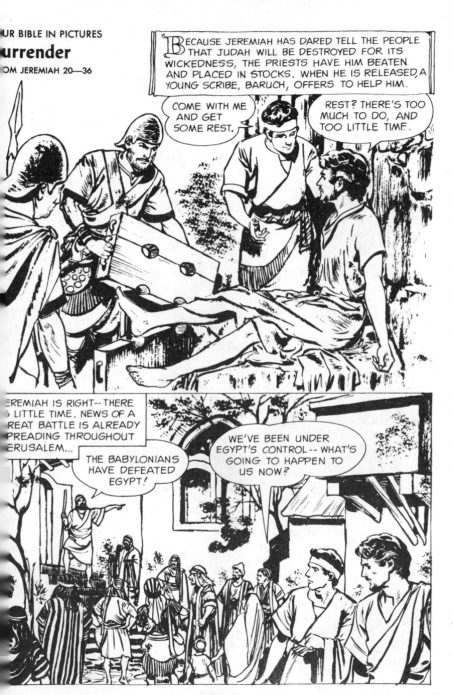

BECAUSE JEREMIAH HAS DARED TELL THE PEOPLE THAT JUDAH WILL BE DESTROYED FOR ITS WICKEDNESS, THE PRIESTS HAVE HIM BEATEN AND PLACED IN STOCKS. WHEN HE IS RELEASED, A YOUNG SCRIBE, BARUCH, OFFERS TO HELP HIM.

COME WITH ME AND GET SOME REST.

REST? THERE'S TOO MUCH TO DO, AND TOO LITTLE TIME.

JEREMIAH IS RIGHT-- THERE S LITTLE TIME. NEWS OF A REAT BATTLE IS ALREADY PREADING THROUGHOUT ERUSALEM...

THE BABYLONIANS HAVE DEFEATED EGYPT!

WE'VE BEEN UNDER EGYPT'S CONTROL -- WHAT'S GOING TO HAPPEN TO US NOW?

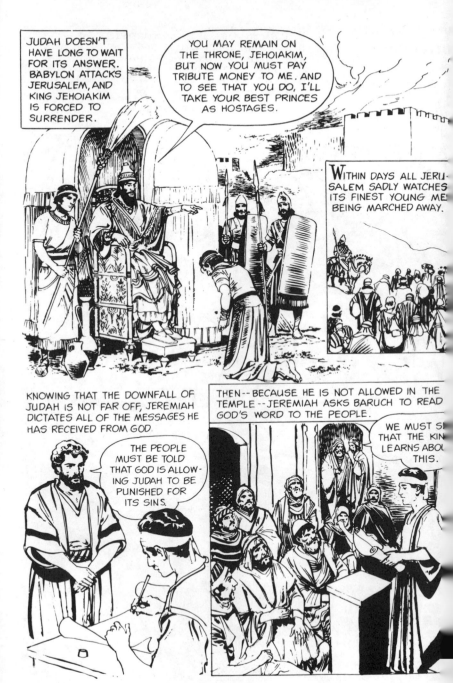

562

THE SCROLL IS READ TO THE KING, HE BE-
[COM]ES SO ANGRY THAT HE CUTS IT UP PIECE BY
[PIE]CE AND THROWS IT INTO THE FIRE.

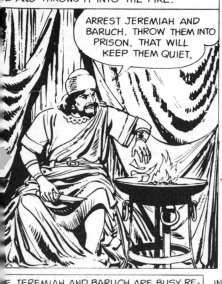

ARREST JEREMIAH AND BARUCH. THROW THEM INTO PRISON. THAT WILL KEEP THEM QUIET.

BUT JEREMIAH AND BARUCH ARE PREPARED FOR THE KING'S ANGER-- ALREADY THEY ARE IN HIDING.

THE KING BURNED THE SCROLL -- BUT WE WILL WRITE ANOTHER.

[WHIL]E JEREMIAH AND BARUCH ARE BUSY RE-
[WRITI]NG THE BURNED
[SCRO]LL, TROUBLE IS
[BREW]ING IN THE PALACE.

[WHY] SHOULD WE PAY
[TRIBU]TE TO BABYLON? I
[SAY L]ET'S STOP IT AND USE
[THE M]ONEY TO BUILD UP
[OUR O]WN ARMY. THEN
[WE'LL] BE READY IF BABYLON
[A]TTACKS US AGAIN.

YOU'RE RIGHT-- THOSE HOSTAGES IN BABYLON ARE NOT AS IMPORTANT AS ALL OF US HERE IN JUDAH.

IN TIME, WORD LEAKS OUT THAT KING JEHOIAKIM IS BREAKING HIS AGREEMENT WITH BABYLON. JEREMIAH IS ALARMED.

THE KING'S DECISION IS AGAINST THE WILL OF GOD. AND NO MAN CAN DEFY GOD!

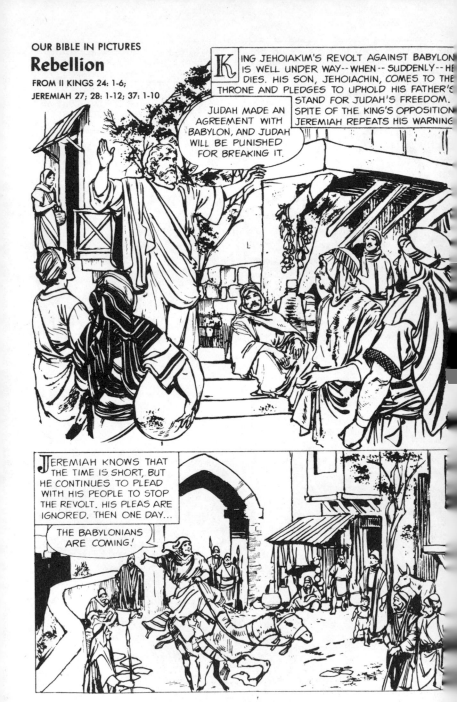

OUR BIBLE IN PICTURES
Rebellion
FROM II KINGS 24: 1-6;
JEREMIAH 27; 28: 1-12; 37: 1-10

KING JEHOIAKIM'S REVOLT AGAINST BABYLON IS WELL UNDER WAY--WHEN--SUDDENLY--HE DIES. HIS SON, JEHOIACHIN, COMES TO THE THRONE AND PLEDGES TO UPHOLD HIS FATHER'S STAND FOR JUDAH'S FREEDOM. IN SPITE OF THE KING'S OPPOSITION, JEREMIAH REPEATS HIS WARNING.

JUDAH MADE AN AGREEMENT WITH BABYLON, AND JUDAH WILL BE PUNISHED FOR BREAKING IT.

JEREMIAH KNOWS THAT THE TIME IS SHORT, BUT HE CONTINUES TO PLEAD WITH HIS PEOPLE TO STOP THE REVOLT. HIS PLEAS ARE IGNORED. THEN ONE DAY...

THE BABYLONIANS ARE COMING!

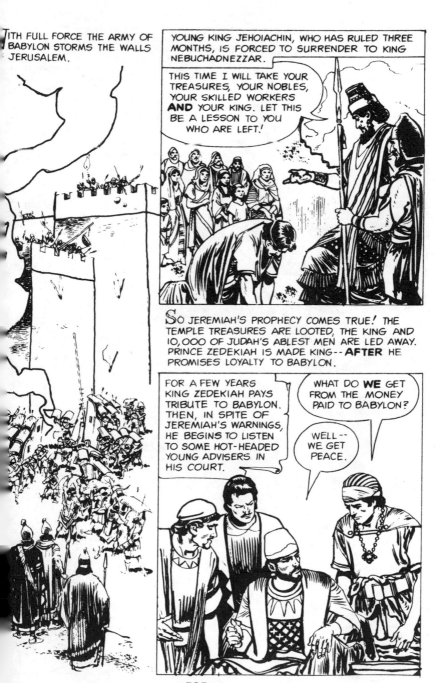

WITH FULL FORCE THE ARMY OF BABYLON STORMS THE WALLS JERUSALEM.

YOUNG KING JEHOIACHIN, WHO HAS RULED THREE MONTHS, IS FORCED TO SURRENDER TO KING NEBUCHADNEZZAR.

THIS TIME I WILL TAKE YOUR TREASURES, YOUR NOBLES, YOUR SKILLED WORKERS **AND** YOUR KING. LET THIS BE A LESSON TO YOU WHO ARE LEFT.'

SO JEREMIAH'S PROPHECY COMES TRUE.' THE TEMPLE TREASURES ARE LOOTED, THE KING AND 10,000 OF JUDAH'S ABLEST MEN ARE LED AWAY. PRINCE ZEDEKIAH IS MADE KING-- **AFTER** HE PROMISES LOYALTY TO BABYLON.

FOR A FEW YEARS KING ZEDEKIAH PAYS TRIBUTE TO BABYLON. THEN, IN SPITE OF JEREMIAH'S WARNINGS, HE BEGINS TO LISTEN TO SOME HOT-HEADED YOUNG ADVISERS IN HIS COURT.

WHAT DO **WE** GET FROM THE MONEY PAID TO BABYLON?

WELL-- WE GET PEACE.

565

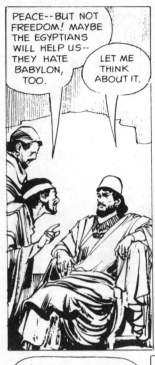

PEACE--BUT NOT FREEDOM! MAYBE THE EGYPTIANS WILL HELP US-- THEY HATE BABYLON, TOO.

LET ME THINK ABOUT IT.

WHEN JEREMIAH LEARNS THAT THERE IS TALK OF ANOTHER REVOLT, HE PUTS AN OX YOKE ON HIS SHOULDERS AND WALKS THROUGH THE STREETS.

WHAT'S THE MEANING OF THIS?

BABYLON HAS STRUCK TWICE, AND IT WILL STRIKE AGAIN. THE NEXT TIME IT WILL DESTROY JERUSALEM. JUDAH'S ONLY HOPE OF SURVIVAL IS TO WEAR THE YOKE OF BABYLON AS I AM WEARING THIS ONE

I'LL SHOW YOU WHAT TO DO WITH THE YOKE OF BABYLON. BREAK IT!

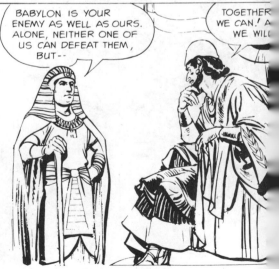

DURING ALL OF THIS TIME, EGYPT KEEPS AN ANXIOUS EYE ON THE GROWING TENSIONS IN JUDAH. AT THE RIGHT MOMENT IT SENDS AN AMBASSADOR TO KING ZEDEKIAH.

BABYLON IS YOUR ENEMY AS WELL AS OURS. ALONE, NEITHER ONE OF US CAN DEFEAT THEM, BUT--

TOGETHER WE CAN! AND WE WILL

BACKED BY EGYPT'S PROMISE TO HELP, KING ZEDEKIAH OF JUDAH REVOLTS AGAINST THE CONTROL OF BABYLON. JEREMIAH ARGUES AGAINST THE DECISION.

BABYLON HAS SPARED JERUSALEM TWICE BEFORE. BUT IF YOU GO THROUGH WITH THIS REVOLT, BABYLON WILL NOT SPARE THE CITY AGAIN.

BUT THIS TIME WE'LL WIN. JUDAH WILL BE FREE!

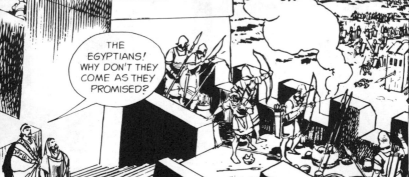

JEREMIAH PROPHESIED, BYLON ANSWERS THE REVOLT H A SWIFT ATTACK. FOR WEEKS E SOLDIERS OF JUDAH FIGHT DEFEND JERUSALEM'S WALLS.

THE EGYPTIANS! WHY DON'T THEY COME AS THEY PROMISED?

567

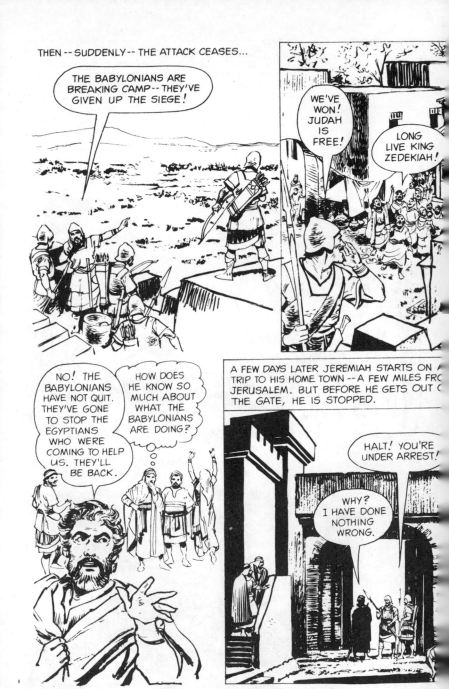

568

IN SPITE OF HIS INNOCENCE, JEREMIAH IS THROWN INTO PRISON. WITHIN A FEW WEEKS THE BABYLONIANS, AFTER DEFEATING THE EGYPTIANS, RETURN TO THE GATES OF JERUSALEM. JEREMIAH'S ENEMIES BRING HIM BEFORE THE KING AND ACCUSE HIM OF BEING A TRAITOR.

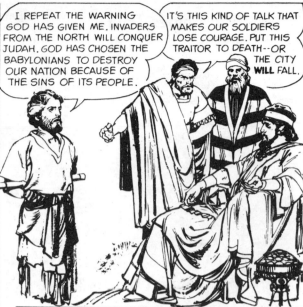

I REPEAT THE WARNING GOD HAS GIVEN ME. INVADERS FROM THE NORTH WILL CONQUER JUDAH. GOD HAS CHOSEN THE BABYLONIANS TO DESTROY OUR NATION BECAUSE OF THE SINS OF ITS PEOPLE.

IT'S THIS KIND OF TALK THAT MAKES OUR SOLDIERS LOSE COURAGE. PUT THIS TRAITOR TO DEATH--OR THE CITY **WILL** FALL.

HE IS IN YOUR HANDS--DO WHAT YOU WANT WITH HIM.

QUICKLY-- BEFORE THE KING CAN CHANGE HIS MIND-- JEREMIAH IS PUT INTO AN OLD CISTERN BENEATH THE PRISON FLOOR.

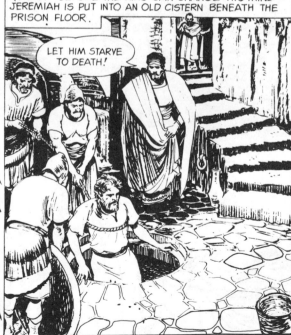

LET HIM STARVE TO DEATH!

A Prophecy Comes True

FROM JEREMIAH 38: 7—43: 7

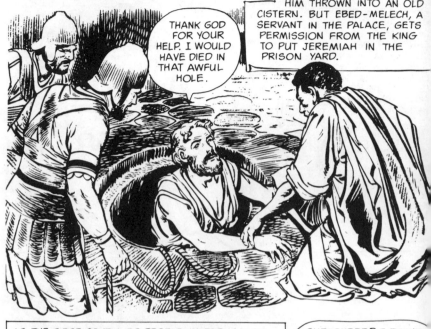

DURING THE SIEGE OF JERUSALEM, SOME NOBLES ACCUSE JEREMIAH OF BEING A TRAITOR AND HAVE HIM THROWN INTO AN OLD CISTERN. BUT EBED-MELECH, A SERVANT IN THE PALACE, GETS PERMISSION FROM THE KING TO PUT JEREMIAH IN THE PRISON YARD.

THANK GOD FOR YOUR HELP. I WOULD HAVE DIED IN THAT AWFUL HOLE.

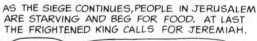

AS THE SIEGE CONTINUES, PEOPLE IN JERUSALEM ARE STARVING AND BEG FOR FOOD. AT LAST THE FRIGHTENED KING CALLS FOR JEREMIAH.

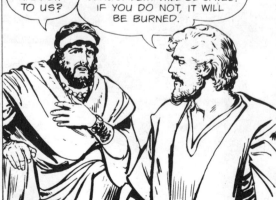

WHAT WILL HAPPEN TO US?

IF YOU SURRENDER, JERUSALEM WILL BE SAVED. IF YOU DO NOT, IT WILL BE BURNED.

SURRENDER? I DON'T DARE. MY OWN PEOPLE WOULD TURN AGAINST ME!

JEREMIAH IS TAKEN BACK TO PRISON... THE SIEGE GOES ON, BUT AT THE END OF 30 MONTHS...

THE BABYLONIANS HAVE BROKEN THROUGH THE WALL!

JERUSALEM WILL BE DESTROYED! BUT IT WILL RISE AGAIN... AND SOMEDAY GOD'S COMMANDMENTS WILL BE WRITTEN IN THE HEARTS OF MEN WHO CHOOSE TO OBEY GOD. THEY WILL LIVE TOGETHER IN PEACE.

KING ZEDEKIAH TRIES TO ESCAPE, BUT IS CAPTURED AND BLINDED. THE KING, JEREMIAH, AND MOST OF THE ABLE-BODIED PEOPLE ARE CAPTURED TO BE TAKEN TO BABYLON.

BUT IN THE CAPTIVE CAMP AT RAMAH...

THE KING OF BABYLON HAS LEARNED THAT YOU TRIED TO KEEP YOUR COUNTRY FROM REBELLING AGAINST HIM, SO HE HAS SENT ORDERS TO SET YOU FREE.

THANK GOD! NOW I CAN HELP THE PEOPLE WHO HAVE BEEN LEFT IN ISRAEL WITHOUT A LEADER.

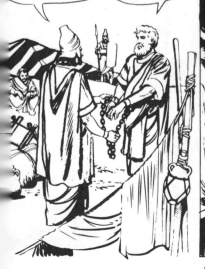

ABOUT A MONTH AFTER JERUSALEM IS TAKEN, A BABYLONIAN OFFICER RETURNS, TAKES MORE CAPTIVES, AND THEN SETS FIRE TO THE CITY.

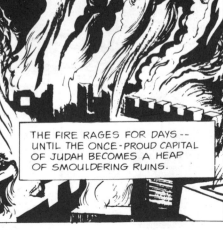

THE FIRE RAGES FOR DAYS -- UNTIL THE ONCE-PROUD CAPITAL OF JUDAH BECOMES A HEAP OF SMOULDERING RUINS.

571

THE BABYLONIANS SET UP HEADQUARTERS AT MIZPAH AND APPOINT AN ISRAELITE TO ACT AS GOVERNOR. JEREMIAH JOINS HIM -- AND BECOMES HIS ADVISER.

TOGETHER WE'LL ENCOURAGE THE PEOPLE TO BUILD UP THEIR HOMES AND REPLANT THEIR VINEYARDS AND FIELDS.

SOMEDAY THE CAPTIVES WILL RETURN-- AND JUDAH WILL BECOME A NATION AGAIN.

BUT BEFORE THE GOVERNOR'S DREAM CAN COME TRUE HE IS MURDERED BY SOME ISRAELITES WHO ARE JEALOUS OF HIS POWER IN THE COUNTRY. FEARFUL THAT BABYLON WILL BLAME ALL ISRAEL FOR THE MURDER, A GROUP OF PEOPLE GO TO JEREMIAH...

WE WANT TO GO TO EGYPT-- WHERE THERE IS PEACE AND PLENTY TO EAT.

YOU WILL FIND NEITHER PEACE NOR PLENTY IN EGYPT. STAY HERE -- THE BABYLONIANS WILL NOT HURT YOU.

BUT THE PEOPLE DO NOT BELIEVE JEREMIAH. THEY FLEE TO EGYPT, FORCING HIM TO GO WITH THEM. AND THERE, UNTIL HE DIES, JEREMIAH TRIES TO LEAD HIS PEOPLE BACK TO GOD.

THE GRIEF OF THE JEWS OVER THE DESTRUCTION OF JERUSALEM IS EXPRESSED IN A GROUP OF POEMS FOUND IN THE

BOOK OF LAMENTATIONS

Ten Thousand Captives

FROM EZEKIEL 1

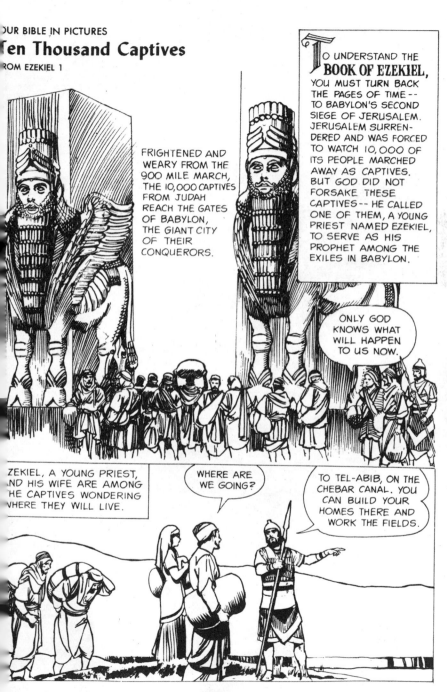

TO UNDERSTAND THE **BOOK OF EZEKIEL,** YOU MUST TURN BACK THE PAGES OF TIME -- TO BABYLON'S SECOND SIEGE OF JERUSALEM. JERUSALEM SURRENDERED AND WAS FORCED TO WATCH 10,000 OF ITS PEOPLE MARCHED AWAY AS CAPTIVES. BUT GOD DID NOT FORSAKE THESE CAPTIVES-- HE CALLED ONE OF THEM, A YOUNG PRIEST NAMED EZEKIEL, TO SERVE AS HIS PROPHET AMONG THE EXILES IN BABYLON.

FRIGHTENED AND WEARY FROM THE 900 MILE MARCH, THE 10,000 CAPTIVES FROM JUDAH REACH THE GATES OF BABYLON, THE GIANT CITY OF THEIR CONQUERORS.

ONLY GOD KNOWS WHAT WILL HAPPEN TO US NOW.

EZEKIEL, A YOUNG PRIEST, AND HIS WIFE ARE AMONG THE CAPTIVES WONDERING WHERE THEY WILL LIVE.

WHERE ARE WE GOING?

TO TEL-ABIB, ON THE CHEBAR CANAL. YOU CAN BUILD YOUR HOMES THERE AND WORK THE FIELDS.

IN THE MONTHS THAT FOLLOW, EZEKIEL WORKS HARD TO MAKE A LIVING IN THE NEW LAND.

IT IS NOT AS BAD AS I FEARED. WE ARE WELL TREATED -- AND WE ARE TOGETHER.

YES. WE MAY HAVE TO STAY HERE THE REST OF OUR LIVES, BUT GOD IS WITH US WHEREVER WE ARE.

BUT NOT ALL OF THE CAPTIVES FEEL THE SAME WAY.

WHAT DO YOU THINK OF EZEKIEL PLANTING TREES AND PLANNING TO BUILD A HOUSE? LOOKS AS IF HE INTENDS TO STAY IN BABYLONIA.

HE'S WASTING HIS TIME. WE'LL BE ON OUR WAY HOME IN A COUPLE OF YEARS.

WHEN THIS NEWS REACHES GOD'S PROPHET, JEREMIAH, IN JUDAH, HE WRITES A LETTER TO THE CAPTIVES.

JEREMIAH SAYS IT IS GOD'S WILL THAT WE STAY HERE. WE SHOULD BUILD HOMES AND WORK FOR THE GOOD OF OUR NEW COUNTRY. WE WILL BE HERE FOR SEVENTY YEARS.

DID YOU HEAR THAT, EZEKIEL? SEVENTY YEARS -- I DON'T BELIEVE IT!

JEREMIAH SPEAKS THE WILL OF GOD.

EZEKIEL SHOWS HIS FAITH BY BUILDING A HOUSE.

WE'LL MAKE A LARGE COURTYARD -- BIG ENOUGH TO INVITE PEOPLE HERE TO WORSHIP GOD. I USED TO THINK THAT WE COULD WORSHIP GOD ONLY IN THE TEMPLE IN JERUSALEM, BUT NOW I KNOW WE CAN WORSHIP HIM ANYWHERE.

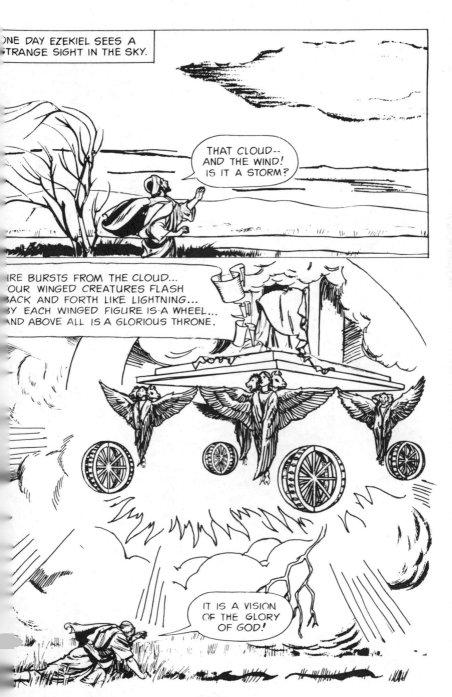

ONE DAY EZEKIEL SEES A STRANGE SIGHT IN THE SKY.

THAT CLOUD-- AND THE WIND! IS IT A STORM?

...IRE BURSTS FROM THE CLOUD... ...OUR WINGED CREATURES FLASH BACK AND FORTH LIKE LIGHTNING... BY EACH WINGED FIGURE IS A WHEEL... AND ABOVE ALL IS A GLORIOUS THRONE.

IT IS A VISION OF THE GLORY OF GOD!

575

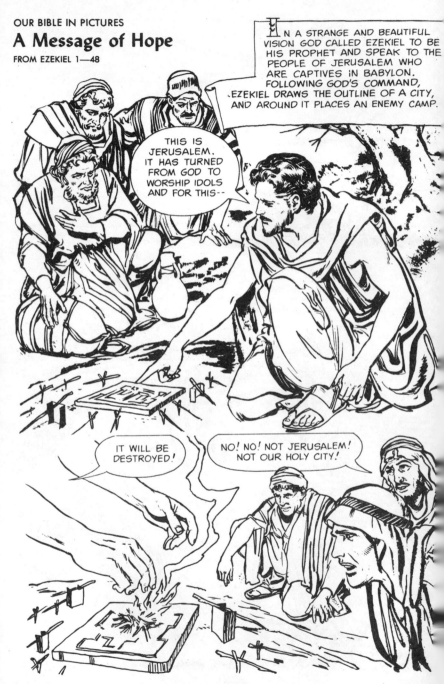

OUR BIBLE IN PICTURES
A Message of Hope
FROM EZEKIEL 1—48

IN A STRANGE AND BEAUTIFUL VISION GOD CALLED EZEKIEL TO BE HIS PROPHET AND SPEAK TO THE PEOPLE OF JERUSALEM WHO ARE CAPTIVES IN BABYLON. FOLLOWING GOD'S COMMAND, EZEKIEL DRAWS THE OUTLINE OF A CITY, AND AROUND IT PLACES AN ENEMY CAMP.

THIS IS JERUSALEM. IT HAS TURNED FROM GOD TO WORSHIP IDOLS AND FOR THIS--

IT WILL BE DESTROYED!

NO! NO! NOT JERUSALEM! NOT OUR HOLY CITY!

EZEKIEL KEEPS WARNING THE PEOPLE THAT JERUSALEM WILL BE DESTROYED, BUT THEY REFUSE TO BELIEVE HIM. THEN -- SUDDENLY -- EZEKIEL'S WIFE DIES. BUT THE PROPHET SHOWS NO OUTWARD SIGN OF GRIEF.

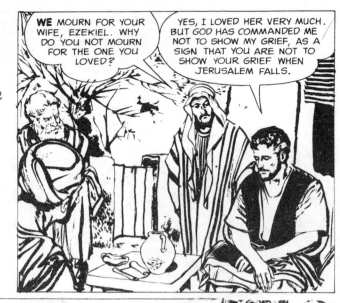

WE MOURN FOR YOUR WIFE, EZEKIEL. WHY DO YOU NOT MOURN FOR THE ONE YOU LOVED?

YES, I LOVED HER VERY MUCH. BUT GOD HAS COMMANDED ME NOT TO SHOW MY GRIEF, AS A SIGN THAT YOU ARE NOT TO SHOW YOUR GRIEF WHEN JERUSALEM FALLS.

BUT THE PEOPLE WILL NOT GIVE UP BELIEVING THAT JERUSALEM WILL BE STANDING -- STRONG AND BEAUTIFUL -- WAITING FOR THEIR RETURN. ONE DAY A MAN STAGGERS WEARILY INTO THEIR MIDST...

WHAT BRINGS YOU HERE?

I'M FROM WHAT WAS JERUSALEM.

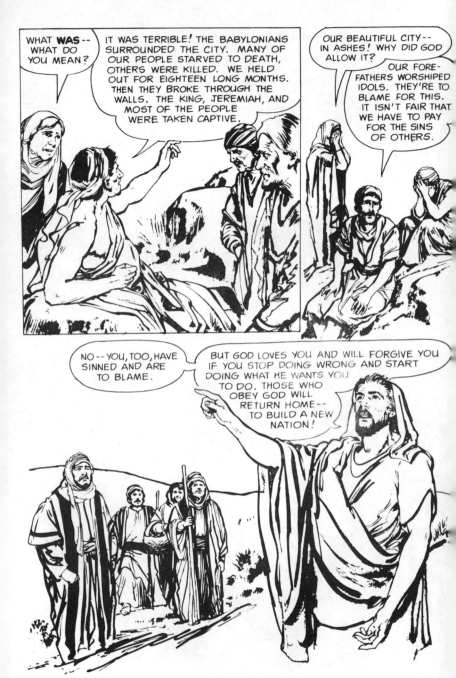

578

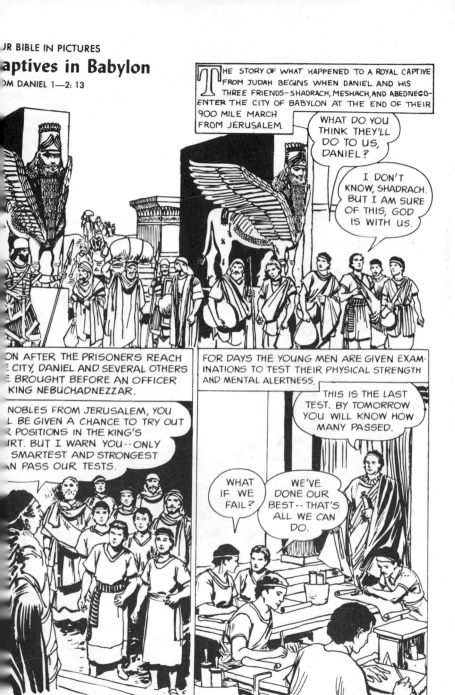

THE NEXT DAY...

YOU HAVE ALL PASSED -- NOW YOU'LL BE GIVEN THREE YEARS TO STUDY UNDER OUR WISE MEN. AFTER THAT THE KING HIMSELF WILL CHOOSE THOSE BEST QUALIFIED TO BE HIS ADVISERS.

O GOD, THANK YOU. HELP US TO PASS THESE NEW TESTS SO THAT WE MAY ADVISE THE KING IN A WAY THAT WILL PLEASE YOU.

THE YOUNG MEN ARE TAKEN AT ONCE TO THE PALACE TO BEGIN THEIR STUDIES. THEY ARE GIVEN THE BEST OF EVERYTHING -- EVEN FOOD FROM THE KING'S TABLE.

THANK YOU, BUT WE CANNOT EAT THIS MEAT AND DRINK THIS WINE. OUR HEBREW LAW FORBID IT. GIVE US PLAIN FOOD AND WATER, PLEASE.

BUT IT'S THE KING'S ORDER -- WE DARE NOT DISOBEY. I LIKE YOU, DANIEL, BUT I DON'T WANT TO GET INTO TROUBLE.

GIVE US A TEN-DAY TRIAL. LET US EAT OUR FOOD AND THEN SEE IF WE ARE NOT STRONGER THAN THE OTHERS.

THE TEST IS MADE, AND AT THE END OF TEN DAYS, THERE'S NO DOUBT -- DANIEL AND HIS FRIENDS NOT ONLY **LOOK** STRONGER, THEY **ARE** STRONGER.

AT THE END OF THREE YEARS, THE YOUNG MEN ARE BROUG BEFORE THE KING. HE TALKS WITH EACH ONE, THEN MAK HIS DECISION.

I HAVE CHOSEN THESE FOUR -- DANIEL, SHADRACH, MESHACH, AND ABEDNEGO -- TO SERVE AS MY ADVISERS.

THERE IS NONE EQUAL THE SI

580

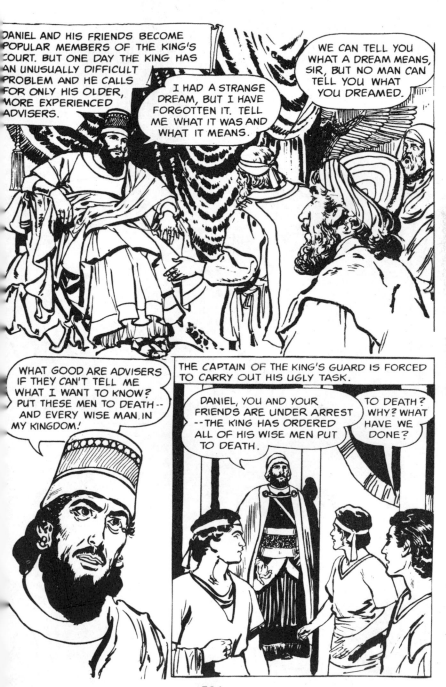

DANIEL AND HIS FRIENDS BECOME POPULAR MEMBERS OF THE KING'S COURT. BUT ONE DAY THE KING HAS AN UNUSUALLY DIFFICULT PROBLEM AND HE CALLS FOR ONLY HIS OLDER, MORE EXPERIENCED ADVISERS.

I HAD A STRANGE DREAM, BUT I HAVE FORGOTTEN IT. TELL ME WHAT IT WAS AND WHAT IT MEANS.

WE CAN TELL YOU WHAT A DREAM MEANS, SIR, BUT NO MAN CAN TELL YOU WHAT YOU DREAMED.

WHAT GOOD ARE ADVISERS IF THEY CAN'T TELL ME WHAT I WANT TO KNOW? PUT THESE MEN TO DEATH -- AND EVERY WISE MAN IN MY KINGDOM!

THE CAPTAIN OF THE KING'S GUARD IS FORCED TO CARRY OUT HIS UGLY TASK.

DANIEL, YOU AND YOUR FRIENDS ARE UNDER ARREST --THE KING HAS ORDERED ALL OF HIS WISE MEN PUT TO DEATH.

TO DEATH? WHY? WHAT HAVE WE DONE?

581

The Statue

FROM DANIEL 2: 16-48

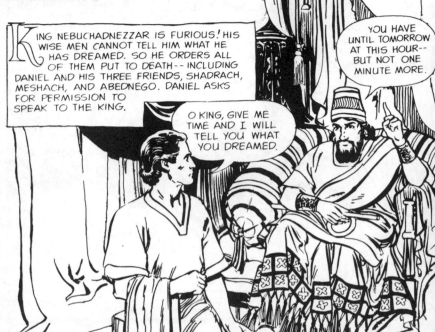

KING NEBUCHADNEZZAR IS FURIOUS! HIS WISE MEN CANNOT TELL HIM WHAT HE HAS DREAMED. SO HE ORDERS ALL OF THEM PUT TO DEATH -- INCLUDING DANIEL AND HIS THREE FRIENDS, SHADRACH, MESHACH, AND ABEDNEGO. DANIEL ASKS FOR PERMISSION TO SPEAK TO THE KING.

O KING, GIVE ME TIME AND I WILL TELL YOU WHAT YOU DREAMED.

YOU HAVE UNTIL TOMORROW AT THIS HOUR-- BUT NOT ONE MINUTE MORE.

DANIEL RUSHES BACK TO HIS FRIENDS WITH THE GOOD NEWS.

BUT, DANIEL, NO MAN ON EARTH CAN DO WHAT YOU HAVE PROMISED TO DO.

YOU ARE RIGHT-- NO MAN CAN DO IT, BUT GOD CAN. AND WE WILL ASK HIM TO GIVE US THE ANSWER.

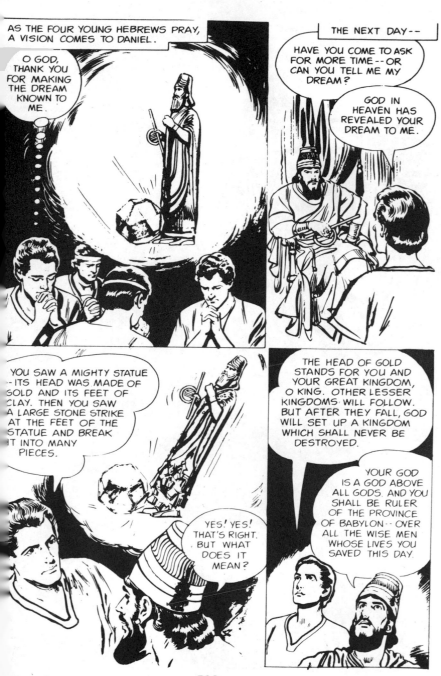

583

DANIEL RELAYS THE GOOD NEWS TO HIS HEBREW FRIENDS.

THE KING HAS MADE ME RULER OVER BABYLON AND EACH OF YOU HAS AN IMPORTANT OFFICE IN THE KINGDOM.

THAT'S WONDERFUL!

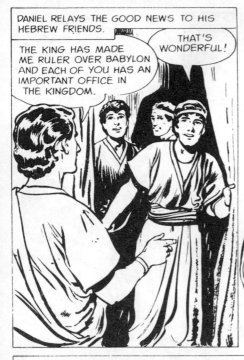

BUT THE NEWS DOES NOT PLEASE THE KING'S OTHER ADVISERS.

SO THE KING HAS PUT THIS YOUNG HEBREW OVER **US!** WE MUST GET RID OF HIM.

NOT NOW-- HE'S TOO POWERFUL BUT IF WE CAN TURN THE KING AGAINST DANIEL'S FRIENDS WE MIGHT BE ABLE TO CAUSE DANIEL TROUBLE.

THEIR OPPORTUNITY COMES WHEN THE KING BUILDS A STATUE AND ORDERS HIS OFFICIALS TO WORSHIP IT--OR BE THROWN INTO A FIERY FURNACE.

THE KING IS PLAYING RIGHT INTO OUR HANDS --HE DOESN'T KNOW THAT HEBREWS WILL WORSHIP ONLY THEIR GOD.

DANIEL HOLDS TOO HIGH A POSITION FOR ANY ONE OF US TO REPORT ON HIM--BUT NOT HIS FRIENDS...

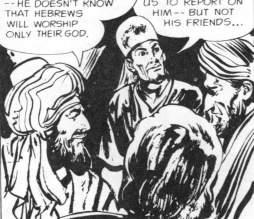

RIGHT--AND TOMORROW WHEN THE TRUMPET SOUNDS FOR ALL MEN TO BOW BEFORE THE STATUE, WE'LL KEEP OUR EYES ON SHADRACH, MESHACH AND ABEDNEGO.

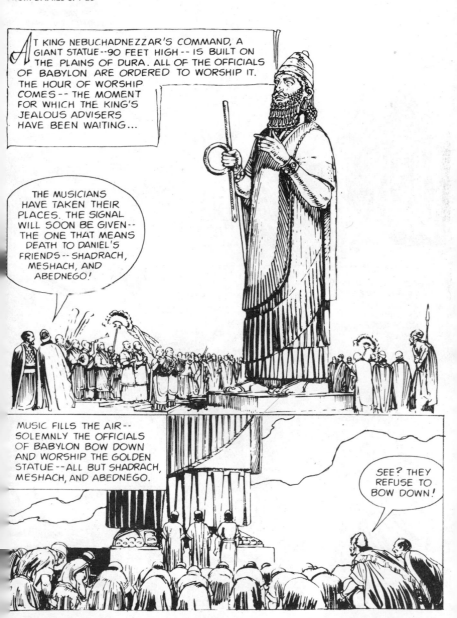

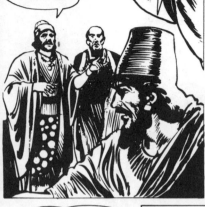

EAGERLY, THE JEALOUS ADVISERS REPORT TO THE KING.

O KING, THREE OF YOUR HEBREW OFFICIALS HAVE DEFIED YOU. THEY REFUSE TO WORSHIP YOUR STATUE.

WHAT? HAVE THEM BROUGHT TO ME AT ONCE!

WORSHIP THE STATUE -- OR BE THROWN INTO THE FIERY FURNACE. AND TELL ME -- WHAT GOD CAN SAVE YOU FROM THAT?

IF WE ARE CAST INTO THE FIRE, THE GOD WHOM WE SERVE WILL BE ABLE TO DELIVER US! BUT EVEN IF WE MUST DIE, WE WILL NOT WORSHIP AN IDOL.

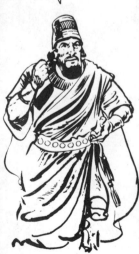

HEAT THE FURNACE -- SEVEN TIMES HOTTER THAN EVER BEFORE -- AND THROW THEM IN IT!

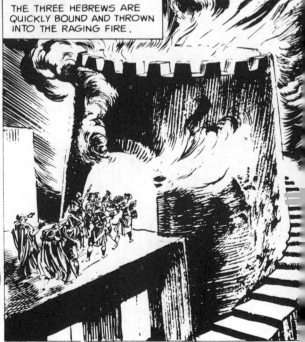

THE THREE HEBREWS ARE QUICKLY BOUND AND THROWN INTO THE RAGING FIRE.

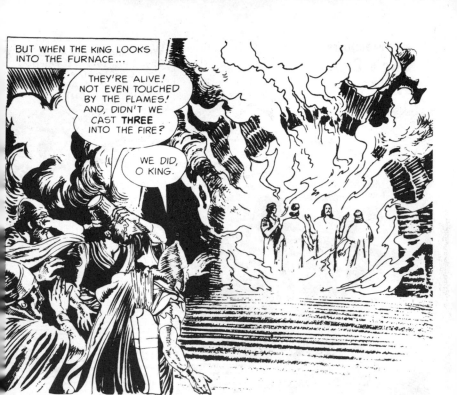

BUT WHEN THE KING LOOKS INTO THE FURNACE...

THEY'RE ALIVE! NOT EVEN TOUCHED BY THE FLAMES! AND, DIDN'T WE CAST **THREE** INTO THE FIRE?

WE DID, O KING.

BUT I SEE **FOUR**! AND THE FOURTH LOOKS LIKE SOMEONE FROM HEAVEN.

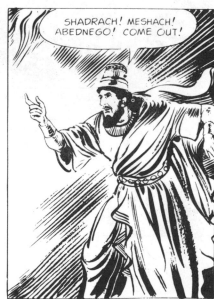

SHADRACH! MESHACH! ABEDNEGO! COME OUT!

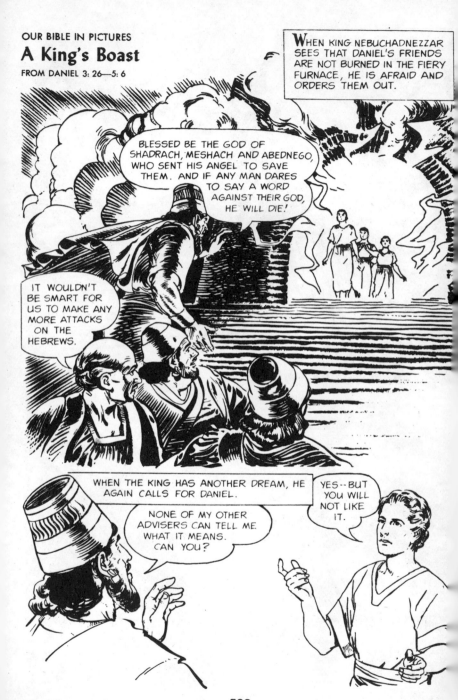

OUR BIBLE IN PICTURES
A King's Boast
FROM DANIEL 3: 26—5: 6

WHEN KING NEBUCHADNEZZAR SEES THAT DANIEL'S FRIENDS ARE NOT BURNED IN THE FIERY FURNACE, HE IS AFRAID AND ORDERS THEM OUT.

BLESSED BE THE GOD OF SHADRACH, MESHACH AND ABEDNEGO, WHO SENT HIS ANGEL TO SAVE THEM. AND IF ANY MAN DARES TO SAY A WORD AGAINST THEIR GOD, HE WILL DIE!

IT WOULDN'T BE SMART FOR US TO MAKE ANY MORE ATTACKS ON THE HEBREWS.

WHEN THE KING HAS ANOTHER DREAM, HE AGAIN CALLS FOR DANIEL.

NONE OF MY OTHER ADVISERS CAN TELL ME WHAT IT MEANS. CAN YOU?

YES--BUT YOU WILL NOT LIKE IT.

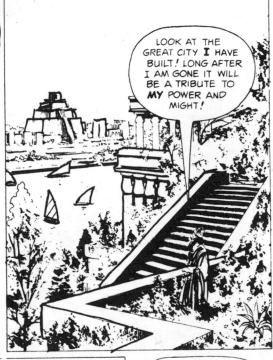

THE KING IS UPSET BY WHAT DANIEL SAYS, BUT IN TIME HE FORGETS... ONE DAY AS HE WALKS IN HIS PALACE ROOF GARDEN...

LOOK AT THE GREAT CITY **I** HAVE BUILT! LONG AFTER I AM GONE IT WILL BE A TRIBUTE TO **MY** POWER AND MIGHT!

THE TREE YOU DREAMED ABOUT IS YOU, O KING-- TALL, STRONG, AND PROUD. YOU SAW THE TREE CUT DOWN. THIS MEANS THAT YOUR POWER AS KING WILL BE TAKEN FROM YOU IF YOU DO NOT HONOR GOD ABOVE YOURSELF.

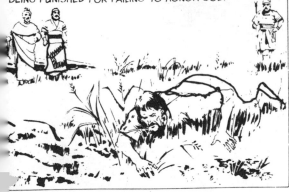

AS THE BOASTFUL WORDS ARE SPOKEN, DANIEL'S WARNING COMES TRUE. THE KING LOSES HIS MIND-- AND FOR SEVEN YEARS HE LIVES LIKE A BEAST OF THE FIELD. THEN ONE DAY THE KING REALIZES HE IS BEING PUNISHED FOR FAILING TO HONOR GOD.

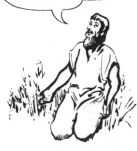

O GOD OF DANIEL AND THE HEBREWS, I HONOR AND PRAISE THEE, WHOSE KINGDOM IS GREAT AND EVERLASTING-- WHOSE WORK IS TRUTH AND JUSTICE.

589

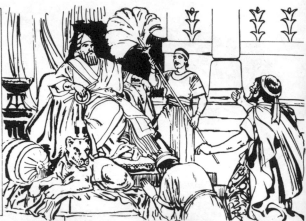

INSTANTLY KING NEBUCHADNEZZAR'S MIND IS RESTORED. HE RETURNS TO THE THRONE AND RULES WISELY WITH DANIEL AS HIS ADVISER.

BUT AFTER HIS DEATH THE RULERS WHO FOLLOW HIM TURN AWAY FROM DANIEL. ONE OF THEM, BELSHAZZAR, IS SO SURE OF HIS OWN WISDOM THAT...

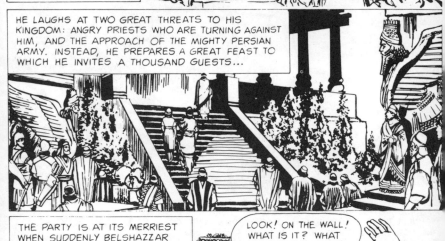

HE LAUGHS AT TWO GREAT THREATS TO HIS KINGDOM: ANGRY PRIESTS WHO ARE TURNING AGAINST HIM, AND THE APPROACH OF THE MIGHTY PERSIAN ARMY. INSTEAD, HE PREPARES A GREAT FEAST TO WHICH HE INVITES A THOUSAND GUESTS...

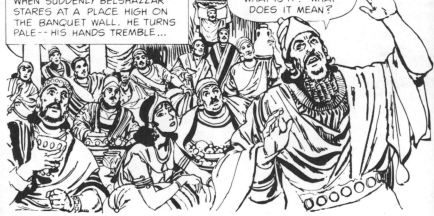

THE PARTY IS AT ITS MERRIEST WHEN SUDDENLY BELSHAZZAR STARES AT A PLACE HIGH ON THE BANQUET WALL. HE TURNS PALE-- HIS HANDS TREMBLE...

LOOK! ON THE WALL! WHAT IS IT? WHAT DOES IT MEAN?

andwriting on the Wall

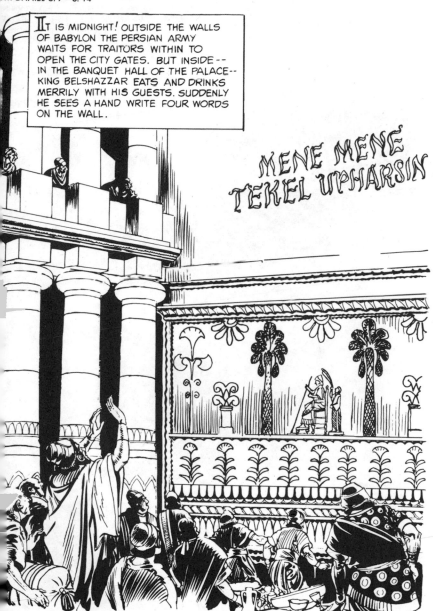

IT IS MIDNIGHT! OUTSIDE THE WALLS OF BABYLON THE PERSIAN ARMY WAITS FOR TRAITORS WITHIN TO OPEN THE CITY GATES. BUT INSIDE -- IN THE BANQUET HALL OF THE PALACE-- KING BELSHAZZAR EATS AND DRINKS MERRILY WITH HIS GUESTS. SUDDENLY HE SEES A HAND WRITE FOUR WORDS ON THE WALL.

MENE MENE TEKEL UPHARSIN

TERRIFIED, BELSHAZZAR CALLS FOR HIS ADVISERS TO EXPLAIN THE WORDS, BUT THEY CANNOT. WHEN THE KING'S MOTHER HEARS THE EXCITEMENT IN THE BANQUET HALL SHE RUSHES TO HER SON.

MY SON, THERE'S A MAN IN YOUR KINGDOM NAMED DANIEL WHO CAN INTERPRET DREAMS. CALL HIM.

DANIEL! YES! YES! BRING HIM HERE AT ONCE!

NOT A SOUND IS HEARD IN THE GREAT BANQUET HALL UNTIL DANIEL APPEARS BEFORE THE KING.

TELL ME WHAT THOSE WORDS MEAN AND YOU SHALL BE SECOND ONLY TO ME IN ALL BABYLON.

O KING, THEY ARE A WARNING FROM GOD YO HAVE BEEN MEASURED AND FOUND LACKING IN THE QUALITIES OF A RULER. YOUR KINGDOM WILL BE GIVEN TO TH: PERSIAN

I DON'T BELIEVE YOUR MESSAGE, BUT I'LL KEEP MY PROMISE. HERE, THIS CHAIN MAKES YOU NEXT TO ME IN ALL THE KINGDOM. NOW, ON WITH THE FEAST!

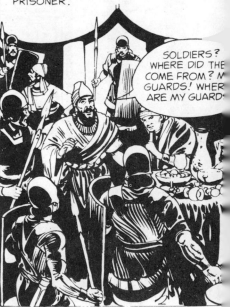

AS BELSHAZZAR SPEAKS, PERSIAN SOLDIERS SUDDENLY FILL THE HALL--AND TAKE HIM PRISONER.

SOLDIERS? WHERE DID THE COME FROM? M GUARDS! WHER ARE MY GUARD:

BEFORE MORNING THE CITY IS IN THE HANDS OF THE ENEMY. BELSHAZZAR IS KILLED. DANIEL IS BROUGHT BEFORE DARIUS, THE COMMANDER, WHO RECOGNIZES DANIEL'S ABILITY AS A LEADER.

YOU WILL RULE OVER MY NOBLES AS LONG AS YOU OBEY ME.

DARIUS FINDS DANIEL VERY WISE AND OFTEN TURNS TO HIM FOR ADVICE.

DARIUS HAS APPOINTED DANIEL RULER OVER ALL OF US.

WE MUST GET RID OF HIM-- AND I KNOW JUST HOW TO DO IT!

O KING, YOUR NOBLES, WHO HONOR YOU ABOVE ALL, BEG YOU TO SIGN THIS LAW SO THAT **EVERYONE** WILL HONOR YOU. IT FORBIDS ANYONE TO BOW DOWN TO ANY GOD OR MAN BUT YOU, FOR THIRTY DAYS.

IF YOU WANT SUCH A LAW, I'LL SIGN IT.

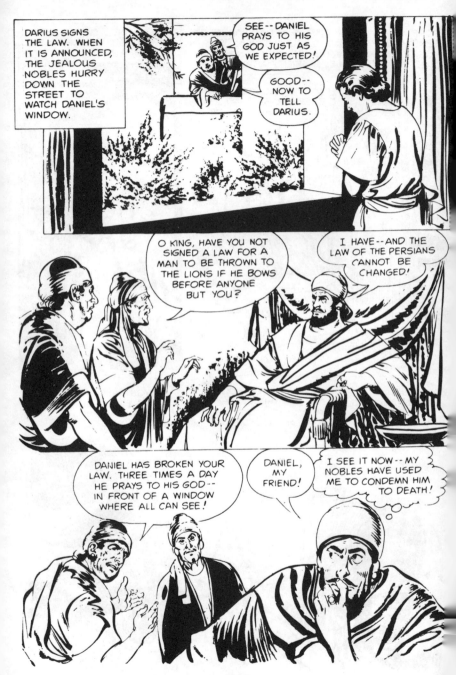

594

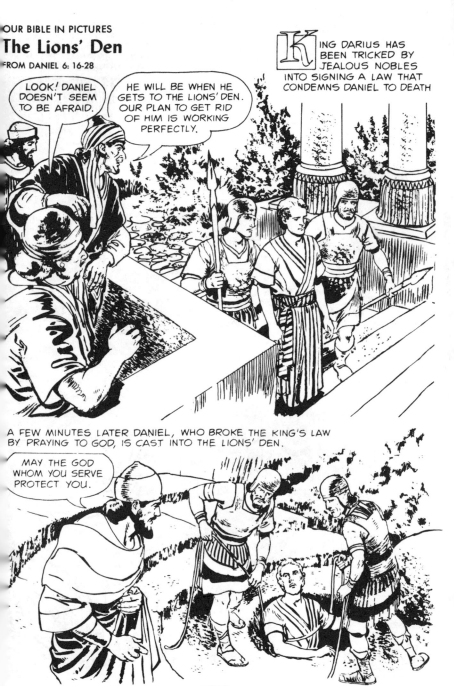

OUR BIBLE IN PICTURES

The Lions' Den

FROM DANIEL 6: 16-28

KING DARIUS HAS BEEN TRICKED BY JEALOUS NOBLES INTO SIGNING A LAW THAT CONDEMNS DANIEL TO DEATH

LOOK! DANIEL DOESN'T SEEM TO BE AFRAID.

HE WILL BE WHEN HE GETS TO THE LIONS' DEN. OUR PLAN TO GET RID OF HIM IS WORKING PERFECTLY.

A FEW MINUTES LATER DANIEL, WHO BROKE THE KING'S LAW BY PRAYING TO GOD, IS CAST INTO THE LIONS' DEN.

MAY THE GOD WHOM YOU SERVE PROTECT YOU.

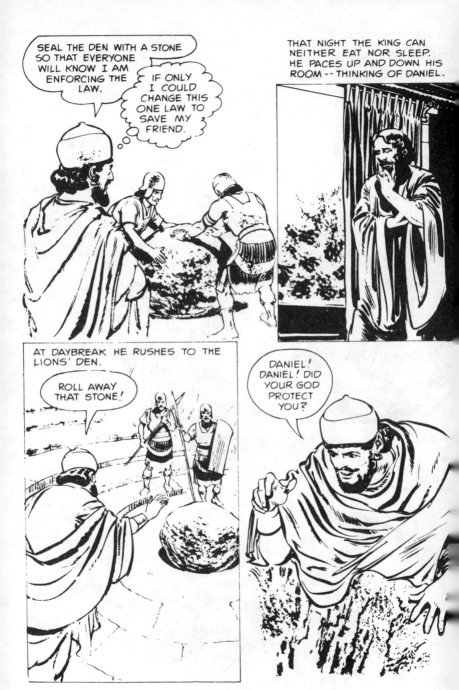

596

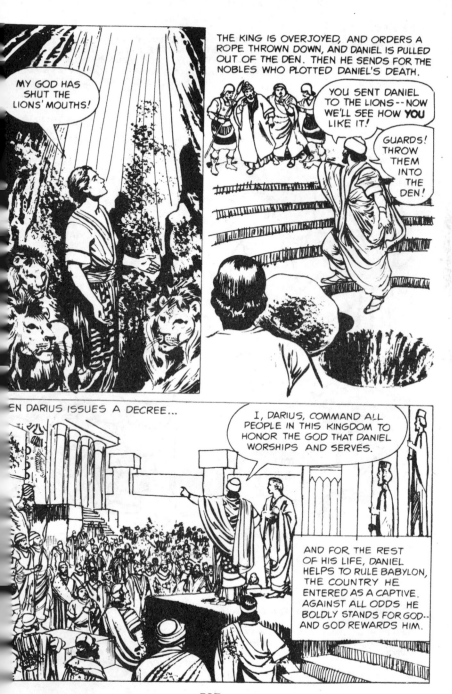

OUR BIBLE IN PICTURES

Twelve Men of God

FROM THE MINOR PROPHETS

THE LAST TWELVE BOOKS OF THE OLD TESTAMENT ARE CALLED THE MINOR PROPHETS. EACH IS NAMED FOR A MAN WHOM GOD CALLED TO SPEAK FOR HIM AT A CRUCIAL TIME IN THE HISTORY OF ISRAEL AND JUDAH.

HOSEA -- the Prophet of Love

HOSEA LOVES HIS WIFE, GOMER, VERY MUCH. BUT ONE DAY SHE RUNS AWAY. HOSEA IS BROKENHEARTED. THEN SUDDENLY HE SEES THAT THE PEOPLE OF ISRAEL HAVE TREATED GOD THE WAY GOMER HAS TREATED HIM. GOD LOVES HIS PEOPLE, BUT THEY HAVE RUN AWAY TO WORSHIP IDOLS.

CAN GOD FORGIVE THEM? "YES," HOSEA SAYS, "FOR I CAN FORGIVE GOMER, AND GOD'S LOVE IS GREATER THAN MINE."

"GOD LOVES YOU. HE WILL FORGIVE YOUR SINS IF YOU CONFESS THEM AND WORSHIP HIM." THIS IS HOSEA'S MESSAGE TO THE PEOPLE OF ISRAEL.

AMOS -- and the Crooked Wall

JOEL -- and the Plague of Locusts

LIKE A MIGHTY ARMY DESTROYING EVERYTHING IN ITS PATH, MILLIONS OF LOCUSTS SWARM OVER THE LAND OF JUDAH. THEY DEVOUR THE CROPS -- LEAVING ONLY BARREN FIELDS BEHIND.

"WHAT WILL WE DO?" THE PEOPLE CRY.

THE PROPHET JOEL ANSWERS: "REPENT OF YOUR SINS. SEEK GOD'S HELP, AND HE WILL RESTORE THE LAND."

THEN HE ADDS THIS PROMISE: "ONE DAY GOD WILL SEND HIS HOLY SPIRIT INTO THE HEARTS OF HIS PEOPLE." (THIS PROPHECY CAME TRUE WHEN THE HOLY SPIRIT DESCENDED UPON JESUS' DISCIPLES ON THE DAY OF PENTECOST -- ACTS 2.)

AMOS, A SHEPHERD OF JUDAH, IS WATCHING HIS SHEEP WHEN GOD CALLS HIM TO DANGEROUS JOB. "GO," GOD SAYS, "TO NEIGHBORING COUNTRY OF ISRAEL AND TELL THE PEOPLE THAT THEY ARE GOING TO BE PUNISHED FOR THEIR SINS."

WITHOUT PROTESTING, AMOS ACCEPTS THE JOB AND GOES TO THE CITY OF BETHEL IN ISRAEL.

"PREPARE TO MEET THY GOD," HE TELLS THE PEOPLE OF ISRAEL, "FOR YOU ARE LIKE CROOKED WALL THAT MUST BE DESTROYED BEFORE A NEW ONE CAN BE BUILT."

OBADIAH --
the Angry Prophet

JONAH --
the Man Who Ran Away

BADIAH IS ANGRY AT JUDAH'S NEIGHBOR, NATION OF EDOM. "YOU CHEERED," HE S TO EDOM, "WHEN BABYLON DESTROYED JSALEM. YOU HELPED TO ROB THE CITY TS TREASURES. YOU CAPTURED THE PLE AS THEY TRIED TO ESCAPE AND TURNED M OVER TO THE ENEMY."

EN HE PREDICTS EDOM'S PUNISHMENT: 'AUSE YOUR CAPITAL CITY IS PROTECTED ROCKY CLIFFS, YOU THINK IT CANNOT DESTROYED. BUT IT CAN! AND IT L-- AS WILL EVERY NATION THAT DBEYS GOD."

NINEVEH IS ONE OF THE MOST WICKED CITIES IN THE WORLD. SO, WHEN GOD TELLS JONAH TO GO TO **NINEVEH** WITH A MESSAGE TO SAVE THE CITY FROM ITS ENEMIES, JONAH RUNS THE OTHER WAY.

BUT AFTER A LESSON FROM GOD, JONAH OBEYS. HE TELLS NINEVEH TO REPENT OF ITS SINS -- AND HE PREACHES HIS MESSAGE SO SUCCESSFULLY THAT THE CITY DOES REPENT AND IS SAVED FROM DESTRUCTION.

THE MESSAGE OF THE BOOK OF JONAH IS THIS: GOD LOVES ALL PEOPLE. THOSE WHO KNOW GOD MUST TELL OTHERS ABOUT HIM.

MICAH --
Champion of the Poor

NAHUM
Condemns a City

CAH, A SMALL-TOWN PROPHET, IS A PION OF THE POOR. HE DARES TO CON- THE WEALTHY LEADERS OF JUDAH 'SRAEL.

U HATE JUSTICE," HE SHOUTS, "AND YOU SS THE POOR. BECAUSE YOU DO, H AND ISRAEL HAVE BECOME SO WEAK ORRUPT THAT THEY WILL BE DESTROYED." EN THE PEOPLE ASK WHAT GOD EXPECTS TO DO, MICAH ANSWERS: "DO JUSTLY, MERCY, AND WALK HUMBLY WITH OD."

TO THOSE WHO WILL LISTEN HE MAKES NDERFUL PROMISE: "IN THE LITTLE TOWN THLEHEM A SAVIOR WILL BE BORN--A SAVIOR KINGDOM OF PEACE WILL LAST FOREVER."

WHEN THE PROPHET JONAH WARNED **NINEVEH** OF ITS WICKEDNESS, THE CITY REPENTED -- AND WAS SPARED.

NOW, ONE HUNDRED AND FIFTY YEARS LATER, ANOTHER PROPHET, NAHUM, IS CALLED TO CONDEMN **NINEVEH** FOR RETURN- ING TO A LIFE OF SIN.

"THE LORD IS SLOW TO ANGER," NAHUM TELLS THE CITY, "BUT HE IS NOT BLIND. HE WILL NOT LET THE WICKED GO UNPUNISHED."

THIS TIME THE CITY IS NOT SPARED-- THE ARMIES OF BABYLON SO COMPLETELY DESTROY **NINEVEH** THAT IT IS NEVER REBUILT.

HABAKKUK--
The Man
Who Asks
Questions

HABAKKUK IS A MAN WHO ASKS QUESTIONS-- OF GOD.

HABAKKUK: THE PEOPLE OF JUDAH ARE GETTING MORE WICKED EVERY DAY. HOW LONG WILL THEY GO UNPUNISHED?

GOD: NOT FOR LONG. THE BABYLONIANS ARE COMING. I AM USING THEM TO TEACH JUDAH THAT EVIL MUST BE DESTROYED.

HABAKKUK: THE BABYLONIANS? AREN'T THEY MORE WICKED THAN JUDAH?

GOD: YES, BUT HAVE FAITH. IN TIME YOU WILL UNDERSTAND MY PLANS.

IN THE MIDST OF ALL THE EVIL AROUND HIM, HABAKKUK IS COMFORTED IN KNOWING THAT GOD IS IN CHARGE OF THE WORLD. "GOD IS IN HIS HOLY TEMPLE," HABAKKUK SAYS, "AND NO MATTER WHAT HAPPENS, I AM NOT AFRAID, FOR THE LORD IS MY STRENGTH."

ZECHARIAH and the Triumphal Entry

ZECHARIAH IS A FRIEND OF HAGGAI AND WORKS WITH HIM TO REBUILD THE TEMPLE IN JERUSALEM. BUT ZECHARIAH SEES BEYOND THE STONE AND WOOD OF THE BUILDING-- HE SEES THE GLORIOUS COMING OF CHRIST: "BEHOLD," HE SAYS, "THY KING COMETH RIDING UNTO THEE."

(THIS PROPHECY CAME TRUE WHEN CHRIST RODE INTO JERUSALEM ON THE DAY WE REMEMBER AS PALM SUNDAY.)

ZEPHANIAH: Repent or Die

"THE DAY OF THE LORD IS AT HAND," ZEPHANIAH WARNED JUDAH. "GOD WILL PUNISH ALL NATIONS OF THE EARTH THAT HAVE DISOBEYED HIM. NEITHER GOLD NOR SILVER WILL BE ABLE TO DELIVER THOSE WHO HAVE TURNED FROM GOD."

ZEPHANIAH PLEADS WITH HIS PEOPLE TO REPENT AND SEEK GOD'S FORGIVENESS. "THOSE WHO DO," HE PROMISES, "WILL LIVE IN PEACE UNDER THE RULE OF GOD."

HAGGAI-- A Temple Builder

WHEN THE HEBREWS FIRST RETURN TO JERUSALEM-- AFTER YEARS OF CAPTIVITY BABYLON-- THEIR FIRST THOUGHT IS TO REBUILD THE TEMPLE. THEY START-- BUT THEY SOON GET DISCOURAGED AND QUIT. FOR FIFTEEN YEARS NOTHING IS DONE.

GOD SPEAKS TO HAGGAI AND HE TAKES THE MESSAGE TO THE PEOPLE.

"BUILD GOD'S TEMPLE," HE PREACHES AND IN FOUR YEARS IT IS BUILT!

MALACHI-- The Final Warning

THE PEOPLE OF JUDAH HAVE RETURNED JERUSALEM FROM CAPTIVITY IN BABYLON-- THE TEMPLE HAS BEEN REBUILT. BUT STILL THEY ARE UNHAPPY. AND MALACHI TELLS THEM WHY--

"YOU DO NOT SHOW RESPECT TO GOD. WOULD NOT DARE BRING CHEAP GIFTS TO THE GOVERNOR. YET YOU BRING CHEAP AND FAULTY OFFERINGS TO GOD."

"GOD KNOWS THOSE WHO ARE FAITHFUL TO HIM. HE WILL REWARD THEM. BUT THE UNFAITHFUL WILL PERISH AS STUBBLE IN BURNING FIELDS AFTER THE HARVEST."

600

he Unfaithful Wife

OM HOSEA 1—13

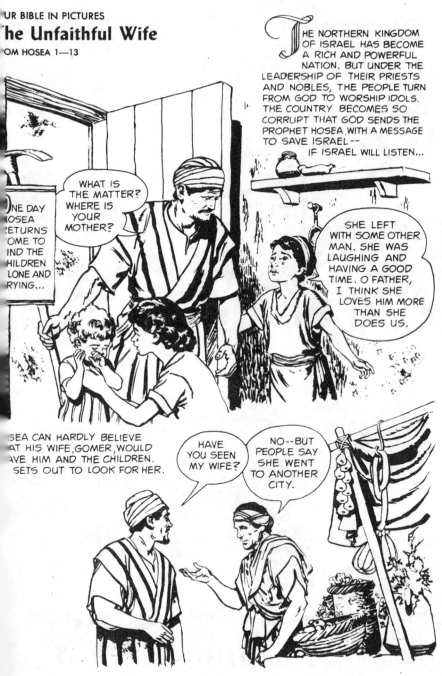

THE NORTHERN KINGDOM OF ISRAEL HAS BECOME A RICH AND POWERFUL NATION. BUT UNDER THE LEADERSHIP OF THEIR PRIESTS AND NOBLES, THE PEOPLE TURN FROM GOD TO WORSHIP IDOLS. THE COUNTRY BECOMES SO CORRUPT THAT GOD SENDS THE PROPHET HOSEA WITH A MESSAGE TO SAVE ISRAEL--
IF ISRAEL WILL LISTEN...

NE DAY OSEA ETURNS OME TO IND THE HILDREN LONE AND RYING...

WHAT IS THE MATTER? WHERE IS YOUR MOTHER?

SHE LEFT WITH SOME OTHER MAN. SHE WAS LAUGHING AND HAVING A GOOD TIME. O FATHER, I THINK SHE LOVES HIM MORE THAN SHE DOES US.

SEA CAN HARDLY BELIEVE AT HIS WIFE, GOMER, WOULD AVE HIM AND THE CHILDREN. SETS OUT TO LOOK FOR HER.

HAVE YOU SEEN MY WIFE?

NO--BUT PEOPLE SAY SHE WENT TO ANOTHER CITY.

HOSEA CONTINUES HIS SEARCH. MEANWHILE, IN A NEIGHBORING CITY...

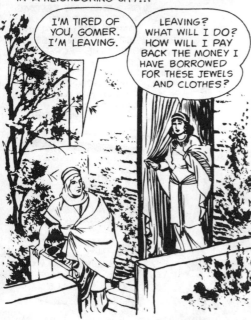

I'M TIRED OF YOU, GOMER. I'M LEAVING.

LEAVING? WHAT WILL I DO? HOW WILL I PAY BACK THE MONEY I HAVE BORROWED FOR THESE JEWELS AND CLOTHES?

GOMER FINDS OUT WHEN THE MONEYLENDER COMES FOR HIS MONEY.

PAY ME-- OR I'LL HAVE YOU SOLD AS A SLAVE!

SLAVE? OH, NO. GIVE ME TIME-- PLEASE--

BUT THE MONEYLENDER WON'T WAIT, AND THE NEXT DAY...

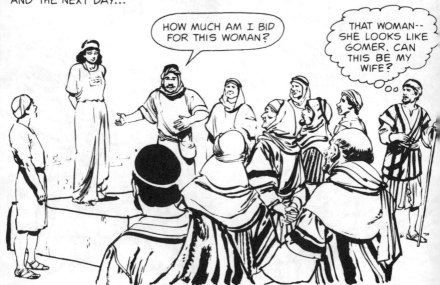

HOW MUCH AM I BID FOR THIS WOMAN?

THAT WOMAN-- SHE LOOKS LIKE GOMER. CAN THIS BE MY WIFE?

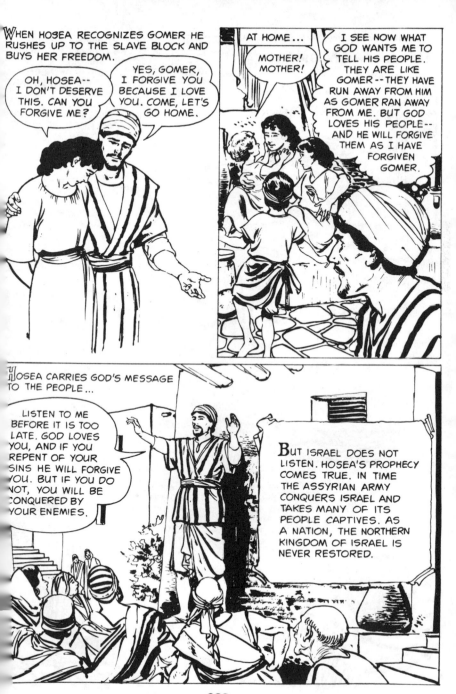

WHEN HOSEA RECOGNIZES GOMER HE RUSHES UP TO THE SLAVE BLOCK AND BUYS HER FREEDOM.

OH, HOSEA-- I DON'T DESERVE THIS. CAN YOU FORGIVE ME?

YES, GOMER, I FORGIVE YOU BECAUSE I LOVE YOU. COME, LET'S GO HOME.

AT HOME...

MOTHER! MOTHER!

I SEE NOW WHAT GOD WANTS ME TO TELL HIS PEOPLE. THEY ARE LIKE GOMER--THEY HAVE RUN AWAY FROM HIM AS GOMER RAN AWAY FROM ME. BUT GOD LOVES HIS PEOPLE-- AND HE WILL FORGIVE THEM AS I HAVE FORGIVEN GOMER.

HOSEA CARRIES GOD'S MESSAGE TO THE PEOPLE...

LISTEN TO ME BEFORE IT IS TOO LATE. GOD LOVES YOU, AND IF YOU REPENT OF YOUR SINS HE WILL FORGIVE YOU. BUT IF YOU DO NOT, YOU WILL BE CONQUERED BY YOUR ENEMIES.

BUT ISRAEL DOES NOT LISTEN. HOSEA'S PROPHECY COMES TRUE. IN TIME THE ASSYRIAN ARMY CONQUERS ISRAEL AND TAKES MANY OF ITS PEOPLE CAPTIVES. AS A NATION, THE NORTHERN KINGDOM OF ISRAEL IS NEVER RESTORED.

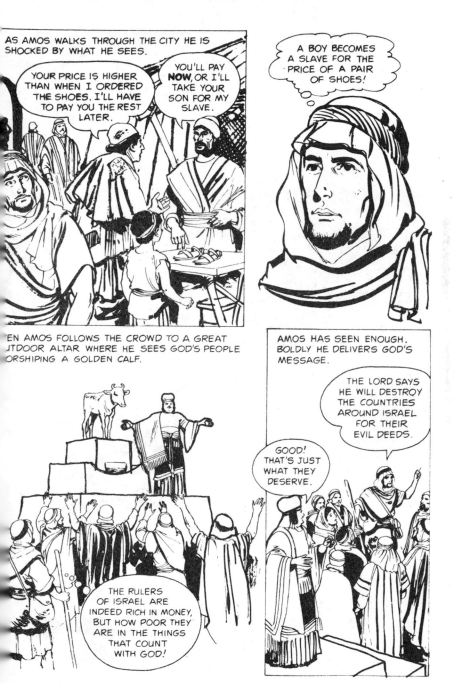

605

IF THOSE COUNTRIES DESERVE PUNISHMENT, HOW MUCH MORE DO **YOU**, O ISRAEL! GOD HAS LOVED AND PROTECTED YOU. BUT YOU HAVE SINNED AGAINST HIM. YOU CHEAT THE POOR; YOU WORSHIP IDOLS. FOR THIS YOU WILL BE PUNISHED. YOUR ENEMIES WILL DEFEAT YOU AND TAKE YOU AS CAPTIVES-- SO, PREPARE TO MEET THY GOD!

GO BACK TO THE HILLS AND PREACH TO YOUR OWN PEOPLE.

GOD SENT ME TO PREACH TO **YOU**! AND FOR **YOUR** SINS, O HIGH PRIEST, YOU WILL BE AMONG THOSE WHO DIE IN CAPTIVITY.

STOP THAT KIND OF TALK OR YOU'LL BE PUT TO DEATH!

THE HIGH PRIEST ACCUSES AMOS OF TREASON -- BUT EVEN THIS DOES NOT STOP AMOS FROM DELIVER-ING GOD'S MESSAGE TO ISRAEL. BUT ISRAEL DOES NOT REPENT...

THE BIBLE DOES NOT SAY WHAT HAPPENS TO AMOS. IT ONLY RECORDS HIS MESSAGE--WHICH COMES TRUE IN LESS THAN FORTY YEARS. THE ASSYRIANS CONQUER ISRAEL AND TAKE ITS PEOPLE AWAY AS CAP-TIVES. THEY NEVER RETURN!

The Runaway

FROM JONAH 1: 1-12

GOD CALLED THE PROPHET JONAH FOR A SPECIAL FOREIGN ASSIGNMENT. THE WAY JONAH CARRIES IT OUT IS FOUND IN THE BOOK THAT BEARS HIS NAME.

TO THE PEOPLE OF ISRAEL THERE IS NO NATION MORE DESPISED THAN ASSYRIA. THE WAY IT CONQUERS SMALLER NATIONS AND TORTURES ITS CAPTIVES MAKES THE HEBREWS SICK WITH FEAR. ONE DAY GOD SPEAKS TO HIS PROPHET JONAH: "GO TO NINEVEH AND TELL THE PEOPLE TO REPENT OF THEIR SINS -- OR THE CITY WILL BE DESTROYED."

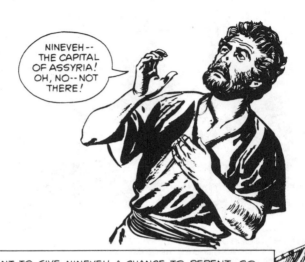

JONAH DOESN'T WANT TO GIVE NINEVEH A CHANCE TO REPENT, SO HE HURRIES TO THE NEAREST SEAPORT.

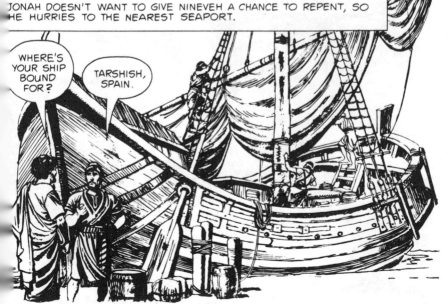

607

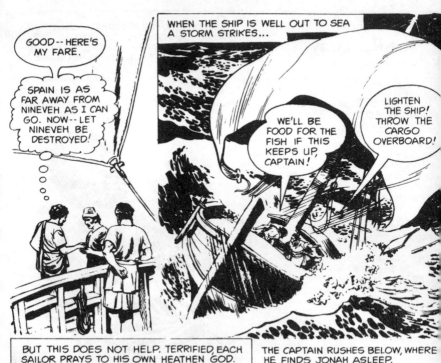

GOOD -- HERE'S MY FARE.

SPAIN IS AS FAR AWAY FROM NINEVEH AS I CAN GO. NOW -- LET NINEVEH BE DESTROYED!

WHEN THE SHIP IS WELL OUT TO SEA A STORM STRIKES...

WE'LL BE FOOD FOR THE FISH IF THIS KEEPS UP, CAPTAIN!

LIGHTEN THE SHIP! THROW THE CARGO OVERBOARD!

BUT THIS DOES NOT HELP. TERRIFIED, EACH SAILOR PRAYS TO HIS OWN HEATHEN GOD. STILL THE STORM RAGES ON...

WHERE'S JONAH? WHY DOESN'T HE PRAY TO HIS GOD?

THE CAPTAIN RUSHES BELOW, WHERE HE FINDS JONAH ASLEEP.

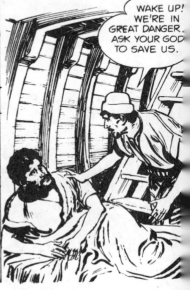

WAKE UP! WE'RE IN GREAT DANGER. ASK YOUR GOD TO SAVE US.

BUT JONAH IS ASHAMED TO PRAY TO GOD. INSTEAD HE HURRIES UP ON DECK...

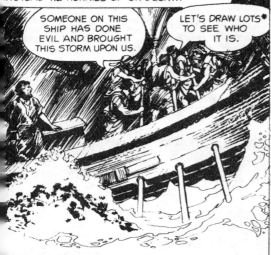

SOMEONE ON THIS SHIP HAS DONE EVIL AND BROUGHT THIS STORM UPON US.

LET'S DRAW LOTS* TO SEE WHO IT IS.

QUICKLY THE NAMES OF ALL ON BOARD ARE WRITTEN ON BITS OF POTTERY AND PLACED IN THE FOLD OF A SAILOR'S GARMENT.

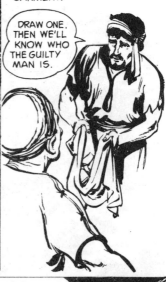

DRAW ONE, THEN WE'LL KNOW WHO THE GUILTY MAN IS.

* THE CASTING OF LOTS WAS A CUSTOM USED BY ANCIENT PEOPLES TO DECIDE IMPORTANT ISSUES. THEY BELIEVED A DIVINE POWER WOULD CAUSE THE RIGHT LOT TO BE DRAWN.

JONAH! WHAT HAVE YOU DONE TO BRING THIS STORM ON US?

I AM A HEBREW--AND I HAVE RUN AWAY FROM GOD.

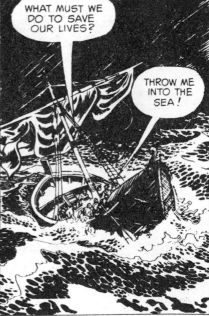

WHAT MUST WE DO TO SAVE OUR LIVES?

THROW ME INTO THE SEA!

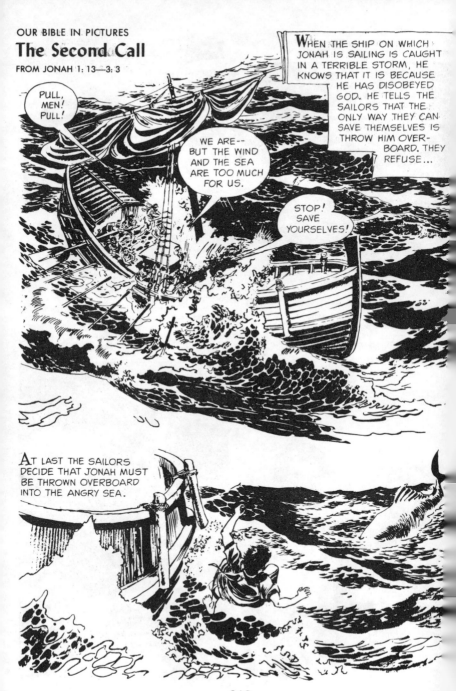

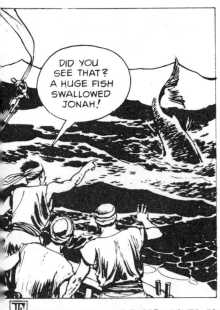

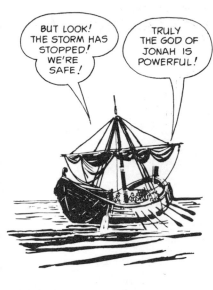

OR THREE DAYS AND THREE NIGHTS JONAH IS IN THE BODY OF THE FISH. THEN GOD CAUSES THE FISH TO CAST JONAH UP ON THE BEACH. AND ONCE AGAIN GOD SPEAKS TO JONAH: "GO TO NINEVEH AND TELL THE PEOPLE THEY MUST REPENT OF THEIR SINS -- OR THE CITY WILL BE DESTROYED."

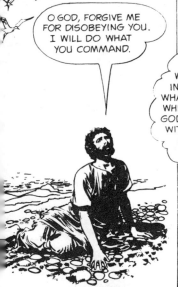

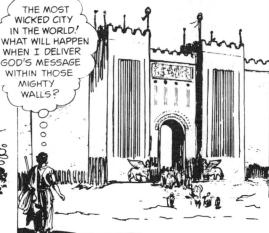

611

A Wicked City—an Angry Prophet—and God

FROM JONAH 3: 4—4: 11

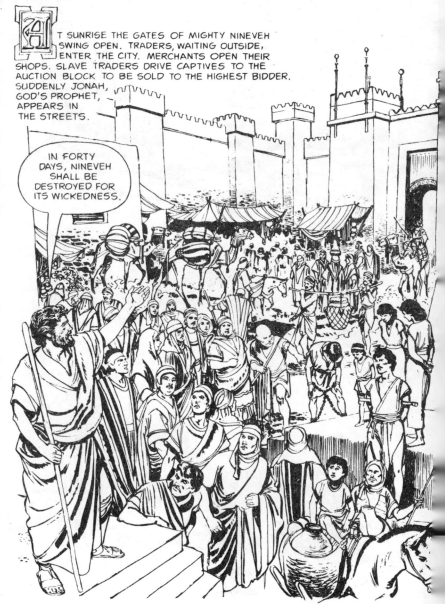

AT SUNRISE THE GATES OF MIGHTY NINEVEH SWING OPEN. TRADERS, WAITING OUTSIDE, ENTER THE CITY. MERCHANTS OPEN THEIR SHOPS. SLAVE TRADERS DRIVE CAPTIVES TO THE AUCTION BLOCK TO BE SOLD TO THE HIGHEST BIDDER. SUDDENLY JONAH, GOD'S PROPHET, APPEARS IN THE STREETS.

IN FORTY DAYS, NINEVEH SHALL BE DESTROYED FOR ITS WICKEDNESS.

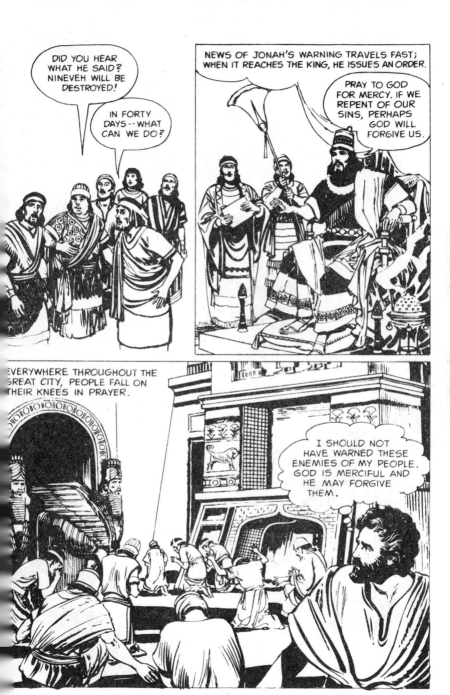

613

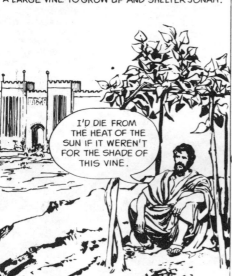

AFTER DELIVERING HIS MESSAGE, JONAH GOES OUTSIDE THE CITY TO WAIT AND SEE WHAT WILL HAPPEN TO NINEVEH. GOD CAUSES A LARGE VINE TO GROW UP AND SHELTER JONAH.

I'D DIE FROM THE HEAT OF THE SUN IF IT WEREN'T FOR THE SHADE OF THIS VINE.

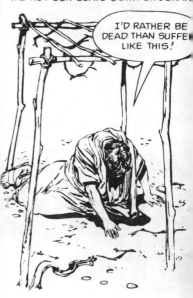

BUT--SUDDENLY--THE VINE DIES AND THE HOT SUN BEATS DOWN ON JONAH

I'D RATHER BE DEAD THAN SUFFER LIKE THIS!

LORD, WHY DIDN'T YOU SPARE THE VINE?

GOD ANSWERS: WOULD YOU HAVE ME SPARE A VINE, JONAH, BUT NOT SPARE NINEVEH WITH ITS 120,000 INNOCENT CHILDREN?

SO GOD SAVES NINEVEH FROM DESTRUCTION AND JONAH UNDERSTANDS HOW SELFISH HE HAS BEEN. HE SEES THAT GOD LOVES PEOPLE OF **ALL** NATIONS AND WANTS THEM TO LOVE AND OBEY HIM.

The Final Message
FROM THE BOOK OF MALACHI

THE VOICE OF THE PROPHET MALACHI IS THE LAST TO
BE HEARD IN THE STORY OF THE OLD TESTAMENT. BUT
BEFORE WE HEAR HIS FINAL MESSAGE--WHICH IS
FOUND IN THE BOOK THAT BEARS HIS NAME --
LET US BRIEFLY REVIEW THE HISTORY OF THE
PEOPLE TO WHOM HE SPOKE.

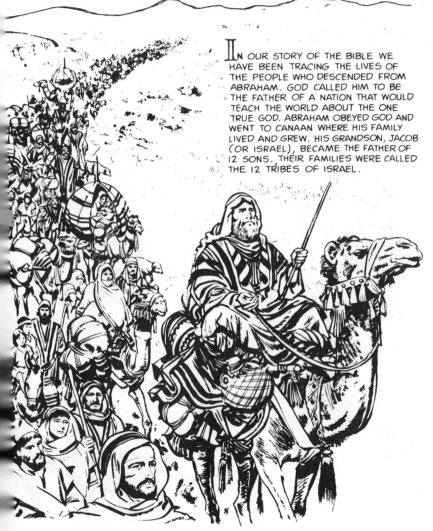

IN OUR STORY OF THE BIBLE WE
HAVE BEEN TRACING THE LIVES OF
THE PEOPLE WHO DESCENDED FROM
ABRAHAM. GOD CALLED HIM TO BE
THE FATHER OF A NATION THAT WOULD
TEACH THE WORLD ABOUT THE ONE
TRUE GOD. ABRAHAM OBEYED GOD AND
WENT TO CANAAN WHERE HIS FAMILY
LIVED AND GREW. HIS GRANDSON, JACOB
(OR ISRAEL), BECAME THE FATHER OF
12 SONS. THEIR FAMILIES WERE CALLED
THE 12 TRIBES OF ISRAEL.

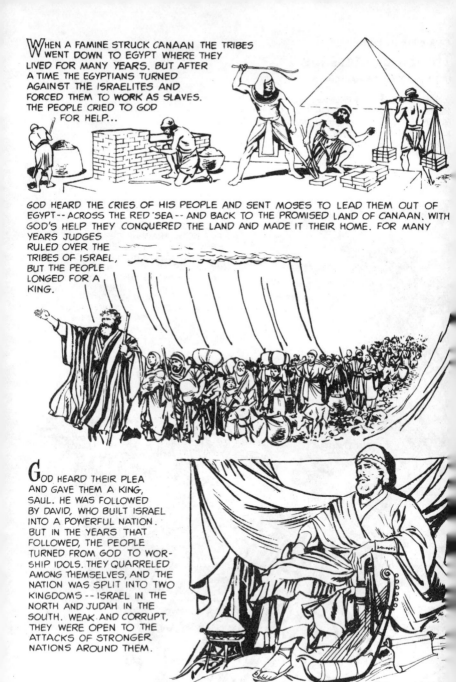

WHEN A FAMINE STRUCK CANAAN THE TRIBES WENT DOWN TO EGYPT WHERE THEY LIVED FOR MANY YEARS. BUT AFTER A TIME THE EGYPTIANS TURNED AGAINST THE ISRAELITES AND FORCED THEM TO WORK AS SLAVES. THE PEOPLE CRIED TO GOD FOR HELP...

GOD HEARD THE CRIES OF HIS PEOPLE AND SENT MOSES TO LEAD THEM OUT OF EGYPT--ACROSS THE RED SEA--AND BACK TO THE PROMISED LAND OF CANAAN. WITH GOD'S HELP THEY CONQUERED THE LAND AND MADE IT THEIR HOME. FOR MANY YEARS JUDGES RULED OVER THE TRIBES OF ISRAEL, BUT THE PEOPLE LONGED FOR A KING.

GOD HEARD THEIR PLEA AND GAVE THEM A KING, SAUL. HE WAS FOLLOWED BY DAVID, WHO BUILT ISRAEL INTO A POWERFUL NATION. BUT IN THE YEARS THAT FOLLOWED, THE PEOPLE TURNED FROM GOD TO WORSHIP IDOLS. THEY QUARRELED AMONG THEMSELVES, AND THE NATION WAS SPLIT INTO TWO KINGDOMS--ISRAEL IN THE NORTH AND JUDAH IN THE SOUTH. WEAK AND CORRUPT, THEY WERE OPEN TO THE ATTACKS OF STRONGER NATIONS AROUND THEM.

IN TIME BOTH KINGDOMS WERE CONQUERED. MANY OF THE PEOPLE WERE TAKEN AWAY TO FOREIGN LANDS. AFTER 70 YEARS OF CAPTIVITY, THE JEWS WERE ALLOWED TO RETURN TO JUDAH AND REBUILD JERUSALEM.

BUT STILL THE PEOPLE WERE UNHAPPY, AND THE PROPHET MALACHI TELLS THEM WHY...

DO YOU CALL THAT GOD'S SHARE OF YOUR GRAIN? HOW CAN YOU BE HAPPY WHEN YOU ROB GOD? BRING YOUR RIGHTFUL GIFTS AND OFFERINGS TO GOD, AND YOU WILL PROSPER.

BUT PEOPLE WHO CHEAT AND BRING NONE OF THEIR GRAIN TO THE TEMPLE PROSPER MORE THAN WE DO.

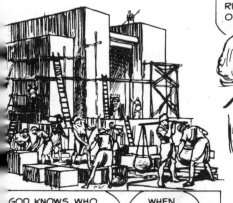

GOD KNOWS WHO LOVES AND OBEYS HIM. HE WILL REWARD THE RIGHTEOUS AND PUNISH THE WICKED.

WHEN WILL HE DO THIS?

FIRST, GOD WILL SEND A PROPHET AS HIS MESSENGER TO GET THE PEOPLE READY. THEN THE LORD HIMSELF WILL COME AND DELIVER HIS OWN PEOPLE FROM EVIL. BUT HE WILL DESTROY THE WICKED WHO DISOBEY.

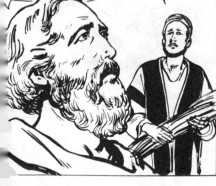

SO, WITH A WARNING -- AND A PROMISE -- THE OLD TESTAMENT ENDS. BUT FOR THE JEWS THE QUESTION REMAINS: WHEN WILL THE GREAT DELIVERER COME?

The Years of Waiting

BETWEEN THE OLD TESTAMENT AND THE NEW

THE LAND OF JUDAH IS STILL UNDER THE RULE OF THE
PERSIANS WHEN ALEXANDER, THE YOUNG KING OF MACEDONIA,
SETS OUT TO CONQUER THE WORLD.
RIDING HIS FAMOUS HORSE, BUCEPHALUS,
HE LEADS HIS ARMY AGAINST THE COUNTRIES
OF THE MIGHTY PERSIAN EMPIRE. ONE
AFTER ANOTHER THEY FALL, AND IN 332 B.C....

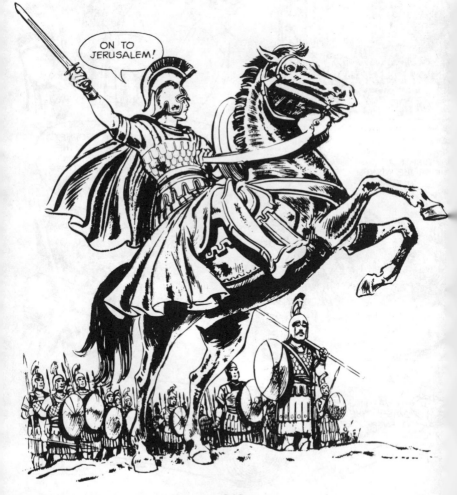

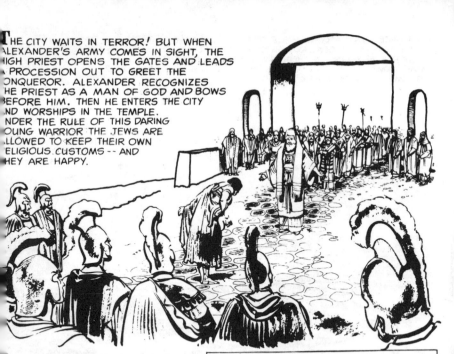

THE CITY WAITS IN TERROR! BUT WHEN ALEXANDER'S ARMY COMES IN SIGHT, THE HIGH PRIEST OPENS THE GATES AND LEADS A PROCESSION OUT TO GREET THE CONQUEROR. ALEXANDER RECOGNIZES THE PRIEST AS A MAN OF GOD AND BOWS BEFORE HIM. THEN HE ENTERS THE CITY AND WORSHIPS IN THE TEMPLE. UNDER THE RULE OF THIS DARING YOUNG WARRIOR THE JEWS ARE ALLOWED TO KEEP THEIR OWN RELIGIOUS CUSTOMS -- AND THEY ARE HAPPY.

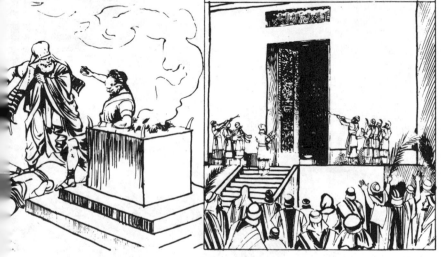

BUT--SUDDENLY--ALEXANDER DIES... AND THE GIANT EMPIRE IS DIVIDED AMONG HIS GENERALS. WHEN THE RULER OVER JUDAH COMMANDS THE PEOPLE TO WORSHIP AN IDOL, A PRIEST SLAYS THE KING'S MESSENGER. THIS BOLD ACT STIRS ALL JUDAH TO REVOLT...

UNDER THE LEADERSHIP OF THE PRIEST'S BRAVE FAMILY (KNOWN AS THE MACCABEES), THE JEWS DRIVE THE ENEMY FROM THEIR LAND, ONE OF THE FIRST THINGS THEY DO IS TO REDEDICATE THE TEMPLE, WHICH THE ENEMY HAD USED TO WORSHIP IDOLS. FOR A HUNDRED GLORIOUS YEARS JUDAH IS FREE!

BUT ONCE AGAIN A CONQUEROR COMES FROM ACROSS THE MEDITERRANEAN SEA. ROMAN SHIPS AND ROMAN SOLDIERS CONQUER EVERYTHING IN THEIR PATH. AND IN 63 B.C. THE MIGHTY ROMAN ARMY TAKES JERUSALEM. AGAIN JUDAH IS DOWN-- AND THIS TIME IT IS TOO WEAK TO RISE.

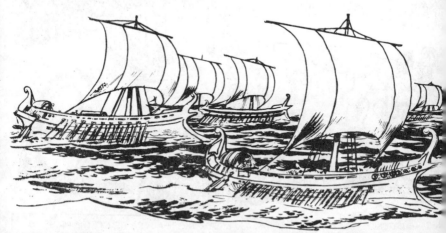

AFTER A TIME THE ROMANS APPOINT A MAN NAMED HEROD TO RULE THE JEWS. A CRAFTY, CRUEL MAN, HE TRIES TO WIN THEIR FAVOR BY BUILDING THEM A NEW AND MORE BEAUTIFUL TEMPLE, BUT THEY DESPISE HIM. BITTERLY THE JEWS CRY OUT: "WHEN WILL GOD SEND THE DELIVERER PROMISED TO US BY THE PROPHETS OF OLD?"

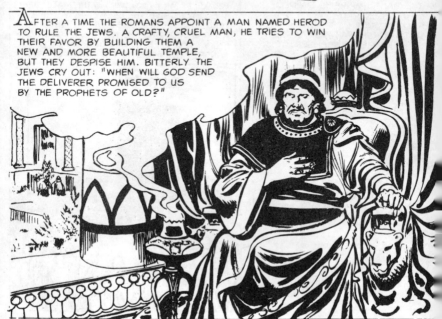

THE Bible

IS THE MOST INTERESTING BOOK EVER WRITTEN. BUT HOW MUCH DO **YOU** KNOW ABOUT IT? FOR EXAMPLE—SEE IF YOU CAN MATCH THESE WORDS TO THEIR BIBLE-TIMES PICTURES. CORRECT ANSWERS ARE AT THE BOTTOM OF THE PAGE.

IN BIBLE TIMES

AN **AQUEDUCT** WAS...

A. A WATER BIRD LIKE A DUCK.

B. A SHIP WITH A PROW LIKE A DUCK.

C. A STRUCTURE THAT CARRIED WATER.

PERSIAN WAS...

A. AN ORIENTAL CAT.

B. SOMEONE WHO LIVED IN PERSIA.

C. SOMEONE WHO TALKED PERSIAN TO PERSIAN ON AN ANCIENT TELEPHONE.

HOMER WAS...

A. A FORM OF HOMING PIGEON.

B. A CIRCUIT CLOUT IN AN ANCIENT BALL GAME!

C. A UNIT OF MEASURE EQUAL TO ABOUT 11⅔ BUSHELS.

The Bible

THE BIBLE AND ARCHAEOLOGY

THIS ANCIENT BABYLONIAN SEAL FROM ABOUT 3000 B.C. LOOKS LIKE THE BIBLE STORY OF EVE REACHING FOR THE FORBIDDEN FRUIT.

"...AND THERE WAS FAMINE IN THE LAND" (GEN. 12:10). AN OLD EGYPTIAN DRAWING SHOWS A THIN, STARVING MAN LEADING HIS OXEN.

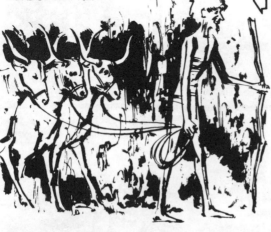

"HEZEKIAH...MADE A POOL, AND A CONDUIT, AND BROUGHT WATER INTO THE CITY."

THIS 1777 FT. LONG TUNNEL WAS BUILT IN 701 B.C. IT WAS RE-DISCOVERED IN 1838. IT STILL CARRIES WATER FROM THE GIHON SPRING TO THE POOL OF SILOAM.

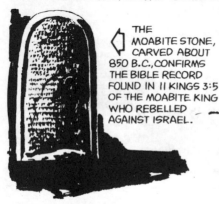

THE MOABITE STONE, CARVED ABOUT 850 B.C., CONFIRMS THE BIBLE RECORD FOUND IN II KINGS 3:5 OF THE MOABITE KING WHO REBELLED AGAINST ISRAEL.

IN 1947 AN ARAB BOY FOUND A CAVE TH/ HELD SEVERAL ANCIENT POTS FILLED WI SCROLLS. EXAMINATION BY ARCHAEOLC GISTS PROVED THE SCROLLS INCLUDED COPIES OF THE BOOK OF ISAIAH WRITTE! ABOUT 100 YEARS BEFORE CHRIST. THEY WERE THE NOW FAMOUS "DEAD SEA SCRO

*For older teens and
adults ..*

LIVING TRUTH

Four paperbacks for new
Christians who want to come
to grips with the teaching of
the New Testament.

A popular style and a popular
version (Living Bible) lead
the reader into a developing
awareness of God's message
for today. Cartoon illustra-
tions give the series an
instant-tell appeal.

*LOVING THE JESUS WAY
GOING THE JESUS WAY
LIVING THE JESUS WAY
GROWING THE JESUS WAY*

DAILY BREAD

Daily Bread notes give straightforward devotional and practical comment and cover most of the Bible in four years. This popular series is enjoyed by a wide variety of people.

Dated and published quarterly.

TODAY

Designed like a newspaper with topical photos, headlines and human situations with which the reader can easily identify, showing that the Bible is relevant to everyday life. Discussion questions with Bible references make it useful for any type of group as well as for individuals. There are eight magazines of 32 pages, each giving three months' readings.